HARPERCOLLINS COLLEGE OUTLINE

History of Art

Charles Minott, Ph.D.
University of Pennsylvania

HarperPerennial
A Division of HarperCollins*Publishers*

To the memory of Clemens E. Sommer and David M. Robb

An American BookWorks Corporation Production

Project Manager: Judith A.V. Harlan
Editor: Robert A. Weinstein

Library of Congress Catalog Card Number: 91-55405
ISBN: 0-06-467131-3

92 93 94 95 96 ABW/RRD 10 9 8 7 6 5 4 3 2 1

Contents

Preface

This is a narrative outline of art history from prehistory to the present. I hope that you will find it readable and expressed in words direct enough to help with the material of a survey course. There is a bibliography at the end of each chapter to lead to further reading in any given area. A Glossary at the end of the book will explain some specialized words of art history. The words and terms that appear in the Glossary have been *italicized* where they are first used in the text.

No book like this is written without kind suggestions and assistance. This writer has taught many times the courses for which this book is recommended. Yet the seemingly simple process of putting the material into published words is a different and demanding process. For their willingness to answer questions and explain details and to discuss ideas, the author would like specifically to thank his colleagues, especially David Brownlee, Renata Holod, Holly Pittman, and Paul F. Watson. Thanks also to Nancy Davenport and finally, to Judith A.V. Harlan and Fred N. Grayson for editorial efforts and patience.

Even more important words of thanks go to Gail Maxwell, who wrote chapter 22, "The Arts of Asia: India, China, Japan." Such a chapter requires learning that I do not have. While few survey courses include both Asian and European art history at once, I am confident that this one chapter will be extremely helpful for a survey course on Asian Art. I have learned from it.

Art is a visual process, and so is learning about it. Avail yourself of all the visual material you can. I have always advised my students to spend time looking at works of art equal to the time spent reading about them. Do both carefully and you can't fail.

Charles Minott
Philadelphia, 1992

1

Learning Art History

This book is intended to help you study the history of art at the college introductory or survey course level. Art history is the study of the visual arts in relation to the civilizations that produced them. In this introductory chapter you will find a number of suggestions that will enable you to understand the material more easily. It will not provide shortcuts—there are none—but it will guide you to the most effective ways to approach the subject. The book is a supplement, not a substitute for a textbook. If you plan to study art history on your own, you should also acquire one of the books listed in the bibliography at the end of this chapter.

As is true of any discipline in the humanities, art history has some vocabulary and usages that are particular to itself. Examples of these and additional useful preparatory information are discussed in this chapter. There is also some general advice on your approaches to the subject.

In spite of the name of the first section of the chapter, there is no universal definition of art. There are works that nearly everyone will agree are works of art. These fit into major art forms including painting, drawing, the graphic arts, sculpture, and architecture. The study of art history is the best way to find an understanding of the term art. *Much more than that, the study of art history is the way to comprehend art as a fundamental aspect of the human experience.*

WHAT ART IS AND WHAT IT DOES

Each of the forms of art mentioned above has many variations and may combine with any or all of the others. This diversity of artistic expression, from the dawn of time to the present, is the proper study of art historians. The broadest and most general compilations of their studies are textbooks for survey courses, usually presented in a sequence of two college semesters. Such courses form an introduction to a vital record of civilization not easily learned elsewhere.

The breadth and generality of a survey course presentation should not imply that the material is simple. Far from it. A good survey of the history of art will be a challenge to your memory and powers of observation. You will find that the study improves both of these faculties. More importantly, it will put meaning into the visual world around you that you never suspected was there or thought you could understand.

There have been innumerable attempts by philosophers, historians, and artists themselves to define what art is. This book will not make another. The difficulty is that *art* has a different meaning to every culture if not every person. For some societies expression in art has been as much a part of life as food and drink. In others it has been effectively relegated to an elite and limited number of practitioners and a select, specially initiated audience. It is ironic that art seems to be a more prevalent and universal part of societies we tend to think of as primitive and more exclusive and inhibiting to people of sophisticated and advanced cultures.

Since the beginning of recorded history, some 5000 to 5500 years ago in the Western Hemisphere, human beings seem to have assumed that art, however expressed and however limited in its practice, is an important factor in human life. Some have suggested that the making of art distinguishes human beings from all other forms of life. Certainly reaction to works of art on an intellectual or emotional level is uniquely human so far as we know.

Art Forms

Art is a means of communication from the artist to the viewers of the work produced. The choice of an art form to express ideas is usually based on the artist's experience and the appropriateness of medium to the idea. Visual representation of recognizable subjects is the first level of such expression. Beyond lie the artist's interpretation and choice of emphasis, mood, meaning, and implication of his or her chosen subject. We see and understand what an artist does in terms of our common human experience and reaction to color, shape, and line within the realm of our own culture and our cognition of the art of our times. Seeing these elements in the art of past cultures is in part another aspect of seeing and understanding our own.

We will begin with a few definitions of the forms of art already mentioned. Many of these terms will be familiar to you, but they may have limitations or special meaning in the context of art history that you should recognize.

PAINTING

Painting is the application of colored pigments on a two-dimensional, usually flat prepared surface. The work of art made by this process is called a *painting*. Brushes, painting knives, or other tools that can be loaded with paint are used to apply colors to the surface. There are many painting media, including fresco, watercolor, tempera, oils, encaustic (wax), and others. Each uses a binding device such as plaster, resins, glue, or oil to hold the pigments in suspension and to make them adhere to the surface.

Mosaic. A related medium, often classified with painting, is *mosaic*. Mosaics are made with small, individual colored pieces of stone, ceramic, and glass called *tesserae* (*tessera,* sing.). These are set in color patterns on a surface prepared with grout to hold them in place. Designs, color planes, and intricate painting-like images can be executed in mosaic.

DRAWING

Drawing is related to painting. It is sometimes included in the graphic arts. It is, again, a two-dimensional process involving lines or tones applied to a surface with instruments: pen or brush and ink, pencils, charcoal sticks, crayon, pastels, and chalk are among the drawing media. Drawing may be preparatory, used in planning for a composition to be finished as a painting. A drawing may also be a detailed study of a particular form, or it may be considered a finished work of art. Some preparatory drawings may come to be accepted as finished works of art. Albrecht Dürer's drawing *Praying Hands,* of 1509, for instance, was initially a detailed study for a figure in one of his paintings. The drawing is now widely acclaimed as a work of art. The painting for which it was initially a study has been lost.

GRAPHIC ARTS

The term *graphic art* is usually reserved for the various processes of artists' printmaking. Ink applied to one prepared surface is transferred to another, usually paper, by contact or pressure. In this manner the design can be repeated by re-inking the surface after each printing to make a number of identical images, called *impressions*.

Relief Printing. In *relief printing*—woodcut, wood engraving, linocut, and other types—the ink is applied to lines or patterns that are raised surfaces. The background is cut away. Woodcut, the oldest of all the graphic processes, was known in Asia from the first century A.D. In the Western Hemisphere woodcutting began in Europe in the late fourteenth century A.D.

Intaglio Printing. *Intaglio printing* includes engraving, etching, drypoint, and aquatint. Intaglio (in-tahl'-yo, from Italian, *intagliare*, "to cut into") means, in this case, that the lines and patterns are incised into a plate, usually of metal. Various tools are used for this purpose, or, in the cases of etching and aquatint, acid is used in a controlled way to create grooved lines or textures in the metal. These are filled with ink by rubbing it onto the surface of the plate. After the plate itself has been wiped clean, printing is accomplished by a roller press, transferring the inked lines onto dampened paper. Engraving, the earliest of the intaglio processes, began in early fifteenth-century Europe.

Planographic Printing. Planographic printing includes *lithography,* a transfer printing technique, and various stencil processes such as serigraphy (silk screen). Lithography was invented in Germany at the end of the eighteenth century. Its name derives from the original technique of drawing upon porous stone, though zinc plates are often used in modern lithography. By a complex procedure the drawing is replaced by printing ink and transferred onto paper using a flatbed press.

Photography. Photography is the most recent form of graphic art. It uses various cameras and optical apparatus to control the degree of exposure of an image to light-sensitive, chemically treated material, usually film. Further controlled light is used to transfer the photographed image, usually a negative, to photographic paper, where a positive image of the original subject will be developed.

SCULPTURE

The sculptor shapes three-dimensional forms according to a design. Volume, represented or implied, is added to line, color, and surface as an element in sculpture. Sculpture may be carved, modeled, cast, welded, or variously bent into the desired form. Two basic types of sculpture are generally recognized: freestanding and relief.

Freestanding Sculpture. *Freestanding sculpture*, or sculpture in the round, is work that has been designed to be seen from all sides. Sculpture in the round may stand upon a base or be suspended from an overhead fixture. It may be fixed or movable.

Relief Sculpture. *Relief sculpture* is carved into or modeled above a planar surface. It is usually designed to be seen from a single vantage point. The extent to which it is sunken into or raised from the surface is differentiated descriptively as *high* or *low* relief. The latter, sometimes called *bas-relief,* is the term applied to sculptural forms raised to the maximum of half their circumference from the surface.

Sculpture ranks as the oldest artist's medium of which we have record. Prehistoric idols carved in stone, mammoth tusk, and reindeer horn predate any paintings that survive. Drawing and painting cannot have lagged far

behind sculpture, however. All of these predate architecture, having their origins when humans lived in the open, seeking shelter in caves when necessary.

ARCHITECTURE

Architecture is both the least and the most abstract of the visual arts: least, because its most obvious purpose is variously to contain and shelter those for whom it is made; most, because the artistic expression is in excess of this practical function. Shape and space, passage, ritual, time, and cultural tradition are some of the elements bound into architecture. Materials, detail, and structural design are essential criteria for the evaluation of architecture.

The Components of Art

In painting, drawing, the graphic arts, and sculpture, the artist's work may be intended to represent figures and forms from the observable world around us. We call such work *representational*. At times artists make work that is *abstract,* using planes, colors, and lines or solid forms that will have an impact on the aesthetic sensibilities of the beholder without conveying recognizable images of objects or persons.

Line, space, form, and color are used by the artist to achieve the ends desired, be it a representation of an understandable event, person, landscape, or still life; an abstract form, drawn or painted, carved or modeled; or a usable and pleasing space. Line defines contours or builds shape by cumulative repetition. It may simply follow and describe the subject, or it may be varied in width and texture to express surface and light. Space depicted may represent a surface or a void in two or three dimensions. Form is created by line and space. It is defined by the contours of a solid or void. Color in material form—that is, colored pigment in suspension of one kind or other—is used by the artist to make lines, spaces, and forms.

One or another of the arts may be dominant in any historical period, although all will be present to some extent. Many of the art terms pertaining to these forms of art are defined in a glossary at the end of the book. Do not hesitate to use this glossary along with other study aids. Far from making a simple study of the abilities of individual artists to represent objects and experience or to build serviceable shelter for human activity, the historian of art works to provide a culture-connected history of the evolution and changes in the arts as they relate to successive eras of civilization.

Sometimes this study can provide a better understanding of the nature of civilization than any other historical discipline. Whatever humans choose to express through their art provides an incomparable opportunity to consider the values, options, and results in meaningful cultural and historical context.

THE OBJECTIVES OF ART HISTORY

Many works of art from the past reflect the reactions of those earlier cultures to events as history. Great events of history have often been used as patterns or models for artists in their own time. Indeed, the understanding of art in the context of a society often tells us more about its systems, philosophy, and nature than any other aspect of its historical records. More than one scholar has noted that art history is the "history of everything."

An example lies in two images of the same battle, the Battle of Issus. The battle itself took place between the armies of the Persian general, Darius, and the Macedonian Greek general, Alexander the Great, in 331 B.C., on the present Turkish-Syrian border, south of the Taurus Mountains by the Illus River.

One image, the *Alexander Mosaic,* was made about 250 years after the battle. It was part of the mosaic pavement in the house of a very rich Roman citizen of Pompeii, the town now famous for its well-preserved ruins, not far from Naples, Italy. The mosaic is thought to be a very close copy of a Hellenistic Greek painting made in the fourth century B.C., not long after the actual battle.

A second representation, called the *Battle of Issus,* is an oil painting on wooden panel. It was made by the German artist Albrecht Altdorfer. Altdorfer painted it in 1527 for Duke Wilhelm of Bavaria who ordered it as the key work in a commissioned series of famous battles. The task was so important to Altdorfer that he turned down the job of burgomaster (mayor) of the important Bavarian city of Regensberg in order to paint it. By this time the actual battle was 1860 years in the past.

Why should a patrician Roman of the first century B.C. and a Bavarian duke of the sixteenth century A.D. each want a picture of the same particular ancient and distant battle? The answer can tell us a lot about the usefulness of art history and something about the two cultures who each turned to a third for a given image.

The battle was a signal event in the record of human endeavor. That much is a given. The Roman citizen, living in Pompeii, a very Hellenized city, admired Greek art as did most Romans. The fury and clash of the mosaic representation of Alexander's victory provided a focal point for his courtyard floor. There is dignity, authority, and power in the realization of this battle as a world event. Historically, the battle stands at the beginning of the spread of Western empire building.

The Romans saw themselves as the natural inheritors of that glory. The choice of such a work, no doubt, reflects the self-image of the householder. It was in a communal part of the house and was given its own special space, a roomlike niche, called an *exedra,* opening off the main peristyle, or interior

court. That special treatment called attention to the work and to the householder's selection of it for the benefit of any guest.

The German duke had a very urgent and very public message to communicate through his commission to Altdorfer. That was to arouse popular awareness and sentiment in the face of the real and present threat from the Ottoman East, another impending clash of civilizations. The painter, who was also an engineer and builder as well as politician, was further given the very material job of rebuilding the city's fortifications. This speaks directly to us of history, for the defeat of the Turks at Vienna in 1529, within two years of the painting, spelled the end of the Ottoman threat. Moreover, over two centuries later another great military tactician, Napoleon Bonaparte, brought the painting to Paris because he loved it so much.

Art informs us of history and enlivens our sense of it. The costume and turmoil of war in the ancient mosaic probably have a high degree of historical accuracy. Beyond the representation of history, Roman taste, and preference for things Greek, the primary image interacts with our own emotions, associations, and understanding of the ancient world and the emergence of the human spirit.

Those same factors in Altdorfer's painting delight us as the fantasized re-creation in sixteenth-century terms of a battle far away and long ago. The great swirl and clash of German knights and stylized Eastern warriors in endless array is an epic, yet fantastic, vision. Utterly different in its appeal, but no less a commanding work of art, Altdorfer's painting communicates the global impact of the event impressively. We see to the curved horizon. The moon and sun, ancient symbols of East and West, respectively, track their courses in the vast sky, asserting the day-long duration of the battle.

There are, of course, many reasons for the making of art beyond those that inspired the mosaic and the panel painting of Alexander's victory. Some buildings require a particular form, and that may inspire an architect to express that form in new patterns. Sculptures and paintings representing everything from the sacred to the intimately familiar are made on commission or independently by artists willing to interpret visual experience and needs for their contemporaries. The more acquainted we are with art, its traditions, and its capacity for interpreting ourselves, the more readily we take to the forms of art as they evolve in our own time. Contemporary buildings, sculpture, and paintings sometimes seem unacceptable at first encounter, only to become indispensable parts of our civilization within a few years. They, in turn, become the standards against which we measure newer and bolder changes.

HOW TO STUDY ART HISTORY

Art history is a visual study. Images are the material of the course. Be prepared to spend as much time as you can looking at pictorial material. You will soon find that there is more in your everyday environment of historical and artistic reference than you ever thought. Buildings will take on new meaning, as will paintings, prints, and sculpture. Knowing the great works of the past in a historical context will enhance your experience of the present.

History and Time

As you progress you will need to develop a time sense of history. Most introductory books on the history of art contain some form of chronological time lines, often arranged as bar graphs, in order to demonstrate the sequences and synchronicities of cultural time and time phases. Understanding the development of visual forms and interchanges of artistic influences depends upon your awareness of interrelated chronologies. As different as they are, for instance, Egypt and Mesopotamia emerged in a similar time frame, between 3500 and 3000 B.C., in demonstrable contact with one another. Time lines, like the glossary already mentioned, are all aids to study. Together they can assist in visualizing the historical evolution of regions and art forms.

Time lines and history are applicable to art history only in the sense that artistic expression changes over time and that styles migrate by historical contacts between cultures. Study of the expression of form and meaning in art is not a study of progress but of change. As such it provides a record of history itself.

TIME PERIODS OF ART HISTORY

There are four more or less traditional time periods into which the ages of art history in the Western Hemisphere are usually divided. These are the ancient, medieval, Renaissance, and modern periods. Most books set them apart as sections of their texts. The ancient world proceeds from prehistory and the dawn of civilization to the preclassical and classical eras. It often includes the late classical world of early Christian and Byzantine art. The Middle Ages, or medieval world, includes the barbarian migrations, the early Islamic, Carolingian, Ottonian, Romanesque, and Gothic periods. The Renaissance, or Renaissance and baroque world, usually includes the fifteenth to mid-eighteenth centuries, and modern covers the period from the second half of the eighteenth century to the present. Each of these areas has many subdivisions.

Although most general art history courses focus on the art of the Western Hemisphere, most cover non-Western art and include primitive and Oriental art history.

LANGUAGE OF TIME

There are conventions for designating time in a historical sense, the most familiar of which are the terms "B.C." (before Christ) and "A.D." (*anno Domini,* in the year of the Lord). Most textbooks, including this one, use these forms. You may encounter the forms "B.C.E." (before the common era) and "C.E." (common era) in some of your reading. They correspond exactly to B.C. and A.D. Not all dates are certain, by any means, so authors use the term "circa" (Latin for "about" or "approximately"), abbreviated "ca." or "c.," with the century or year when the exact date has not been established.

Be sure to understand references to centuries. To be historically exact, the years 1901–2000 inclusive represent the twentieth century A.D.; and 1–100, the first century A.D. The years 1999–1900 are the twentieth century B.C., and 99–0 B.C. are the inclusive years of the first century before Christ. A monument from 421–405 B.C. (the *Propylea on the Acropolis in Athens)* is of the late fifth century B.C.; one from A.D. 118–125 (the *Pantheon,* Rome) belongs to the first half of the second century A.D. For the terminology designating art historical periods, eras, cultures, movements, schools, and so on, familiarize yourself with this usage, but remember that the distinctions and divisions of time periods are not so much facts as guidelines.

This book also contains a bibliography of more specialized reading in the areas covered by each chapter. These listings provide a useful guide to more extensive information available in the most dependable source books.

The study of art history is, in many ways, the study of humankind's assessment of itself. Events come to life when we see material evidence of them. Works of art express this no less, and in many cases more, than site markers or material relics.

It has already been suggested that this book, if not used in conjunction with a course, should be used with one of the general texts listed in the bibliography at the end of this chapter. Any one of these will provide illustrations of most, or all, of the works of art discussed in our text. You may also want to pursue some areas further in the books listed at the end of each chapter.

Where possible, combine your reading with museum visits and excursions to sites of buildings or other works or collections. No amount of description and no book illustration, photograph, or slide is capable of communicating the full impact to be found in the direct encounter with original works of art.

In whatever form they choose to express themselves, artists seek to communicate. Our understanding of that communication is expanded the more we look at art. Painting, sculpture, drawing, and printmaking are often grouped as representational arts. They are pictorial, intended to form a visual representation of the material or emotional world. Architecture is an even more participatory art. Awareness of it comes through our direct experience of space and the framework that the architect has used to define it.

An artist's view of his or her culture is often defined by his or her own knowledge of history and the influence of the past. A concept of a heroic age past may encourage references to that age in an artist's present works. Roman art in the guise or style of Periclean Athens expresses Roman admiration for that period in Greece. The Renaissance in Italy is based on awareness of the ancient world, its parallels extrapolated from experience. Famous victories may be used to encourage confrontation in new conflicts, and famous treaties may urge continued peace. Calling such events and deeds forth in art brings their impact to a wider audience.

These are only some of the considerations brought out in a course of study in art history. They should be kept in mind as part of the rationale of all art. You will have the joy of finding many others.

Selected Readings

TEXTBOOKS

De La Croix, H., R. G. Tansey, and D. Kirkpatrick. *Gardner's Art Through the Ages.* 9th ed. New York: Harcourt Brace Jovanovich, 1991.

Gombrich, E. H. *The Story of Art.* 15th ed. Englewood Cliffs, NJ: Prentice-Hall, 1989.

Hartt, F. *Art: A History of Painting, Sculpture, Architecture.* 2d ed. Englewood Cliffs, NJ: Prentice-Hall, 1985.

Honour, H., and J. Fleming. *The Visual Arts: A History.* 3d ed. Englewood Cliffs, NJ: Prentice-Hall, 1991.

Janson, H. W., and A. F. Janson. *History of Art.* 4th ed. Englewood Cliffs, NJ: Prentice-Hall, 1991.

Kostof, Spiro. *A History of Architecture: Settings and Rituals.* Oxford: Oxford University Press, 1985.

ART DICTIONARIES AND ENCYCLOPEDIAS

Murray, P., and L. Murray. *A Dictionary of Art and Artists.* 4th ed. New York: Penguin, 1976.

Encyclopedia of World Art. 17 vols. New York: McGraw-Hill, 1959–1968; supplementary vol. 16, 1983; vol. 17, 1987.

International Dictionary of Art and Artists: From the Renaissance to the Present. 2 vols. Chicago: St. James, 1990.

HISTORICAL DOCUMENTS OF ART

Holt, Elizabeth G., ed. *A Documentary History of Art:* vol. 1, *The Middle Ages and the Renaissance*; vol. 2, *Michelangelo and the Mannerists;*vol. 3, *The Baroque and the Eighteenth Century*, Princeton, NJ: Princeton University Press, 1982.

Janson, H. W., ed. *Sources and Documents in the History of Art.* series. Englewood Cliffs, NJ: Prentice-Hall. See individual entries in relevant chapter bibliographies.

2

Prehistoric and Primitive Art

Prehistoric Art

c. 35,000–8000 B.C.	Upper Paleolithic Age
c. 30,000–10,000 B.C.	Arrival of Asian people in North America
c. 25,000 B.C.	*Venus of Willendorf*
c. 25,000–15,000 B.C.	Small sculptures of stone, horn, mammoth ivory, bone
c. 15,000–10,000 B.C.	Relief sculpture of animals in caves in France, Spain
c. 15,000–8000 B.C.	Cave paintings
c. 10,000–3000 B.C.	Mesolithic Age (end of Ice Age); improved tools, agriculture, painting on rock walls
c. 8000–3000 B.C.	Neolithic Age
to c. 1500 B.C.	Neolithic Europe
c. 7000 B.C.	Ancient Jericho
c. 6000 B.C.	Çatal Hüyük
c. 2500–2000 B.C.	Origins of Harappa culture, Indus River region

c. 2000 B.C.	Stonehenge
c. 1500 B.C.	Shang Dynasty, China

Primitive Art AFRICA

(In Africa have been found the earliest traces of humankind. There are also Neolithic painting sites in the Atlas Mountains.)

500–200 B.C.	Nok, central Nigeria; terra-cotta heads and figures
10th–12th century A.D.	Ife, Tassila region, western Nigeria, southern Algeria, terra-cotta and bronze heads
16th–17th century	Benin; bronze figures, plaques, vessels
18th–20th century	Yoruba; carved wooden figures
19th–20th century	Zaire; wooden ancestor figures
18th–20th century	Dan (Liberia, Sierra Leone, Ivory Coast); masks, carved wood, added materials

SOUTH AMERICA

c. 1000– c. 100 B.C.	Chavin culture
c. 100 B.C.– A.D. c. 700	Moche culture, northern Peru; temples, metal ornaments, ceramics
	Nasca culture, southern Peru; ceramics.
	Tihuanaco culture, Lake Titicaca region, southeastern Peru; sandstone buildings, relief sculpture
A.D. c. 1000– A.D. 1500	Inca culture, Cuzco, Peru; Coricancha (Temple of the Sun), Macchu Picchu

MESOAMERICA

c. 2000 B.C.– A.D. 200	Olmec culture, La Venta, Mexico; colossal basalt heads, jade sculpture
c. 100 B.C.– A.D. c. 600	City of Teotihuacan, valley of Mexico, Zapotec and Mayan cultures; pyramids, town planning, relief sculpture
A.D. c. 700–c. 1550	Totonnac, Mixtec, Mayan, Toltec, and Aztec cultures

NORTH AMERICA

c. 10,000 B.C.	Earliest cultures
c. 1000 B.C.– A.D. 1650	Prehistoric period; Adena-Hopewell culture; Ipiutac, Mesa Verde, Mississippian, Mimbres, and Kuana Pueblo cultures
c. 1600 to present	Historical era; Eskimo, northern tribes, Plains, Eastern Woodlands, Southwest, tropical cultures

The records of human activity before there was written language as a means to document the events or experiences of any society or group of people have been divided into ages. Thus we refer to the Stone Age, Paleolithic (Old Stone Age), Mesolithic (Middle Stone Age), and Neolithic (New Stone Age); Bronze Age; and Iron Age in reference to early humans. These are not so much time periods as stages in human development. They are not synchronous in all parts of the inhabited world.

Until the present century, for example, there have existed societies of Stone Age people. The study of their cultures, primarily by anthropologists, helps to provide parallel evidence for early human development and early culture in parts of the world where technology, civilization, and historical time have superseded this first stage.

PREHISTORIC ART

Evidence of human endeavor in art can be traced to sometime after 35,000 B.C., particularly to the Late or Upper Paleolithic period. The whole Paleolithic Age lasted from the beginnings of human use of stone tools to about 8000 B.C. It includes the greater part of all human history since humans appear to trace back more than four million years in time. Much of our information about prehistoric art refers to works produced in the Late Old Stone Age, not long ago in the whole course of time.

The Upper Paleolithic Period (Late Old Stone Age)

The best-known works of the Upper Paleolithic period include a few works of sculpture in the round. These include the famous *Venus of Willendorf*, a tiny, 4-inch (11.5-cm) sculpture in stone of a nude female, dated around 25,000 B.C. She is believed to represent a fertility idol. Other small sculptures of stone, horn, mammoth tusk, and ivory survive, mostly dated before 15,000 B.C. They include other small figures, mostly female and also presumably fertility figures, along with carvings of animals, including horses, bison, and others.

Relief sculptures of humans and animals appear on cave walls in France and Spain. These, some as large as life-size, date from 15,000 to 10,000 B.C.

Paintings, too, are found on cave walls depicting animals and human figures. Many of these are also life-size. They were made using powdered red ocher, magnesium, and other natural materials as pigments that were either blown onto the surface with hollow tubes or brushed on with moss or matted hair. The paintings on cave walls were mostly in remote or hidden caves away from those used as dwellings. They are deemed likely to have served ritual or magic purposes. Caves in Altamira, in the mountains of northern Spain, and at Niaux and Lascaux, in the French Pyrenees and the Dordogne region of France, are especially famous.

The art historian's interest in prehistoric art is in part similar to that of the ethnohistorian and anthropologist. How were these paintings and carvings related to the tribe or group that produced them? Has the image some empowering role over the thing portrayed, invested in the artist or transmitted to others by its very portrayal? Such questions are foreordained to remain speculative. Art historians have also grouped these works, particularly the cave paintings, by style and region, giving them such names as *Aurignacian*, *Magdalenian*, and *Mousterian*. Their major attraction to the art historian is the extraordinary energy and accuracy of the images, particularly in the cave paintings of bison, horses, and deer. These show a sophistication in visual observation and depiction that might be unexpected of a "primitive" society.

It should be noted that from earliest times the representation of animals shows a surprising ability to depict the creature in recognizable form and with sophisticated suggestion of motion and proportion. On the other hand, when humans are portrayed, they are greatly reduced in detail, often as unarticulated stick figures. Whatever fear or superstition governs this, it is, as near as can be told, a universal fact. It leads us to speculate that lifelike representation empowers the artist or the tribe over the thing depicted, perhaps the earliest manifestation of the fear that extracts the proscription of images or special reverence toward them in many later cultures.

The Mesolithic Age

After the last Ice Age, when the temperate zones of earth were left fertile and amenable to agriculturally based human societies, a transitional period called the *Mesolithic* has been identified. It lasted from before 10,000 to around 8000 B.C. and extended to around 3000 B.C. in some places. New skills with technology led to tools with affixed handles and advanced hunting materials in this period. Humans no longer lived in caves. They made their paintings and drawings on open rock surfaces rather than in caves. Hunting and war scenes predominate. Mesolithic sites are in Spain and other Mediterranean locations.

The Neolithic Age

The Neolithic Age (New Stone Age) began around 8000 B.C. Although it paved the way for historical humankind and the birth of civilizations, the Neolithic Age has left little evidence of itself. Settlements that became villages and ultimately expanded to fortified cities appeared in this period, with the development of irrigation and stock-raising. Shrines, temples, and megalithic structures indicate rituals related to seasons, life, and death. Until the present century, moreover, there have persisted societies of Stone Age people. The beginnings of civilization in the Near East, marking the end of the Neolithic Age in the areas of earliest development, occur between 3500 and 3000 B.C. in Egypt and Mesopotamia, as noted above. In Europe the Neolithic Age continued until past the middle of the second millennium (1500) B.C.

Cities dating as far back as 8000–6000 B.C. have been excavated in the Near East. Jericho, Çatal Hüyük, and others were built of mud brick with defensive walls. The European Neolithic Age is characterized by megalithic (literally, "large stone") structures. *Menhirs* are vertical stones 10 to 20 feet (2.6 to 5.2 m) high raised singly or in rows. *Dolmens* are made from two vertically placed stones supporting a lintel or capstone. These are also between 10 and 20 feet (3 and 6.1 m) high. *Cromlechs* are circular arrangements of menhirs or dolmens such as the famed circle at Stonehenge of c. 2000 B.C. The function of these megalithic structures included use as shrines or the alignment of stones for astronomical calculation. In some cases the dolmens are burial sites.

Most of the dwellings of Neolithic peoples in Europe were impermanent wooden structures, partially sunken with roofs on short posts. Some lake dwellings on pilings have been discovered in Switzerland and in the Danube region of Germany.

Very crude relief sculpture appears on some Neolithic megaliths, especially menhirs. Wall painting appears in Near Eastern Neolithic art. Çatal Hüyük in southern Anatolia is one such site. Hand-built pottery with painted patterns on the surfaces appears in both Near Eastern and European Neolithic art.

PRIMITIVE ART

Various conditions of climate, geography, and communication have contributed to differing rates and stages of development in the populations of the world since the beginnings of civilization in the ancient Near East. The development of a culture in the valley of the Indus River in western India marks the origins of South Asian civilizations. This took place in the

late third millennium B.C. A major site is Harappa, from which the early culture takes its name. Later, in the mid-second millennium, Far Eastern culture is recorded in the region of the Huang Ho (Yellow) River in China. Traditionally, the Hsia dynasty extends as far back as the fourth millennium.

The expansion of world cultures, however, failed to reach all corners of human habitation until the present century. Thus while advanced civilizations have progressed remarkably in centers of world population, their expansion has periodically crossed and ultimately absorbed or destroyed others at less developed stages. Our knowledge of the Etruscans or of the pre-Columbian civilizations of the New World, for instance, has suffered in this way.

In Africa, North America, and the South Pacific—on the Australian continent and the island archipelagoes reaching eastward as far as Easter Island—groups, tribes, and settlements of people have resisted or escaped the encumbrances of civilization. Their art, which some call *ethnographic* and others *native* in lieu of *primitive,* represents a usable parallel to the art of Neolithic cultures. One may be impressed with the arts of these cultures, yet their study remains largely in the province of anthropology. Fetish figures, carved idols, totems, masks, and body decoration are all symbolic manifestations of primitive belief. They also display evidence of an innate design sense common to all humanity. The skills with wood, stone, and other natural materials and the Bronze Age technology achieved by some of these cultures express a universal imperative toward image making.

In the most significant encounters with these arts, their style and images have brought changes to the mainstream of art. Notable examples are the primitivism of Paul Gauguin at the close of the nineteenth century and the African tribal masks that influenced Picasso's early cubism. These have increased our understanding and perspective in approaching the meaning and value of the art of all cultures.

African Art

From Guinea along the north and west coasts of the Gulf of Guinea to Gabon on the equator and inland eastward to Zaire is a vast tropical region of Africa that has produced a wide array of black tribal cultures with richly varied styles of art.

IFE

The Ife culture, which flourished between 1000 and 1500 A.D. in Nigeria, developed bronze casting in the lost-wax process, perhaps independently of the Mediterranean practice developed in antiquity. Ife bronzes are detailed and approach a naturalism in the heads of figures though the allover proportions are not naturalistic.

BENIN

The Benin kingdom, also in Nigeria and related to the Ife culture, began in the fourteenth century. Benin preserved a bronze-casting tradition until late in the nineteenth century. Benin bronze reliefs of kings and attendants are astonishingly complex and vital. The extraordinary head of a "princess" in the British Museum, London, from fourteenth- to sixteenth-century Benin, is an expressive masterpiece, comparable in its own power to the head of an Akkadian ruler in the Iraq Museum in Baghdad.

YORUBA

The Yoruba culture centered at Ikerre, between Ife and Benin, has preserved some of the stylistic traditions of its predecessors. A wooden carved door of recent date with ritual scenes from Yoruba tribal life reflects the relief style of Benin bronzes.

Primitive African art from all these areas began to be collected for anthropological and ethnographic study in the nineteenth century. Guardian figures of wood coated with brass from the Bakota tribe of Gabon and masks made in all of these cultures from Sierra Leone eastward to Zaire, the former Belgian Congo, found resonance within the emerging styles of modern art at the beginning of the twentieth century. Picasso and the expressionists of the twentieth century made works that depend partly on African models.

Arts of the Americas

From the sixteenth century onward, North, Central, and South America have been explored, colonized, and developed by Europeans. The inexhaustible resources of two newly discovered continents provided irresistible motivation to the Spanish, French, and British for conquest and exploitation. Firearms and armor aided in making short work of the destruction of highly sophisticated pre-Columbian cultures in Central and South America. North American native cultures, too, fell to the expansion of trade, colonization, and agriculture. None of these cultures had progressed much beyond the Stone Age in material technology, although most had written and spoken language and highly sophisticated art forms and many had a substantial architectural tradition.

It is presently believed that the peoples of North and South America arrived from Asia across the land bridge that once connected Asia and America at the Bering Strait. This migration occurred at least 10,000 years in the past and perhaps extends back as many as 30,000 years ago. Over subsequent centuries these people spread to both of the Americas. Their cultures developed within the climate and resources of the areas they settled, thus resulting in a wide variety of separate languages and traditions.

SOUTH AMERICAN ART

In South America the most notable cultures were those of the Andes regions of Ecuador, Peru, and Bolivia from the Pacific coastal plain to the high mountain plateaus and the eastern slopes of the Andes to the Amazon River. Chavín, Mochica, Nasca, Tiahuanaco, and Inca are the best-known names of cultures extending from the first millennium B.C. to the sixteenth century, when the Incas were destroyed by the armies of the *conquistador* Francisco Pizarro.

Inca. The Inca capital was at Cuzco, where there are preserved remains of the great temple *Coricancha* (Court of Gold). The preserved mountain village of Macchu Picchu is the best example of the Inca civilization. Perched on a ridge 2000 feet (610 m) above valleys on either side and 9000 (2750 m) feet above sea level, Macchu Picchu is a remarkably well preserved city of A.D. c.1500 built of mortarless fitted ashlar stone, shaped in the absence of metal tools by abrasion alone.

MESOAMERICAN ART

Mesoamerican culture extends from southern Mexico and the Mexican Yucatán to Guatemala, Belize, and Honduras.

Olmec. The oldest of these cultures is the Olmec. From beginnings as early as 2000 B.C. the Olmec culture continued to around A.D. 300. Olmec territory extends along the southernmost coast of the Gulf of Mexico in the present states of Vera Cruz and Tabasco. Its best-known monuments are the colossal stone heads found at La Venta and other sites.

Four of these stood at corners of a plaza before the temple-pyramid at La Venta, each 6 to 8 feet (1.8 to 2.4 m) high, weighing around 10 tons (9100 kg). The Olmec heads are carved with intense frowning expressions, large fleshy lips, and astonishingly subtle planes in cheeks and jowls.

Aztec and Maya. The Aztecs of Mexico and Maya of Yucatán have left enough records of their cultures to indicate a high degree of sophistication in building and sculpture. Writing systems, unknown to the Incas, have provided detailed records of the activities of Mayan rulers and Aztec history. Hernando Cortes was the Spanish conqueror of Mesoamerican lands. The richness of Aztec and Mayan sculpture, pottery, and architecture is still in process of discovery.

The Mayan culture in Yucatán, Guatemala, Belize, and Honduras may have begun as early as the ninth century B.C., though the classic period of its theocratic city-states probably began early in the first century A.D. and lasted until the tenth. Archaeological discovery and Mayan records themselves reveal a culture of great sophistication. It was ritualistic, dependent upon astronomical and mathematical knowledge, a hieroglyphic writing system, and an enormous number of gods of whom the ruling human king

was identified as a principal deity. Maya religion also depended upon ritual sacrifice, bloodletting, and execution of enemies.

Cities were primarily laid out as public spaces with plazas and temples dominant. High and steep-stepped pyramidal temples faced the courts. They combined tombs for rulers, temple chambers, and platforms for ritual human sacrifice.

In Mexico, the Mixtec, Toltec, and Aztec civilizations emerged after the classic Mayan period. They survived to Cortez's conquest. Archaeologists and anthropologists are still developing knowledge of these civilizations from the reconstructed language and tradition of the pre-Columbian civilizations of the Americas.

NORTH AMERICAN ARTS

North American natives constituted a varied assortment of cultures settled in all regions of the continent. In the Arctic were Eskimos (Inuit) and northwestern tribes Tlingit, Chilkat, Haida, and others. The Native Americans of the Great Plains included many separate tribes, as did the Eastern Woodlands tribes. The tropical Seminoles, the desert tribes of the Southwest, and many others were distributed throughout the North American continent. Their arts were widely arrayed through available materials from walrus ivory, bone, shell, hide, stone, wood, sand, pottery, and textiles.

In North America, as in South America and Mesoamerica, the conquest of the native peoples was accomplished with little interest in their cultures or traditions. The process was longer, not spurred by the lust for gold, though just as inevitable in outcome. Although much has been lost, more records and memory survive of the Native Americans of this continent.

Arts of Oceania

Oceania includes the land mass of Australia, the island groups of Melanesia and Micronesia, including New Guinea and the Solomon Islands with several other island clusters, and Polynesia, an enormous triangular area of the South Pacific extending from New Zealand to Hawaii to Easter Island, including the Cook Islands, the Society Islands, and the Marquesas. The arts of these regions are not extensively studied or traceable to any historical evolution. Their histories are vague and the materials of their art mostly perishable: wood, fibers and feathers, bark, and body paint.

POLYNESIA

The notable exception to the predominance of organic materials used in the arts of Oceania are the most famous of all the arts of the region, the great rock Guardian Figures on Easter Island, known to exist as early as the seventeenth century but so old that when discovered by European explorers they predated the memories of the island people. Carved war-god images (*Kukailimoku*) from Hawaii of stone or wood, wooden god figures from the

Cook Islands, and later ancestor figures from Easter Island were carved in complex patterns in regional styles. Tattooing, practiced in most of the Polynesian islands, and bark-cloth (*tapu*), painted and decorated, are also characteristic Polynesian arts.

MELANESIA AND MICRONESIA

Melanesian art is characteristically more intricate, colorful, and flamboyant than that of Polynesia. Masks, ancestor figures, spirits, and ornamentation appear in almost all the Melanesian and less productive Micronesian islands. Again, wood and organic materials are the mainstay of the craft materials used in these regions.

AUSTRALIA

The native arts of the vast Australian continent have been little studied. By about 5000 B.C. there were Paleolithic peoples in Australia, and these cultures remained relatively unchanged until the arrival of Europeans around A.D. 1800. Best known of native Australian works are the diagrammatic historical scenes representing the origins of tribes and the anatomical "X-ray" views of hunted animals that depict organs, skeletons, and form of the game sought. These are painted on bark. Little sculpture has been found or discussed in studies of the Australian native arts.

The religious or cultic use of ancestor paintings invokes the origins of tribes in the mythical past, known as the *Dreamtime*. As with most all primitive art, the myths of creation are closely linked with the well-being and perpetuation of the tribe.

There have been humans on earth for more than four million years. Only the most recent one-hundredth of that time contains any records of "art" made as a visual indicator of human consciousness.

The way that primitive societies first recorded any experience of what could be seen is found in simple line drawings scratched on bone or mammoth ivory. Later, painted or stenciled images appear on cave walls, made by artists of the Upper Paleolithic period in places apart from ordinary living quarters.

Between 35,000 and 3500 B.C. human abilities developed further than they had in the entire history of human existence prior to that. From cave dwellings and cave painting, groups emerged to a system of building cities and temples and to a religion requiring visualized images, symbols, and various astronomical observations, calculations, and record keeping.

The first steps to a culture or civilization depend upon the understanding of shared abilities and annual cycles of planting and harvesting. These establish the rhythm from which all aspects of culture and civilization, especially its arts, are derived. It is not surprising, then, that the first

civilizations appear where the land is most fertile and the annual cycle most predictable. Mesopotamia and Egypt are such places.

Selected Readings

PREHISTORIC ART

Bandi, H. G., and H. Breuil. *The Art of the Stone Age: Forty Thousand Years of Rock Art*. 2d ed. London: Methuen, 1970.

Bataille, G. *Lascaux: Prehistoric Painting or the Birth of Art*. Lausanne: Skira, 1980.

Breuil, H. *Four Hundred Centuries of Cave Art*. Reprint. New York: Hacker, 1979.

Leroi-Gourhan, A. *The Dawn of European Art: An Introduction to Cave Painting*. Cambridge: Cambridge University Press, 1982.

Megaw, J. V. S. *The Art of the European Iron Age*. New York: Harper & Row, 1970.

Sanders, N. K. *Prehistoric Art in Europe*. 2d ed. New York: Penguin, 1985.

PRIMITIVE ART

General

Anton, F., et al. *Primitive Art: Pre-Columbian, North American Indian, African, Oceanic*. New York: Abrams, 1979.

Boaz, F. *Primitive Art*. New York: Dover, 1955.

Fraser, D. *Primitive Art*. London: Thames and Hudson, 1962.

Wingert, P. *Primitive Art: Its Traditions and Styles*. New York: Oxford University Press, 1962.

Africa

Allison, P. *African Stone Sculpture*. New York: Praeger, 1967.

Bascom, W. R. *African Art in Cultural Perspective: An Introduction*. New York: Norton, 1973.

Ben-Amos, P. *The Art of Benin*. New York: Thames and Hudson, 1980.

Cornet, J. *The Art of Africa*. New York: Phaidon, 1971.

Davies, O. *West Africa before the Europeans: Archaeology and Prehistory*. London: Methuen, 1967.

Gillon, W. *A Short History of African Art*. New York: Facts-on-File, 1984.

Laude, J. *The Arts of Black Africa*. Berkeley: University of California Press, 1971.

Lieris, M., and J. Delange. *African Art*. New York: Golden, 1968.

Willet, F. *African Art*. London: Thames and Hudson, 1971.

The Americas

Broder, P. J. *American Indian Painting and Sculpture*. New York: Abbeville, 1981.

Coe, M. D., and R. A. Diehl. *In the Land of the Olmec*. 2 vols. Austin: University of Texas Press, 1980.

Feest, C. F. *Native Arts of North America*. New York: Oxford University Press, 1980.

Franch, J. *Pre-Columbian Art*. New York: Abrams, 1983.

Kubler, G. *The Art and Architecture of Ancient America* (Pelican History of Art). 2d. ed. Harmondsworth: Penguin, 1975.

Lupiner, A. *Pre-Columbian Art of South America*. New York: Abrams, 1976.

Oceania

Bernot, R. M. *Australian Aboriginal Art*. New York: Macmillan, 1964.

Dodd, E. H. *Polynesian Art*. New York: Dodd Mead, 1967.

Guiart, J. *Art of the South Pacific*. New York: Golden, 1963.

Kaeppler, A. L., and D. Newton. *The Art of the Pacific Islands*. Washington, DC: National Gallery, 1967 (exhibit catalog).

Schmitz, C. A. *Oceanic Art: Myth, Man, and Image in the South Seas*. New York: Abrams, 1971.

Stubbs, D. *Prehistoric Art of Australia*. New York: Scribner, 1975.

3

The Art of the Ancient Near East

3500 B.C.	Protoliterate period in Mesopotamia, predynastic Egypt
3000–2300 B.C.	Sumerian Mesopotamia
3000–2686 B.C.	Early dynastic Egypt, first dynasty, King Narmer
2686–2150 B.C.	Old Kingdom in Egypt, third dynasty, King Zoser
2300–2150 B.C.	Akkadian Mesopotamia
2150–2050 B.C.	First Intermediate period in Egypt
2150–1900 B.C.	Neo-Sumerian Mesopotamia
2050–1750 B.C.	Middle Kingdom in Egypt
1900–1600 B.C.	Babylonian period in Mesopotamia
1790–1750 B.C.	Hammurabi
1750–1570 B.C.	Second Intermediate period in Egypt
1600–1150 B.C.	Kassites and Mittanni in Mesopotamia; Hittites in Anatolia, Boghazköy, c. 1400
1570–1070 B.C.	New Kingdom in Egypt; Hatchepsut Temple, Dier el-Bahari, c. 1400
1361–1352 B.C.	Amarna period in Egypt (Akhenaten)
1150–538 B.C.	Assyrian empire in Mesopotamia
1070–716 B.C.	Third Intermediate period in Egypt
716–332 B.C.	Late period in Egypt

625–538 **B.C.** Neo-Babylonian kingdom

538–331 **B.C.** Persian empire

525 **B.C.** Persians conquer Egypt

332 **B.C.** Alexander the Great conquers Egypt

331 **B.C.** Alexander conquers Persians at Battle of Issus

Between 3500 and 3000 B.C., two civilizations emerged. They were very different from each other in terrain and traditions, but they were in contact with each other from earliest times. Ancient Mesopotamia was the earlier of the two to take form. There the stabilization and continuity of settlements was enabled by the development of agriculture. The ancient Mesopotamians used artificial irrigation systems by digging canals to divert water from the Tigris and Euphrates rivers.

Egypt, the locus of the second civilization, also depended upon agriculture for its development. Here it was based upon the predictable annual flooding of the Nile River. The floods left renewed silt deposits on the valley floor, ensuring each year's crops. The stabilization of the population by the conquest of Lower Egypt on the part of the Upper Egyptians led to a continuous and inspired civilization beginning close to 3000 B.C. It lasted for about two and a half millennia. The land is protectively bordered by the Red Sea and Syrian Desert to the East and the Sahara Desert to the West, a daunting blockade against external invasion.

A civilization requires a settlement of people, a government of laws, a written language, and the establishment of a system of life that depends upon the interactions of its members to feed, educate, and defend one another for the common good. The presence and preservation of these in Mesopotamia and Egypt may be taken to represent the origins of Western civilization as a whole. In Mesopotamia the lands are open and devoid of natural defenses. This led to a succession of city-states and peoples with very different cultures and traditions who dominated the territory in sequence. By contrast, the rule and culture of Egypt changed little over time until the Persian conquest in the sixth century B.C.

ANCIENT MESOPOTAMIAN ART

Mesopotamian Art

From the northern coast of the eastern Mediterranean, the Anatolian peninsula, to its eastern coast, where Israel, Jordan, and Syria are now located, across northern borders of the Arabian desert to Persia (present-day

Iran) are the remains of Neolithic settlements. Some, like Jericho in Israel, are very ancient indeed, with intricate streets and walled boundaries from 7000 B.C. The east-central regions of this territory, collectively the ancient Near East, represented by present-day Iraq, contains two major rivers, the Tigris and the Euphrates. The common valley between them, called *Meso-potamia*, "land between the rivers," produced the earliest of civilizations commonly recognized as such with language, productivity, and territories in place. This civilization emerged between 3500 and 3000 B.C.

THE PROTOHISTORIC PERIOD

During the half millennium before 3000 B.C. the Mesopotamian region was settled by people who built walled villages. The walls and their houses and temples were made of mud brick, there being little stone in the region. Pottery and cylinder seals have been excavated from this period. At the same time, language evolved to a written form.

SUMERIAN ART: THE DYNASTIC PERIOD

The Sumerians were a people of unknown origin who moved into southern Mesopotamia around 3000 B.C. Their culture replaced the Neolithic tribes of earlier settlement. The region was then coastal, each river emptying separately into the Persian Gulf. Individual cities, Ur, Uruk, Telloh, and others, were founded, and Sumerian influence extended to Syria in the West and Susa, in present-day Iran, to the East.

Overland trade with Egypt to the West and as far as the Indus River to the East extended the growth and sophistication of the Sumerians. Their cities evolved as city-states with their own gods and human rulers. A pantheon of Sumerian deities also emerged, and legends of heroic human exploits in confrontation with the gods, such as the Gilgamesh legend, established a lasting cultural tradition. Writing became a sophisticated means of recording archival and historical information as well as a system of communication.

The Sumerians built temples and palaces, mostly of mud brick. High temples (*shakhuru*) were built on mounds, 40 to 50 feet (12.20 to 15.25 m) high, that evolved to *ziggurats*, raised stepped platforms accessible by ramps. The White Temple at Uruk (Warka) atop its ziggurat dates from about 3000 B.C.; the temple of Ur-Nammu at Ur was built about 2100 B.C. The tradition of ziggurat construction lasted through several civilizations. The seventh-century Neo-Babylonian temple of Bel stood upon a ziggurat over 200 feet (61 m) in height. It was the original of the Hebrew story of the tower of Babel.

Sculptured figures from the Sumerians include statues of gods or priests from Tell Asmar (The Iraq Museum, Baghdad). These are characterized by large wide eyes, inlaid with shell and black stone; clasped hands; and

stylized rippling hair and beards. They are made of imported marble and none is over 2.5 feet (76 cm) in height.

Gold leaf and gold, lapis lazuli, and shell inlay decorate a royal lyre from Ur with a carved bull's head and fabulous animals on the sound box (The University Museum, Philadelphia). It dates from about 2600 B.C.

Shell, lapis lazuli, and red limestone inlay also appear on a small box, the *Standard of Ur* (British Museum, London), of about a century earlier than the lyre. The figures show a military campaign in three tiers and include wheeled wagons and chariots drawn by horses, and a panel of victory celebrations.

By its nature, Sumerian art is stylized and conventionalized in the animals and figures it represents. The scale is usually small, given the value and rarity of the materials.

AKKADIAN ART

During the period from about 2300 to 2150 B.C., the region of Mesopotamia was dominated by the Akkadian people. Sargon of Akkad was the first notable ruler. He and his successors held absolute power and sought world domination. For a period they controlled the entire fertile crescent from the Mediterranean to the Persian Gulf. The bronze *Head of an Akkadian King* (The Iraq Museum, Baghdad) may represent Sargon. Though damaged, it expresses great insight and power. It represents a technical accomplishment that heralds the Bronze Age and an artistic accomplishment of great vitality.

The *Stele of Naram-Sin* (The Louvre, Paris), is a powerful statement of Akkadian warfare. (Naram-Sin was the grandson of Sargon.) Contrasted to the *Standard of Ur*, it depicts the narrative of a battle with fury and action as well as a landscape of mountainside passages, trees, and astral representations of the gods Shamar and Ishtar, emblazoning Naram-Sin's triumph. The pink sandstone stele is 6.5 feet (2 m) tall.

A mighty tribe called the Guti overthrew Akkadian rule. They carried off Naram-Sin's stele as booty and created a chaotic interval of approximately sixty years in the region of Sumeria and Akkad. They left nothing of their culture to history and were finally overthrown by the resurgent cities of Sumeria.

NEO-SUMERIAN ART

The most prominent of the kings in the Neo-Sumerian period was Gudea of Lagash of whom many statues survive. They show him seated or standing, hands clasped in front of him in a manner similar to the statues from Tell Asmar. These are made from imported dolerite, a very dense and heavy *basaltic* stone. The blocky, stylized figures of Gudea reach a height of about 3.5 feet (1.07 m) in the largest examples.

For a period, Lagash came under the domination of Ur at the end of the third millennium. Ur managed to gain brief dominance of the whole Mesopotamian region but fell to additional foreign invaders. Two centuries of regional independent city-states existing side by side followed until Hammurabi, king of Babylon, was able to gain control of the region.

BABYLONIAN ART

Hammurabi is known to history for the codification of ancient Mesopotamian law, an act that had ramifications in Egypt, in Mosaic law, and all subsequent ancient civilizations. Fortuitously, the law code of Hammurabi is inscribed on the most famous Babylonian work of art, the *Stele of Hammurabi* (The Louvre, Paris). The upper part of this 7-foot, 4-inch (2.23 m) stele shows Hammurabi receiving inspiration from the enthroned Shamash, god of the sun. There are winglike flames issuing from Shamash's shoulders, and the king has assumed a reverent attitude.

The Babylonian empire was conquered and Babylon sacked by the Hittites, a fierce Anatolian people, early in the sixteenth century B.C. (c. 1595). The Hittites had their capital at Hattusas, near modern Boghazköy in Turkey. Their fortified city was built of stone, plentiful on Anatolia. The *cyclopean* walls feature passages, such as the Lion Gate, of about 1400 B.C. Arched over the passage are great stone blocks featuring high-relief sculptures of the heads, chests, and forelegs of gigantic lions, about 7 feet (2.13 m) high.

ASSYRIAN ART

The Assyrians, of northern Mesopotamia, rose to power after 1000 B.C. Their opportunity came with the successive, debilitating battles of Hittites, Mittani, Elamites, and Kassites who had dominated the region. Assur, which lent its name to the region and people, Nimrud, Khorsabad, and Nineveh were its cities. In this region rock is not scarce. Builders used stone and mud brick in combination for the construction of palaces and citadels.

Khorsabad, built by Sargon II around 750 B.C., has been extensively excavated. The palace was a complex of adjoining rooms surrounding a complex of courtyards. Included were a huge ziggurat, temple, throne room, state halls, harem, service quarters, and guard rooms. Never completed, Khorsabad was to have covered some 25 acres (10+ hectares) of land. It was surrounded by a defensive wall with many towers spaced regularly on the perimeter. The walls of Khorsabad were mostly of mud brick and were easily breached by the conquerors who succeeded Sargon II in power among the Assyrians.

Guardian figures of human-headed, winged bulls, called *lamassu*, carved in limestone and nearly 14 feet (4.26 m) high, were placed in the arched gateways of Khorsabad (The Louvre, Paris). Their heads may repre-

sent the king himself, and the stylization of hair, beard, crown, and animal features represents his royalty and power.

The gateway towers and arches were decorated by brightly colored, glazed tiles. These were used even more elaborately by the Neo-Babylonians later. The throne room and ziggurat were painted in bright colors.

Assyrian palaces are also noted for the relief sculpture slabs, sometimes covering entire walls of rooms or corridors. The best known of these come from the palaces of Ashurnasirpal at Nimrud from around 875 B.C. and Ashurbanipal at Nineveh dated about 650 B.C. Elaborate blocks of limestone and alabaster show battle scenes, royal assemblies, and vigorously carved lion hunts. Though ceremonious and symbolic, these are carved with expressive detail.

The Assyrians were known in their turn as ferocious and brutal warriors, locked throughout their ascendancy in almost constant warfare among themselves. Their conquests extended through Syria, to the Sinai peninsula and into Lower Egypt. They, in turn, fell to the Scythians and Medes who invaded Assyria late in the seventh century B.C.

NEO-BABYLONIAN ART

Nebuchadnezzar II, king of a revived Babylon, led a new cultural resurgence of his city in the early sixth century B.C. To its celebrated hanging gardens, one of the wonders of the Ancient World, he added a palace and ziggurat. The fortified city walls were elaborated with eight monumental gates. The gate to the processional way leading to the inner city was dedicated to the goddess Ishtar (Astarte). Of glazed brick, the Ishtar Gate was 47 feet (14.33 m) high. On the bright blue glaze of the surface are clusters of the glazed brick that form raised reliefs. They portray bulls, lions, and dragons in bright, natural color.

Persian Art

The Persians emerged in the sixth century B.C. Their kings, Cyrus the Great, Darius I, and Xerxes I, overran Mesopotamia, Syria, Asia Minor, Egypt, and parts of India. Between the sixth and fourth centuries they ruled a huge empire, mainly from Persepolis in southern Iran, northeast of the present reaches of the Persian gulf. The influence of Mesopotamian, Ionic Greek, and Egyptian art has been revealed in the study of Persian art.

Their encounters with the Greeks resulted in the sacking of Athens in 480 B.C. and their defeat at Marathon. The overthrow of their empire by Alexander the Great at Issus in 331 B.C. (see Learning Art History, pp. 6–7) stemmed the expansion of the Persian empire into Europe itself.

The audience and throne halls of the palace at Persepolis were many-columned spaces standing on great stone platforms almost 10 feet (3 m) high. The graceful, fluted columns were 40 feet (12.20 m) high with capitals representing the paired foreparts of bulls and lions shaped to cradle roof

timbers. The capitals themselves were over 7 feet (2.13 m) high and 12 feet (3.66 m) wide. Limestone reliefs from Persepolis of offerings and royal audiences were inspired by Assyrian reliefs, but they differ greatly in style. They are in higher relief and less stylized in their expression. The sense of order in Persian art reflects the well-disciplined government of regions, called *satrapies*, ruled by regional governors (satraps) who were responsible to the emperor.

ANCIENT EGYPTIAN ART

Egypt is a land defined by the Nile, the longest river in the world. The Nile flows north from its sources in central Africa past ancient Nubia and Aswan, through Upper Egypt, ancient Thebes, Luxor, Karnak, and the Valley of the Kings near Dier el-Bahari. A widening flood plain begins in Lower Egypt past Beni Hasan. There lie Tell el-Amarna, the Fayum Oasis, Saqqara, Memphis, Cairo, and Gizeh. Alexandria, founded by Alexander the Great, stands on the westernmost of the Nile Delta's several outlets to the Mediterranean Sea. Agriculture is possible in the Nile Valley because the annual flooding provides new silt deposits, renewing the arable soil. In the Egyptian predynastic period, lasting about a half millennium before the emergence of dynastic Egypt, two racially and culturally different peoples have left their traces in Upper and Lower Egypt.

The Palette of King Narmer

The slate *Palette of King Narmer,* in the Egyptian Museum, Cairo, comes from Hierakonpolis and is dated c. 3000 B.C. It records the conquest of Lower Egypt by this semimythical Upper Egyptian king, though it is likely to represent symbolically a process that may have taken years or even generations to accomplish. The palette was once a ceremonial bowl for ritual cosmetic paint (in the depression formed by the elongated lions' necks on one side). Its importance is similar to the stelae of Naram-Sin and Hammurabi. The relief sculpture on the palette signals the unification of the two Egypts, a requisite to the formation of a civilization in the region.

Sculpturally, the *Palette of King Narmer* reveals conventions used in figural representation that remain nearly constant throughout ancient Egyptian history. Narmer is shown in much larger scale than all other humans to designate his importance. His figure combines profile and frontal elements, selectively shown to characterize the human body. He has two full arms and legs, both shoulders, head, and feet in profile with eyes shown frontally. Such figures are instantly recognizable as belonging to Egyptian art.

Like the Mesopotamian stelae, the palette is a living record meant for day-to-day use and perception. In this it is dissimilar to much of the art of ancient Egypt that survives to us. An almost fanatical focus upon burial and the preservation of the dead marks Egyptian culture from the predynastic period, throughout the two and a half millennia of the dynastic era. Tomb construction, sculpture, and painting not only provide the best record of the fine arts but of the life-style of their makers who were anxious to bestow it upon their dead in art, in models, and in grave goods.

Desirous of a wealthy, peaceful afterlife, those who merited the attentions of elaborate burial were portrayed with these amenities. Thus whatever the sway of battle, governments, and leadership in the physical world, the picture we gain of Egypt is of a continuous, unchanging civilization, formed in Narmer's day and only lost to Persian conquest in the sixth century B.C. Subsequently, Egypt fell under Greek rule with Alexander the Great's occupation in 333 B.C. and defeat of the Persians in 331 B.C. Alexander's general, Ptolemy, and his successors ruled from Alexandria until the Roman conquest in 30 B.C.

Art of the Old Kingdom

The first six dynasties of ancient Egypt lasted well over 800 years from the unification of the two Egypts signaled by the palette of Narmer. In this period the pyramids were built, massive stone structures that, more than any other form, symbolize ancient Egypt. For most of the Old Kingdom the capital was at Memphis in Lower Egypt.

THE PYRAMIDS

The pyramids are royal tombs, evolved from the form of a *mastaba* (Arabic, "bench," from its shape), a stone monumental tomb in turn evolved from a Neolithic burial mound. The mastaba was a rectangular structure with sloping sides. One wall opened to a funerary chapel. Concealed beneath was a burial chamber and secreted in its structure was a hollow space for a statue of the deceased, prepared to hold the *ka* (spirit) of the deceased, should his or her mummified body be destroyed.

The enormous pyramids were conspicuous, and they were successfully robbed of their contents during the Old Kingdom. Later pharaohs continued to build smaller-scale pyramids into the Middle Kingdom, attempting to frustrate robbery by hiding entrances and tomb chambers. Ultimately the kings were forced to remove sites for their burial to more distant, less inhabited parts of Upper Egypt.

The Step Pyramid of King Zoser. Such elaborate burial monuments were limited, of course, to overlords and noblemen who could afford them. In the third dynasty, about 2750 B.C., the pharaoh Zoser built a tomb for himself at Saqqara that took the form of six mastabas of regularly decreasing size atop one another. This formed a colossal step pyramid. Its designer, the

architect Imhotep, also designed a royal walled precinct with courtyards and temples in a huge rectangular space to commemorate the king.

The Great Pyramids at Gizeh. It is easy to recognize the Great Pyramids at Gizeh as descendants of the mastaba and step pyramid. They were built between 2530 and 2470 B.C. by the pharaohs Cheops, Chefren, and Mycerinus (Khufu, Khafre, and Menkaure). Each has its own precinct and connected valley temple. Smaller pyramids and mastabas rest at the base of the Great Pyramids in groupings known as *necropolises* (literally, "cities of the dead").

The Sphinx. Chefren had a separate temple built between the forepaws of a giant *Sphinx*, a lion-bodied image with a human head, generally thought to represent Chefren. The Sphinx rises 65 feet (19.8 m) above the causeway between the valley temple and Chefren's pyramid.

OLD KINGDOM SCULPTURE

Old Kingdom sculptors produced much sculpture in large scale, establishing forms that would characterize Egyptian culture throughout history. Among them are statues of pharaohs, seated or standing, alone or in company with assorted gods. Most are frontal, rigid, and attached to a back slab. They are not fully definable as sculpture in the round. The seated *Chefren* from Gizeh, c. 2500 B.C., in the Egyptian Museum, Cairo, is a good example. He is carved from a huge block of diorite, 5 feet 6 inches (1.8 m) high. His throne is emblazoned with the entwined lotus and papyrus plants, symbolic of united Egypt. A carved hawk, symbolic of the sun, protectively enfolds the pharaoh's head within his wings. His passive inaction, arms resting on thighs, reflects imperturbable power.

Standing figures in stone, terra-cotta (kiln-baked clay), or wood representing the owner of a tomb and concealed in it as a residence for the *ka*, or spirit of the dead, establish the skills of Egyptian sculptors in traditional stylization and in representational portraiture. Such a figure is *Ka-Aper*, a wood sculpture also in the Egyptian Museum in Cairo. The figure is fully in the round and standing in a frontal pose. His features are more relaxed than those of the pharaoh, and his body has a corpulent, middle-aged physique. We gain a sense of the individual in such a portrait.

OLD KINGDOM LOW-RELIEF SCULPTURE AND PAINTING

Painted low-relief sculpture and fresco on the walls of Old Kingdom tombs show a wide array of subjects drawn from Egyptian life and culture. These include scenes of hunting and fishing, agricultural scenes, and elegant, descriptive representations of wildlife related to the Nile. Fishes and water birds, even hippopotamuses, are shown with a sensitive understanding of these creatures.

Art of the Middle Kingdom

The Old Kingdom lasted until the sixth dynasty, during which it weakened from a combination of ineffective leadership, civil unrest, outside invaders, and a succession of poor harvests caused by several successive years of irregular flooding of the Nile. For about a century, from 2150 to 2050 B.C., Egypt was without a strong, central, dynastic goverment. A reinvigorated eleventh dynasty marks the beginning of the Middle Kingdom. It lasted for about 300 years, through the twelfth and thirteenth dynasties, from about 2050 to 1750. The Middle Kingdom capital was Thebes in Upper Egypt.

BENI HASAN

Remote burial at Beni Hasan characterizes the Middle Kingdom effort to provide for a continuous afterlife. Sculpture shows greater intensity and expression but maintains essential characteristics established in the Old Kingdom. Tomb painting in the rock-cut tombs at Beni Hasan shows some development of overlapping space and foreshortening, yet most of the conventions are maintained.

The tombs themselves are of interest. They were hollowed from the solid rock face. The portals and chambers contained *reserved* columns, shaped as if they were planed wooden logs with rectangular, boardlike capitals. They "support" great timber-shaped stone beams. Though all are continuous parts of the rock, the sculptured shapes represent simple wooden chambers built on a *post-and-lintel* system.

Middle Kingdom Egypt was overrun in the thirteenth dynasty by the Hyskos, a displaced Asiatic tribe who ruled in Egypt for nearly a century and a half until driven out by the Thebans in the sixteenth century B.C. This 150-year period corresponds to the rise of Babylon under Hammurabi and its conquest, around 1600 B.C., by the Hittites.

Art of the New Kingdom

Thebes remained the New Kingdom capital for most of the 500 years of the eighteenth to twentieth dynasties, from c. 1570–1070 B.C. New technologies in warfare and the introduction of the horse brought by the Hyskos led to a strengthened Egypt and an expansive empire that extended eventually all the way to the Euphrates through Syria and Palestine in the East and far south into the Sudan.

The extraordinary tomb of Queen Hatshepsut at Dier el-Bahari (or Bahri) characterizes the tendency toward larger and more elegant tomb complexes in the New Kingdom. Set against the valley walls, the temple and tomb structure rises in three consecutive terrace levels on long ramps bisecting grand colonnades. Once richly planted gardens set with many sculptures, these colonnaded terraces preceded a rock-cut tomb chamber within the valley walls.

Many well-preserved wall paintings from tombs at Thebes demonstrate the continuing and expressive tradition of frescoes for the afterlife. Hunting, fishing, and feasting are depicted with remarkable sophistication and occasional variations on the traditional poses assumed by major figures. The frontal figures of musicians and supple rhythm provided by dancing girls from the tomb of Nebamun, now in the British Museum, characterize the new forms.

The New Kingdom flourished under such pharaohs as Mentuhotep, Queen Hatshepsut, Thutmose III, and others. During the fourteenth century the pharaoh Akhenaten (Ikhnaton) established a brief aberrant epoch. He ejected the god Amon and his cult at Thebes as well as the traditional pantheon of Egyptian gods on behalf of a single sun god, Aten, whose priest Akhenaten claimed to be. He established a new capital at Tell el-Amarna, downriver from Thebes.

ART OF THE AMARNA PERIOD

The art of this Amarna phase of the New Kingdom departs radically from the traditions of Egypt. The style is softer and more descriptive. Sculpture in the round and relief sculptures of the period show the king and members of his family in relaxed, nonceremonial poses. Even the formal representations of Akhenaten and his queen, Nofretete (Nefertiti), are softer and more fluid in their elegance and grace. The sculptured bust, *Queen Nofretete* (c. 1360 B.C.), in the States Museum in Berlin, is the most famous of the works of this period. A colossal *Pillar Statue of Akhenaten* (c. 1375 B.C.), from the temple of Amen-Re at Karnak, is now in the Egyptian Museum at Cairo. Although it is ceremonially rigid and frontal, the figure is composed of swelling and shrinking curved forms. The face is long and slender with emphasis on eyes, nose, and lips clearly related to the king's true visage.

The Amarna phase did not long outlast Akhenaten. Tutankhamen, who succeeded Akhenaten, returned to the traditional religion though elements of Amarna style remain in the art of his period. The tomb of this king was found intact in 1922 with an astonishing array of artifacts and art in place. Later kings returned to a stricter traditional Egyptian style, restored the gods, and sought to destroy all traces of Tell el-Amarna and its monotheism. A distinguished array of rulers carried out great building programs in the later fourteenth and the thirteenth century.

RAMESES II

Rameses II, who ruled in the first half of the thirteenth century B.C., is associated with most of these programs, although some were begun centuries before his reign. Among the best known is his own mortuary temple at Abu Simbel far above the first cataract of the Nile at Aswan. This deep

rock-cut tomb is fronted by four seated colossal statues of Rameses, each 60 feet (18.3 m) high, paired and flanking the entrance to chapel and tomb.

Rameses also enlarged and modified two great temple complexes: the temple of Amon, Mut, and Khonsu at Luxor and the temple of Amen-Re at Karnak. These were pylon temples, dedicated to the gods, rather than mortuary temples. They were both colossal in size, built upon a central axis parallel to the Nile. The great entrance gates and gateway dividers between segments of these temples are huge truncated pyramids, called *pylons,* from the Greek word for "gateway."

Characteristically the precinct for each of these temples was surrounded by mud-brick walls. A causeway led to the first pylon flanked by sphinx statues (Avenue of Sphinxes). Through the first pylon was a walled, colonnaded court. Only initiated priests were allowed further, past the second pylon wherein was a many-columned ("hypostyle") hall. This hall was roofed, lit only by a *clerestory* formed by the taller columns flanking the axial path toward the third pylon and the sanctuary beyond.

Rameses was the last of the great pharaohs. The New Kingdom dwindled in the eleventh century B.C. Egypt was overrun by the Assyrians and eventually conquered by the Persians in 525 B.C.

Alexander the Great, on defeating the Persians, occupied Egypt, setting his general, Ptolemy, to rule the land. The Romans conquered Egypt in 30 B.C.

*C*ivilization *began in ancient Mesopotamia and Egypt. We have noted that differences in their geography led to separate cultural development. Yet there was significant contact between them. Important trade connected the two regions. Peripheral civilizations also maintained connections with Egypt and Mesopotamia. South of Egypt was Nubia, with gold, copper, and ivory to trade. Mesopotamia's successive cultures were connected to Phoenicia, Anatolia, and by passage through the Persian Gulf and Arabian Sea, to the Indus River civilizations at Harappa and Mohenjo–Daro. Egypt and Mesopotamia, however, remained the viable ancestors of the Greek and other Mediterranean cultures. Their civilizations produced the art and architecture that are ancestral to the Western world.*

Selected Readings

ANCIENT MESOPOTAMIAN ART

Amiet, P. *Art of the Ancient Near East.* New York: Abrams, 1980.

_____. *Art in the Ancient World: A Handbook of Styles and Forms.* New York: Rizzoli, 1981.

Frankfort, H. *The Art and Architecture of the Ancient Orient.* Baltimore: Penguin, 1971.

Ghirshman, R. *Iran from Earliest Times to the Islamic Conquest.* New York: Penguin, 1978.

Groenewegen-Frankfort, H. A. *Arrest and Movement: An Essay on Space and Time in Representational Art of the Ancient Near East.* Cambridge, MA: Belknap, 1987.

Lloyd, S. *The Art of the Ancient Near East.* New York: Praeger, 1969.

Mellaart, J. *The Earliest Civilizations of the Near East.* New York: McGraw-Hill, 1965.

Parrot, A. *The Arts of Assyria.* New York: Golden, 1960.

———. *Sumer: The Dawn of Art.* New York: Golden, 1961.

Porada, E., and R. H. Dyson. *The Art of Ancient Iran.* New York: Greystone, 1969.

Wooley, C. L. *The Art of the Middle East, Including Persia, Mesopotamia and Palestine.* New York: Crown, 1961.

EGYPTIAN ART

Aldred, C. *The Development of Ancient Egyptian Art from 3200 to 1315 B.C.* 3 vols. London: Academy, 1973.

Badawy, A. *A History of Egyptian Architecture.* 3 vols. Berkeley: University of California Press, 1973.

Baines, J., and J. Malek. *Atlas of Ancient Egypt.* New York: Facts-on-File, 1980.

Lange, K., and M. Hirmer. *Egypt: Architecture Sculpture and Painting in Three Thousand Years.* London: Phaidon, 1968.

Mahdy, C., ed. *The World of the Pharaohs: A Complete Guide to Ancient Egypt.* London: Thames and Hudson, 1990.

Robins, G. *Egyptian Painting and Relief.* Aylesbury, England: Shire, 1986.

Romer, J. *The Valley of the Kings.* New York: William Morrow, 1981.

Smith, W. S. *The Art and Architecture of Ancient Egypt.* rev. ed. New York: Viking, 1981.

4

Aegean Art

3000–2000 B.C.	Early Minoan, Early Helladic periods
c. 2500–2000 B.C.	Cycladic idols, musician figures
c. 2000 B.C.	Potter's wheel introduced to Aegean region
1800–1700 B.C.	Kamares ware, Cretan pottery
c. 2000–1550 B.C.	Middle Minoan, Middle Helladic periods
c. 1700 B.C.	Destruction of old Minoan palaces (earthquakes?)
c. 1600 B.C.	Minoan snake goddess
c. 1600–1400 B.C.	Knossos palace
c. 1550–1200 B.C.	Late Minoan, Late Helladic (Mycenaean) periods
c. 1500 B.C.	*"The Toreador Fresco"*
c. 1500 B.C.	*Vaphio Cups*
c. 1400–1200 B.C.	Tiryns citadel
c. 1300 B.C.	Mycenaean Lion Gate
c. 1200 B.C.	Mycenaean *Warrior Vase*
c. 1200–1000 B.C.	Sub-Minoan, sub-Mycenaean periods

Northwest from the Nile Delta, across a considerable expanse of the Mediterranean Sea, rises the island of Crete. Crete is at the southern base of the Aegean Sea, which extends northward between the Greek mainland to the west and Asia Minor to the east. Crete and the rich archipelago of the Cyclades are a gateway to Europe. Here a separate civilization formed about 2500 B.C.

The people who settled on the mainland of what is now Greece were a closely related group, though the experience of a growing island kingdom is inevitably different from that of a mainland civilization. Thus the Aegean peoples are usually studied as two parallel cultures within the same rubric, subdivided between the Minoan (island peoples) and the Helladic (mainland culture).

The earliest remains are from the islands of the Cyclades in the latter half of the third millennium. The art of this period, generally called Cycladic, already shows the vigor and sense of vitality that will translate to Minoan art of Crete and the mainland Helladic culture. In Aegean art in particular we come to the roots of the classical world, the core of European civilization.

CYCLADIC AND MINOAN ART

Cycladic Art

The appearance of stone sculptures of goddesses in the form of idols, 1 to 3 feet (30 to 90 cm) tall, of stylized human form made about 2500 B.C., marks the earliest account we have of an established Aegean art. These figures are from tombs in the Cyclades.

The Cycladic idols represent the human form in an abstracted form, without detail, yet they are expressive of the figure in sophisticated simplification. The curves and planes of the sculptures reflect an understanding of the articulation of anatomy similar to that expressed in Upper Paleolithic cave paintings and sculptures. Traces of pigment found on them support the idea that features of face and body were painted on their surfaces.

Cycladic idols appear at the beginning of an immensely sophisticated and diverse cultural development. The Cyclades, Crete, mainland Greece, and western Asia Minor share in the development of this art. Many of these peoples were seafarers and traders, thus their culture developed in contact with that of Egypt and Mesopotamia. We can certainly find the influence of these outside civilizations on the art of the Aegean, yet the Aegean civilization produced work that is separate from both in its values and forms.

The culture that produced the early idols in the Cyclades marks the emergence of the Early Minoan period, about 2500 B.C. Male figures of standing musicians with flutes or seated figures with lyres, similarly styl-

ized, have also been found in the Cyclades. Few architectural remains survive from this early period.

The term *Minoan* belongs more properly to Crete, as it is derived from the mythical Cretan King Minos of Greek legend. *Minoan* is used, nonetheless, to designate the whole island kingdom tradition, distinct from that of the mainland predecessors of the Greeks, whose civilization is called the *Helladic*.

Middle and Late Minoan Art

MIDDLE MINOAN: 2000–1700 B.C.

Around 2000 B.C. the people of Crete began building great palace complexes as bases for the extensive maritime trading ventures for which they became famous. The three centuries from around 2000 to 1700, when these palaces thrived, represent the Middle Minoan period. It is significant that the palaces were built without the defensive walls and towers that characterize the citadels of Mesopotamia. As Egypt was protected from invasive attack by the deserts that surround it, the Minoans were protected by the sea and presumably a significant naval force.

Pottery. The special art form of the Middle Minoan period is its pottery. This was built on a potter's wheel, a technological advance introduced at the beginning of the period. Middle Minoan jars and pitchers are full-bodied and decorated with contrasting colors in abstract patterns that beautifully complement the form of the vessel. Organic plant forms are suggested in these patterns although they are usually undefined.

LATE MINOAN: 1600–1400 B.C.

About 1700 B.C. the palaces of Crete were destroyed, probably as a consequence of an earthquake or a series of them. The Late Minoan (New Palace) period emerged after about a century. It is this period that is most well known and productive, at least in terms of surviving material. It lasted to about 1400 B.C., when another natural disaster (an earthquake and consequent huge tidal wave?) destroyed the island kingdom forever.

The new palaces were at Knossos, Phaistos, Mallia, and other sites. These later palaces were also unfortified and irregular in plan. They were built with myriad rooms opening from corridors and courtyards with no rigid prior site planning. Great staircases and spacious rooms are characteristic. The columns of various porticoes, stairs, and halls tapered from a small base to a wide top, reversing the usual column forms we know.

Knossos. The largest of the Late Minoan palaces was at Knossos. It was excavated and extensively reconstructed by the archaeologist Arthur Evans at the beginning of the twentieth century. It is a huge, widespread site whose colossal underpinnings and ground level rooms gave rise to the mythical "labyrinth" built by Daedalus for King Minos. Here Theseus slew the

Minotaur. The Greek myth of that monstrous creature surely stems from the prominent figure of the bull in Minoan culture.

"The Toreador Fresco." Rich and colorful paintings adorned the walls of palaces such as Knossos. Among them, the "Toreador Fresco" is a clear reference to the bull as a cult figure of the Minoans. This painting shows three figures in the act of somersaulting over a bull by grasping its horns and leaping onto its back. Although much restored, the fresco conveys the sense of motion and the muscular power of the animal with subtlety and balance.

More recent finds among the ruins of Minoan civilization on the island of Santorini (ancient Thera) have enlarged our knowledge of the colorful and rich style of wall painting in the Late Minoan period.

Late Minoan Pottery. The brilliantly executed pottery of the time is painted with abstract and representational plant and animal patterns that are carefully harmonized to the ceramic forms. Pots such as a small round jar from Palaikastro decorated with a swirling octopus, painted as if entrapped with bits of seaweed and flotsam in the vessel itself, characterize the style.

Late Minoan Sculpture. The sculpture that survives is small in scale. The most familiar are figures of a snake goddess, frontal standing female figures with bared breasts and long, flounced skirts. Their arms are raised and they hold a snake in each hand. Small pottery animals have also been found. The distinct impression of a harmonious graceful life is conveyed by Late Minoan art, its forms designed for the living and for the delight of experience. Few monumental tombs are known.

MYCENAEAN ART

The Helladic peoples of the ancient Greek mainland may have begun as colonists from the Cycladic or Minoan island kingdoms. Or possibly matters were exactly the opposite, or the Helladic people may have different origins entirely. Their cultures developed with the same written language, however, a version of which began around 2000 B.C. By 1400 B.C. it had evolved to a script called linear B that only recently (1950s) has been deciphered.

Late Helladic Civilization

The evolved Late Helladic civilization is nonetheless different from contemporary Late Minoan culture. The people of this Late Helladic period are called the *Mycenaeans* after the best known of their citadels, Mycenae in the Peleponnessus, between Sparta and Corinth. As mainlanders the Mycenaeans were concerned with land defenses. Their cities were built as walled citadels with strong fortifications and defensive layouts. Huge cyclopean walls mark the boundaries of their hilltop locations. These cyclo-

pean walls are more expertly built than those of the nearly contemporary Hittites, as at Hattusas (Boghazköy) in central Anatolia. Like the Hittites, the Mycenaeans used corbeled vaults in the long passages to the interior of the citadel. They also formalized the entry to the citadel at Mycenae with a gate enhanced by lions.

The Mycenaeans are the heroes of the Greek Homeric epics. Their citadel at Mycenae and the ancient city of Troy in Asia Minor were excavated in the late nineteenth century by the German archaeologist Heinrich Schliemann. Schliemann's pursuit of the sites of the Trojan Wars proved that the Homeric epics were based on historic fact and real places. These tales were preserved over centuries as verbal memory and adopted by the Greeks as a mainstay of their own heritage.

The Mycenaean Citadel. Warlike, austere, and vigorous, the Mycenaeans were builders rich in conquests. They celebrated life and made a ceremony of burial for their heroes. Mycenae, Tiryns, and other citadels of the Mycenaeans were dominated at the center by palace structures. Near the center of all such palace complexes is located a council chamber of rather consistent form. Called a *megaron,* the chamber consisted of a square room with four columnar roof supports within, surrounding a circular central hearth. An antechamber with two columns flanked by extended walls of the main hall preceded the council room itself. Little more than the foundation of any megaron still stands, yet their consistent form and *post-and-lintel* construction mark a tradition that can be seen as the ancestor of Greek temple format. These columns, as those in Minoan palaces, were tapered inward from the top to the base. Such a column is portrayed in relief sculpture on the Lion Gate of Mycenae. There it is flanked by two lions who once boasted fixed bronze lion heads.

The Beehive Tomb. Very elaborate tombs have been found in or near the Mycenaean citadels; the most typical form is a "beehive" tomb. One of these, "The Treasury of Atreus," as Schliemann called it, is built underground within a hill, in the form of a domed, corbeled vault. A burial chamber opens off of it and a long entryway (*dromos*) and elaborate doorway lead into the main chamber. The doorway, with its post-and-lintel opening and corbeled relieving arch above, echoes the construction of the Lion Gate.

Mycenaean Gold Works. Inlaid gold work on the blades of bronze daggers, a solid gold funeral mask about 12 inches (30.5 cm) in diameter, and the gold *Vaphio Cups* characterize the representational arts of the Mycenaeans. The latter are a pair of handled vessels, about 3.5 inches (8.9 cm) high. The theme of bull trapping and snaring and the costumes of the figures on these cups are distinctly Minoan. Thus they may represent spoils from Crete or Mycenaean copies of Minoan themes. The point is still unsettled. All of these works are datable to around 1500 B.C.; the daggers may be earlier.

Mycenaean Pottery. The pottery of the Mycenaeans is very similar to that of Crete though slightly more rigid in forms and designs. Nonetheless, there is a remarkable strength and expression in the *Warrior Vase*, a late Mycenaean work of c. 1200 B.C.

The Minoan civilization declined rapidly after 1400 B.C.; some have suggested that it was at the hands of invading Mycenaeans. A vestige of people continued in the palaces until the Dorian conquests of Greece around 1200 B.C. Mycenaean civilization continued to about 1200 B.C. but without the vigor of its earlier generations. Then it, too, was overrun by the new invaders.

During the period that Mesopotamian and Egyptian civilizations emerged, there were Neolithic tribes on Crete, the Cyclades, and the mainland of Greece. By about 3000 B.C. there is evidence of a Bronze Age culture on the island of Crete, but the majority of artifacts before 2000 B.C. are from the Cyclades in the form of human figures, represented schematically. Most are nude female figures of marble of quite small scale.

The intriguing sense of design and natural rhythm in these figures seems to prevail in the centuries that follow in production of art works among the succeeding cultures. That of the islands is usually called the Minoan *civilization; the mainland culture is called the* Helladic *or, in the late phase,* Mycenaean *civilization.*

These civilizations emerged in contact with the Mesopotamian and Egyptian worlds through sea trade. The Minoans, particularly, depended upon the sea for survival. They were nonetheless independent civilizations. There is a clear rift between the destruction of these civilizations by about 1200 B.C. and the beginnings of Greek civilization after 1000 B.C., but in many ways the Aegean cultures were the true antecedents of the Greeks.

Selected Readings

Boardman, J. *Pre-Classical: From Crete to Archaic Greece.* Harmondsworth: Penguin, 1979.

Chadwick, J. *The Mycenaean World.* New York: Cambridge University Press, 1976.

Cottrell, A. *The Minoan World.* New York: Scribners, 1980.

Demargne, P. *Aegean Art/The Origins of Greek Art.* London: Thames and Hudson, 1964.

Higgins, R. *Minoan and Mycenaean Art.* London: Thames and Hudson, 1967.

Vermeule, E. T. *Greece in the Bronze Age.* Chicago: University of Chicago Press, 1972.

Wace, A. *Mycenae: An Archaeological History and Guide.* New York: Biblo and Tanner, 1964.

Warren, P. *The Aegean Civilizations.* London: Elsevier-Phaidon, 1975.

Willets, R. F. *The Civilization of Ancient Crete.* Berkeley: University of California Press, 1978.

5

Greek Art

c. 1200 B.C.	Dorian (and Ionian?) invasions
c. 1000–900 B.C.	Proto-Geometric art
c. 850–800 B.C.	Homer
900–700 B.C.	Geometric art
700–480 B.C.	Archaic period
776 B.C.	First Olympiad
497–479 B.C.	Persian wars
480–323 B.C.	Classical period
448–432 B.C.	Parthenon built
431–404 B.C.	Peloponnesian War
323–146 B.C.	Hellenistic period (death of Alexander the Great to Roman conquest of Greece)

Inscribed on the temple of Apollo at Delphi was the command "Know Thyself," Socrates' motto. This simple imperative can be said to have driven the entire development of ancient Greece. The capacity to express profound truth with simple, even spare, phrases, to place enormous visual realization into a minimum of exquisite forms is an assured outcome of self-understanding and a basic characteristic of the ancient Greeks.

Little is known of the origins of the Dorians, who invaded the Greek mainland, the Peloponnesus, and the Cyclades. Even less is known of the Ionians, who occupied the western coast of Asia Minor. These are the people,

however, who brought Greek art to the fore. Even so, there can be little doubt that a survival of Helladic and Minoan visual tradition was absorbed into the elements of Greek art just as the histories of Mycenae and Knossos are interwoven in Greek epic poetry.

Wherever they came from, the Dorian invaders of Greece seem to have brought little in the realm of established art form with them. For three centuries, from 1200 to 900 B.C., little would proceed from this part of the world in the way of art. The Minoan and Mycenaean people, we assume, were assimilated into this new group. Their art survived to play a significant part in the evolution of Greek art thereafter. But it was a long process, forged no doubt in conflict and difficulty. The ultimate result, as we shall see, was an art that would eventually have an effect on the entire planet.

The Dorians invaded the Greek mainland around 1200 B.C. The Mycenaean civilization, evidently weakened by then, collapsed with the pressure. Some authorities believe that the Mycenaeans were displaced from the Peloponnesus to Attica (the region of Athens) and to the coast of Asia Minor by the Dorians and that it was these people in Asia Minor who are now known as the Ionians. There are, in fact, Mycenaean remains on the Athenian Acropolis. Others believe that a separate Ionian culture was already in Asia Minor by the time of the Dorian invasions. Whatever the case, the calamitous changes effected by these movements are signified by the fact that no appreciable Greek art appears until the end of the ninth century, around 800 B.C.

The Greek art that evolved, nonetheless, is the foundation of much that we understand about the art of Europe. The art of ancient Rome, the Middle Ages, the Renaissance, and much of the modern world depends in various ways upon the art and nature of the Greeks.

GEOMETRIC AND ARCHAIC PERIODS

Geometric Greek Art

A few pottery works indicate the development of the earliest Greek art. Called Proto-Geometric, the vases of this period are decorated with continuous or repeated linear patterns encircling the vessel. The Geometric period, extending from the tenth through the ninth and much of the eighth centuries, takes its name from these pottery patterns: regularized stripes and *meanders*, along with dots and diamonds. Animals and human figures were gradually introduced though these are constructed on patterns of triangles and lines. Great vases such as the *Dipylon Amphora*, over 5 feet (1.52 m) high, from the Dipylon cemetery in Athens, or large *kraters*, 3 feet (91.5 cm) high, from the same location, exemplify Geometric pottery. Small bronzes of human figures and animals were also made in the Geometric period.

Also, terra-cotta models of temples made in the Geometric period seem to echo the form of the Mycenaean megaron, helping to confirm the ancestry of the classic Greek temple from this known element of the Mycenaean civilization.

Archaic Greek Art

The art of the Greeks that appeared toward the end of the seventh century B.C. is called *Archaic (Old) Greek*. From the vantage point of historical observation, it is easy to define Archaic art as an anticipation of the more familiar classical Greek period and to visualize the development of Archaic art as a continuous learning process by which the Greeks "classicized" themselves. Such comparisons are inevitable, but it is worthwhile to observe here that the determination of progress in art is an advantage the art historian holds in retrospect.

Stylistic changes are the product of a variety of influences within a culture including but not limited to the innovations and development of the artists' skills. In the realm of Archaic art we confront a style that is itself a powerful expression of form. In it are elements of stylization that are a part of the Aegean civilization from as far back as the Cycladic idols of 2500 B.C.

In the last part of the eighth century B.C. and into the seventh, the art of Greek Geometric pottery was influenced by that of Egypt and the Ancient Near East. This Orientalizing style gradually replaced the Geometric. One of its aspects was an array of new decorative motifs from eastern sources, spirals, interlaces, and rosettes. Another aspect was thematic; the pottery known as Proto-Attic developed scenes of heroes, gods, and myths that would later characterize the great products of Attic Greek pottery. Proto-Corinthian pottery, with animal motifs closely adapted from the Near East, anticipated the pottery for which Corinth became famous.

The Orientalizing style, best represented in pottery, indicates the development of trade and the stabilization of Greek culture in the late eighth century. The Greeks established their own chronology from the founding of the Olympic Games in 776 B.C. Archaic Greek art, as it developed in the seventh and sixth centuries, continued to show external influence, but its strength is in its demonstrable continuity with the past and the emergence of new native forms. In the Archaic period, Greek temple architecture, architectural and monumental sculpture, and a variety of pottery styles emerged with a consistent cultural imprint.

THE GREEK TEMPLE

The basic form of classical Greek temples was developed in the Archaic period. These were built in two different architectural styles, called orders: the Doric and the Ionic. The Greeks usually built their temples on high ground, on a rectangular base, two or more steps in height, called a *stereobate*. The top step and plane surface supporting the temple structure is called

the *stylobate*. It supports the walls and the columns (Greek, *stylos*, "pillar") of the temple.

The simplest temple is formed of a rectangular-walled room (*naos* or *cella*) with a door at one narrow end. The long side walls extend forward in *antae* (wings) on either side of the door to the front edge of the stylobate. Between the antae runs a lintel made up of architrave, frieze, and *cornice,* collectively called the *entablature*. The entablature encircles the entire temple. The entablature between the antae is supported by a pair of columns. The enclosed space between the columns, antae, and doorway is the *pronaos*, or portico or porch of the temple. Above the entablature the roof is gabled lengthwise. The triangular openings at the gable ends are the *pediments*.

More elaborate forms of Greek temples include a portico at either end, a whole colonnade across the front of the porticoes, and, eventually, a colonnade around the entire structure (peristyle), supporting the entablature and roof. The two orders in which the Greeks built temples in the Archaic period are named for their origins. The Doric order is the temple form of mainland Greece; the Ionic order that of Asia Minor and the islands of the Aegean. Both continued in use throughout the history of ancient Greece. Joined by the later Corinthian order, they survive in Greek, Roman, Renaissance, and neoclassical architecture.

The Doric Order. Doric temples are identified by the form of column, capital, and entablature. Doric columns do not have bases. They are usually fluted and taper on a curved profile (the taper is called *entasis*). They narrow from bottom to the top at the *necking,* just below the simple unornamented capitals. The capitals combine a dishlike *echinus* and a square *abacus*. The entablature includes the architecture above the columns. The architrave, or lintel, supports the frieze.

The comparatively simple components of the Doric order are assumed to represent the structural elements derived from the wooden framework of the earliest of these temples. The Doric Temple of Hera at Olympia of about 600 B.C. provides the best evidence of early wooden construction. Its columns, originally of wood, have been replaced in stone as they deteriorated. The styles of the substitutes matched that of the period of replacement rather than the rest of the peristyle. As many as six different proportional schemes for Doric columns and capitals are included.

The Ionic Order. The columns and entablature of the Ionic order are different and variable. Basically the columns stand upon molded bases. The shafts are more slender than Doric columns in proportion to their height. A double scroll, or volute, is added to the echinus and abacus of the capital. The architrave is divided into three lateral planes, or fascie (fascia, sing.), and the frieze, often sculptured in relief, is continuous rather than divided into metopes and triglyphs. The great Ionic Temple

of Artemis, built at Ephesos in the Archaic period, had sculptural reliefs on the lower drums of its peristyle. The Archaic Treasury of the Siphnians at Delphi and, later, the south porch of the Erechtheum on the Athenian Acropolis used female standing figures (*caryatids*) as columns. These figures bear basketlike headgear in place of the voluted capital.

The perfection of the Greek temple form as a constant conceptual ideal in architecture has no parallel in history. Its proportions and refinements changed as Greek art changed, yet its principles and visual statement have a nearly universally understandable aesthetic. Its monumentality, nevertheless, was external. The interior of a Greek temple was not designed spatially. It was entered only by a limited number of privileged persons. Rituals, sacrifices, and honors to the cult were performed and celebrated at outside altars, adjacent to the temple.

Archaic temples in general are more heavyset than their Classical successors, reflecting a muscularity similar to the figural sculpture and painting of the period. The individual parts of columns and entablature are more emphatically identified; the stout columns taper sharply and their capitals are proportionally large.

ARCHITECTURAL SCULPTURE

To the Greeks the temple had another aspect. Its architecture served as a framework for sculpture, an element as intrinsic to the temple as the building itself. Characteristically, sculpture was placed in the pediments, on the friezes, and inside the cella in the form of a cult image of the god to whom the temple was dedicated. Ionic temples sometimes incorporated sculpture into the columns themselves.

The sculpture on Greek temples usually followed a program related to the dedication and cult of the god. The pediment sculpture of the Archaic Doric Temple of Artemis at Corfu (c. 600 B.C.) and the Temple of Aphaia at Aegina (c. 490 B.C.), though both are much reconstructed, effectively demonstrate the form and its evolution. There were large Archaic Ionic temples in Asia Minor and the Aegean Islands, at Ephesos, and on Samos, for instance. Little remains of these temples.

The Siphnian Treasury at Delphi. The Siphnian Treasury, c. 530 B.C., built on the sacred way leading to the Apollo Temple at Delphi, represents some of the varieties of sculpture applied to early Ionic buildings. Though no longer standing, the façade of the Siphnian Treasury has been reconstructed in the Delphi Museum, with pediment sculpture, frieze, and caryatid columns. Much of the original frieze survives in the museum as well. The heavyset, slightly stiff figures resemble the freestanding sculpture of the period and the figures painted on Archaic pottery. All have the sturdiness and definition of form that can be seen in the temple architecture as well.

MONUMENTAL SCULPTURE

The only survivors of the arts of Greece in the Geometric period are works of pottery and bronze sculpture, the latter on a small scale and very simple. The intercultural era of the Orientalizing period established new artistic endeavors by the Greeks. An emerging tendency to larger-scale figural sculpture, done in stone, may well be traced to Egyptian influence. The most important forms of Archaic monumental sculpture are standing figures, male and female, called *Kouros* and *Kore* figures. These vary from about half to nearly twice life-size.

The Kouros. The male Kouros figures characteristically stand nude, with hands clenched into fists, one leg forward, and weight equally distributed to the two feet. The stance strongly suggests awareness of standing figures carved by the ancient Egyptians. Kouros figures are typically beardless, with stylized hair and facial expression. The head is usually large in proportion to the body, contributing to a youthful, adolescent appearance, hence, the generic name *Kouros* (Greek, "youth"). Examples from the sixth century B.C. show increasing interest in the muscular structure and organic articulation of the body.

The Kore. Female Kore (Greek, "maiden") figures are equally static, standing with both feet together and with weight equally distributed. These figures are usually clothed and some show remains of applied color, painted in encaustic (pigment mixed with heated wax and applied to the surface while still fluid). This technique is remarkably permanent, and it was also used in ancient panel painting. The eyes, hair, and garments are all stylized.

ARCHAIC POTTERY

Pottery painting, the oldest of the arts of Greece, emerged in the sixth century B.C. as a major art form. From its earliest phases Greek pottery is characteristically red and black in color. From the Geometric through most of the Archaic period the figures and designs were black, displayed on the natural red color of kiln-fired clay. These were created by painting the designs in specially prepared slip (liquified clay) on the surface and firing the work in a kiln. In one phase of the firing the painted surface turns black. White and purple glazes, used sparingly, also appear in Archaic pottery.

Athens became the most important center of pottery production. Both potters and painters signed the works indicating a pride of execution and recognition of accomplishment. In these instances the stylization of figures, the limitations of color and shape, forced an ideal combination of opportunities for expression and restriction of means upon the artist. The expertise is closer and finer than that of Minoan vase painting, but the balance and emphasis on design is similar in each case.

The *François* Vase. The comparatively early *François vase*, in the Archaeological Museum, Florence, dates from c. 575 B.C. It is signed by Ergotimos, the potter, and Kleitias, the painter. It is over 2 feet (60 cm) high, a *krater* decorated with five tiers of mythological scenes. The figures are still related to those of Geometric pots, but they are more active, combined in overlapping sequences and in narrative interaction.

Exekias's Dionysus Kylix. A later black figure vessel is a *kylix* (wine cup) painted by Exekias around 540 B.C. The bowl of the vessel appropriately shows Dionysus, the Greek god of wine, sailing in a boat. The mast has been transformed into a grapevine with huge clusters of grapes. Dolphins leap in the "wine-dark" sea near his craft. The subtle and spare design painted in this cup, contrasting the curvature of ship, sail, and dolphins, is a fine example of the combination of visual emphasis and design in Archaic Greece.

The white, wind-filled sail is particularly evocative. Here the white glaze has been applied over black, allowing the artist to scratch out the lines of the standing and running rigging of Dionysus' boat. The curved yard and the taut lines across the bellying sail visually express the wind's force on the little craft.

Red Figure Ware. Near the end of the sixth century, pot painters began to produce red figure ware. This reversal of the process left the figures in the natural red of the unglazed pot while the body of the vessel was glazed black. Linear details of anatomy and costume were added in black line and areas. The tendency was toward greater organic naturalism, also visible in the figure proportions and detail. These tendencies represent the values that attracted major artists to the realm of pure painting in the Classical period. Although their works are lost, the celebrated names of painters of the fifth century are those of monumental painting. *Naturalism*, which is the tendency toward the depiction of figures in visual space, color, and proportion, is inappropriate to the surface of pottery.

TRANSITIONAL AND CLASSIC GREEK ART

The fifth century B.C. marks a heightened balance between the visual world and its artistic interpretation. This is true in painting if we are to believe the words of the ancient Greeks themselves and in sculpture, though much of this is known best through Roman copies. As for architecture, the most renowned and universally admired buildings of humankind are those of the late fifth century on the Athenian Acropolis.

Transitional Greek Art

The early fifth century was marked by two Persian invasions of Greece. One was repulsed at Marathon in 490 B.C. The other ended a decade later with the destruction of the Persian fleet at Salamis in 480 B.C. by the

Athenians and Spartans, but only after Athens had been taken and sacked by the Persians, reducing the Archaic buildings of its Acropolis to rubble. Perhaps because their city had suffered most, the Athenians awarded themselves the most credit for the victories. In any case they mark the ascendancy of Athens in the fifth century. The city is justly celebrated to this day for its political system, philosophy, drama, poetry, and the visual arts.

The Acropolis (Greek, "high city") is a hill on the southeastern boundary of ancient Athens. It had been a Mycenaean citadel, fortified in the manner of Mycenae and Tiryns. The Greeks held it sacred to Athena, patron goddess of Athens. Unlike the Mycenaeans, they built their city at the foot of the Acropolis, using its elevated platform for their temples, for festival and ceremony, and as a fortress in time of war.

Discovered in the rubble used to rebuild the fortified Acropolis walls after the Persian War were broken Archaic statues. Included were several well-preserved Kouros and Kore figures.

THE *KRITIOS BOY*

Also found was a damaged sculpture of a standing youth, 34 inches (86 cm) tall, about half the height of a typical Kouros. This work is attributed by some to the Athenian sculptor Kritios; hence, it is popularly called the *Kritios Boy*. It has been dated to the immediate years prior to the Persian War of 490–480 B.C. The *Kritios Boy* shows an important change in the artist's approach to figural representation.

The standing youth is based upon principles of balance in an active figure; that is, the weight is not equal on both legs as in Archaic statuary. Most of it is on the left leg; the advanced right leg is bent and relaxed. As a result the pelvis is tilted, the left hip is higher and the left buttock compressed. In order that the weight of the figure be balanced, the backbone of the *Kritios Boy* is subtly curved to bring his head and upper torso over the supporting left leg. The term used for this by art historians is *contrapposto* (counterpoise). Once understood, these principles were used in Greek sculpture and translated to relief sculpture and painting during the fifth century.

THE SEVERE STYLE

During the first half of the fifth century there was a residual formality in much of the sculpture, reminiscent of Archaic stiff poses and hard surface. We see it in the bronze *Charioteer* from Delphi, of about 470 B.C., the large bronze *Poseidon* found in the sea off the Greek coast, made around 460–450 B.C., and the surviving sculptures from the Temple of Zeus at Olympia. The style of these works is sometimes called *Severe* and sometimes *Transitional*.

These terms apply, mostly, to the sculpture of the period. There are examples of *contrapposto* in Transitional pottery painting as well, and we can be certain that its principles also found their way into monumental painting.

The architectural orders evolve to their Classical proportions at their own pace not divisible into stages. They, too, develop toward more proportionate interrelation between their structural elements in the fifth century. A comparison between the temples preserved at Paestum, especially the old temple of Hera, called the *Basilica*, of about 540 B.C., and the temple of Hera II, of around 460, shows the remarkable changes of the Doric order in an 80-year period. Paestum is in southern Italy, one of many Greek colonial settlements on the mainland and in Sicily where Doric temples can be found.

Classic Greek Art

The rebuilding of the Acropolis at Athens was the most notable achievement of the second half of the fifth century B.C. It was done under the leadership of Pericles, Athens's foremost statesman, and with the artistic direction of Phidias, the most famous sculptor of his time. The project was financed by the city and, not ungrudgingly, by the other members of the allied city-states who had defeated the Persians, the so-called Delian League. Their money had been collected ostensibly to finance defenses against any further Persian attack.

THE ARCHITECTURE AND SCULPTURE OF THE ACROPOLIS

The Parthenon. Dominant on the Acropolis was the Parthenon, which was built in 447– 432 B.C. This Doric temple, dedicated to Athena, was built by Iktinos and Kallikrates over the foundations of an unfinished temple destroyed by the Persians. The Parthenon is widely acclaimed as being the ideal example of Doric temple architecture. The architects worked out a system of refinements for the building, effectively relieving the apparent rigidity of the marble. The stylobate, which is very slightly domed, follows the curvature of the hilltop setting. The columns are regularly spaced closer together toward the corners and incline toward the center of the building. These refinements are not noticeable to the viewer without making a deliberate search. Nonetheless, they stabilize the building on its site. They complement the carefully designed proportional system of the building's Doric elements.

Although it is the "perfect embodiment of Classical Doric architecture" (Janson), the Parthenon was the first building to introduce Ionic elements on the Acropolis. In the smaller room beyond the the cella, the treasury, stood four Ionic columns. A continuous Ionic frieze extended some 525 feet (160 m) around the exterior of the cella, treasury, and interior porches, within the peristyle.

The Ionic frieze depicted the Panathenaic Procession, highlight of the ritual quadrennial celebration of the goddess Athena. It was part of an elaborate program of sculpture on the building. This included the pediments, which depicted the birth of Athena and the contest of Athena and Poseidon. The Doric friezes included a battle of gods and Giants, a battle of Centaurs and Lapiths, a battle of the Amazons and Greeks, and a Trojan Wars cycle. Within the cella stood Phidias' great statue of Athena, made of ivory and gold.

Much of the original sculpture of the Parthenon has been lost. Part of the pediment sculpture, the Ionic frieze, and some of the metopes of the Doric friezes were brought to London at the beginning of the nineteenth century by Lord Elgin. They are in the British Museum at present. There is no doubt that Lord Elgin's motives were altruistic. He saved the sculptures from almost certain destruction. An understandable sentiment for their return to Greece, especially with the current extensive restoration project on the Acropolis, persists.

The Propylaion. The main entrance to the Acropolis was through the Propylaion, an elaborate gateway with Doric faces and a passageway between them flanked by slender Ionic columns. The Propylaion was irregular in plan because of the site. Rooms of different sizes bordered the central passageway. A chamber on its north side was known in antiquity as the *pinakothek* (picture gallery). The Propylaion was built by the architect Mnesicles between 437 and 432 B.C.

The Temple of Athena Nike. A bastion outside the southern flank of the Propylaion supports the small Temple of Athena Nike, said to have been built by Kallikrates between 427 and 424 B.C. It is of simple plan, with graceful yet sturdy Ionic columns with large capitals and bases.

The Ionic Erechtheion was the most sacred shrine of Athena on the Acropolis. It was the last structure built there in the fifth century, made between 421 and 405 B.C. The cella of the Erechtheion was also divided, and the building was flanked on the north and south by porches. The north porch is celebrated for its stately Ionic columns and for the elegant proportions and moldings of its doorway into the temple. The smaller south porch is famous for the caryatids, the columnar "maidens" who support the entablature.

MONUMENTAL GREEK SCULPTURE

The Riace Bronzes. Two bronze sculptures of Greek warriors were found in the sea off Riace, on the southern coast of Italy, in 1972. Nearly intact, they have been cleaned and put on exhibition in the National Museum in Reggio. They are unattributed but appear to date from the middle of the fifth century, on the verge of the Classical period. Their condition tells us much about freestanding Classical sculpture in bronze for which the great

artists of the period were celebrated. Inlaid with silver eyelashes and teeth, copper lips and nipples, and glass and paste eyes, the figures exude an approach to naturalism unimaginable in the marble copies made by the Romans of the famed bronze works of Myron and Polyclitus.

Freestanding Sculpture. Yet the *Discobolus* (Discus Thrower) by Myron and *Doryphorus* (Spear Carrier) by Polyclitus are only known in such copies. Both enlarge upon the *contrapposto* of the Transitional phase. Myron's *Discobolus* carries the sense of balance to the tensed figure whose body is coiled to unleash the force of his throw. Brilliant contrasted arcs of arms, legs, and torso show ideal interaction between energy and control. The *Doryphorus* strides forward, emphasizing the shift of weight to his right leg and the bodily compensation for it in the shoulders sloping toward his right, compressing the flesh of his waist on that side.

Canon of Proportions. Polyclitus is said to have invented the canon of idealized human proportions for Classical sculpture. This was a modular measurement of comparative features of the body, based on a theoretical ideal. Polyclitus, Myron, Phidias, and others of the period shared the canon. Classical male figure sculptures are characteristically about eight and a half times the height of the head. Other proportional features were based on fractions and multiples of a unit of measurement, or module.

Female figures were based upon a slightly different canon; a proportion of eight heads to the total body height represents the ideal concept of the female figure as more compact. Female figures are still characteristically draped, as Archaic Kore figures had been. The drapery works better at revealing the body than concealing it, however. This representation in marble, especially of contrasted and combined textures of fabric and flesh, was a particular skill of the Classical sculptor. Examples to study include the *Three Goddesses* from the east pediment of the Parthenon, *Nike Fastening Her Sandal* from the parapet of the Temple of Athena Nike, the statue *Nike* (Victory) from Olympia by Paionios, and the *Grave Stele of Hegeso*, all from the late fifth century B.C.

THE CORINTHIAN ORDER

The third style of Greek architecure originated at the end of the fifth century. It appears first inside the Doric Temple of Apollo at Bassae in the Peloponnesus. In essence the only difference between the Corinthian and Ionic orders is in the capital. A Corinthian capital has a circular basket shape, surrounded by tiers of carved acanthus leaves. Small volutes extend to the corners of the square abacus. The Corinthian capital appears only in interior settings until the latter part of the fourth century.

LATE CLASSICAL ART

Athens suffered from the loss of Pericles' leadership after his death in 429 B.C. The city was soon embroiled in war with Sparta and ultimately lost its ascendency as well as the war. Sparta, then Thebes, and by the middle of the fourth century, the kingdom of Macedonia with its capital at Pella, near modern Salonika, dominated the Greek mainland. Philip II, the Macedonian king, and his son, Alexander III (the Great), extended the Greek sphere by conquest of the Persian Empire, including lands all the way from Egypt to India.

Architecture

During the fourth century a number of building programs on the Greek mainland and in Asia Minor produced buildings of rich variety. The Tholos (Round Temple) at Epidaurus was built with an exterior Doric order and an interior colonnade that was Corinthian. The Theater at Epidaurus is a well-preserved example of the Greek open-air forum. A circular stage was the focus of a more than semicircular seating arena, nearly 400 feet (120 m) in diameter. The theater was built into a hillside, forming a natural slope for the audience and reinforcing the splendid acoustics.

THE MAUSOLEUM, HALICARNASSUS

Mausolus, prince of Caria at Halicarnassus in Asia Minor under Persian rule, built his own tomb before his death in 353 B.C. It was called the *Mausoleum* for its builder and was one of the wonders of the Ancient World. Not preserved, the Mausoleum stood on a high pedestal, was surrounded by an Ionic peristyle, and was finished above the entablature by a great pyramid. Atop the pyramid was a platform with sculptured likenesses of the prince and his wife, Artemesia, in a four-horse chariot (*quadriga*).

Several new colossal temples were built in Asia Minor during the fourth century B.C. Some of these replaced Archaic versions. The Temple of Apollo at Didyma and the Temple of Artemis at Ephesos are characteristic. These great temples, Ionic in style, were built with two successive peristyles, one within the other, called *dipteral* temples. They were only partially roofed.

Hippodemos of Miletus. Ancient Priene, a fourth-century city in Asia Minor, is frequently cited as a developed settlement built on the basis of a grid plan. This architectural form was developed in the fifth century by the architect Hippodemos of Miletus. The *Hippodamian Plan*, as it was called, laid out orderly rectangles on the site and established the central public areas of the town and a system of regular cross streets surrounding the center, establishing regular blocks (*insulae*) for residences.

Monumental Sculpture

The sculptors Lysippus, Praxiteles, and Skopas are foremost among those who established great reputations in the Late Classical world.

LYSIPPUS

Lysippus was a court sculptor to Alexander the Great. He is credited with establishing a new canon of proportions for the figure, taller and more slender than the Polyclitan canon, in which figures are about eight and a half heads in height. Lysippus' works survive only in Roman copies.

Apoxyomenos. Best known is the *Apoxyomenos* (Scraper), a standing athlete scraping the oils and mud from his body after competition. His body and head turn as if his attention has been diverted, perhaps to the performance of a competitor. Added to Late Classical sculpture is the sense of an environment or interaction in gesture and expression.

SKOPAS

Skopas worked on the reliefs of the Mausoleum at Halicarnassus with vigorous battle scenes and on the sculptures of the Temple of Athena Alea at Tegea. He is famed for the expressions of emotion on his figures, another Late Classical innovation.

PRAXITELES

Hermes with the Infant Dionysus. Praxiteles is famed for the sculpture *Hermes with the Infant Dionysus*, a marble work found near the Temple of Hera at Olympia, close to the site where the original stood. The work is claimed by some to be the original; others argue with equal vigor that it is a Roman copy. Either way, it is a remarkable example of Late Classical weight shift and of the Late Classical style in Hermes' relaxed pose and gentle interaction with the infant.

Aphrodite of Knidos. Praxiteles' other major innovation was a sculpture of Aphrodite, made for her temple at Knidos. The figure was nude, a change in Greek tradition that immediately became the reference point for countless copies and versions. None of the copies is close enough for a clear reconstruction of the entire form and pose of the original.

HELLENISTIC GREEK ART

In the thirteen years of his reign, Alexander the Great blazed a furious path across the world. He established new cities and governorships of his conquered territories. Hellenism, the style and principles of Greek culture and arts, touched upon far-flung outposts and cultures. From the late fourth century, after Alexander's early death in 323 B.C., the Classical style was elaborated and modified in countless ways. Great sculptors built upon the evolved Late Classical sense of emotion, action, atmosphere, and expression in a wide array of works.

Notable are works such as the *Dying Gaul*, a Roman marble copy of a bronze sculpture from a series set up by Attalus I of Pergamum about 220 B.C. to commemorate a victory over these barbarian invaders. Attalus II of Pergamum celebrated his victories by building a huge altar to Zeus with a great frieze between the pedestal and the stereobate. The frieze represented the battle of the gods and Giants, an initial scene in the mythological creation cycle of the Greeks.

Nike of Samothrace. The statue *Nike of Samothrace* (The Winged Victory), now in The Louvre, Paris, was made about 190 B.C. It is an effective descendant of *Nike* from Olympia by Paionios. Here the wind whipping about the body of Nike molds the fabric of her garment to her body and simultaneously billows it across her legs. Air pressure catches the undersides of the outspread wings, curving them and adding to the expression of transience, an important characteristic of the goddess' nature.

Laocoön. The Laocoön Group, in the Vatican Museum, may date as late as the first century A.D., according to recent evidence. It is the work of the Rhodes sculptors Agesander, Athenodorus, and Polydorus. It represents an episode of the Trojan War, when the priest, Laocoön, and his two sons were strangled by sea serpents for an offense against either Apollo or Poseidon.

Hellenistic Painting

We know Hellenistic painting from Roman copies that have been preserved. The *Alexander Mosaic* in Naples, discussed in chapter 1, is an example. Unfortunately little actual painting of the period is preserved.

The civilization of the Greeks produced art that is pertinent to all Western art history and reached far into the Eastern Hemisphere in its sphere of influence. Greek art is built upon the measure and qualities of human worth, the first art to significantly detach itself from the overpowering forces of gods and kings.

There is a foreshadowing of this in the art of the Aegean world, and the Greeks knew and recognized their spiritual ancestors. The pride of intellectual and reasoned achievement is strong in the Greek concept of the past and the emergence of human awareness. The best that people have been able to accomplish since has been based upon principles of Greek thought in philosophy and the arts. It is present in Roman civilization and in the Renaissance. Less obviously it underlies much that is best about the Christian world of the Middle Ages, too.

The sense of expression, economy of design and line, and the proportion of Greek art are its strong features. The history of Western art seems based upon these principles, even as a measure with which to determine the degree of variance one or another culture will stray from the norm.

Selected Readings

Beazley, J. D., and B. Ashmole. *Greek Sculpture and Painting to the End of the Hellenistic Period.* Cambridge, England: Cambridge University Press, 1966.

Bieber, M. *The Sculpture of the Hellenistic Age.* New York: Columbia University Press, 1961; reprint, New York: Hacker, 1980.

Boardman, J. *Greek Art.* rev. ed. New York: Thames and Hudson, 1987.

Branigan, K., and M. Vickers. *Hellas: The Civilizations of Ancient Greece.* New York: McGraw-Hill, 1980.

Brilliant, R. *Arts of the Ancient Greeks.* New York: McGraw-Hill, 1973.

Cook, R. M. *Greek Art: Its Development, Character and Influence.* Harmondsworth: Penguin, 1976.

Dinsmoor, W. B. *The Architecture of Ancient Greece.* 3d ed. New York: Norton, 1975.

Havelock, C. M. *Hellenistic Art.* 2d rev. ed. New York: Norton, 1981.

Janson, H.W., ed. *Sources and Documents in the History of Art.* Series. Englewood Cliffs, NJ: Prentice-Hall.

Lawrence, A. W. *Greek Architecture.* 2d ed. Baltimore: Penguin, 1967.

Pollitt, J. J. *The Art of Greece: 1400–31 B.C. Sources and Documents.* Englewood Cliffs, NJ: Prentice-Hall, 1975.

Richter, G. M. A. *A Handbook of Greek Art.* 6th ed. London: Phaidon, 1969.

_____ . *The Sculpture and Sculptors of the Greeks.* 4th rev. ed. New Haven, CT: Yale University Press, 1970.

Robertson, D. S. *Greek and Roman Architecture.* 2d ed. Cambridge, England: Cambridge University Press, 1969.

Robertson, M. *History of Greek Art.* 2 vols. Cambridge, England: Cambridge University Press, 1975.

Scranton, R. L. *Greek Architecture.* New York: Braziller, 1972.

Scully, V. *The Earth, The Temple, and the Gods: Greek Sacred Architecture.* rev. ed. New Haven, CT: Yale University Press, 1979.

Wycherly, R. E. *How the Greeks Built Cities.* 2d ed. London: Macmillan, 1962.

6

Etruscan and Roman Art

753 B.C. Founding of Rome

c. 700–509 B.C. Etruscan domination of Italy

c. 510 –27 B.C. Roman Republican period

27 B.C.–A.D.14 Reign of Augustus

A.D. 79 Eruption of Mount Vesuvius destroys Pompeii and Herculaneum

A. D. 118–125 Pantheon built

A.D. 312–315 Arch of Constantine

A.D. 410 Visigoths sack Rome

A.D. 455 Vandals sack Rome

A.D. 476 Abdication of Romulus Augustulus; end of the Roman Empire

Italy, from Naples south, and Sicily were the sites of a number of Greek coastal city-states from the eighth to the fifth centuries B.C. and later. Inland and to the north were indigenous peoples. The most advanced of these people during that period were the Etruscans. They inhabited the region from the Tiber to the Arno rivers. Most of modern Tuscany, Umbria, and much of Lazio include Etruscan sites. From the seventh to the third centuries B.C., the Etruscans were a major power in Italy. Etruscan kings ruled in Rome in the sixth century until 510 B.C., when the Roman Republic was founded. Their presence as traders in the Mediterranean was competitive with that of the Phoenicians and Greeks.

The origins of the Etruscans have not been traced successfully, though the strongest indications are that they came from Asia Minor. The Etruscan language is not Indo-European and has only partially been deciphered. Etruscan art is clearly influenced by the Classical art of Greece as it develops, but it is very different at its roots. The Etruscans bought Greek artifacts, adopted the Greek alphabet, and assimilated gods such as Apollo and Artemis into their own religion. A great percentage of the Greek pottery that survives has been found in Etruscan tombs.

According to ancient tradition, Rome was founded in 753 B.C. As the chief city of an expanding hegemony, it emerged on its own in the fifth century B.C., once free of Etruscan domination. In the next century the western Gauls invaded Italy. They overran the Etruscans and even sacked Rome in 390 B.C.

The Romans and Etruscans recovered to continue warring with each other. Rome also began an expansion that was systematic and extraordinary. By the third century Rome had assumed control over the Greek city-states in southern Italy and conquered most of Spain. In the second century B.C., Greece, Macedonia, Carthage, and parts of Asia Minor and Gaul all fell to the Romans. By the first century B.C., Syria, Egypt, the rest of Gaul, and all of the Etruscan city-states had been absorbed into the Roman domain.

ETRUSCAN ART

Etruscan Architecture

The Etruscans walled their cities and used true arches at major entrances. They built temples, although none has been preserved. The Roman architect and author Vitruvius, writing in the first century B.C., described Etruscan temples in his *Ten Books on Architecture*, from which we have knowledge of their appearance.

ETRUSCAN TEMPLES

Etruscan temples were built upon a raised podium. Most were of mud-brick and wood construction. A large porch covered the front half of the podium; a cella, the full width of the podium, stood at the rear, divided into three adjacent chambers. Columns supported the porch but did not extend in a peristyle around the cella. The roof was gabled with a low sloping roof. Little is known about the entablature or pediment. Sculpture in the form of *acroteria* and *antefixes* stood atop the roof on the eaves, over the pediment, and along the ridge.

ETRUSCAN BURIAL SITES

Most Etruscan cities were associated with elaborate burial complexes. The Etruscans were concerned with the commemoration and preservation of an afterlife. In this their attitude is more closely related to the ancient

Egyptians and Mesopotamians than to the Greeks. The necropolis at Cerveteri includes many *tumuli* (*tumulus*, sing.): round, domed underground stuctures with rectangular chambers within.

The Tomb of the Reliefs. The interior of one of these *tumuli* in Cerveteri, the Tomb of the Reliefs, with piers and a ridged ceiling, is reminiscent of the architectural pattern in the rock-cut tombs of Middle Kingdom Egypt. On the piers are reserved carvings of tools, weapons, and utensils. Niches and benches for sarcophagi and cinerary urns line the walls and extend between piers.

Etruscan Sculpture

The Etruscans were able and expressive sculptors. They worked in bronze and terra cotta.

APOLLO OF VEII

The famous *Apollo* of Veii is a terra-cotta ridge figure from a temple, made about 500 B.C. It shows clear inspiration from Archaic Greek sculpture in its stylized expression, hair, and drapery. This figure is heavier than a typical Kouros, however, and he is striding with a weighty gait; he has a decidedly non-Classical appearance.

SARCOPHAGUS SCULPTURE

Similar stylization appears on a sarcophagus of about 520 B.C. from ancient Caere (Cerveteri). A life-size married couple reclines on the top of the sarcophagus. They and the body of the sarcophagus are made of terra cotta. Many such sarcophagi have been discovered with one or two figures. Most are carved from stone. A number of them depict middle-aged, overweight male figures, clearly at odds with the youthful ideal of Classical art.

ETRUSCAN SCULPTURE IN THE ROUND

Capitoline She-Wolf. Additional sculpture of the Etruscans includes the famed *Capitoline She-Wolf*. This bronze sculpture of around 500 B.C. is a remarkably vigorous, fiercely protective beast, alert, with her hackles raised against an intruder. She has long been the symbol of Rome, taken to represent the wolf who traditionally suckled the infants Romulus and Remus, the city's legendary founders. A pair of bronze babies representing the twins was added to the sculpture in the Renaissance.

The *Chimera* from Arezzo. The bronze *Chimera* from Arezzo is also an energetic figure of the monstrous beast of ancient tradition. It has a lion's body and head, a second head of a goat at its withers, and a serpent-headed tail. The *Chimera* is dated about 400 B.C. It is in the Archaeological Museum in Florence.

Mars of Todi. From about the same time as the *Chimera* is the standing warrior figure, known as the *Mars of Todi*, named for the town near which it was discovered. Nearly life-size, clad in waist-length body armor, the figure appears in an awkward pose. His weight is on both legs, but a pronounced hip-shot stance casts his body at an odd angle with his legs. He has a long, columnar neck and gestures almost delicately with his arms. In brief, the sculptor seems to have deliberately avoided the Classical pose. The original inset eyes, affixed helmet, and the weapon or staff once held in the warrior's left hand have all been lost.

Etruscan Painting

The best examples of Etruscan paintings are tomb decorations. The large necropolis at Tarquinia has provided the richest assortment of these. The tombs at Tarquinia are rock-cut underground chambers rather than *tumuli*. Stylized and colorful, the Tarquinian murals give little evidence of progression in naturalism. Dancers, animals, ritual figures, and mythological scenes drawn from Greek pottery grace the walls of these subterranean chambers. The figures are usually silhouetted in bright color with little internal modeling. They are less formal or traditional than the tomb paintings of the Egyptians. Closer in spirit are the paintings of the Minoan palaces though there is no link between the two cultures, separated as they are in function and by a half millennium.

ROMAN ART

Early Roman Art

In the fourth century B.C. and after, the growth of Rome was a steady, inexorable process. The Romans proved adept at absorbing their conquered territories. Their art is reflective of the many cultures that would ultimately fall within the Roman sphere. Classical and Hellenistic Greek art are surely the greatest influences upon the Romans. The Etruscans, too, were instrumental in the development of Roman art. It seems that the adaptation of foreign styles was a matter of pride to the Romans, symbolizing their conquests.

REPUBLICAN ROMAN ARCHITECTURE

Roman engineering and building is without peer in the ancient world. The style may well be adopted from Greece, Egypt, or elsewhere, but Roman building depends upon Roman technology. Arches and vaults became as much a mainstay of spatial enclosure as the *trabeated* architecture of the Greeks. Roman building depended on the development of Roman concrete, a mixture of mortar and aggregate. The mortar was made of lime and *pozzolano* (a volcanic sand from Pozzuoli near Naples). The aggregate was

rubble, pieces of stone and brick. This mix would dry and slowly harden into an inert solid. This allowed far larger vaults and much greater variety of building forms than ever before attempted. The concrete was faced with marble, stone, brick, or plaster for a finished appearance.

The "Temple of Fortuna Virilis." A basic type of Roman temple is exemplified by the "Temple of Fortuna Virilis" (actually Portunas), in Rome near the Tiber Island. This temple dates from the early first century B.C. It is clearly derived from the Etruscan type of temple.

It has a raised podium and pronounced porch, and the cella extends to the full width of the podium. The cella is a single chamber, however; it is surrounded by engaged (attached, half-diameter) columns and capitals that continue the order around the building. This gives the temple the appearance of an Ionic Greek peripteral temple (thus, "pseudoperipteral").

Round Temples. A second form of Roman temple was adapted from the Greek *tholos* type. Also typically on a raised podium, this form of temple has a cylindrical cella surrounded by a genuine peristyle. "The Temple of the Sibyl" (or Vesta), at Tivoli, and the Round Temple near the "Temple of Fortuna Virilis" are both examples of this type. Both of these are also from Republican Rome, built in the late second or early first century B.C.

Sanctuary of Fortuna Primigenia. From the same period is the building complex at Palestrina (ancient Praeneste) called the Sanctuary of Fortuna Primigenia, consecrated to an ancient oracle and sacred to a pre-Roman cult. The Romans perpetuated the cult and built a huge system of structures here, aligning them symmetrically in seven tiers on the side of a great hill. The visitor ascends from the valley by assorted stairs and ramps to each successive level. At each level, colonnades, vaulted passageways, arcades, and plazas open in variations. Much of the construction has been facilitated by concrete. Near the top a row of shoplike cubicles were fronted by an arcade on which a colonnade was superimposed. This combination of arches flanked by columns became a mainstay motif of Roman art as well as Renaissance art.

Above this tier at Palestrina was a huge semicircular stair, similar to a Greek theater. It led up to a colonnaded *hemicycle*. Beyond it was the Round Temple of Fortune at the apex. The whole complex was imposed on a single axis on the hillside. It provided platforms for ritual and monumentality for pageantry. The most obvious predecessor to Rome in the use of such large-scale symmetry was ancient Egypt. The mortuary temples of Mentuhotep and Hatshepsut at Dier el-Bahari bear comparison.

POMPEII AND HERCULANEUM

In A.D. 63, a large earthquake struck the region of Naples, near Mount Vesuvius. Among the nearby towns damaged by the earthquake were Heculaneum and Pompeii. Much of the local damage had been repaired or

rebuilt with new structures when, in A.D. 79, the volcano Vesuvius erupted. Pompeii and Herculaneum were destroyed in the eruption; Pompeii was buried in volcanic ash and cinders; Herculaneum, by lava flow.

The rediscovery of these sites and formal archaeological exploration began in the eighteenth century. The circumstances of their destruction, so rapid and total, preserved for all time an exacting record of Roman life in the Early Imperial period. Moreover, many of the buildings and artworks were of the Republican period, as was the layout of the two towns. In Herculaneum, only part of the ancient town, including its poorer quarter, has been excavated. There, tenements and apartment houses, little different from similar housing in modern Naples, have been found. Some of the buildings are patrician villas divided later into apartments. The Roman economy was changing. Cities and towns were becoming crowded with people driven from the agricultural lands by the introduction of slave labor, a by-product of Rome's colonial expansion and wars.

Pompeii, more an aristocratic resort than Herculaneum, was rich in patrician houses and villas. The town center was the Forum, with open space, flanked by the pre-Roman Temple of Apollo, Temple of Jupiter, Basilica (civic center), and Macellum (market). Additional public buildings in Pompeii included the amphitheatre, grand theater, Odeon (small theater), baths, and bakery.

Private houses in neighboring streets presented narrow entrances between blank walls or rows of single-room shops to the street fronts. The inner coutyard, called the *atrium*, was surrounded by rooms for family use. Behind was a second open space, a garden. In some houses this garden was quite large and surrounded by a covered colonnade, termed a *peristyle*. On the outskirts of Pompeii were freestanding landscaped villas. The Villa of the Mysteries, a short distance northwest of town, is one such villa.

PAINTING AND SCULPTURE IN THE LATE REPUBLICAN AND EARLY IMPERIAL PERIODS

Pompeii and Herculaneum have provided the best examples of Republican and Early Imperial Roman representational arts. Houses and villas have yielded well-preserved sculpture, wall paintings, and floor mosaics. A rich variety of their styles and subject matter provides an indication of Roman taste and skills. A strong factor in this is the Roman taste for Late Classical and Hellenistic painting, usually reproduced by skillful copying. The *Alexander Mosaic*, from the House of the Faun, now in the Archaeological Museum in Naples, is an example.

Villa of the Mysteries. The great frieze of paintings on the walls of a room in the Villa of the Mysteries represents the performance of initiation rites into the cult of Dionysus. The elegant, nearly life-size figures perform a stately ritual, regarding one another across the space of the room. They

are painted as if standing on a narrow ledge that surrounds the room backed by panels of solid Pompeian red color. Neither the details of the ritual nor the authorship of the paintings is known. The poses and the cult reflect Hellenistic origins. Some scholars speculate that the mistress of this villa was a priestess of this mystery cult.

The Four Styles of Pompeian Painting. Pompeian painting has been divided into four separate styles of increasing complexity. These are not historically sequential or of Pompeian origin. Simplest are the representations of blocks or panels of stone in various colors. This simple form was often combined with the other styles in various ways. The second style showed architecural elements illusionistically as if seen over a baluster or out a window. Occasionally, as in the frieze of the Mysteries, the illusion of depth formed a stage for figures.

Subsequent discoveries in Rome and elsewhere have extended our knowledge of Roman painting and its styles. *View of a Garden,* a wall painting from the House of Livia at Primaporta, includes all the walls of a room painted as if it were surrounded by a fenced, private garden. Flowers, trees, and caged and wild birds suggest a tended sheltered open space. The paintings from the House of Livia and the Odyssey Landscapes, from a house on the Esquiline hill in Rome, are both from the end of the first century A.D. The Odyssey Landscapes are painted as a continuous landscape partitioned by a colonnade, each section of which shows a sequence of Odysseus' adventures on his ten-year journey homeward after the siege of Troy. Both of these complexes of paintings represent further treatment of the second Pompeian style.

In the third style, framed pictures painted as if set in the wall or hung upon it are substituted for the illusionary views of the second style. These include mythological scenes, landscapes, and still-life paintings. Additionally, the third style showed fantastic architecture. More than one, often all three, of the earlier styles are combined in the fourth style.

It is worthy of note that the art of Pompeii and Herculaneum, as it began to be discovered and published, made an enormous impact on the arts of the eighteenth century. This extended from painting and sculpture to costume and furniture, wall decoration, and landscaping.

The Roman Empire: Architecture and Sculpture

ARCHITECTURE

The Roman skills at building with concrete and using vaults resulted in the construction of many brilliant works of architecture in the Imperial period.

The "Golden House" of Nero. Severus, architect for the emperor Nero, designed his "Golden House" in Rome, a vast palace built in A.D. 60–68 and partially preserved beneath the later Baths of Trajan. In the Esquiline wing of the palace is a complex of an octagonal hall with chambers facing its five

interior sides. The other three sides faced a garden through a portico. The hall is domed, its eight sides merging to a round dome with an open *oculus*. The surrounding chambers, alternately barrel- and groin-vaulted, are left open above their juncture with the springing of the dome. Light enters the octagonal hall through the oculus and the five chambers through the open surrounding space. It is an ingenious and complex architectural achievement.

The Colosseum. Rome's great Flavian Amphitheater, known as the Colosseum, was built in A.D. 70–82 at the foot of the Roman forum, near the "Golden House" of Nero. It was built by the emperor Vespasian, first of the Flavian dynasty of Roman emperors. The design suits the extravagant spectacles for which the Romans are infamous: gladiatorial combats, battles between animals or men and animals, and various human duels. Even naval battles were staged in the flooded arena.

The oval structure is 161 feet (52 m) high, built of concrete with an elaborate vaulting system. It had seventy-six entrances leading to the seating area from the exterior. The outside was faced in ashlar stone. There were four stories, the lower three with regular arched openings flanked by engaged columns in the three Classical orders. The simple, burly Doric columns at street level are in the Tuscan Doric style used by the Romans. Tuscan Doric columns are not fluted and they have bases. The second story is Ionic and the third is Corinthian. The outer shell of the fourth story is faced with a series of flat pilasters with Corinthian capitals. This sequence is traditional in Roman buildings that combine the orders. It is specified and described in Vitruvius's architectural treatise.

The Roman Forums. From the founding of the city of Rome, the Forum Romanum was the commercial, civic, and religious center of Roman life. It was the site of the earliest settlement, a valley between the Capitoline, Palatine, and Esquiline hills just a short distance west from the Tiber River. Various temples, basilicas, and monuments line the Via Sacra, the thoroughfare of the Forum along which triumphal processions proceeded to the Capitoline Hill.

By the time of the Caesars the forum had become overcrowded. A new forum, the first of a series, was built by Julius Caesar in 46 B.C. The largest and last of these was the Forum of Trajan. Collectively known as the Imperial Forums, these great spaces were each dominated by a temple set on axis within a large architecturally enclosed space. They were a magnificent expression of the city's vitality and achievement. Little remains of them now.

Trajan's Forum. Trajan's Forum was built between A.D. 112 and 117. It was entered through a ceremonial archway. First came an enormous courtyard dominated by an equestrian statue of Trajan in the center. It was colonnaded all around and flanked on either side by semicircular extensions of the flanking walls.

Beyond the colonnaded court was the Basilica Ulpia, a huge public hall outfitted for all sorts of civic activity including large assemblies. It extended lengthwise across the width of the forum. Large, semicircular *apses*, mimicking the shape of the walls of the forecourt, were at the ends of the Basilica Ulpia. Each apse was used ceremonially. The central great hall was elevated above the colonnaded aisles that surrounded it. This provided a clerestory for daylight to enter the interior. Reconstructions usually show the interior aisles supporting a second-story gallery above them. Both levels may have been partitioned into offices. The Basilica Ulpia was one of the largest buildings of antiquity. From end to end it measured some 600 feet (183 m), including the apses. It was 200 feet (61 m) wide.

On axis with the entrance, equestrian statue, and center of the basilica stood Trajan's Column, the only recognizable part of Trajan's Forum still in place. Facing the column on either side were two libraries for Greek and Latin works. The large temple of the deified Trajan was the climax of the long axis. Again, this long axis, the symmetry and focus of Trajan's Forum, may be compared to the sanctuary of Fortuna Primigenia at Praeneste or, in line with the tradition of such structural complexes, with the giant pylon temples of ancient Egypt.

The Pantheon. The Pantheon, built between A.D. 118 and 124, is a temple of extraordinary design, a well-preserved example of the capacity of concrete construction for shaping and enclosing space. Once approached by a large colonnaded forecourt, the Pantheon's portico is that of a rectangular temple front with eight columns across and a large pediment. Two more rows of columns behind the first, third, sixth, and eighth columns of the façade create a vast, three-aisled inner space of the portico. The naos is an enormous domed rotunda, little revealed by the cylindrical walls of its exterior. These great walls, as much as 20 feet thick, house seven interior niches for shrines to the pantheon of Roman deities. Outside they mask the springing of the dome up to half its total height, leaving a shallow upper half visible on the exterior, ringed by stairlike indentations that proportionally decrease the thickness of the dome to about 4 feet. The heavy walls and ringed lower dome buttress the accumulated weight of the whole.

Additional lightening of the weight is accomplished by a pattern of coffering, square recesses in tapering grid patterns, on the dome's interior surface. Even without the screen once provided by its colonnaded forecourt, the unprepossessing exterior of the Pantheon does nothing to prepare the visitor for the grandeur of the interior space. At its summit the dome has an oculus, 30 feet (9 m) in diameter. It is 144 feet (46 m) in the air, as high as a fourteen-story building, and open to the sky.

The Baths of Caracalla. Additionally the Romans built large public bath complexes, vast in size and functions. The Baths of Caracalla were built in the early third century A.D. Their central building contained pools

of water graduated from cool to warm to hot. The warm room (*tepidarium*) was a great, groin-vaulted space. Surrounding gardens and buildings housed shops, libraries, restaurants, gymnasia, and other spaces for cultural activities.

SCULPTURE

Roman sculptors learned from Etruscan traditions and from the Greeks. The Etruscans are said to have mastered the idea of portraiture. Early Roman works in this art are meticulous representations of persons as they appeared, without idealization, capturing the individuality and irregularities of faces.

The *Augustus of Primaporta*. By Augustan times the proportions of the Classical period and idealization, at least of imperial portraits, were introduced. The statue *Augustus of Primaporta,* made around 20 B.C., is an example. The figure stands in Polyclitan pose and proportions. He has a mature idealized face and wears armor that bears symbolic imagery relevant to the emperor's conquests and achievement of peace.

The Ara Pacis Augustae. These combined traits can be seen in the relief sculptures adorning the Ara Pacis Augustae (Altar of the Augustan Peace), built in 13–9 B.C. Allegorical subjects, a processional relief, and panels of floral acanthus patterns are on the outer walls of the altar.

One of the allegorical friezes shows Tellus (Mother Earth) seated and nursing two infants. She is flanked by two seated figures who symbolize night and day. They are also said to represent the elements and winds. All sit in a naturalistic landscape with animals, plants, and rocks beneath an atmospheric sky. Wind-filled draperies billow over the figures on either side.

The processional frieze of the Ara Pacis shows individual members of the Julio-Claudian dynasty approaching the altar at its dedication. Some of the figures are surely portraits. The carving is frequently compared to the processional frieze of the Parthenon. The figural proportions are similar, but the Roman frieze is relentlessly crowded. The figures overlap to greater depth, and this is expertly treated by simplification and lower relief of the background figures. There are few voids between standing figures and little of the relaxed, almost casual interchange suggested by the stance of the Greek figures.

The Arch of Titus. On the Arch of Titus, built in A.D. 81 to celebrate the emperor's victories, are friezes on the inner sides of the arch, facing one another. One shows captives and spoils from Titus' victory in Jerusalem. The great Menorah from Solomon's Temple appears. With expressive variety and logic, the procession moves from left to right, marching toward and through a depicted arch of triumph. Opposite and parallel, headed from right to left, is the emperor's chariot. He stands within it accompanied by Victory. Four horses draw the chariot and the emperor's guard accompanies him on foot. But the hierarchy of the imperial portrait here overwhelms the simple

processional logic of the opposite scene. The figures stand at a kind of formal attention and the horses, energetic but immobilized by their formal, almost uniform stance, are not aligned with the royal vehicle.

Trajan's Column. Trajan's Column, in Trajan's Forum, dates around A.D. 106–113. It is almost 100 feet (30 m) high and was originally surmounted by a statue of the emperor (St. Peter has supplanted him in this post). Around the column's circumference in a spiral from bottom to top is a frieze showing the battles and episodes of the Dacian Wars, Trajan's great victories in central Europe. The frieze is about 50 inches (1.27 m) high, crowded with figures, landscape, and architectural details, focusing on a narrative account of the actions leading to victory. It is a continuous 656 feet (200 m) long.

Scale is less important here than impetuous storytelling with much detail. The figures are smaller in scale with the pictorial space than the processional figures of the Ara Pacis or the friezes of the Arch of Titus, allowing for landscape and other narrative elements. Individually, however, the soldiers are often larger than their horses or the buildings and other elements they accompany.

Trajan's Column is the prototype for many later columns of this type. One, set up by the emperor Marcus Aurelius in A.D. 181 in celebration of his victories over the Germans, is still standing in Rome.

The Equestrian Statue of Marcus Aurelius. Better known among the monuments of Marcus Aurelius is his equestrian bronze portrait, made between A.D. 161 and 180. This sculpture was placed in the center of the Piazza del Campidoglio by Michelangelo in 1538. The emperor is much larger in scale than his horse. The raised right forefoot of his steed once hovered over a captive barbarian. Yet the expressive naturalism and authority of both rider and horse are particularly effective.

The Later Empire

Administratively, economically, and in most every other way, the Roman Empire outgrew the means to sustain itself. Its later history is a long process of change, deterioration of authority, colonial revolts, and losses of territory resulting from German attacks in the north and Persian raids in the east.

DIOCLETIAN

This deterioration was arrested for a time by Diocletian at the end of the tempestuous third century. Diocletian invented the tetrarchy, wherein the empire was ruled by one *augustus* and one *caesar* in the east and a similar pair in the west.

The Tetrarchs. The porphyry statue, *The Tetrarchs*, A.D. c. 305 in Venice at San Marco, represents this cast of characters. Clinging together, these figures are intended to express the idea of strength in unity. They have lost the vigor of Classical proportions and gestures, however; thus their gestures suggest an apprehensive, defensive huddle.

Rock-Cut Tombs at Petra. As the Romans encountered more and more distant cultures, the concepts of art multiplied and the expression resulted in recombinations of Classical and non-Classical forms. As early as the second century, the rock-cut tombs at Petra in Jordan combine architectural forms in stories and stratifications. The tomb Al-Kazneh (the Treasury) has a six-columned portico on the first story, supporting an entablature and small pediment. A platform at the pediment level supports another split portico and pediment framing a small *tholos*-like temple over the central door. It is reminiscent of the fantasy architecture of Pompeian painting.

Diocletian's Palace. Diocletian's own palace on the Adriatic coast of present-day Yugoslavia at Split (Spalato) is a fortified citadel enclosing an extraordinary array of late Roman combined forms of architecture. Here are long colonnades supporting arches (arcuated architecture), "broken" pediments, and combinations of arch and temple fronts in intriguing variety.

Piazza Armerina. The remains of a luxurious villa at Piazza Armerina in Sicily, possibly that of Maxentius, defeated rival of Constantine, is another early fourth-century structure of great architectural variety. It is most famous for its vernacular mosaic floors with allegories, hunts, and in one area a group of exercising young women dressed in what look remarkably like twentieth-century bikinis.

CONSTANTINE

The emperor Constantine, in conquering Maxentius and all rivals, did away with Diocletian's tetrarchic system. He ruled alone and established a familial dynasty. He and his descendants divided the empire among themselves, a practice that would continue, often with catastrophic results, into the Middle Ages.

In Rome after A.D. 312, Constantine completed two architectural projects that express the Late Imperial mode particularly well.

The Basilica of Constantine and Maxentius. The first was begun by Maxentius about A.D. 306. It is a huge basilica, 328 by 249 feet (approx. 100 by 75 m), located in the Roman Forum and adjacent to the Forum of Peace at the lower end of the Imperial Forums. The Basilica of Constantine and Maxentius was a vaulted structure. Its great hall, now destroyed, was 114 feet (approx. 35 m) high, and groin-vaulted, even larger than the similarly vaulted tepidarium in the Baths of Caracalla. Two aisles flanked the great hall, each divided into three bays by large barrel vaults. Only the three vaults of the north aisle are still standing. The interior was richly adorned with marble facing. Eight great columns supported the three groin vaults of the great hall. One of the columns survives, standing alone in the piazza before the façade of the early Christian church of Santa Maria Maggiore. It is approximately 47 feet (14.3 m) high.

Colossal Statue of Constantine. An apse on the west end of the Basilica of Constantine and Maxentius once contained the colossal statue of Constantine, now partially preserved in the Capitoline Museum collection on the Campidoglio. The head of Constantine from this statue is 8.5 feet (2.6 m) high. The features are simplified and the eyes huge in proportion to the face. The cheeks are simple planes and the neck is a heavy cylindrical form.

The Arch of Constantine. The second architectural project of Constantine was his own triumphal arch, built between the Colosseum and the Roman Forum in A.D. 313–315. Superficially, at least, the structure of the Arch of Constantine is characteristic of Roman triumphal arches. It commemorates his victory over Maxentius in A.D. 312. It is a triple arch, enhanced with columns and covered with a rich variety of sculpture, much of which has been appropriated from monuments of Hadrian, Trajan, and Marcus Aurelius. These were selected as works of "good emperors" with whom Constantine wished to identify his reign. Their marked contrast in style to the Constantinian reliefs on the arch re-emphasizes the extraordinary change from the Classicism of the earlier emperors to the later Roman style of the fourth century. The figures in the triumphal scenes of Constantine are only slightly articulated, proportionately stubby in stature, with large heads about one-fifth of their total height. They are shown in rows, and a second row behind them appears as an extra line of heads above the first. The proportions are not simple regression to ignorance. They are harbingers of a style that persisted well into the Middle Ages.

Constantinople. Constantine's most significant political act was the foundation of the city of Constantinople on the site of the ancient Greek city of Byzantium. He and his court moved there in A.D. 330. In some aspects this was the beginning of the split between the eastern and western halves of the empire. From the fourth to the sixth century the Italian peninsula was besieged by invaders from the north. Rome was sacked in A.D. 410. The last of the Roman emperors in the West, Romulus Augustulus, abdicated at Ravenna in A.D. 476. The Eastern Empire, though besieged and gradually bereft of its territories, survived until 1453, when the city of Constantinople fell to the Turks, who renamed it Istanbul.

The Romans built and conquered on a large scale. Their civilization grew and absorbed the lands of conquest readily into the imperial sphere. Added to the Classical mode adapted from the Greeks and the skills and forms absorbed from the Etruscans, the Romans adapted elements of Egyptian and Near Eastern art to their repertory. They were accomplished engineers who designed and built for the ages. Some of their roads and buildings are still very much in use.

The development of vaulted architecture, mosaic decoration, landscape and still-life painting, books, and a large segment of modern Western language comes from Roman efforts. What is more, the Roman respect and love for Greek art and learning preserved much of what we know of that culture. We are deeply indebted to Roman civilization, a point we are apt to recognize with some poignancy when walking through eerily familiar streets in ancient Pompeii or Ostia.

Selected Readings

Andreae, B. *The Art of Rome.* New York: Abrams, 1977.

Boethius, A., and J. B. Ward-Perkins. *Etruscan and Roman Architecture.* Baltimore: Penguin, 1970.

Brendel, O. J. *Etruscan Art.* Harmondsworth: Penguin, 1978.

Brilliant, R. *Roman Art: From the Republic to Constantine.* New York: Praeger, 1974.

Brown, F. E. *Roman Architecture.* New York: Braziller, 1971.

L'Orange, H. P. *Art Forms and Civic Life in the Later Roman Empire.* New York: Rizzoli, 1965.

MacDonald, W. L. *The Architecture of the Roman Empire.* rev. ed. New Haven, CT: Yale University Press, 1982.

Maiuri, A. *Roman Painting.* Geneva: Skira, 1983.

Pallottino, M. *Etruscan Painting.* Geneva: Skira, 1952.

Pollitt, J. J. *The Art of Rome: 753 B.C.–A.D. 337.* Englewood Cliffs, NJ: Prentice-Hall, 1966.

Richardson, E. *The Etruscans: Their Art and Civilization.* Chicago: University of Chicago Press, 1976.

Sprenger, M., and G. Bartoloni. *The Etruscans: Their History, Art, and Architecture.* New York: Abrams, 1973.

Vickers, M. *The Roman World.* Oxford: Elsevier-Phaidon, 1977.

Ward-Perkins, J. B. *Roman Architecture.* New York: Electa-Rizzoli, 1988.

7

Early Christian and Early Byzantine Art

A.D. 313 Edict of Milan

A.D. 330 Founding of Constantinople

A.D. 402 Western capital moved to Ravenna

A.D. 476 Abdication of Emperor Romulus Augustulus; fall of the Western Empire

A.D. 525–548 Building of San Vitale

A.D. 526–565 Reign of Justinian

A.D. 532–537 Hagia Sophia rebuilt

Among the first acts of the Roman emperor Constantine after his victory over Maxentius was to proclaim toleration for Christians in a document called the Edict of Milan. It was issued in A.D. 313. By that time the Christian religion had grown, despite official suppression, to include members of the ruling class in the empire. It is quite possible that Constantine was himself a Christian. His mother, St. Helen, was a prominent religious activist. As emperor and defender of the laws of state, including its recognized pantheon of gods, however, he could not have declared his faith publicly.

The Edict of Milan did not advocate Christianity, and the rule of Julian the Apostate (361–363), Constantine's own descendant, saw the temporary reinstatement of paganism. Nonetheless, Christians took immediate advantage of the legal freedom afforded them. Julian's rule proved short-lived,

doomed in the rapid growth of the Christian religion. Before the end of the century, the emperor Theodosius the Great (ruled 379–395) had proclaimed Christianity the official state religion.

Once free to worship and to gather as they saw proper, the Christians set about to build large places of assembly especially at shrines marking the sites of martyrdoms and other holy events. The style of the churches they built corresponds in most parts to buildings of the Late Imperial age of Rome. Its vestiges of the Classical world are similar to those found in pagan art of the regions where the shrines were built. It is not unreasonable to assume, as has been suggested, that the sculptors of the reliefs on the Arch of Constantine also found employment as carvers of Christian sarcophagi.

EARLY CHRISTIAN ART

There are few works of Christian art that date before the third century A.D. The original concept of Christianity avoided ostentation. It encouraged both modesty and humility for its practitioners, most of whom, at first, were also of the lowest social classes, little accustomed to artistic expression as an element of life. Even when works of Christian art begin to appear in the third century they are limited to areas of shared traditional customs, mostly funerary. Tomb decoration and carved figural scenes on sarcophagi are among them. The rival mystery cults, of Isis and Mithras among others, in the first centuries after Christ also held a belief in life after death and practiced burial rather than cremation of their dead.

The Christian religion derived from an assortment of traditions. Originally an outgrowth of Judaism, Christianity depends upon the realization in the teachings, acts, and life of Christ, and of the prophetic teaching and acts of the Hebrew prophets and heroes. *Typology*, the comparative paralleling of events that expressed this realization, is a commonplace in Christian art from the outset. Such stories as that of Jonah and the great Whale were represented as a *type* for which the story of Christ's death and resurrection was the *antitype*; the willingness of Abraham to sacrifice his son Isaac was a type for the Crucifixion. Prophecy fulfilled is an integral element in the texts of the Gospels. The Hebrew Bible was thus never discarded but remains an essential part of the revealed laws of the Christians.

Christian beliefs in the equality and brotherhood of humankind, in strict virtues, and in the liberation of slaves all coincided with the ideals of Republican Rome. They only became seditious as Roman emperors declared themselves divine, sanctioned slavery, and promoted a caste system allocating rights by station in life. For these reasons the Christians were more

severely persecuted than the adherents of less adamant mystery cults. Because of their beliefs, however, the Christians attracted followers and gained power even as the Roman Empire was losing it.

Architecture

The form of Christian worship determined the structure of churches. Before the churches were built, existing structures were sometimes modified to Christian use.

THE *DOMUS ECCLESIAE*

One particular need of Christians from the outset was for places of assembly for worship and communion. The earliest Christian meeting places were simply houses or rooms within houses adapted for worship. Such a building is known as a *domus ecclesiae,* or "house church."

One preserved example is the House Church found in the excavations of Dura-Europos, a Roman frontier town on the Euphrates River in northern Mesopotamia (present-day Syria). This house was converted in A.D. 231 into a church. It included rooms for a sanctuary and an adjoining hall for the uninitiated to hear the services, a vestry, and a baptistery.

Fragments of the paintings in the baptistery are preserved at the Yale University Art Museum in New Haven, Connecticut. They include a large-scale wall painting, *Three Marys at the Sepulchre*. There are small-scale depictions of the Good Shepherd, Adam and Eve, and details from at least one healing scene in a *lunette* over the reconstructed baptismal font. Through Christ—the Good Shepherd—by means of baptism, original sin is washed away. Baptism is also likened to Christ's death and Resurrection. Thus the paintings are a programmatic element in the baptistery and provide visual affirmation of the Christian belief.

THE CATACOMBS

The same kind of programmatic decoration embellishes the burial chambers in the Roman catacombs. These were customary burial sites on the outskirts of the city. They consisted of underground passages cut from the soft porous rock (*tufa*) that characterizes the uppermost bedrock in the area of Rome. The catacombs provided underground space in niches (*loculi*) hollowed out in the sides of long passageways or in chambers (*cubicula*) opening off these passages for such burial. The dead, sealed into the niches or placed in sarcophagi in the chambers, were remembered and their fellow worshipers reassured by the painted and sculpted images that confirmed the Resurrection. The Good Shepherd prevailed; images of Jonah and the Whale, the Three Hebrews in the Fiery Furnace, the Raising of Lazarus, Daniel in the Den of Lions were repeated, painted in a simple pattern-book, Late Classical style. Understandably, the affirmation of the Resurrection is

a major theme here. There is little evidence that any regular worship services were held in the chambers of the catacombs.

THE BEGINNINGS OF CHURCH BUILDING

Constantine's personal patronage established the building of several churches. St. John in the Lateran (still the cathedral of the city of Rome), the Church of the Nativity in Bethlehem, the Church of the Holy Sepulchre in Jerusalem, and Old St. Peter's in Rome were all constructed or planned in his reign.

The earliest Roman churches, and thereafter many others, were built as *basilicas*, a term bearing upon sources among traditional Roman structures of this name, built for government offices and civic functions. The Christian basilica is not a refabricated form of earlier structure, however. Its design specifically fills the needs of Christian worship. Most of the components of a Christian basilica have been retained to the present through many varieties of building styles.

Old St. Peter's. The main space of a basilican church such as Old St. Peter's, in Rome, is comprised of a long hall colonnaded on either side. This hall, called the *nave*, is taller than the *aisles* on either side of it. This allows for clerestory windows to illuminate the interior. St. Peter's and some of the other large basilicas had two side aisles on each side of the nave. At the end of the nave was an *apse*, a semicircular extension of the nave within which was the shrine, at which stood the high altar.

At Old St. Peter's a second hall, set at right angles to the nave, crossed between the nave and apse. This *transept* was open to the nave through a large arch called a *chancel arch* in some sources and a *triumphal arch* in others. A second arch opened to the *chancel*, either directly upon the apse of the church, as at Old St. Peter's, or in later examples on an extension of the nave followed by the apse. The nave extension, when present, was called the *choir*. It led to the apse. Within the space of the apse and the apse end of the choir is the holiest part of the church, the *sanctuary*, which is the location of the high altar.

At the front entrance to the nave and side aisles of an early Christian basilica was a covered portico, or *narthex*. This was frequently preceded by a covered passageway around a rectangular open court, or *atrium*, in front of the building.

The long nave of a basilican church was focused toward the high altar and afforded room for a large congregation of worshipers. The transepts could accommodate more. Side aisles could be reserved for the uninitiated, or catachumens. It was a practical arrangement. All of the earliest basilicas were truss-roofed with timber and tiles. This was partly for genuine economical reasons. Moreover, the elaborate groin vaulting of the great halls in baths, such as those of Caracalla, and secular structures, such as

the basilica of Maxentius and Constantine, may have been deemed too ostentatious.

CENTRAL-PLAN CHURCHES

A second form of the early Christian church was built on a centrally oriented plan. These buildings were built in the shape of either a square, octagon, circle, or Greek cross (having arms of equal length extending from the four sides of a square nave).

The Church of Santa Costanza, Rome. The Church of Santa Costanza in Rome, built on a circular plan about A.D. 350, is a good example. Santa Costanza was originally built as a mausoleum for the sister or daughter of the emperor Constantine next to the Church of Sant'Agnese, also founded by the emperor. Its circular nave is ringed by a barrel-vaulted aisle in which are still preserved early Christian mosaics.

Constantine also began the octagonal baptistery, San Giovanni in Fonte, adjacent to the Lateran Basilica of St. John. Central-plan churches were usually either mausoleums, baptisteries, or oratories. The form relates to Roman tombs such as that of Hadrian (Castel Sant'Angelo), in Rome, or of Diocletian, within his palace at Spalato.

The Church of Santa Sabina. Among the forms of basilican and centrally planned church structures in the early Christian period was a notable variety of possibilities. The Church of Santa Sabina, built in A.D. 422–432 in Rome, is a well-proportioned example of the simplest type. It has carefully matched Roman Corinthian columns from some demolished Classical building. These define a simple nave with side aisles. Its apse is without a transept. A little of its original mosaic decoration is preserved as is an unusual door of cypress wood carved with Old and New Testament scenes. Among the scenes is the oldest-known depiction of the Crucifixion of Christ.

The Church of St. Simeon Stylites, Kal'at Siman. By contrast, one of the most complex of combined architectural forms was the monastery church of St. Simeon Stylites at Kal'at Siman in Syria, built around A.D. 470. Here four basilican structures merged in cross formation at a central octagon, ranged around the saint's pillar. The eastern basilica had apses at its east end. The other basilicas had monumental entrances. St. Simeon was an ascetic but beloved monk, a teacher who spent the last thirty-six years of his life atop this pillar. The shrine became an important pilgrimage site.

The Church of St. John, Ephesos. The Church of St. John in Ephesos was originally a simple, square, centrally planned, and domed *martyrium* over the grave of St. John the Evangelist. It, too, was elaborated with four basilica arms in the fifth century A.D. extending in all four directions with emphasis toward the East. St. John's Church was rebuilt in the sixth century by the Byzantine emperor Justinian, who created a much larger structure with multiple domes. It is no longer standing.

RAVENNA

During the fourth century in the Western Empire there were increasing barbarian pressures on the Italian peninsula. For most of the fourth century, Milan had served as the Roman capital for strategic reasons. Theodosius the Great, whom we have noted was the first to proclaim Christianity as the official state religion, divided the empire at his death between his sons— Arcadius, who ruled in the East, and Honorius, in the West. In A.D. 404 the emperor Honorius moved the western capital to Ravenna, situated on the northeastern coastal plain of Italy, with access to the Adriatic Sea at Classe. Ravenna stood in the way of the invasion routes, though it could not prevent the capture and sack of the city of Rome in A.D. 410 by Alaric, king of the Visigoths, and in A.D. 455 by Genseric, king of the Vandals.

The Orthodox Baptistery. At Ravenna, Honorius established a cathedral (rebuilt in the eighteenth century) next to which the fifth-century baptistery still stands. The latter is an octagonal, domed structure that still retains elaborate stucco and mosaic decorations. It was built about A.D. 425. The central mosaic of the dome is the *Baptism of Christ.*

The Mausoleum of Galla Placidia. A small mausoleum near the Church of San Vitale in Ravenna is traditionally said to be that of Galla Placidia, Honorius' sister. It is dated about the same time as the Orthodox Baptistery, built before Galla Placidia's death in A.D. 450. It is a small, cross-plan structure, rich in mosaics in the central dome and in the vaults adjoining it.

Ravenna itself fell to the barbarian Odoacre in A.D. 476. The abdication of Romulus Augustulus in favor of Odoacre marks the end of the Roman Empire in the West. Under the Ostrogothic king Theodoric (A.D. 493–526), the city flourished. Theodoric was Christian, albeit an Arian. Arians were followers of the Monophysite sect, preached in the East by Arius. They were thus heretical in the eyes of Orthodox Christians.

The Arian Buildings in Ravenna. Theodoric built churches and a baptistery for his own people. The Arian Baptistery of A.D. c. 500 has a dome mosaic of the Baptism inspired by that of the Orthodox Baptistery. The Church of Sant'Apollinare Nuovo, a basilica without transept of about the same date, contains mosaics from this period partially overlaid with sixth-century mosaics. Theodoric's own mausoleum, a curious, decagonal, two-storied stone building, stands on the outskirts of Ravenna; its domed top is an immense carved monolith. Theodoric died in A.D. 526. In A.D. 540 Ravenna was captured by Belisarius, a general in the armies of Justinian, on behalf of the Eastern Empire.

Painting and Sculpture

As an outgrowth of the Judaic tradition, Christianity was not at first prone to much figural illustration or expression in art. Christianity taught humility, and the lack of ostentation was seen as a virtue. The laws of Moses

were also confirmed in Christ's teaching. God's second commandment to Moses was the proscription against "graven images" (Exodus 20:4). At times this would make deep inroads into the history of art in the Western world.

Two factors were to militate for the early appearance of Christian art despite these restraints. One involved the appeal that Christianity held for a sophisticated Gentile world in which art was an established factor. The other, expressed by a number of the earliest Christian apologists, was the capacity for art to teach. In this capacity, early Christian art may be seen to have a particular pictorial emphasis, particularly in the realm of symbolism. Simple animal or object representations could be invested with great power of expression. A fish, for instance, became a symbol for Christ, because the initial letters for the phrase "Jesus Christ, Son of God, the Savior" in Greek spelled "*ICHTHOS*," Greek for "fish." Similarly, lambs, peacocks, palm trees, wreaths, and vines held special meaning. Moreover, as we have noted, pictorial references to biblical events might refer as typologies not only to the event as shown but as it confirmed some credo or other redemptive event.

Such symbolic use did not originate with the Christians, but we know and can confirm more of its use and meaning in their art than any other. The art of the catacombs generally confirms this need by its selectivity and purposeful uses. Sculpture was predominantly limited to reliefs on sarcophagi and to ivory carving. Paintings on the walls of catacombs and early churches, mosaics in churches, icons, and book illumination were all included among the representational arts in the early Christian and Byzantine periods.

SARCOPHAGUS RELIEFS

Some wealthy Roman Christians—Junius Bassus, for instance, a Roman prefect who died in A.D. 359—had elaborate sarcophagi, carved with rich detail. His sarcophagus has two tiers of scenes from the Old and New Testaments on its front, separated by columns and architectural detail. Others were carved with scenes of the story of Jonah, the Good Shepherd, and other subjects related to salvation, resurrection, or rebirth.

IVORY CARVING

Small-scale carved works from this period have also been preserved. Carved ivory *diptychs* were produced by the Romans to commemorate major political and ceremonial events. These included election to consulship and marriages of powerful families.

The Symmachus–Nichomachus Diptych. A pagan example of about A.D. 380, commemorating the marriage of members of the Symmachus and Nicomachus families, is preserved in the Victoria and Albert Museum, London. There are subtle carvings of priestesses of the marriage cult on each plaque. There is special emphasis on Classical forms in the carving on each

of these plaques. This probably represents the conscious emphasis on pagan tradition still maintained by some Roman patrician families through the fourth century.

A Sixth-Century Plaque of St. Michael. Ivory diptychs were carved by the early Christians as well in commemoration of Christian events of a similar nature. An early sixth-century ivory showing St. Michael, now in the British Museum, London, is one-half of a diptych. It probably was made in Constantinople. It retains much of the carving style found in Classical work, although the angel's figure has lost logical connection in space with the architectural framework surrounding him. His feet overwhelm the stairs to the pedestal on which he stands. His arms and wings appear in front of the columns at his sides even though these columns stand on piers placed in front of him.

MOSAICS

When the building of churches began, their decoration with frescoes, mosaics, and carvings started as well. Mosaic, which had primarily been used as ground paving by the Romans, was converted to use in vaults and on walls by the early Christians.

Christ-Helios. An early example is the vault of a burial chamber near the burial place of St. Peter under the church of St. Peter in the Vatican. The mosaic dates to about A.D. 250–275 and shows Christ as the sun god Helios (Apollo) driving the chariot of the sun through the heavens. This adaptation of the Classical attributes of Apollo would suit a wealthy Christian who had chosen to be buried in the same cemetery as St. Peter, near his martyrium.

The fourth-century mosaics in Santa Costanza and fifth-century examples at Santa Pudenziana and Santa Maria Maggiore, both in Rome, demonstrate the early popularity of the medium. The mosaics preserved at Ravenna are also of great importance.

The Mausoleum of Galla Placidia. In the Mausoleum of Galla Placidia the entire surface of the vaults over the doors and walls is covered by mosaic. A mosaic lunette of the Good Shepherd, seated and attending his flock, over the entrance retains some of the Classic simplicity and landscape aura of the Tellus relief on the Ara Pacis Augustae.

The Orthodox Baptistery. Centered among the ornate Orthodox Baptistery dome mosaics is the *Baptism of Christ*. In the river with the baptized Christ is a small classical river god, labeled the *Jordan*. Surrounding the scene are the Twelve Apostles and in another ring are altars with the four Gospels and Thrones. Decorative stucco reliefs appear in ornamental niches and elsewhere on the walls of the baptistery.

Sant'Apollinare Nuovo. There are scenes of Christ's ministry and Passion high on the walls of Sant'Apollinare Nuovo over the clerestory windows. Various styles among the models used by the mosaicists produce

an interesting variety within the products of one workshop. One scene, *Christ Separating the Sheep from the Goats* (Matthew 25:31–46), is frontal and symmetrical, a forerunner of the great Last Judgment compositions of later centuries. Others are more strictly narrative scenes that show the events as straightforward pictorial history. We see Christ brought before Pilate and the Roman governor washing his hands as a regular progression. In the scene the formal enlargement of Christ and Pilate, Christ's halo, and Pilate's throne are used to explain the narrative.

BOOK ILLUMINATION

More than any earlier religion except Judaism, Christianity is a faith reliant upon books. Primarily the Scriptures, the Old and New Testaments, were transmitters of the Word of God. The Christian altar required these texts, gathered in special service books, for worship. A particularly luxurious art, continued from antique tradition, is the *illumination* of books, especially for the great shrines.

The major book form until Roman times was the papyrus scroll, a few inches high and several feet long, handwritten in short columns of text. The scrolls were unrolled from one side and rewound on the other. Frequently, several scrolls were required for a single text. These were boxed together to form a volume. Many fragments of such scrolls survive. Some are illustrated in their text columns with figural scenes of the events taking place.

Sometime in the first century A.D., the Romans invented the paginated book (*codex*). These, too, were illustrated. The variety of codex illustration indicates that variation could have existed in illustrated scrolls as well, although the evidence remains conjectural. It has been suggested, for instance, that the sculptural frieze of Trajan's Column imitates a continuous scroll illustration.

There are several illustrated secular books of the fifth century A.D. that have survived. By this time, the preferred material for books was parchment, prepared sheepskin or goatskin. Two versions of Virgil's texts are in the Vatican Library, and a copy of the *Iliad* survives in the Biblioteca Ambrosiana in Milan.

EARLY BYZANTINE ART

Constantinople was consecrated in A.D. 330 by Constantine. He founded it on the site of the Greek city of Byzantium, itself founded in the seventh century B.C., on the Bosporus, the strait between the Black Sea and the Sea of Marmara that leads to the Aegean and the Mediterranean world.

The foundation of a new capital at Constantinople was not intended to sever the old empire in two, but that would be the ultimate result. The external pressures on East and West, the differences of language, and, eventually, theological differences based on different interpretations of the Scriptures and Church law would sever the Roman and Constantinopolitan churches.

The differences in artistic traditions between East and West would also result in considerable differences in styles and uses of art. There are still many controversies in the interpretation of these differences because the surviving works are so few in number and so little is known about their origins. Nonetheless, in the sixth-century Age of Justinian, the art of the Byzantine world boasted a style that was rich in Classical survival and powerful in its widespread influence while the West was particularly distracted by movements of whole tribes of people through its heartlands.

The Age of Justinian the Great

The Eastern Empire, ruled from Constantinople until 1453, fared much differently from the Latin West. It came to great prominence and success with the rule of Justinian the Great (A.D. 527–65). Justinian is noted for his political and military strengths and for his patronage of the arts, especially architecture.

EARLY BYZANTINE ARCHITECTURE

Hagia Sophia. Political riots between rival factions known as the Greens and the Blues in A.D. 532 destroyed the basilica of Hagia Sophia (Divine Wisdom) founded by Constantine, along with much of the city. Justinian managed to quell the riots and rebuild Constantinople. The replacement of Hagia Sophia in A.D. 532–537 with the present great-domed structure ranks as one of Justinian's greatest successes. Two architects, Anthemius of Tralles and Isidorus of Miletus, were responsible for the design and construction.

Hagia Sophia is crowned by a great dome that rises 180 feet (55 m) in the air, as high as an eighteen-story building. It is 108 feet (33 m) in diameter, supported on *pendentives*. The dome is buttressed by four great piers at the corners of the pendentives and by semidomes on the long axis from narthex to apse. Side aisles, passing through the piers, flank the nave.

Spatially, the interior of Hagia Sophia combines the centrality of domed Early Christian churches with the lengthened nave and side aisles of a basilican church. This duality plays an important role in Byzantine church architecture throughout. Both the dome and apse are retained as points of focus in Eastern churches. The form derives from several smaller churches that were built at the outset of the sixth century in Constantinople and elsewhere.

The Church of San Vitale, Ravenna. One of these smaller churches is the most famous of Ravenna's buildings, the Church of San Vitale. It was begun in Theodoric's reign, about A.D. 525, though not finished until 548, after the capture of Ravenna by the forces of Justinian. San Vitale is usually discussed as a Byzantine building because its design relates closely to contemporary churches in Constantinople. San Vitale is an octagonal building, domed in the central nave area. A vaulted aisle surrounds the nave on seven sides, supported on the interior by a rich array of piers and columns. These support a second-story gallery around the nave. The eastern segment of the octagon is slightly larger. It is occupied by a square chancel and an apse that projects beyond the octagonal perimeter of the church. Opposite, the west and southwest segments of the octagon are joined to an offset narthex.

In the chancel and apse is a rich arrangement of mosaics. Two panels within the apse area flank the semidome itself. They show Justinian and his retinue, with his general, Belisarius, and Ravenna's archbishop, Maximian, approaching from the right and the empress Theodora with her own retinue on the left. Each makes a stately procession toward the enthroned Christ at the center of the apse. Christ is accompanied by angels, the patron St. Vitalis, and Archbishop Ecclesius, founder of the church.

Related offertory mosaics and other subjects are on the chancel walls and vault. Rich pavements, inlaid marble on the walls, and delicately carved column capitals relate San Vitale to the best of Byzantine architecture of the period.

The Basilica of Sant'Apollinare in Classe. Contemporary with San Vitale is the Basilica of Sant'Apollinare in Classe, built in Ravenna's port city to house the relics of the saint. It is a beautifully proportioned structure, best known now for its great apse mosaic. This colorful composition shows Saint Apollinaris as a bishop in prayer, flanked by sheep representing his faithful flock. Behind him, in a stylized landscape, three additional sheep gaze at a great blue glory, studded with stars and enclosing a gemmed cross with a tiny head of Christ at its vertical-horizontal intersection. Above in a golden, clouded sky are half-length figures of Moses and Elijah and a hand of God reaching from the summit.

The composition can be deciphered as a representation of Christ's Transfiguration (Matthew 17:1–8). The three sheep represent the apostles Peter, James, and John witnessing the miracle. That this same subject was represented in an entirely different style in the monastery church of St. Catherine at Mount Sinai, also in the mid-sixth century, indicates that Byzantine art, at its height, had receptivity to regional variations of style.

The Ivory Throne of Maximian. In Ravenna's Archepiscopal Museum is an ivory throne that was made for the archbishop Maximian, whose portrait appears with Justinian in the mosaic at San Vitale. The throne was

probably made about A.D. 550 in Constantinople. The whole throne is covered with ivory plaques, with decorative borders, Old and New Testament subjects, evangelists, and St. John the Baptist. Different styles are here, too, enhancing the mysteries of regions and styles in Byzantine art of the Golden Age.

BYZANTINE BOOK ILLUMINATION

Several early Byzantine books, or fragments of books, have survived with similar varieties of illustration from the late fifth and sixth centuries. Some of these were written on purple-stained parchment in silver or gold ink, suggesting imperial patronage. These books include illustrations within the text, full-page illustrations, and author portraits.

A considerable variety of styles exists simultaneously in the early Byzantine period. They may correspond in some instances to their places of origin, or they may be ranged in order of their proximity to a preconceived Classical ideal. There is little agreement on the identification of regional styles and no evidence that the changes represent a simple deterioration of knowledge and ability.

The Vienna Dioscourides. An early sixth-century copy of the text *De Materia Medica*, a treatise on herbal medicine compiled by the Greek physician Dioscourides, was made in A.D. 512 for the Byzantine princess Juliana Anicia. Probably written and illustrated in Constantinople, it is now in the National Library in Vienna.

The *Vienna Genesis*. One of the purple manuscripts is the *Vienna Genesis*, probably of the sixth century, now in the National Library in Vienna. It is a Greek manuscript, probably from Constantinople, with an abbreviated text and detailed illustrations. The individual illustrations often show more than one event, repeating characters as needed. One, with the story of Jacob, even doubles back on itself to form two tiers of scenes separated by a subtly curved bridge at the right side of the illumination.

The *Rossano Gospels*. In the cathedral treasury of Rossano in southern Italy are the *Rossano Gospels*, another Greek manuscript of the late fifth or early sixth century on purple-stained parchment. This is a fragment of a book of the Gospels. It contains very specialized pages of illustration, including one author portrait—of Saint Mark the Evangelist, two full-page miniatures of the trial of Christ, and several pages of teaching and Passion scenes from Christ's life. The latter are accompanied by pictures of the prophets with their texts that allude to the events shown. Pictorial evidence links this book with Jerusalem, but it may have been made in Constantinople for a shrine in Jerusalem.

Book illumination continued to be an important part of the history of art throughout the Middle Ages in both the Byzantine East and the Latin West. Books were exclusively handwritten, usually on parchment, for centuries.

Only the development of paper, printing, and printed illustrations for books, after the middle of the fifteenth century, would make any significant change in the process.

Iconoclasm. Unfortunately we must resort to such outposts of the Byzantine empire as Ravenna and Mount Sinai for much of our visual evidence of Justinian's times. The emperor's other great church, the Holy Apostles, was destroyed after the fall of the city. Its multidomed form is best known in imitation in the Basilica of San Marco in Venice.

The reason for a great loss of Constantinopolitan art comes from within the empire itself, however. From A.D. 726, under the reigns of Leo III, his son Constantine V, and grandson Leo IV, to the latter's death in 780, and again from A.D. 813 to 843, under Leo V, the policies of *Iconoclasm*, opposition to the Byzantine cult of images promoted by the *Iconodules*, were in force in the capital and many parts of the empire. Icons were destroyed, mosaics and frescoes were eradicated, and *Iconophiles*, those who supported the cult of images, were persecuted. "The divine nature is uncircumscribable and cannot be depicted or represented by artists in any medium whatsoever" read the edict of A.D. 726 against the veneration of images (Snyder, p. 128).

The ideas of Iconoclasm are complicated. Inherent in them are beliefs that survive from humankind's earliest prehistory concerning the power and magic of images. Objects and pictures representing fertility idols, fetishes, and animals to be hunted were used to grant or extract power. Most religions have held particular rules and practices concerning images. Among these were the Judaic prohibition of images, from God's second commandment to Moses, and the many negative accounts of idol worship in the Scriptures. To these, particularly in the Greek East, one may add the Platonic concept of the icon as clue to the idea; that is, the image (icon) brings the idea of heavenly things to the mind. In essence this led to worship of the image itself as sacred. As this developed, the concept of icons became highly restrictive. The Iconoclasts saw such a connection as dangerous. While in power, they outlawed images and their worship.

Briefly, from A.D. 787 to 813, in the reign of the empress Irene, and finally after 843 during that of the empress Theodora, the veneration of icons was restored. After enormous losses, Byzantine art came into production again in what is known as the Second Golden Age.

As it became obvious that the empire in the West could not prevail against the influx of new peoples into western Europe, Constantine removed the capital of his empire to Constantinople, the city he had founded on the Bosporus. Subsequent rulers in the Latin West attempted to defend against invasion and occupation, removing the center of government to Milan and then Ravenna.

Rome remained the seat of the papacy and defended itself as best it could against waves of invaders. The Church promulgated a worthy and glorious reward for its faithful in the seamless joys of paradise, "the City of God," as St. Augustine defined it. Building with established techniques to their own specifications, the early Christians established forms of expression that were their own and were to continue.

The eastern sector of the empire, though not unscathed, grew stronger until, in the sixth century under Justinian, Byzantine art reached its own major form. Justinian's Golden Age would not prevail. During the eighth and ninth centuries the great works of art in Constantinople and other major Byzantine centers were destroyed by Iconoclasts.

Selected Readings

GENERAL BOOKS ON MEDIEVAL ART

Snyder, J. *Medieval Art: Painting, Sculpture, Architecture: 4th–14th Century*. New York: Abrams, 1989.

Stokstad, M. *Medieval Art*. New York: Harper and Row, 1986.

Zarnecki, G. *Art of the Medieval World*. New York: Abrams, 1976.

BOOKS ON EARLY CHRISTIAN AND EARLY BYZANTINE ART

Beckwith, J. *Early Christian and Byzantine Art*. New York: Penguin, 1979.

Demus, O. *Byzantine Art and the West*. New York: New York University Press, 1970.

Grabar, A. *The Golden Age of Justinian*. New York: Odyssey, 1967.

Hutter, I. *Early Christian and Byzantine Art*. New York: Universe, 1989.

Kitzinger, E. *Early Medieval Art*. Bloomington: Indiana University Press, 1983.

Krautheimer, R., and S. Curcic. *Early Christian and Byzantine Architecture*. 4th rev. ed. New York: Penguin, 1986.

MacDonald, W. L. *Early Christian and Byzantine Architecture*. New York: Braziller, 1962.

Rice, D. T. *Art of the Byzantine Era*. London: Thames and Hudson, 1966.

Volbach, W., and M. Hirmer. *Early Christian Art*. London: Thames and Hudson, 1962.

Von Simson, Otto G. *Sacred Fortress: Byzantine Art and Statecraft in Ravenna*. Chicago: University of Chicago Press, 1976.

Weitzmann, K. *Ancient Book Illumination*. Cambridge, MA: Harvard University, 1959.

_____ . *Art in the Medieval West and Its Contacts with Byzantium*. London: Variorum, 1982.

_____ . *Illustrations in Roll and Codex*. Princeton, NJ: Princeton University Press, 1970.

8

Early Medieval and Islamic Art

500 B.C.–A.D. 200 Celtic La Tène culture

476 Fall of Ravenna to Odoacre; abdication of Emperor Romulus Augustulus

542 Founding of the monastery at Monte Cassino

568 Lombards move into Italy

622 Hegira of Muhammad

637 Islamic conquest of Jerusalem

664 Synod of Whitby

711 Islamic conquest of Spain

732 Battle of Poitiers

1453 Fall of Constantinople

More than one scholar has remarked that the art of Rome became "medieval" before it became Christian. In other words, the elements of style and meaning in art no longer sustained the concepts of Classical art as an ideal in the later Roman Empire. This assertion implies that the change was a selective process, not simply the result of losses of skill or impoverishment of ideas.

This viewpont is, in fact, true enough. The new forms and the appearance of new stylistic criteria for artists were repeated throughout the later Roman Empire. A new sense of abstraction and pattern is visible. The architectural

orders were replaced by decorative, restyled capitals and entablatures when needed. The arts were used in new ways. Yet, until the fall of the Western Empire and the end of the first Golden Age of Byzantine art, there remained a constant memory, an echo of the Classical past in the work produced.

The void thus created by the deterioration of the Classical tradition was to be filled in an entirely new way. New populations moved into the regions where once the Romans had conquered. Eventually they moved into or across the most constant of Classical lands. These people brought with them a form of expression evolved from migration and portability. It was a far cry from the huge buildings, large sculptures, and the permanence of temples and their decoration.

EARLY MEDIEVAL ART

The newly arrived tribes of the Migration period came to settle in lands that had once been Roman territories or bordered them. Their ancestors had been migrational or nomadic for generations untold. They brought skills with them in small-scale portable goods, fabrics, harnesses, weaponry, jewelry, and ornamentation. Their skills with enamels and precious metals included a rich variety of patterns and motifs abstracted from nature. Obviously their past traditions had no place for architecture or sculpture and painting on a monumental scale.

They did bring with them a decorative tradition that is known as the *animal style*, passed on to them from the Scythians and Sarmatians, nomadic people from the steppes north of the Black Sea. The Scythian *Stag*, of chased gold, 12.5 inches (32 cm) long, now in the Hermitage Museum, St. Petersburg (formerly Leningrad), is the most famous and splendid of their works. It dates from the seventh or sixth century B.C. and represents an extraordinary stylization of the form and characteristics of the graceful animal. The stylization of hooves and antlers into intricate repeating patterns and the sectioning of the animal's body into masses that are based on surface form rather than anatomy are clear elements in the evolution of the art of the Migration period.

Some of these migrating tribes had been converted to Christianity on the move; others received the missionary ministries of Rome or, once settled, of the monastic centers then evolving in the western European lands. Their early efforts in Christian art relate very closely to the culture of their past. Their abstract patterns and stylized animal forms were applied to the symbol world of Christian art. A whole new world of expression was thereby added to the medievalism of the Late Classical era.

An important but still imperfectly known subtext to the history of human culture regards the history of population movements and changes. We have already seen such important movements as those of the Dorians and Etruscans and noted the Gauls, as they affected the centers of ancient civilization.

The Gauls included Iron Age Celts and Britons who settled in western Europe by the first millennium B.C. We have encountered them when they invaded Italy in the early fourth century B.C., temporarily defeating the Etruscans and capturing Rome. They invaded Greece, pillaging Delphi, and Asia Minor in the third century B.C. The statue *Dying Gaul* was set up with others by King Attalus I of Pergamum to celebrate his victory over them. From about 800 to 500 B.C. the milieu of the Celtic Gauls is known as the *Hallstatt culture,* named for an excavated cemetery site near that town in Austria. Archaeological finds there from the sixth century B.C. include artifacts of Etruscan and Archaic Greek origin. Wool fabric interwoven with silk from China was also found, indicating an extensive trade network.

From about 500 B.C. until they were conquered and absorbed by the Romans, the Celtic Gauls' culture is known as La Tène after an archaeological site on Lake Neuchâtel in Switzerland. Some of the motifs from La Tène metalwork—spirals, peltas (shield shapes), and triskelions (figures based on three branches radiating in curves or spirals from a common center)—were to become basic motifs in Celtic book illumination. By about 200 B.C. the only unconquered holdings of the Celts were in northern Scotland and Ireland, beyond the Roman occupation of Britain. North and east of Roman Europe were the Teutonic German tribes, Dacians, and others with whom the Romans had experienced ceaseless battles. Among them are the battles recorded in relief sculpture on the great Triumphal Column in the Forum of Trajan.

Further to the East there were additional nomadic and migratory peoples, still skirting the margins of history. Like the Gauls, their origins had been the steppes of central Asia. The steppes are the high, treeless grasslands that extend eastward from the Danube River across Russia all the way to China. During the Migration period, from about A.D. 350 to 750, these tribal peoples appeared in significant movements, corresponding at first to the weakening of the Roman Empire and the consequent inability of the Western world to hold them at bay.

On the heels of the Huns, Goths, and Vandals of the fourth and fifth centuries came new incursions into western Europe. The Visigoths (western Goths) who sacked Rome in 410 moved across Europe to arrive in the Iberian peninsula before the end of the fifth century. The Ostrogoths, as we have seen, conquered northern Italy and Ravenna only to be overcome by the Byzantine reconquest in 539–540. Lombards moved into Italy in 568. The Franks, among them Merovingians, Burgundians, and Salines, moved

into Germany, France, and the Lowlands. Angles and Saxons entered northern Germany and the British Isles, displacing or absorbing the earlier Roman Britons and Celts, some of whom moved northward to Scotland and Ireland. Vikings from the Scandinavian lands also invaded England and began a series of raids on Europe that would continue until the eleventh century.

During these unsettled times a system of monastic life was established. More than any other institution, the monasteries of early medieval Europe preserved the traditions of learning, literature, and doctrine. Monasteries provided a unifying and civilizing force on the frequently confused jostlings of kingdoms and tribes. Benedictine monasticism was founded by St. Benedict in 542 at Monte Cassino in Italy between Rome and Naples. St. Benedict wrote a Rule for monastic life that was strict and stabilizing. Before Monte Cassino was destroyed for the first time, in 581 by the Lombards, enough monastic houses had been founded by the Benedictines to assure the continuance of the Rule and, with it, the intellectual life of Europe. A stricter ascetic monasticism had been founded in Egypt by St. Anthony, best known of the "desert fathers" of the fourth century. This ascetic monasticism was the chief influence upon the early Celtic Christians. The surviving monks' cells at Skellig Michael, a ninth-century monastery on an island off the west coast of Ireland, are an example. There, corbeled, beehive-shaped huts of flat, mortarless fieldstone "cling like stony limpets to the cliffs of the most inhospital rocks imaginable . . . exposed to the undeflected, constant battering of the North Atlantic winds," as one authority has expressed the sense of the place.

Lombard Art

The Lombards were a Teutonic tribe who invaded Italy in 568. Most of them settled in northern Italy in the Po River valley, establishing their capital at Pavia. The region is still called *Lombardy*. Additional Lombards settled in the region of Spoleto in Umbria, others in Benevento in southern Italy, not far from Naples.

The Lombards were Arian Christians until the early eighth century. Few works of Lombard art survive that are dated before the Lombards' conversion to Catholicism. Remarkable Lombard stone sculptures are the eighth-century cathedral and baptistery at Cividale in Friule, northeast of Venice near the Yugoslavian border. These include the altar frontal of Dukes Ratchis and Pemmo, with reliefs of the *Majestas Domini*, the Visitation, and the Adoration of the Magi, made from 731 to 744, and the baptistery relief inscribed by Archbishop Sigwald (772–776), made around 750. The relief shows the symbols of the Evangelists, a stylized cross, and a remarkable Tree of Life.

These sculptures reveal the external influence of patterns in metal and fabric. The stylization of figures and forms is dramatic and more centered upon decorative symmetry than natural form.

Hiberno-Saxon and Northumbrian Art

By far the most extensive and varied realm of artistic expression surviving from the Migration period is that of the British Isles. There the local traditions and the crafts of new settlers intermingle to form an especially rich and complex art. The Celts of northern Scotland and Ireland were Christianized during the fifth century. Their religion was monastic, developed upon the principles of ascetic monasticism practiced by the "desert fathers" of Egypt, on the pattern of Saints Anthony and Paul the Hermit. Related to their conversion are the eastern Mediterranean sources for early Christian Celtic art. The Irish Christians did not owe allegiance to either Rome or Constantinople. Though their Christianity is popularly credited to St. Patrick, an educated Roman Briton missionary to Ireland, it substantially predates St. Patrick's mission of 456.

The Irish monastics in their turn set up missions to the Anglo-Saxons, Franks, and Lombards. They established monasteries in England, France, Germany, Switzerland, and even Italy. Not until the Synod of Whitby in 664 were the differences resolved between the Roman Catholic Britons and Anglo-Saxons and the independent Irish church. There the churchmen agreed upon subjection to Rome.

THE SUTTON HOO TREASURE

A genuine pre-Christian treasure trove was discovered in a ship-burial of an Anglo-Saxon king, Raedewald (d. c. 625) at Sutton Hoo, in Suffolk, England. Raedewald's treasures included Byzantine coins, a Byzantine silver bowl, and Anglo-Saxon items, including a gold reliquary box in the form of a belt buckle, a richly decorated purse cover, and several gilt bronze decorations from a great shield. The Anglo-Saxon items demonstrate skills in metalwork and enameling, and provide examples of intricate interlacing patterns of zoomorphic forms.

THE *LINDISFARNE GOSPELS*

Most famous for the art of this period were the *scriptoria* of the Irish monasteries. The need for Christian books evolved into the specialty of elaborate book illumination. With the unification of the Irish and Anglo-Saxons came the commingling of traditional motifs from each. The images of these *Hiberno-Saxon* manuscripts are unforgettable. The *Lindisfarne Gospels*, made about 700 and which today are in the British Library, London, are the best-known Northumbrian books. They originated in the scriptorium of the monastery on the island of Lindisfarne, the first Celtic monastery in Northumbria (635).

The *Lindisfarne Gospels* include full-page portraits of the Evangelists, clearly derived from Mediterranean models, though flattened to color patterns and accompanied by abstract decorative features. Matthew is depicted as a seated scribe, a descendant of Dioscourides from the early Byzantine

herbal in Vienna. Matthew appears as a colorful pattern. Over Matthew's head, balancing on his halo, is the half-length representation of Matthew's symbol, a winged man, here with a horn-shaped trumpet. The head of another, unnamed figure appears at the edge of a drapery on the right margin.

Other pages of the *Lindisfarne Gospels* are filled with stylized and wonderfully intricate cross-shaped patterns on rich fields of interlaced knotwork representing the extended bodies of birds and hounds intertwining and biting one another. Such illuminated pages are called *carpet pages*. The interlace is remarkably close to the Anglo-Saxon items in the Sutton Hoo trove.

THE *BOOK OF KELLS*

The masterpiece of Irish book illumination is the *Book of Kells*, made about a century later on the Irish island of Iona. It is now in the Trinity College Library, Dublin (Ms. 58, A.1.6.). Among its many illustrations are full-page miniatures of holy persons, narratives of Christ's life, carpet pages, and even full-page initials.

One of the latter, the so-called Chi–Rho Page, uses the two Greek letters as symbols of Christ's name at the opening of the Gospel of Matthew. It is an exuberant combination of spiral, interlace, whorl, and weave, punctuated occasionally by a human face and, at one point, by a cat and some playful mice. One early author found it difficult to believe that human hands rather than those of angels had fashioned the design of this page.

THE HIGH CROSSES

Another Hiberno-Saxon tradition is manifest in the monumental sculptured stone crosses marking the countryside of Ireland, Scotland, and northern England. Some are as high as 16.5 feet (5 m). These progress from carved interlace patterns on the body and arms of the earliest examples to remarkably detailed, narrative figural scenes in the later examples.

The Art of the Franks and Visigoths

Clovis, leader of the Merovingian Franks, won a final victory over the army of the last Roman consul in Gaul in 486. He established his capital at Paris. By the time of his death in 511, Clovis had settled his people among the Gallo-Roman population and united a substantial number of the Frankish tribes from the Pyrenees to the lands east of the Rhine. He and his followers had become Christian in 496.

FRANKISH ART: MEROVINGIAN MANUSCRIPTS

Few Frankish buildings survive, and those that do are very modest structures. More numerous are the manuscripts from Merovingian monasteries. Of these there are two famous examples: the Gelasian Sacramentary, of the mid-eighth century in the Vatican Library (Ms. Reg. Lat. 316), with astonishing animal alphabet lettering and La Tène patterns on symbolic crosses; and the eighth-century Gellone Sacramentary in Paris (Bibliothèque

Nationale, Ms. Lat. 12048), with vigorous figural initials. One of these is a Crucifixion forming the *T* of *Te igitur,* the beginning words of a Mass. The artist's sense of pattern and expression far outweighs his skill or concern for figure drawing. In both, as is characteristic of Merovingian works, there is a vitality and energy soon to be reflected in the Carolingian descendants of these artists.

VISIGOTHIC ART

The Visigoths, who had plunged across Europe ahead of the Franks, were noted for their metalwork, including fibulae, brooches, and most notably, the crown of King Recceswinth, of the seventh century, now in the Archaeological Museum in Madrid. It is a rich circlet of gold, pearls, and sapphires 8.5 inches (20 cm) in diameter with pendant letters spelling the king's name and bearing more gold and sapphire decorations.

Many elements of Visigothic art survived in the Christian kingdom of Asturias in northwestern Spain during the Islamic occupation of most of Spain. Only in the eleventh century was their long isolation from western Europe ended, with the opening of the pilgrimage routes to Santiago de Campostela. The art produced in the monasteries of this region, largely manuscript illumination, is termed *Mozarabic*. The word derives from Arabic *mustarib,* "Arabized," although there is almost no Arab influence in the art.

Mozarabic Art: Beatus Manuscripts. Most famous are the illustrated text commentaries on the Apocalypse, known as Beatus manuscripts for the author, Beatus of Liebana, an eighth-century Spanish monk. The tenth-century artist-monk Magius signed the earliest surviving manuscript of Beatus, now in the Pierpont Morgan Library in New York City (Ms. 644). Noted for vivid color and design, flat patterns, and inventive images, the Beatus manuscripts are an isolated phenomenon in contemporary medieval Europe.

THE ART OF ISLAM

An additional powerful and enormously important element in the early medieval world was the birth of the Islamic faith and the rapid expansion of its impact accompanying the Arab conquests of the seventh and eighth centuries. Mohammed (d. 632) founded the religion of Islam, also called Mohammedan or Moslem.

The Islamic calendar begins in 622, the year that Mohammed fled from Mecca to Medinet-en-Nabi (modern Medina). His flight is known as the *Hegira*. Mohammed's teachings were assembled by the caliph Othman

(644–656) in the Moslem Holy Book, the *Koran*. It proclaims the worship of but one God, Allah. To Moslems the Koran is the Word of God revealed to his prophet, Mohammed. Allah is identical with the God of Abraham, and Islam recognizes the Old Testament prophets and Jesus as Mohammed's predecessors.

From its beginnings in Arabia before 640 until about 750, the Moslem conquest had crossed the Middle East all the way to the Indus River. Arab armies conquered Syria, Palestine, Iraq, Iran, and Afghanistan, along with all of Arabia. In the West, North Africa and much of Spain came under Moslem domain. In 732 the Arab armies had reached Poitiers in southern France, poised to overrun Frankish Europe. There, however, they were defeated by an army of Franks led by Charles Martel, grandfather of Charlemagne. Despite subsequent raids, the Moslems never extended their conquests beyond the Pyrenees. Their power and holdings gradually were reduced until they were finally expelled from Spain in 1492 by Ferdinand and Isabella.

In the East the Byzantine Empire held off the forces of Islam with decreasing success and with gradual loss of territories until the Moslem capture, in 1453, of Constantinople. The remarkable victories of the Moslem armies are a credit to military strategies and to the tenacity and power of the Islamic faith.

Islamic Architecture

The major need for worship among the Moslems is a gathering place, a *mosque*, for daily prayer at five stated hours. One wall of the mosque, the *qibla*, faces Mecca. A portico for shade extends from the *qibla*. A pool for ritual ablution, the *sahn*, is included in the courtyard. The *mihrab*, a sacred niche installed in the *qibla*, points to Mecca. To the right of the mihrab is the *minbar*, a pulpit for reading the Koran and for preaching. Adjacent to the mosque is a *minaret*, a tower from which the *muezzin* calls the faithful to prayer. These requirements were met in increasingly elaborate buildings as the Moslem faith gained strength and wealth.

Islam was spread almost exclusively by conquest and force, as opposed to the missionary persuasion of early Christianity. Moslem lands were governed by *caliphs*, originally Mohammed's relatives and descendants.

Despite their vicious armed conquests, the Islamic Arabs became major preservers of Classical Greek and Roman learning in science and philosophy. They invented algebra. Botany and medicine, as they had been known since antiquity, were preserved in Arabic texts. The numerals we use are of Arabic origin.

In the fine arts, however, the prohibition of graven images adopted by Mohammed from Old Testament law led to destruction of the sculptures, mosaics, frescoes, and paintings in conquered lands. As architects, on the other hand, they built well, with a strong aesthetic sense of proportion.

Unable to work in the representational arts, Islamic designers developed an inspired sense of abstract ornament. This they painted on manuscript pages or applied in glazed tiles, stucco, mosaic, or carved stone to buildings.

Two forms of building are important in Islamic architecture. The mosque, already described, has a relatively consistent assortment of parts. The enormous varieties of mosque construction relate mostly to the traditions and skills of the regions conquered. The other major form of Islamic building is the palace, a complex of living quarters and social and office areas. The palace often includes an internal mosque for the use of the palace residents.

Initially neither of these building types was built with ostentatious exterior decorations. The mosque could be identified by its minaret. Later, domes and towers would become characteristic of Islamic buildings.

PALACE OF CHOSROES, CTESIPHON

The pre-Islamic, mid-sixth-century Sassanian Palace of Chosroes at Ctesiphon, near Baghdad, is divided at the center by a huge pointed arch that opens into a vaulted central hall. The arch, façade, and stucco relief panels with flower and leaf decorations represent the combination of provincial Hellenistic, Byzantine, and other influences that were a source for Islamic culture as it developed.

THE DOME OF THE ROCK, JERUSALEM

The oldest surviving Moslem building is the Dome of the Rock in Jerusalem. The city fell to the Arabs in 637, and a simple mosque was constructed and still in use when the Dome of the Rock was begun in 685. The Dome of the Rock is a special shrine surrounding the rocky outcrop upon which Abraham prepared to sacrifice Isaac and from which Mohammed ascended to heaven. Its octagonal central space is covered by a dome and surrounded by two concentric *ambulatories*. The form derives from early Christian martyria, notably the Holy Sepulchre across the city.

The exterior is much modified above the original marble paneling at the lowest level. Blue tiles, rich with colorful decorative patterns, are of the sixteenth century, and the dome itself, once gilded, was surfaced with gold anodized aluminum in 1960. Much of the original seventh-century decoration in marble, mosaic, and metalwork is preserved on the interior.

THE GREAT MOSQUE, SAMARRA

Between 848 and 852 Caliph al-Mutawakkil of Samarra built a great mosque for the city of Samarra, 784 by 512 feet (240 by 156 m) with 464 piers supporting a frame roof. It was the largest in the world, capable of sheltering 100,000 male worshipers. On the north is an attached spiral minaret 176 feet (54 m) high, that suggests, at least to modern eyes, its

ancestry in the concept of a Mesopotamian ziggurat. The roofed area toward the south, where the *qibla* wall and mihrab are situated, was a forest of piers, 9 deep and 24 wide. The piers continued, skirting the central courtyard, four deep on either side, and three deep on the north end, toward the minaret. The fired brick walls and minaret still stand but the roof and mud-brick piers have mostly been destroyed. More modern mosques in Samarra have long since replaced the building for practical use.

THE MOSQUE AT CÓRDOBA

In Spain the caliphate was centered at Córdoba. Its great mosque was built in 961–976. Córdoba had grown rapidly in Islamic hands after its capture in 711. At one point there are said to have been 3000 mosques within its walls. The Great Mosque survives. It was always the most important, adjacent to the caliph's palace. The mihrab at Córdoba is a domed chamber, its dome on *squinches* resting on eight intersecting arches. All the surfaces are covered with decoration. The stone blocks are all delicately carved, and they support areas of mosaics in colored glass. Many of the arches in the mosque are horseshoe-shaped. Many are double arches, supported by columns that also support piers extending upward to higher arches that support a groin-vaulted ceiling. The *voussoirs* of these arches are alternately red brick and white stone. This provides a colorful, decorative continuity to the interior, offsetting the irregular sizes among the variety of columns and capitals reused in the construction. Especially complex are the intersecting lobed arches at the entrance to the mihrab.

The first moves to reshaping Europe after the Classical period were the last phases of tribal movements westward. The origins of these movements are lost in the unrecorded past. Among these people the teachings of Christianity, as they encountered them, struck a promising chord.

The combination of their arts, the traditional arts of a migratory people, with the Early Christian and Late Classical traditions resulted in art forms that are entirely new, energized by their own originality and the inspiration of a new faith.

It is possible to say the same about Islamic art as it grew and spread so rapidly through the world during the seventh and eighth centuries and after. Essentially, then, the Early Medieval period and the rise and spread of Islam represent the first stages in the formation of the post-Classical world in the Western Hemisphere.

Selected Readings

Alexander, J. J. G. *Insular Manuscripts: 6th to the 9th Century*. London: Miller, 1979.

*Busch, H., and B. Lohse. *Pre-Romanesque Art*. New York: Macmillan, 1966.

*Davis-Weyer, C. *Early Medieval Art: 300–1150*. Sources and Documents, Englewood Cliffs, NJ: Prentice-Hall, 1971.

Finlay, I. *Celtic Art: An Introduction*. London: Faber and Faber, 1973.

Henry, F. *Irish Art in the Early Christian Period to 800 A.D.* Ithaca, NY: Cornell University Press, 1965.

Grabar, A., and C. Nordenfalk. *Early Medieval Painting*. Geneva: Skira, 1957.

Grabar, O. *The Formation of Islamic Art*. New Haven, CT: Yale University Press, 1963.

Henderson, G. D. S. *Early Medieval Style and Civilization*. Baltimore: Penguin, 1972.

Hoag, J. D. *Islamic Architecture*. New York: Abrams, 1977.

*Kitzinger, E. *Early Medieval Art*. Bloomington: Indiana University Press, 1964.

*Lasko, P. *Ars Sacra: 800–1200*. Baltimore: Penguin, 1972.

Nordenfalk, C. *Early Medieval Book Illumination*. Geneva/New York: Skira-Rizzoli, 1988.

Papadopoulo, A. *Islam and Muslim Art*. New York: Abrams, 1979.

*Snyder, J. *Medieval Art: Painting, Sculpture, Architecture: 4th to 14th Century*. New York: Abrams, 1989.

*Stokstad, M. *Medieval Art*. New York: Harper & Row, 1986.

* Indicates a book useful in additional chapters.

9

Carolingian and Ottonian Art

Charlemagne was crowned Roman emperor by Pope Leo III on Christmas Day, A.D. 800. He was grandson of the Frankish general Charles Martel, who had stopped the Moslem advance into Europe in 732. Charles Martel's son Pepin the Short drove the Moslems back across the Pyrenees. Pepin became king of the Franks, crowned in 754 by Pope Stephen II at St.-Denis near Paris. Pepin had responded earlier to a papal appeal for defense against the Lombards. He won several victories against them. He also captured the remains of the Byzantine territories in northern Italy, centered at Ravenna. These lands he gave to the papacy.

Charlemagne succeeded his father as king in 768. He made a complete conquest of the northern Lombards in 774. This expanded his territories and strengthened the ties established by Pepin between the Franks and the papacy. Further, Charlemagne subjugated the Saxons, Bavarians, Avars, and Slavs, gaining unified control of most of western Europe for the first time since the Romans withdrew their legions. Together, the actions of the Carolingian

dynasty exacerbated the rift between the Eastern and Western churches. The Byzantines held legal title to Ravenna, and their leader still held the legal designation of Roman emperor. The increased Moslem pressure on Byzantine territories and internal strife over Iconoclasm, however, held them from challenging this new world power.

Charlemagne's descendants, Louis the Pious, Charles the Bald, and Lothair I, managed to preserve the Carolingian dynasty for a period, but the division of rule among them and their successors diverted the central authority to small principalities. Assailed by the Vikings in the North, the Hungarians to the East, and the Moslems in the South, the Holy Roman Empire had to resort to a defensive mode. The Moslems captured Sicily from the Byzantines and from there they raided southern Italy, reaching Rome in 846, where they pillaged St. Peter's. In another raid in 881 they burned down the monastery at Monte Cassino. From the latter half of the ninth century to after the middle of the tenth century, western Europe was more intensely involved with its defense than with the arts.

In 911 the Vikings established a permanent holding in northwestern France. There they founded the dukedom of Normandy in the region still known by that name. During the tenth and eleventh centuries they gained power, conquering the last Byzantine lands in southern Italy and winning control of Sicily from the Moslems. In 1066 William the Conqueror successfully invaded England and became its king.

In 955, the Saxon king Otto I, known as "the Great," won a decisive victory over the Hungarians. Otto reestablished a strong central power in Germany. In 962 he was made emperor by Pope John XII in Rome. The Ottonian dynasty lasted through most of the eleventh century. It includes the Saxons: Henry I; Otto I, II, and III; Henry II; and the Salian rulers Conrad II and Henry II. Throughout the Middle Ages, the Holy Roman Empire remained a German institution, its authority in Germany, France, Italy, and the papal states in constant dispute.

The Ottonians outspokenly sought a renovatio (renewal) of their own, the revival of the Carolingian state. This conscious revival is another important step in the development and affirmation of forms in all the arts. Through these efforts, some were preserved from the early Christians. Others were developed from the art of the Migrations. Together, they would invigorate the European arts in the emerging High Middle Ages.

CAROLINGIAN ART

Charlemagne established his court in Aachen (then Aix-la-Chapelle) in Germany. His studied attempts at resuscitation of the old Roman Empire are frequently called the *Carolingian Renaissance*. His contemporaries referred to it as a *renovatio* of the empire. Long before his coronation as emperor in 800, Charlemagne had actively sought the most brilliant men of the time for his court. He took personal leadership in reviving the arts of statesmanship, learning, and religious thought. Charlemagne wished to emulate the court of Theodosius, whose successor Leo III had proclaimed him to be, and those of Constantine and Justinian.

Carolingian Architecture

At Aachen, Charlemagne built a palace complex. The buildings included a royal basilica and a palace (palatine) chapel. The basilica no longer stands. It is said to have imitated one that still does stand, built at Trier in the early fourth century for Constantine. The Palace Chapel of Charlemagne is still in place. Einhard, adviser and biographer of Charlemagne, supervised the palace building. Odo of Metz was the builder of the chapel.

THE PALACE CHAPEL, AACHEN

The chapel is octagonal, supporting a dome at the center, surrounded by an ambulatory with a gallery above. A large two-towered entrance is on the west, and an apse once projected from the east. The building has similarities to San Vitale in Ravenna, which no doubt served as a model for Odo. The Carolingian version, however, is made of weighty masses of hewn stone, especially at ground level. Although it is lacking the lightness and spaciousness of its model, the double tier of antique columns at the gallery level manages to enhance the upper space of the structure.

The stair towers flanking the west entrance to the Palace Chapel led to a royal loge in the gallery above the entrance. There Charlemagne had a throne facing two altars in the eastern apse. One was dedicated to Christ at the gallery level; the other, dedicated to the Virgin Mary, was at the ground level. The monumentalized two-level, two-towered façade finds a parallel in some of the contemporary and later monastic churches of the Carolingian period, as we shall see.

THEODULF'S ORATORY, GERMIGNY-DES-PRES

Theodulf, bishop of Orléans, built a small oratory near his country villa at Germigny-des-Pres. It was consecrated in 806. The oratory was a Greek cross in plan, with apses in each direction. The arches opening into the apses are horseshoe-shaped. Theodulf was of Spanish ancestry and birth; therefore the arch might have common origin with Moslem Spanish building.

The main apse of Theodulf's oratory has a mosaic representation of the Ark of the Covenant (3 Kings 8:6–7), an image that can be found in early Spanish Bibles. Two angels stand atop the Ark, overarched by two larger angels (cherubim) as protectors. The image may be a symbolic substitute for an image of Christ. From his writings it appears that Theodulf was a man who supported the proscription of images of the divine, sympathetic at least in part to the contemporary Byzantine prohibition of religious figurative art.

THE MONASTIC BASILICA

The major building achievement of the Carolingian period was the new construction of large basilicas. These were part of an invigorated monastic development that saw the foundation of new monasteries as well as reconstruction of established sites. Charlemagne's court moved periodically to one or another of these centers. St.-Denis near Paris, St.-Riquier (Centula Abbey) in France, Fulda Monastery in Germany, and St. Gall, a Celtic foundation in Switzerland, were all enlarged. They all included a central nave, side aisles, transept, and apse. Several new and significant features appear in them.

St.-Denis and Fulda had a basic *T*-shaped plan similar to Old St. Peter's, yet each had an apse and altar in the western as well as eastern end of the building. This feature would characterize abbey churches into the Romanesque period. Partially, this can be seen as another echo of the church of St. Peter, whose altar and apse were at the western end. Monastery churches, too, have their main entrances from the cloister, an atrium-like enclosure for the monks, usually on the southern side. This enabled the builders to align altars at opposite ends of the church.

Plan of a Monastery, St. Gall. The concept of a Carolingian monastery is preserved in the St. Gall Plan, a parchment drawing in the Chapter Library at St. Gall, dated about 820. A schematic plan for an entire monastery is drawn in red ink on the parchment. It shows a double-ended basilican church, cloister, monks' quarters, workshops, guesthouse, stables, and gardens. The plan is laid out sensibly, according to practical use for a community. The buildings are designed on modular proportions and set to human scale. Thus the plan forms a model ready to be adapted to the terrain. Regrettably there is no record of the actual layout of Carolingian St. Gall. The monastery has been completely rebuilt. Enough records survive of other monasteries, however, to suggest that this plan is at least schematically accurate.

THE CAROLINGIAN WESTWORK

The emphasis on the western entrance of Charlemagne's Palace Chapel at Aachen had, as previously noted, an echo in monastic church architecture of the period. Centula Abbey (St.-Riquier), Corbie, and

Corvey included western structures with stair towers flanking the entrance and two stories, the upper one containing a chapel with altar. This structure, called a westwork, is the nucleus of a major change in church design. The Romanesque and Gothic emphasis on the church façade combined with two large towers begins with this modification.

Carolingian Sculpture and Painting

The emperor Charlemagne brought an equestrian bronze statue of an emperor from Ravenna for the great court of his palace at Aachen. He believed it to represent Theodoric. A small bronze sculpture made in the Carolingian era, possibly representing Charlemagne, is now in The Louvre, in Paris. It is only 9.5 inches (24 cm) high, but it and the Theodoric sculpture are equivalent referents to the Roman tradition exemplified by the *Equestrian Statue of Marcus Aurelius* in Rome. Very little large-scale Carolingian sculpture or painting survives. Aside from the mosaic in the apse of Theodulf's oratory at Germigny-des-Pres, other examples include extensive frescoes from the ninth century in the church of St. John in Müstair, Switzerland. They show scenes of Christ's infancy and ministry along with an exceptional Last Judgment.

SANTA PRASSEDE, ROME

In Rome a resurgence of building in the late eighth and early ninth centuries reflects papal optimism at the successes of the Franks and the renewal of the empire. Best known is the new reconstruction of the Church of Santa Prassede (St. Praxedes, sister of St. Pudenziana). Santa Prassede is said to be a miniature copy of Old St. Peter's. It is richly embellished with mosaics also chosen to reflect early Christian themes and monuments.

CAROLINGIAN MANUSCRIPTS

The Palace Styles. A rich and varied heritage of Carolingian book illumination survives, traceable by style to assorted scriptoria, including the royal palace at Aachen, and many of the major monasteries. The *Gospel Book of Charlemagne*, now in the Treasury of the Kunsthistorisches Museum in Vienna, and the Aachen Gospels, now in the Cathedral Treasury in Aachen, are both from the palace. Their illustration style is decidedly imitative of the earlier Classical styles of book illumination. The Evangelists appear as ancient author portraits. In the Aachen Gospels all the Evangelists are gathered on one page, seated and writing in an atmospheric landscape.

Also from the palace are a group of manuscripts in another style. These are works of great vigor that combine the visual tradition of early Christian and early Byzantine manuscript illumination with a new energy

derived from the vigor of Frankish and Hiberno-Saxon art in color, pattern, and design.

The Reims Style. In a variety of styles, this new vigor is incorporated into regional monastic scriptoria as well. The style of the monastery at Reims is characterized by two famed manuscripts, the *Gospel Book of Archbishop Ebbo of Reims,* in the Municipal Library at Epernay, France, of about 820, and the *Utrecht Psalter* (Book of Psalms), of the same date, in the University Library, Utrecht. Both exhibit a vigorous, nervous, or sketchy style. The illustrations found in the *Utrecht Psalter* have a particular impact. They are small, deft drawings done in brown bister. The figures act out the poetic text of David's Psalms with dynamic gesture, movement, and expression. The images were immediately popular, and they were copied in Carolingian ivory carvings and several psalter manuscripts down to the Romanesque period.

Tours Bibles. Alcuin of York, "the greatest scholar of his day," was a leader of the Carolingian court and teacher of Charlemagne. He retired to the monastery of St. Martin at Tours in 796, working there on a revision of the Vulgate Bible until his death. The Tours monastery is well known for its susequent production of great Bibles. One, called the *Alcuin Bible* or the *Moutier-Grandval Bible* (c. 840), now in the British Library (Ms. Add. 10546), has a full-page miniature of Genesis scenes. These were clearly inspired by early Christian models, perhaps from one of Alcuin's library volumes.

Other Carolingian centers were at Metz, St.-Denis, Milan, and elsewhere. Most of these centers also employed artisans to produce carved-ivory plaques. These were in great demand for use as book covers for the rich manuscripts in production. The extraordinary achievement of Carolingian ivory carving follows the stylistic development of the manuscript illuminations. The ivories, too, were frequently imitative of Early Christian examples. So close was their style in some instances that plaques long thought to be Early Christian have only recently been reattributed to Carolingian workshops.

Also used in book covers was intricate metalwork, a skill natural to northern Europeans from their ancestry. Jewels and reused cameos were beautifully set in precious-metal covers along with ivory plaques. The upper and lower covers of the *Lindau Gospels* in the Pierpont Morgan Library in New York City (Ms. 1) are good examples. The lower (back) cover was made about 800 in the Hiberno-Saxon style, with intricate interlace and enamels. Its design echoes the cross pages of the Northumbrian manuscripts, but the cloisonné figural designs place it in the Carolingian sphere. The upper (front) cover was probably made at the royal abbey of St.-Denis around 870. Its style reflects work done under the sponsorship of Charles the Bald, who was also a patron of that abbey.

Here a beautiful gold repoussé relief of the crucified Christ with expressive mourning angels is combined with a rich assortment of mounted jewels. The figure of Christ maintains a serene standing posture, alive with his arms outstretched. Tiny figures of the sun and moon appear against the cross above his head. The anguished angel figures show the influence of the earlier Reims school.

OTTONIAN ART

The last Carolingian monarch in German lands died in 911. By then the power of the Carolingians had so declined that Europe had become subject to attack from all quarters. Defense of German lands had fallen to the Saxon kings. Otto I, who married a Lombard noblewoman, managed to gain control of much of Germany and Italy and to assume the imperial crown. This shift of the center of the Holy Roman Empire to German lands would have far-reaching implications. France emerged separately; Germany and Italy would never be reconciled satisfactorily.

Ottonian Architecture

The abbey church of St. Pantaleon, in Cologne, Germany, was founded about 980 by Archbishop Bruno, brother of Otto I. Its two-story westwork is still in place with two stair towers flanking it. This represents the continuation of traditional westwork architecture that we encountered in the Carolingian age. St. Pantaleon also has a transept on each end with a tower over the crossing. Many of the large churches founded in the Ottonian period included this rich display of towers, usually six in all.

THE ABBEY CHURCH OF ST. MICHAEL, HILDESHEIM

St. Michael's Monastery in Hildesheim, Germany, was built in 1010–1033. The abbey church provides an excellent example of the continuing development of medieval church architecture. Among its features is the clear expression of modular construction. The proportions of the church are based on the square plan of the crossing at the transepts. Here as at St. Pantaleon there was a transept at each end of the church. The nave of St. Michael's between the transepts is divided by piers into three square bays of the same size as the crossing. These piers alternate with two columns in between each in regular spacing. The transept arms are of the equivalent square shape, each terminated by a polygonal stair tower. A square tower also tops each of the transept crossings. Here, too, a total of six towers rises over the church. Unlike St. Pantaleon, St. Michael's included a major apse at either end rather than a westwork.

THE CATHEDRAL OF SPEYER

In its first form, the great Cathedral of Speyer in Germany was begun in 1030 by Conrad II as a monument and mausoleum for the Salian dynasty. It boasted a great westwork topped by an octagonal tower and another octagonal tower over the crossing. Square towers flanked both the apse and the inner portals of the westwork. Thus Speyer, too, had six towers above its roofline.

The nave arcade at Speyer is supported by square piers that continue upward to form great arches over the clerestory windows. Engaged shafts extended upward on the nave piers. The aisles were groin-vaulted. The nave was originally truss-roofed, but after 1061, when the church was first finished, the east end was rebuilt and the whole nave was groin-vaulted. The vaulting of churches toward the end of the eleventh century is a rich panoply of styles and choices, problems and solutions, that we will discuss in chapter 11, "Romanesque Art."

Ottonian Sculpture and Painting

THE BRONZE DOORS, HILDESHEIM

The western apse of St. Michael's in Hildesheim was raised over a vaulted crypt, surrounded by an ambulatory. Within the crypt is the tomb of the founder, probable architect, and first abbot of St. Michael's, St. Bernward (c. 960–1022). Bernward's name appears in an inscription on two valves of a bronze door with the date of their casting, 1015 (MXV). These portals, now at the Cathedral of Hildesheim, were cast of solid bronze, each approximately 16 feet, 6 inches by 4 feet (5 by 1.22 m). Bernward's monastery boasted a sophisticated bronze foundry. These doors and a 12.5-foot (3.8-m) bronze column are the major surviving works.

Each of these bronze works was cast with relief sculptures. On the column they spiral upward in imitation of the Classical columns of Trajan and others. The doors each include reliefs in eight panels. That on the left depicts a sequence from Genesis, the story of Adam and Eve, beginning at the top. The right door shows scenes from Christ's infancy and Passion beginning in sequence from the bottom. They are arranged to correlate; the expulsion of Adam and Eve is opposed to the presentation of Christ in the Temple, and the Fall of Man is opposite the Crucifixion, representing humankind's redemption to Christian believers. These are typological choices, reminiscent of those made by the early Christians.

The vigorous figures in the narrative scenes express feeling through gesture and pose very effectively. They relate to manuscript illustrations in Carolingian manuscripts such as the *Utrecht Psalter* or the *Moutier-Grandval* Bible. Their larger scale and monumental setting indicates a tendency among the Ottonians to make more outspoken works of art than those we know from the Carolingian period.

OTTONIAN SCULPTURE

The Basel Antependium. Among these is a large altar frontal (antependium) made in 1019 for Emperor Henry II and his Empress Kunigunde. They appear as tiny donor figures at the feet of Christ. The Lord is the largest and central figure in the repoussé gold, gilt copper, and enamelwork of the frontal. Beside him stand St. Benedict and the archangels Michael, Raphael, and Gabriel, in an arcade. The frontal is 4 feet by 6 feet (1.2 by 1.8 m). The altar frontal was presented to Basel Cathedral and is now in the Musée Cluny in Paris. This work, too, displays the figures in high relief, beginning to suggest a freedom from the background that securely holds the relief sculptures in ivory and gold of the Carolingian period in place.

The *Gero Crucifix.* Also among the larger works is a life-size representation of the Crucifixion, made for the archbishop Gero of Cologne about 970. It is in the Cathedral at Cologne and is 6 feet 2 inches (approx. 1.90 m) high. Unlike the Crucifixion on the upper cover of the Carolingian *Lindau Gospels*, the *Gero Crucifix* shows Christ slumped in death, his body sagging and his head fallen forward. The strain of muscles distorts his arms and shoulders.

The Ottonian artist has chosen to express Christ's Passion with emphasis upon suffering and pain. The sculptor, perhaps, was influenced by contemporary Byzantine Crucifixions, but his work brilliantly foreshadows German masterpieces in this emotional and expressive form. This sculpture is fully in the round by an artist "who appears far ahead of his time," as one scholar has described him.

OTTONIAN MANUSCRIPTS

The Byzantine Iconoclastic epoch ended in 843, too late for the art of Byzantium's second Golden Age to have had much impact on Carolingian artists. In the Ottonian period the new freedoms of the art of the Eastern Empire began to show their effects quite soon. This was reinforced by the marriage of the emperor Otto II to the Byzantine princess Theophano. The import of Byzantine ivories, enamels, silks, and manuscripts is in evidence late in the tenth century. Byzantine craftsmen also appear to have been employed in some of the Ottonian workshops.

Ottonian manuscripts, which show the influence of Early Christian, Carolingian, Byzantine, and other sources, are also stylistically quite homogeneous. They are unmistakably Ottonian. The bright colors, imaginative designs, and richness of the works are justly celebrated. At one time they were considered to be products of one scriptorium, at the monastery of Reichenau on Lake Constance in Germany. It now seems probable that more than one location was involved. Possibly the style originated at Trier with additional centers emerging at Reichenau, Echternach, and Cologne. The

products include illustrated Gospel Books, lectionaries, and other service books made for prominent churchmen and for the individual Ottonian emperors.

Gospel Book of Otto III. The *Gospel Book of Otto III*, made about 1000, now in the Bavarian State Library, Munich (Ms. Clm 4453), is a good example of the royal manuscripts. On one page (folio 16r.) Otto is enthroned in purple robes and chlamys, with all his imperial regalia, crown, orb, and scepter. His figure is large and centered frontally. Behind him is an architectural backdrop representing his palace. Two ecclesiastics attend him at his right, holding Gospel books. Two state officials are on his left, with sword and shield, acclaiming his leadership. As with the saints flanking Christ in the Basel Antependium, the smaller scale of Otto's attendants emphasize his power.

The Evangelists' portraits in the same manuscript are equivalently energetic. Each sits frontally, supporting an imposing array of disks over his head like some colossal clockwork. These each contain the symbol of the Evangelist, prophets, and angels. All appear within great arches variously decorated with patterns, ribbands, and leafy branches with decorative birds.

The Gospels also include full-page scenes illustrating the text. These are drawn from the same sources—Early Christian, Carolingian, and Byzantine—as the emperor portrait and the Evangelists. They have also been given the same inimitable, colorful style.

The Carolingian period—some call it a Renaissance—began properly with the coronation of Charlemagne in Rome in A.D. 800. It sprang from the return to Latin literature and scholarship and led to the founding of schools and monasteries, to the copying of Classical manuscripts and arts, and to the return to large-scale building.

The forms of these revivals survived the dissolution of the Carolingian hegemony and the relative chaos of the late ninth and early tenth centuries to be taken up and carried forward in Ottonian courts, monasteries, and other centers in the late tenth and the eleventh centuries. The Ottonian period saw the return to large-scale sculpture and painting and the development of architectural systems that would carry forward to the Romanesque period.

Selected Readings

* Conant, K. J. *Carolingian and Romanesque Architecture*. Norwich: Penguin, 1974.
* Dodwell, C. R. *Painting in Europe: 800–1200*. Pelican History of Art. Baltimore: Penguin, 1971.
* Duby, G. *History of Medieval Art: 980–1440*. Geneva/New York: Skira-Rizzoli, 1986.
 Hinks, R. P. *Carolingian Art*. Ann Arbor: University of Michigan Press, 1960.
 Hubert, J. *The Carolingian Renaissance*. New York: Braziller, 1970.
 Mütherich, F., and J. E. Gaehde. *Carolingian Painting*. New York: Braziller, 1976.
* Pevsner, N. *An Outline of European Architecture*. Baltimore: Penguin, 1960.

* Indicates a book useful in additional chapters.

10

Late Byzantine Art

843 End of Iconoclasm in Byzantine centers

972 Theophano married to Otto II, Holy Roman Emperor

1204 Fourth Crusade conquers Constantinople

1204–1261 The Latin Empire reigns over Constantinople

1453 Fall of Constantinople to Ottoman Turks

With the end of Iconoclasm in 843 came a resurgence, a second Golden Age of Byzantine art in Constantinople and the major centers of the Eastern Empire. These were fewer in number than Justinian had governed in the first Golden Age. There had been great losses of Byzantine territories in the seventh and eighth centuries. Moslem armies had taken Syria, Palestine, and North Africa. The northern Italian holdings of the Byzantines, centered at Ravenna, had fallen to the Carolingian dynasty. Sicily and southern Italy would soon fall into Moslem and then Norman hands.

The ninth and tenth centuries saw a resurgence of Byzantine power. The period from 842 to 1050 has also been termed the Age of Conquest. It may have been a hollow exercise, depleting the strength of the empire while enlarging it to indefensible borders. To the Byzantine emperor it was, nonetheless, an obligation to restore the legacy of Constantine to the limits of Roman domains.

More Middle and Late Byzantine art survives from this period than from the fifth and sixth centuries. From the restoration of images we learn more about the eastern tradition of Christian art. New forms of church building and decoration, new varieties of icons, ivory carvings, and manuscripts appear. The

art of Constantinople and its dependencies also has an important role to play in the development of art in the Latin West from the Ottonian period forward.

Many of the earliest works after the restitution of images, especially in manuscript illumination and ivory carving, are rich in Classical reference and form. The term Macedonian Renaissance *has been used to describe this work because of the Classicism and the dynasty of emperors beginning with Basil I, "the Macedonian" (867–886).*

LATE BYZANTINE ARCHITECTURE

The architects of the Late Byzantine world never attempted to rival the size or splendor of Justinian's Hagia Sophia. Most surviving Late Byzantine churches are quite modest in scale.

Predominant among them are churches built on an inscribed cross-in-square plan. These have a narthex on the west side and an eastern sanctuary and apse. The central dome, frequently on squinches, is sometimes surrounded by smaller domes over the bays at the corners between the arms of the central Greek cross. This form of church is called a *quincunx*. Such a church was the *Nea* (new church), completed at the palace at Constantinople in 880 for Basil I.

Examples of Quincunx Churches

The *Nea* has been destroyed, but many churches with a variety of similar plans survive. Examples at Salonika, Mount Athos, Hosios Lukas, and Daphni in Greece, from the tenth and eleventh centuries, are characteristic. Others are in the Greek islands and in the provinces of Slavic lands to the north of Greece.

SAN MARCO, VENICE

In the West, the present Church of San Marco in Venice, begun in 1063, is a prominent example of the expanded influence of Byzantium. It is consciously derived, in plan and elevation, from Justinian's sixth-century Church of the Holy Apostles, which had been extensively renovated in the tenth century. Like the Holy Apostles, San Marco was built on a Greek-cross plan with domes over each arm of the cross as well as the center. The rich mosaic and sculptural decorations of San Marco suggest Byzantine splendor and lead the way to increased inspiration of Byzantine art in the West.

PISA CATHEDRAL

Pisa Cathedral was begun in the same year as San Marco. Its architect, Busketos, was apparently a Greek, and although the elements of its style are an important part of Tuscan Romanesque, there are also Eastern elements

in the complex. The plan of Pisa Cathedral resembles an Early Christian basilica and has been likened to the Greek church of St. Demetrios in Salonika (fifth century). Its long transept arms resemble individual basilicas, each with a nave, side aisles, and an apse of its own. Thus the complex is also reminiscent of early Byzantine structures in Syria, such as the churches of St. Simeon Stylites or St. John in Ephesos.

BYZANTINE SCULPTURE AND PAINTING

BYZANTINE ICONS

The Eastern church used images in its daily liturgy. Paintings, called *icons*, for the major feasts, saints' days, and seasons were arranged in a regular cycle throughout the year. They were displayed on an *iconostasis*, a screen wall designed to hold them, which separated the sanctuary from the nave of the church. With the end of the Iconoclastic period, this practice resumed at once.

Byzantine worshipers paid direct reverence to the icons on display. Although icons were supposed to inspire the worshiper to remember and desire the saints and events depicted, the icon was itself reverenced as a holy object. For this reason, artists of the Byzantine world were on the whole much more conservative than their Latin contemporaries. In composition and content there are few variations in Byzantine icons that depict holy events and saints.

CHURCH MOSAICS

The characteristic Middle Byzantine church, too, was decorated in a more-or-less standard fashion. Mosaic was the preferred medium. Typically, the dome atop the church held a representation of Christ as *Pantokrator* (Ruler of All), usually a bust-length portrait. This highest point was the realm of the heavens. Christ holds the Scriptures and makes a gesture of blessing. Around the dome stand figures of twelve to sixteen prophets with inscribed scrolls defining the Lord from their own books of prophecy.

In the concave vaults formed by the squinches, there were images of major feasts: the Annunciation, Nativity, Baptism, and Transfiguration. These represent Christ's incarnation and the revelation of his nature. The other eight major feasts of the Byzantine liturgical year were distributed in various parts of the sanctuary at the upper level. This second level represents the spiritual paradise of significant events in the heavens.

Below, on the level of walls and piers, is the terrestrial world. Here are represented the persons who have attained sainthood in the everyday world. The worshiper and celebrants are allied with the saints on this level of the hierarchy.

A characteristic apse included a mosaic representation of the Virgin and Child in the semidome. The enthroned Virgin and Child in the apse of Hagia Sophia in Constantinople served as a model. It was placed there by the first strong champion of images, the empress Theodora, who reigned before 867 and had aided in their restoration.

In many Byzantine churches the archangels Michael and Gabriel and other major saints accompanied Mary in the sanctuary, either in the apse or nearby. The feast picture in the sanctuary vaults, when one was present, was the Pentecost, the appearance of Christ to the Virgin and the Apostles fifty days after his Ascension. The event established the mission of the Church, validated the role of the Virgin Mary, and gave the promise of the Second Coming of Christ.

BYZANTINE MANUSCRIPTS

A rich array of illuminated manuscripts survives, from the Middle and Late Byzantine periods. A manuscript of the Psalms in the Bibliothèque Nationale, Paris (Ms. Grec. 139), made about 900, is an example of the rich Classicism of the first period after Iconoclasm. Known as the *Paris Psalter,* it includes full-page miniatures of Old Testament events. Most well known is the illustration of David composing the Psalms. In this miniature, David as a youthful shepherd is seated in a landscape with his harp. A sheepdog and his flocks are near his feet. Next to him sits a young woman identified as Melody. Another woman peeks at David from behind a pillar in the right background. She is Echo. A seminude figure in the foreground is labeled *Mount Bethlehem*, and the village of Bethlehem itself, David's city, appears in the upper left background. The whole is painted in a colorful style that approaches Pompeian art. The non-Christian personifications and the Orpheus-like pose of David reflect the artist's enthusiasm for antique art.

BYZANTINE SCULPTURE

Almost no monumental sculpture emerges in the Late Byzantine world. Early Byzantine artists had continued to produce Imperial portraits in the Roman fashion, but the practice was not resumed. Stone sculpture was mainly limited to architectural detail, decorative moldings, and capitals. Carved ivories were produced in large numbers as book covers, portable altars, and small decoratively carved caskets, as were small reliefs in precious metals and stone.

THE LATIN CONQUEST AND AFTER

Between 1204 and 1261 the Latin world, headed by the papacy, held Constantinople and divided up most of the Imperial centers of the Eastern church. This followed the conquest and sacking of Constantinople by the errant Fourth Crusade. Despite this setback and increasing external pressure, the Eastern Church managed to revive after regaining its sovereignty. Energetic works, such as the murals in the *Kariye Camii* (Church of the Savior in Chora), in Constantinople, painted in the early fourteenth century, exemplify this energy. Paintings such as the *Anastasis* (Resurrection) in the apse of the Funerary Chapel attached to the church and many others in the vaults of this chapel are fine examples of this later phase.

Additional examples of Byzantine fresco decorations survive in Slavic lands, at places such as Ohrid, Nerezi, Prizren, Sopoćani, Studenica, and Dečani, all in Serbia and Macedonia, and dating from the eleventh to fourteenth centuries. Recent study suggests that the art of Italy in the thirteenth and fourteenth centuries was profoundly affected by spoils brought back from the Crusader conquest and by continued contact with these provincial Byzantine locations.

Although almost all of the Early Byzantine art was lost in the Iconoclastic period, enough survives to indicate that the resurgence represents an astonishing achievement. Byzantine art of the ninth to twelfth centuries is of great quality. It appears to have continuity with the earlier works and to rival their achievement. In the Ottonian period and thereafter, Byzantium will again serve to inspire Latin artists.

Though they will not build as large, the Byzantine church builders built beautifully, and Byzantine artists splendidly decorated their churches with elaborate programs of mosaic and fresco. The miniaturists illuminated books with brilliant paintings, and painters refashioned icons with the great feast pictures and saints' portraits. Somehow in the midst of dwindling territories, space, and time, Byzantine artists clung to the last vestiges of Classical art until after the Renaissance had begun in Italy.

Selected Readings

(*See also* the Selected Readings listed in chapter 7.)

Beckwith, J. *The Art of Constantinople*. London: Phaidon, 1968.

Grabar, A. *Byzantine Painting*. Geneva: Skira, 1953.

Mango, C. A. *Byzantine Architecture*. New York: Abrams, 1975.

Meyer, P. *Byzantine Mosaics: Torcello, Venice, Monreale, Palermo*. London: Batsford, 1952.

Weitzmann, K., et al. *The Icon*. New York: Alfred A. Knopf, 1982.

11

Romanesque Art

The historical period of art called Romanesque *accompanies an extraordinary variety of events and developments in European history. Among these was the evolution of feudalism, a pyramidal system of government developed from Roman, Carolingian, and Germanic landholding practices. Land, owned by a lord, was held in feud (feod, fief) by a vassal in return for service.*

In the same period, monastic reform movements, pilgrimages, and Crusades also affected the arts as well as political and geographical developments. France, the Latin kingdoms, and the Holy Roman Empire, mainly consisting of Lombardy and Germany, evolved as a complex of rival systems striving for power.

The word Romanesque *began as a descriptive architectural term. It derives from the character of the buildings, mostly churches, dating from about 1050 to 1150. These have a remarkable continuity of style throughout most European lands. Their heavy round arches and vaulting systems approximate the architecture of the Romans.*

Without the technology of Roman concrete construction, however, the Romanesque builder had to rely on cut stone and mortar. This was a cumbersome alternative, but it also provided many challenges to architectural ingenuity. The resolutions of structural problems give Romanesque architecture its extraordinarily inventive character. In fact, it was basically by recombining Romanesque architectural inventions that Gothic architecture was made possible.

The Romanesque period is now also celebrated as a special time of achievement in sculpture and painting. We can follow up the tendencies to larger expression already seen in some Ottonian sculptures. Painting, mosaic, and manuscript illumination also flourished in a variety of centers, with new input to enlarge upon the efforts of Carolingian and Ottonian artists.

ROMANESQUE ARCHITECTURE

Monastic Reform

Western monasticism, we have noted, began with the foundation of Monte Cassino Abbey by St. Benedict in the sixth century. St. Benedict's monastic Rule was the formulation for a constructive way of life for a monastic community. For the first few centuries it was the pattern text for life in virtually every western monastery.

CLUNY AND THE FIRST ROMANESQUE

The monastery at Cluny, in Burgundian France, was founded under the Benedictine Rule in 909 by Duke William of Aquitaine. William stipulated that the monastery be run under the direct control of the papacy. Its abbots remained answerable to no one but the pope.

Under the zeal and inspiration of a succession of distinguished abbots, Cluny became, by the mid-eleventh century, the center of Christendom in the North. Over 1500 additional churches and monastic communities were dependent upon Cluny at its height.

A reform movement of the Benedictine order, begun with the first abbots of Cluny, spread all the way back to Monte Cassino. The reform was also extended through France, Spain, and England with Cluniac influence. It inspired a succession of building programs to accommodate the growing communities of monks. A number of the new monastery churches from Lombardy along the Mediterranean coast to Spain were constructed during the tenth and early eleventh centuries. They had tunnel-vaulted roofing systems and apses at the ends of each aisle as well as the nave. These earliest experiments in what would become Romanesque architecture are called *First Romanesque* buildings.

A new basilica was built at Cluny in this style. Most of the construction was done during the abbacy of St. Odilo (944–1049). Cluny II, as it is known, had in addition a large *Galilee porch,* an enlarged narthex outside its front portals for gatherings, assemblies, and processions. It also had a westwork with two towers. Cluny II also had small chapels on the east side of each transept arm.

The most elaborate First Romanesque church that survives is St.-Philibert at Tournus, built in 950–1009. It contains more varieties of vaulting than any other Romanesque church. Most unusual is the nave, crowned by a series of barrel vaults that cross over each bay. St.-Philibert seems like an elaborate experiment in vaulting. Nothing quite like it was ever built again.

MONTE CASSINO AND THE ORIGINS OF ITALO-BYZANTINE ART

In the latter eleventh century, from about 1065, Monte Cassino was rebuilt, still under the influence of the reform movement. By then the movement had become Churchwide and was known as the Gregorian Reform, named for Pope Gregory VII, himself a Cluniac. Desiderius, abbot of Monte Cassino, modeled his new abbey church after the great Early Christian basilicas of Rome: St. Peter's and St. Paul's Outside the Walls. A superb politician as well as churchman, Desiderius was able to contract with Byzantine centers for workmen and mosaicists to build and decorate his church and cloister.

A chronicle of the rebuilding, several manuscripts with Byzantine-style illustrations, and a few churches decorated with mosaics or frescoes under Monte Cassino's influence in the late eleventh century are all that survive of Desiderius' activities. The monastery itself has been destroyed and rebuilt several times, most recently in World War II. It represented a significant beginning of the influence of Byzantine art in Italy, soon to be followed by the building of San Marco in Venice and the Norman churches in Sicily. The emergence of this Italo-Byzantine style would pervade Italian art, particularly in painting, until the beginning of the fourteenth century.

CLUNY III

Cluny was rebuilt once more by the abbot St. Hugh of Semur (1049–1109) and his successors, beginning in 1088. Abbot Hugh had been a friend, councilor, and sometimes mediator in the disputes of Pope Gregory VII with the emperors Henry III and Henry IV and King Philip of France. Cluny's abbot was close to running the papacy by this time.

The new church, Cluny III, was not finished and dedicated until 1130. It was the largest church in Europe until the new St. Peter's was built in Rome in the sixteenth century. Cluny III was 616 feet (188 m) long with a nave vault 96 feet (29 m) high. It was built in much the same plan and style as contemporary pilgrimage churches such as St.-Sernin in Toulouse and

Santiago de Compostela. The nave was barrel-vaulted with reinforcing transverse ribs. There were also two side aisles on each side of the nave. These were groin-vaulted. Two transepts crossed the church, each with a crossing tower. The larger transept had additional towers on each side. Five chapels opened off an ambulatory around the apse; ten more were on the transept arms.

Cluny III was demolished in the years after the French Revolution, 1791–1810. Only a fragment of one transept arm still remains, along with some of the sculptured capitals of the ambulatory, now in the *Musée Ochier,* in Cluny. The capitals reveal a sense of the sophisticated style of carving that emerged at Cluny and can still be seen at some of its many dependencies.

No one knows the real reason for the great size of Cluny III. Some have suggested it was a rivalry with the huge Imperial church at Speyer, begun in the Ottonian period and enlarged and vaulted at the end of the eleventh century.

Others have speculated that Abbot Hugh, at the time of his death, was negotiating for a great relic in order to transform Cluny into a major pilgrimage center. In any case, the monastic population of Cluny at its height seems to have been only about two hundred monks. The church could have held several times that number.

THE CISTERCIAN ORDER

One outcome of the reform movement of the Benedictines was the foundation of a new monastic order, the Cistercians, established at Cîteaux, near Dijon in Burgundy, in 1098. Their aim was an ascetic religious reform, rejecting the worldly riches and influence boasted by Cluny. The simplicity and austerity of Cistercian abbeys was based on St. Benedict's original Rule.

From Cîteaux, which grew too rapidly and became too luxurious for his taste, the most famous of all Cistercians, St. Bernard, left to found his own abbey at Clairvaux in 1125. Bernard is famous for his written works, especially his sermons, but also for his diatribes against the excesses of Romanesque art; the height, width, and sumptuous decoration of Cluniac buildings; and the distractions from devotions provided by the ornateness of sculpture and painting.

By the early twelfth century Cîteaux had an active scriptorium producing richly illuminated manuscripts. One famous example, a commentary on the Book of Job by St. Gregory, included figural initials of a decorative sort that must have irritated the austere St. Bernard. One image in the *Moralia in Job* shows a large capital R figured with a knight and his servant slaying dragons. The figure may or may not be St. George, as it is usually called, but it is far from the simple and reverential pattern the great churchman was calling for. In the second quarter of the twelfth century, Cistercian manuscripts produced at Cîteaux began to show Byzantine style as those at Cluny had around 1100.

Much of the writing by St. Bernard promoted a new devotion to the Virgin Mary. The rise in Mary's popularity and importance was inevitable and spectacular in the Romanesque and Gothic periods. Ironically, the vivid imagery in St. Bernard's texts provided a wealth of new imagery to generations of later medieval artists.

Fontenay Abbey Church. Fontenay Abbey Church, built in 1139 near Dijon, is a surviving and characteristic Cistercian structure. It has no towers and a simple, undecorated square apse. A heavy arcade in the nave supports a pointed tunnel vault, reinforced by transverse arches. There is no gallery or clerestory, no carving of the column capitals. Light filters in from the side aisles, from small windows in the entrance wall, and from the sanctuary. The other monastic buildings are simply laid out in a rectangular pattern to the north side of the church. No painted or sculptured decoration enlivens this somber structure.

German and Lombard Romanesque Architecture

SPEYER CATHEDRAL

Speyer was the largest of the Imperial churches built along the Rhine. Similar cathedrals were built at Mainz and Worms. Speyer was rebuilt after 1080 by the emperor Henry IV, the great adversary of Pope Gregory VII. It is 435 feet (132 m) long, with six great towers and additional decorative features on the exterior. These include details adapted from Lombard architecture including *corbel tables* and *dwarf galleries*.

In the interior, at Speyer, groin vaults were added in place of the original wooden truss roof. The groin vaults are domed. They represent a characteristic solution to a classic problem of Romanesque masonry construction. Unlike Roman concrete that became a solid when it set, Romanesque vaulting required the permanent stabilization of its true arches, vaults, and buttresses. The domes of such groin-vaulted churches were required to accommodate semicircular arches over the diagonals of the square bays. These naturally had to be higher than the arches over the sides of the squares. The disadvantage to this solution is that it divides the bays into individual segments. The nave lacks a unified appearance.

The square bays created to support the groin vaults of the nave at Speyer and similar groin-vaulted churches were made by reinforcing every other nave pier with an engaged colonnette, or *respond*. This created an *alternating system* with two aisle vaults on each side of every nave vault.

SANT'AMBROGIO, MILAN

The close political ties between Lombardy and Germany extend back to the Frankish conquest of Lombardy in the Carolingian period. Lombard elements in the German Romanesque structures are therefore easily explained. In fact, elements of Lombard architectural decoration are widespread in the Romanesque period. One architectural element essential to the

further advance of building design is the diagonal rib, found in the Church of Sant'Ambrogio in Milan. The church was begun about 1080 and finished in the early twelfth century. The diagonal rib structurally reinforces the intersecting elements of a groin vault. The exact date of the vaulting design is unknown.

The nave of Sant'Ambrogio is divided into three large bays with high, domed groin vaults. Like Speyer it uses an alternating system of piers and columns. Each of the *compound piers* is comprised of responds that carry the thrust of each of the five ribs it supports. A gallery above the aisles conceals buttresses that extend through it to projecting buttresses opposite each pier on the exterior of the church. The buttresses appear on the exterior as sections of wall set at right angles to the church walls. The gallery level and heavy buttressing eliminate the opportunity for direct interior lighting of the nave through a clerestory. The interior of the large domed vaults is thus given a gloomy, mysterious atmosphere.

PILGRIMAGE CHURCHES

One aspect of the rapid conversion of Europe's new populations to Christianity was the rising popularity of pilgrimages. These led to the sites at which sacred events had occurred and to the locations where relics of the saints could be venerated. The most difficult and arduous travel was to the Holy Land, under Moslem control since the seventh century. Rome afforded many relics and sacred sites to attract the pilgrim who was willing to traverse the great distance and prohibitive Alpine crossing. Santiago de Compostela in northwestern Spain became an especially venerated site because of its great shrine containing the relics of the apostle St. James the Greater.

En route, the pilgrims lodged at hostelries and monasteries. At various locations along the routes, some churches held relics deserving special veneration. To accommodate increasing numbers of visitors, many of these churches were built to a new standard and in a particular form. Characteristic Romanesque pilgrimage churches were built, as we noted, on much the same plan as Cluny III, even if they were not as large or elaborate. None had two transepts, and few of them had four side aisles. St.-Martin at Tours, Ste.-Foy at Conques, St.-Martial at Limoges, St.-Sernin at Toulouse, and St. James (Santiago) at Compostela were all pilgrimage churches.

St.-Sernin, Toulouse. St.-Sernin, in Toulouse, France, is one of the largest and best preserved of pilgrimage churches. Its long, barrel-vaulted nave is reinforced at each bay with a transverse arch; it has four groin-vaulted side aisles with a gallery over the inner pair. The outer aisles continue around the transept arms and modify to an ambulatory circling the apse. Five chapels radiate from the perimeter of the ambulatory. Four additional chapels open off the aisles on the east side of the transept arms.

These provided nine altars in addition to the high altar for participation in Masses, an obligation of the pilgrim visitor. The ambulatory provided a passageway around the main altar and facilitated the flow of pilgrims to view the relics and to attend services at various chapels.

The barrel vault of the nave of a typical pilgrimage church required substantial buttressing. This was provided by vaults over galleries at the clerestory level. These vaults carried the weight down and outward to the aisle vaults and their supports. As a result the nave also received no direct lighting. Windows on the outer gallery walls and the outer aisle walls filtered light into the interior as best they could.

Romanesque Art and Architecture in England and Normandy

The duchy of Normandy in France was founded in 911 as the result of a treaty between the French king Charles the Simple and the Vikings, who had been raiding and sporadically settling in France since Carolingian times. The Normans, Christianized, still bore the aggressive traits of their ancestors. They were to affect all European history during the eleventh and twelfth centuries. William the Conqueror, best known of the Norman dukes, invaded England in 1066. His victory at Hastings in October made good his claim to the throne of England.

THE BAYEUX TAPESTRY

The record of William's victory is embroidered on a 77-yard-by-20-inch (70.4-m-by-51-cm) piece of linen known as the *Bayeux Tapestry*, in the Town Hall, Bayeux. The work shows events of the Battle of Hastings, the appearance of Halley's Comet, and an array of exotic marginal images. One tradition holds that this colorful work was the product of needlewomen from Kent, in the region of Hastings, but the evidence is inconclusive.

DURHAM CATHEDRAL

In 1093, Norman builders began the Durham Cathedral in Northumbria. The cathedral was finished in 1133. Like Sant'Ambrogio in Milan, Durham Cathedral was vaulted with rib vaults. Scholars may never agree whether Durham Cathedral or Sant'Ambrogio came first or whether the rib vault was independently invented at each location. The form of the diagonal ribs at Durham is more elaborate, and they were used more intricately throughout the building.

The vaults of the nave at Durham are nearly all built on the alternating system; great compound piers alternate with weighty columns. The three major nave bays are oblong. Diagonal ribs spring from the compound piers and cross each other at the summit of the vault. They descend to corbels over the intermediate columns. This forms a double set of diagonals in each bay and a curious seven-part division of the vault.

ST.-ETIENNE, CAEN

The introduction of the rib vault enabled architects to work with greater flexibility in vaulting systems. This is made most effectively apparent in the abbey church of St.-Etienne in Caen, founded in 1064 by William the Conqueror. St.-Etienne was vaulted about 1120. The exterior was built with a westwork and two great towers. The three stories of the façade reveal the horizontal division of the nave into three levels. The towers anticipate the classic Gothic church façade.

The nave of St.-Etienne is rib-vaulted in an alternating system. The major divisions of the bays are compound piers supporting arches over the clerestory, and diagonal and transverse ribs. The piers between support the clerestory arches and transverse arches that bisect the diagonal ribs, reinforcing them and enabling the transverse and diagonal ribs to reach the same height. The vaults are no longer domed, and a clerestory is introduced over the gallery. Thus light enters directly into the nave and the flow of space is opened the length of the nave. The six-part vault combines spatial unity and light, a feature lacking in all the earlier Romanesque vaulting systems. This system is used in early Gothic buildings as well.

Tuscan Romanesque Architecture

Not all of the concern of Romanesque architecture is with vaulting. There are styles and forms that continue with simple truss roofs or variations thereon. Outside of the Lombard groin vaulting at Sant'Ambrogio and the domes of San Marco in Venice, few Italian Romanesque churches were vaulted. Tuscan Romanesque is characterized by its outer decorative qualities more than anything else.

PISA CATHEDRAL

Pisa Cathedral, already mentioned as the work of a Greek architect, Busketos, is at the same time the most exemplary of Tuscan Romanesque churches. The cathedral is part of a complex of buildings; the church was begun in 1063; the baptistery, in 1153; and the campanile (bell tower, the famous Leaning Tower), in 1174.

The simple geometric shapes of the church, campanile, and baptistery at Pisa are embellished by the use of blind colonnades and arcades and by "zebra"-banded stonework. The narrow bands of black marble added to the white exterior also emphasize the form.

SAN MINIATO AL MONTE

The Benedictine abbey church of San Miniato al Monte on the outskirts of Florence was built in the eleventh century. Its façade, added between 1060 and 1150, is an elaborate design in white and dark green marble that effectively describes the simple basilica shape behind it. The nave and side aisles are fronted by an arcade set on Corinthian columns.

These support a cornice on which rests a pedimented temple front covering the upper half of the nave. Decorative triangular fillets front the roof lines over the side aisles.

THE BAPTISTERY, S. GIOVANNI

In Florence, too, the cathedral baptistery uses a combination of piers, columns, and marble of green and white to set off its solid geometric octagonal form. The baptistery was consecrated in 1059, but the date of the building is problematic. It stands on the alleged site of a Roman temple of Mars. The core of its walls may be very old, indeed.

The Norman Churches in Sicily

Norman raiders had ventured as far as the Mediterranean in the eleventh century. By 1060 they had a strong foothold in southern Italy and invaded Sicily, occupying the island by 1091. The Norman Empire of the Two Sicilies, including Sicily, Calabria, and Apulia, was proclaimed in 1130 by Roger II.

The Imperial model for the Norman Empire was Byzantium. Byzantine craftsmen made the mosaic decorations for churches founded by Roger II and his successors. These churches were built primarily in the Western basilica form, but Sicily is an extraordinary crossroads of styles. The stylistic elements in Norman churches came from Tuscan Romanesque, Byzantine, and Moslem sources.

PALACE CHAPEL, PALERMO

The Palace Chapel in Palermo, built in the mid-twelfth century, combines a basilica plan with a Greek cross-in-square nave. The wooden ceiling of the nave, here as in the rest of the Norman churches, was built by Egyptian craftsmen in the elaborate interlocking cell pattern of Moslem architecture.

CEFALÚ AND MONREALE CATHEDRALS

Cefalú Cathedral, c. 1148, and Monreale Cathedral, 1174–1183, were also built as basilica churches. At both Cefalú and Monreale are apse mosaics of Christ as *Pantokrator*. These emulate the dome mosaics of Middle Byzantine churches. All were richly decorated with mosaics.

Monreale Cathedral is discussed in many textbooks as a Byzantine monument as is San Marco in Venice, though neither was built for the use of Eastern Church liturgy.

ROMANESQUE SCULPTURE AND PAINTING

In the arts of sculpture and painting the Romanesque period provides a rich renewal of expression. Much of the work is associated with the new and energetic building programs discussed above. In sculpture, particularly, the return of large-scale work marks a resurgence that will dominate this period and the Gothic as well.

Toulouse and Moissac

ST.-SERNIN, TOULOUSE: THE AMBULATORY RELIEFS

Stone reliefs in plaque form are set into the ambulatory of the pilgrimage church of St.-Sernin in Toulouse. They date to about 1096. These show the Lord in Majesty (*Majestas Domini*), enthroned in a glory with the Evangelist symbols, and additional plaques of angels and saints. Their style resembles that of much enlarged ivory carvings. Sculpture soon became more vigorous.

ST.-PIERRE, MOISSAC: THE CLOISTER

A related style appears in the cloister sculptures of the church of St.-Pierre in Moissac, about 24 miles (40 km) northwest of Cluny. One cloister pier displays a relief sculpture of the abbot of St.-Pierre, Durandus, who supervised a revival of the monastery under Cluniac influence. This work and the capitals of the columns in the cloister were done about 1100. The capitals included religious scenes, fabled animals, and decorative motifs.

ST.-PIERRE, MOISSAC: THE PORTAL

A second sculptural effort at Moissac, the major portal of the church of St.-Pierre, reflects its relationship to the outside world. Moissac stood upon one of the pilgrimage routes leading to Santiago. The church has been rebuilt but the sculpture of the great portal, opening onto the town square from the south side of the narthex, is preserved and justly famed as one of the great monuments of the Romanesque period.

The *tympanum* holds a sculptured representation of the Second Coming of Christ. It is based on illuminations of Beatus' Commentary on the Apocalypse. In the center is Christ, seated and blessing the others. He is surrounded by the four Evangelist symbols and two attending angels. Gathered about this group are the Twenty-four Elders (Rev. 4:4). The tympanum is supported by an elaborately carved lintel. The *jambs* and *trumeau* that support the lintel are also richly carved with figures and animals. The intertwined lions of the trumeau are flanked by carved figures on the sides. Especially powerful is the slender, elaborate turning figure of Isaiah on the right side.

Within the entry of the portal of Moissac are also scenes related to the Last Judgment and the Incarnation of Christ. They are an amplification of the Apocalyptic theme of the tympanum.

The style of Moissac carving relates in part to Visigothic survivals in the local Languedoc region of France. Partly it also relates to a continued regional tradition that is traced back to the Roman period. The style is also influenced by contemporary developments in Burgundy, especially at Cluny. The style also can be found in works in the church of St.-Marie at Souillac in the region of Moissac.

Cluny and Burgundian Romanesque Sculpture and Painting

A small amount of sculpture and a few manuscripts are preserved from Cluny. In themselves they present little evidence of the arts at Cluny in the early twelfth century. They do provide a link to related monuments in the region by which we know more about this important aspect of Cluniac contribution to the Romanesque.

BERZÉ-LA-VILLE

The tiny priory church of Berzé-la-Ville, close to Cluny, contains the remains of an elaborate program of frescoes painted about 1100. The church was a favorite retreat of the abbot Hugh of Semur. Its apse fresco, a large representation of Christ giving the keys to St. Peter, is a symbol of papal authority, descended from a mosaic of the same subject in Santa Costanza in Rome. The style is notably influenced by Byzantine art.

MANUSCRIPTS AT CLUNY

The Byzantine style also appears in two famous Cluniac manuscripts of the same date. It may well have reached Cluny through the influence of Monte Cassino. Some of the manuscript paintings from Cluny's scriptorium were surely painted by an artist trained in Byzantine techniques. Such paintings appear in a lectionary made at Cluny, now in the National Library in Paris, and in a manuscript treatise on the Virgin Mary by the monk Ildefonsus, now in the Palatine Library in Parma, Italy.

Burgundian Sculpture

Sculpture produced at significant churches in the region of Burgundy in the Romanesque period is related to the style of the few surviving sculptural fragments from the great monastery. One great master, trained at Cluny, is known by name: Gislebertus. He worked at Autun between 1120 and 1135.

THE CATHEDRAL OF ST.-LAZARE, AUTUN

Gislebertus signed his name on the portal sculpture of the Cathedral of St.-Lazare in Autun. The tympanum is the *Last Judgment*. Here Christ appears as judge between the blessed to the left (Christ's right) and the damned to the right. Also on the right in this expressive work is the archangel

Michael weighing the souls of the resurrected, who appear in great numbers on the lintel, awaiting their judgment.

Gislebertus is also responsible for many of the carved capitals in the church and for the sculpture of the north portal of the church, though that has been destroyed. The largest remaining fragment of the north porch is now in Autun's *Musée Rolin*. It is a representation of Eve, reclining and plucking a fruit from the tree. Her pose fits the shape of the right half of the lintel; the rest, with Adam and the serpent, is missing. Working in his individualistic style, Gislebertus managed to create Eve as a mysterious, sensuous seductress, indeed.

THE CHURCH OF STE. MADELEINE, VEZELAY

At the church of Ste. Madeleine in Vezelay, the great portal sculpture is within the narthex. The tympanum here is titled *The Mission to the Apostles*. This is the significance of Pentecost (Acts 2) and the Lord's instruction to the Apostles to preach to all the world. St. John the Baptist appears in the tympanum as the *Forerunner*, the prototype of the preacher. (The monks at Ste. Madeleine were a preaching order.)

The sculptures of the two smaller portals, made earlier and sometimes attributed to Gislebertus of Autun, show the Adoration of the Three Kings and the appearance of Christ to two apostles, after the Resurrection, on the road to Emmäus. Both are theologically related to the mission of the Apostles. The workshop changed but the overall plan of execution remained the same.

It is important to remember that the visual images found on the great church portals in the Romanesque and Gothic periods were meant to convey meaning to an informed audience of pious pilgrims as well as to the simplest of unconverted passersby—to instill the joy of salvation and inspire the terrors of damnation.

"Mosan" Metalworkers

A twelfth-century school of metalworkers working in the region of the Meuse and Rhine rivers where present-day Belgium, France, and Germany meet was responsible for a further development of monumental sculpture. The golden altar frontal made in the Ottonian period for Henry II and Kunigunde about 1019 is an early example of the work of this region, called *Mosan* after the Meuse River.

RENIER OF HUY

A large bronze baptismal font for Liège Cathedral exemplifies the early twelfth-century mastery of an artist of this region named Renier of Huy. The font is 2 feet high by 2 feet 7.5 inches in diameter (0.6 by 0.8 m). The vessel is supported on the backs of a dozen oxen and displays baptism scenes in

high relief. The draperies and modeling are in a newly emphatic and defined style, suggesting the influence of ancient relief sculpture.

NICHOLAS OF VERDUN

The most important of the Mosan artists of the twelfth century was Nicholas of Verdun. Nicholas made a huge champlevé (enamel) pulpit for the abbey of Klosterneuburg, on the Danube near Vienna. It was dedicated in 1181. It includes many panel scenes of Christ's life and typological parallels from the period before the Law (*ante Legem*) and under the Law (*sub Legem*). The scenes are drawn with a surety and expressiveness of figures and draperies that evolve past the formulas of Byzantine style and its rendition in manuscripts such as the Bury Bible.

Nicholas also worked in the sculptural three dimensions. His best-known work is the *Shrine of the Three Magi*. This is a huge reliquary casket, 68 inches high by 72 inches long and 44 inches deep (1.73 by 1.83 by 1.12 m). It was made for Cologne Cathedral to hold the relics (three skulls) of the Magi. The casket is silver and gilt bronze and was made in 1181–1230. Working in traditional materials but giving them a sculptural vitality that is new for the Middle Ages, Nicholas produced a sculptural style that is critical to the transition from Romanesque to Gothic.

SPANISH ROMANESQUE PAINTINGS

Santa Maria, Tahul. In Catalonia in Spain are Romanesque churches whose frescoes are colorful and expressive. Several frescoes are collected in the Romanesque Museum in Barcelona, including the apse of the church of Santa Maria in Tahul. It shows the Virgin and Child enthroned, approached by the Magi. The large central figures of Mary and Jesus monumentalize the narrative scene in much the manner of the sculptural tympanums we have seen. The expressive color and form is reminiscent of the Spanish tradition of miniature painting.

Frescoes in France, England, and Germany of the period all show the same combination of regional styles with newer expressive qualities of the Romanesque.

The introduction of Byzantine form into the art of the Romanesque, prevalent in Italy and in increasing numbers of centers north of the Alps, hardened in the twelfth century to certain patterns of expression evolved from both East and West. In a variety of locales the forms became linear, defined areas with stylized drapery and color patterns. Works such as the Bury Bible in Corpus Christi College Library, Cambridge, illuminated by Master Hugo of the abbey of Bury St. Edmonds in England, are exemplary.

*W*e have noted that the reforms of monasticism, the international links of pilgrimage and of the Crusades, and the political changes of the tenth to twelfth centuries gave shape to architecture, sculpture, and painting of the period we designate as Romanesque. The result in each medium is a mixture of styles, sometimes based on regional traditions, usually overlaid with broader influences.

The Byzantine style that made its way into Italy through Venice, Pisa, Monte Cassino, and Norman Sicily also appeared in the painting and illumination of Cluny, Cîteaux, and other scriptoria. In each it was transformed.

Romanesque art remains remarkably vital and varied. The artists drew inspiration from assorted sources, but the vigor of their own invention seems renewable in each new structure, sculptural relief, fresco, or miniature.

Selected Readings

Conant, K. J. *Carolingian and Romanesque Architecture*. Baltimore: Penguin, 1979.

Demus, O. *Romanesque Mural Painting*. New York: Abrams, 1970.

Focillon, H. *The Art of the West in the Middle Ages*. London: Phaidon, 1969.

Hearn, M. F. *Romanesque Sculpture in the Eleventh and Twelfth Centuries*. Ithaca, NY: Cornell University Press, 1981.

Porter, A. K. *Romanesque Sculpture of the Pilgrimage Roads*. Reprint. New York: Hacker, 1969.

Saalman, H. *Medieval Architecture: European Architecture, 600–1200*. New York: Braziller, 1962.

Swarzenski, H. *Monuments of Romanesque Art*. Chicago: University of Chicago Press, 1974.

Zarnecki, G. *Romanesque Art*. New York: Universe Books, 1971.

12

Gothic Art

1140–1144	Ambulatory and chapels of St.-Denis built
1145–1170	West (royal) portal built, Chartres Cathedral
1160	Laon Cathedral begun
1163–1167	Notre Dame, Paris, begun
1179–1184	Canterbury Cathedral (England)
1194	Chartres Cathedral rebuilding begun
1215	Founding of the University of Paris
1220	Amiens Cathedral begun
1220	Salisbury Cathedral begun (England)
1225	Reims Cathedral begun
1243–1248	Ste.-Chapelle built
1248	Cologne Cathedral begun (Germany)

The term Gothic, like Romanesque, also originated as an architectural expression. It was invented in the Renaissance as a disparaging term, signaling its opposition in style and principle to Classical building ideals and forms. The distinction is real enough even though the architecture has no relationship to the early medieval Goths. The value judgment in comparing Gothic unfavorably with Renaissance is no longer relevant.

Gothic now refers to a period that begins with a revolutionary new architectural form. The building progress of Gothic architecture is usually subdivided into Early, High, and Late Gothic, supplemented by Rayonnant, Flamboyant Gothic, and Gothic Revival. The rise and dominance of Gothic architecture lasts from 1135 through the fourteenth century.

In most respects, the Gothic era represents the culmination of the Middle Ages. Gothic is no longer strictly an architectural term. Painting and sculpture also emerged in the Gothic period as monumental arts, independent of the architecture. The intellectual life, with the rise of universities and the scholasticism of such men as Vincent of Beauvais and St. Thomas Aquinas, took on great value.

Politically, the Gothic era was also important in its new emphasis on the town and the emergence of a merchant class. First in twelfth-century Italy, then in France, England, Germany, and the rest of Europe, the communal system was established to balance the power of feudal lords. Cities received charters and as free communes built town halls and cathedrals. Craft guilds protected the workers as monasteries had in the past and much as unions would in future.

EARLY GOTHIC ARCHITECTURE

As noted in the previous chapter, the basic elements of Gothic architecture are all to be found in the Romanesque period but not in the combination that defines true Gothic buildings. The particular clarity of Gothic architecture results in an essential combination of form and function that has won the admiration of modern architects professing the same ideals. Gothic architects achieved the unified space and the almost unlimited availability of light that their predecessors in the Romanesque era seem to have been seeking. Gothic architecture was invented in France, but it rapidly developed into an international building style.

Building in the Gothic style was never fully abandoned. The building of Renaissance architecture spread gradually through Europe in the fifteenth and sixteenth centuries and beyond. Building on Gothic principles continued in some regions until the late eighteenth century, when we first encounter a Romantic revival of the Gothic.

Abbot Suger and St.-Denis

Suger, a friend of King Louis VI and counselor of King Louis VII, was the abbot of the royal abbey at St.-Denis from 1122 to 1151. He set out to reform the monastery and began a reconstruction of the church in 1135. By 1140 he had reconstructed the portal with a new two-tower façade and westwork. By 1144 Suger had completed a new choir for the church. These

two building projects are complementary; both were built in an expressive fashion that is quite different from all their predecessors.

Nearly all scholars agree that Suger's building program is the first instance of Gothic construction. While he left a treatise, *Things Done Under His* [Suger's] *Administration,* telling of the building progress, Suger did not name the architect. His account shows an intimate awareness of the architecture and a sense of the spirituality conveyed by the new light (*lux nova*) made available, both physically and symbolically, by the building style. It would have required an architect to build the actual structure, however, and this unnamed genius deserves credit for achieving an enormously significant milestone in building history.

The new façade of St.-Denis has three large portals with sculptured jambs divided by great vertical buttresses as at St.-Etienne in Caen. A rose window appears in the central portal at the top story. Towers surmounted the outer sections of the façade. This form led to a succession of remarkable cathedral fronts in the Gothic period. The present nave, choir, and apse were built later, but the ambulatory and chapels still survive. They evoke the principles of Gothic in dramatic contrast to their Romanesque predecessors.

GOTHIC AND ROMANESQUE: A COMPARISON

Comparing the ambulatory and radial chapels of Romanesque St.-Sernin in Toulouse with those of Gothic St.-Denis demonstrates the difference between the two styles. The groin-vaulted ambulatory of St.-Sernin is designed so that the weight of its vaults is absorbed into the walls. A series of chapels is attached to the outside of the ambulatory as five separate semicircular apses. The central chapel, on line with the axis of the church, is extended by one bay. At St.-Denis the whole ambulatory and chapel system is linked in an interlocking and systematic network of ribbed vaults. The ribs carry the weight to two rows of columns circling the apse and to a succession of piers, or buttresses, on the outer perimeter. These piers are set on a radius from the apse. Between the piers, because they bear the weight, the architect has created space for large windows.

The flexibility of the rib system is made possible by the use of pointed arches. The pointed arch can be traced to Islamic architecture, and it was used on occasion in various Romanesque buildings. It is a key element in Gothic architecture. The pointed arch is a means to span greater or lesser distances with vaults of equal height. Meanwhile the ribs act as a weight-bearing network, directing the forces to the supporting columns, piers, and buttresses.

Suger's church was not completed as planned. Its nave was finished by the architect Pierre de Montreuil in the thirteenth century in the high Gothic style. Yet, within a short span of years after Suger began the work at

St.-Denis, several new cathedrals were under construction in the Île-de-France region. Their completed structures were built upon the same bases as the original designs for Suger's St.-Denis. Cathedrals at Sens (1145–1164), Noyon (1150–1170), Paris (begun 1163), and Laon (1165–1205) were all built with six-part vaults and an alternating system of piers.

Laon Cathedral

Laon is northwest of Paris. Early in the twelfth century its townspeople sought a charter of their own from the king. When the bishop attempted to frustrate them, the townspeople murdered him and burned the cathedral. The cathedral was temporarily repaired, and the people of Laon eventually received a new charter. Their new bishop began a whole new cathedral in 1165.

The Early Gothic Structure of Laon. The nave of Laon Cathedral is four stories high. At the first level, the nave arcade is supported by great columns. Above the column capitals on the nave side arise alternate clusters of five and three shafts extending up to the six-part nave vaulting. They support ribs at each bay and each half bay, respectively.

Above the side aisles is a *tribune gallery,* opening onto the nave at the second-story level. The aisle and gallery vaults help to buttress the nave. Over the vaults of the tribune gallery is a sloped timber roof. Between the vaults and roof, the inner space is called a *triforium,* masked on the nave by an arcaded, shallow gallery. This triforium gallery is the third nave level. Above the roof line, the clerestory windows and nave vaults form the fourth-story level of the interior.

The façade of Laon Cathedral is more deeply sculptural than St.-Denis. It has cavernous porches surrounding the doorways, a large, deep-set rose window fronting the nave, and *lancet windows,* heavily framed, on either side of the rose. The two towers rise from the mass of the building façade, which is not so clearly divided as St.-Denis. Within the turrets on the corners of these towers the Laonnaise citizens placed statues of oxen. The statues honor the heavy labors of these creatures who were credited with miracles in hauling and raising the stones of the cathedral.

Notre Dame Cathedral, Paris

Most of the cathedrals of the Gothic period were dedicated to the Virgin Mary (*Notre Dame,* or "Our Lady"). The cathedral of Paris is particularly known by this name. It is an early Gothic building, still using the six-part nave vaulting system. It was designed with a complicated four-storied elevation similar to that used at Laon.

The triforium at Notre Dame was first designed to display a series of open circular rosettes over the tribune gallery. After 1225 a new system of flying buttressing was applied, the triforium rosettes were eliminated, and the clerestory was extended down to the gallery level by placing a dual-pitched roof in place of the triforium. The outer piers still supported flying buttresses that reached to the gallery vaults. Above them were

added great soaring flying buttresses that arched over the galleries all the way to the nave.

The façade of Notre Dame of Paris returns to the vertical and horizontal geometric divisions as at St.-Denis. The three large recessed portals are rich with sculpture, much restored at present. A sculptural frieze of standing figures crosses the entire structure above the doors. At the second level the large rose window is clearly separated from the arched windows beside it by large buttresses that evenly divide the façade into three vertical spaces. At the upper level an arcade screens the bases of the portal towers and masks the peak of the nave roof.

The square-topped towers of the cathedral's façade contrast with its slender, needlelike crossing tower. These and the slender struts of the flying buttresses give Notre Dame of Paris its unique appearance and make it a familiar city landmark.

HIGH GOTHIC ARCHITECTURE

Chartres Cathedral

Chartres is about 50 miles (80 km) southwest of Paris. The cathedral has an important history as a pilgrimage site because of its relic, the tunic of the Virgin Mary from the time of Christ's birth. The church was rebuilt in 1028 after a fire. Early in the twelfth century a new portal was begun. The north tower was built first (1134–1145), then the south tower and narthex (1145–1170).

In 1194 the church burned down again. A rebuilding was immediately undertaken. The towers and portal, as well as the crypt with its great relic, had been spared and were incorporated into the new structure. The nave of the new cathedral at Chartres was built in a four-part vaulting system, no longer requiring an alternating system of piers for support. The rectangular nave bays were vaulted with ribbed pointed arches. The galleries over the side aisles were eliminated, leaving only the triforium between the nave arcade and the large stained glass windows of the clerestory. Double-arched flying buttresses spring from the great stone buttresses above the side aisles on the exterior.

The portal of Chartres, designed earlier than St.-Denis, is small, wedged between the two great towers. As if to make up for this the architects of the later building campaign gave the church two huge portal complexes, one on each of the transept arms.

Chartres is at once the best preserved and most admired of Gothic cathedrals. Its building history is visible in the distinct features of its many parts. The oldest is the base of the north tower (1134). The spire of the same tower, in the Flamboyant Gothic style, is the latest feature (1507).

Amiens Cathedral

Of the High Gothic cathedrals built since Chartres, that at Amiens, built 1220–1236, is often designated as the most satisfactorily proportioned and designed. Its architect was Robert de Luzarches. Amiens' façade is divided into stories and vertical sections again, but nearly every surface is decorated with sculpture, arcades, or pinnacles. The rose window is raised to the upper level, at the clerestory level of the nave, as at St.-Denis.

Bourges, Reims, Beauvais: the High Gothic Triumph

During the thirteenth century many additional High Gothic cathedrals and churches were constructed. Bourges was begun about 1195, at the same time as Chartres. It had two side aisles and no transept. Reims, begun around 1212, was smaller but even more richly embellished with sculpture than Amiens.

Beauvais Cathedral was begun in 1227 and intended to rival Amiens. The vaults were not sufficiently buttressed and they collapsed. A second attempt to vault the church failed in 1272. The nave was finally finished, with additional columns and buttresses added, in 1284. The transepts were built in the Flamboyant Gothic style after 1500. Architects of this later period were inspired to rival St. Peter's in Rome. They built an enormous crossing tower, over 500 feet (152 m) high. The tower fell down in 1573, bringing much of the transept and choir of Beauvais Cathedral down with it.

Ste.-Chapelle, Paris: Rayonnant Style

In 1239, King Louis IX (Saint Louis) of France acquired from Constantinople several valuable relics of the Passion of Christ, including part of the crown of thorns, a piece of iron from the lance, the sponge, and a fragment of the true cross. He commissioned a new palace chapel to hold these treasures.

Ste.-Chapelle was built from 1243 to 1248, probably by Pierre de Montreuil, who is also credited with finishing the work at St.-Denis. The present Palais de Justice that surrounds Ste.-Chapelle stands on the site of the original royal palace of Paris. King Louis had direct access to the chapel at the upper level through a balcony over the portal.

The chapel is two-storied; its upper level on the interior gives the initial impression of glass walls rising from just above eye level to the vaults. Slender clustered columns and strips of tracery form wiry patterns in the glass. They seem almost frail in contrast to the open, radiant stained glass that they surround.

Ste.-Chapelle's structural system and linear delineation mark a style of Gothic building termed *Rayonnant*. This style dominates the second half of the thirteenth century in France. The term derives from the radiating tracery of rose window designs, but it extends to the decorative use of lighter moldings and tracery and clustered columns instead of pier and column combinations.

Other Rayonnant Gothic Examples. The transept portals at Notre Dame of Paris were added around the mid-thirteenth century and were Rayonnant in style. The church of St.-Urbain at Troyes, built after 1261, is

another well-preserved example of Rayonnant Gothic. The *Flamboyant* style that emerged in the fourteenth century is an outgrowth of the Rayonnant style. It derives its name from the flamelike twist and whorl of Late Gothic tracery.

GOTHIC ARCHITECTURE OUTSIDE FRANCE

The rich variety of Gothic construction is a lifetime study in itself. Once the principles were established, the architects and masons who worked on the buildings were in great demand at home and outside of French lands. The style spread quickly to England, Germany, and beyond. It evolved with characteristics of its own in each region and country. Gothic became known as the *ars nova* and actually was so prevalent that it was used as a symbolic element in painting of the fourteenth and fifteenth centuries; Gothic represented *ecclesia*, "the church," as opposed to the Romanesque *synagoga*, or the Judeo-Classical world of Christianity's origins.

The Gothic style never really took hold in Italy. There are strong elements of Gothic in Italian thirteenth- and fourteenth-century art, nonetheless, and we discuss these in the next chapter.

English Gothic

The first fully Gothic construction in England was the choir of Canterbury Cathedral. It was rebuilt after a fire in 1174 by two architects, William of England and William of Sens. The latter brought the new style of building from France. English Gothic churches placed less stress on verticality; their interiors are generally lower and the horizontal division of stories is more marked. English designers delighted in complex rib vault designs. Lincoln Cathedral, built in the late twelfth century, even has asymmetrical rib patterns in a section of its choir.

Many English Gothic churches have enormous screen façades that extend well beyond the width of the church. Lincoln, Wells, Salisbury, and Lichfield cathedrals share this element. These screens conceal the structural form of the building behind them. The portals within these church façades are small and unemphasized. Sculpture covers the surfaces, including many single figures in separate niches.

German Gothic

STRASBOURG CATHEDRAL

Strasbourg (German, *Strassburg*) is on the upper Rhine River, south of Mainz and Speyer. The city, in what is now French Alsace, was in the German Imperial domain in the Middle Ages. The cathedral was begun in 1176 in Romanesque style. The apse and north transept were built by 1225. In the

1240s the south transept and choir were built in the Gothic style by the architect Rudolph. His son completed the nave in 1275. A delicate Late Gothic screen was added to the façade by Erwin von Steinbach in 1277, "resembling," as one scholar has phrased it, "a huge trellis surmounted by a splendid rose window." The upper parts of the façade and the single spire of the north tower were added to Strasbourg in the fourteenth and fifteenth centuries, respectively.

COLOGNE CATHEDRAL

In Germany a number of Gothic churches were built in the thirteenth century. Cologne Cathedral, begun in 1248, is the largest and best known though its nave and towers were not completed until the nineteenth century. The nineteenth-century builders followed the thirteenth-century design of the church, however, and at 150 feet (46 m), the vaults of Cologne are higher than those of Amiens, which had served as its model.

HALL CHURCHES

In Germany, too, the Gothic *hall church* (*Hallenkirche*) developed from a form that had originated in Romanesque France. The Church of St. Elizabeth in Marburg, built in 1238–1283, is an example. In these churches the side aisles are as tall as the nave. The aisle vaults and the piers on their outer walls buttress the nave vaults. Two tiers of windows between the buttresses on the aisles provide ample light inside St. Elizabeth. Thus the interior appears more spacious than that of typical Gothic church interiors.

GOTHIC SCULPTURE

Sculpture is an essential element of the Gothic. The style of Gothic is even more suitable for sculpture than Romanesque, providing endless junctures, niches, pinnacles, columns, and capitals to which decorative sculptural detail may be added. The great portals afforded new space for expressive statements of faith.

Sculpture at Chartres

Among the best-preserved and most readable programs of Gothic sculpture are those on the west portal and the two large side portals of Chartres Cathedral. They display the great stylistic differences between Early and High Gothic sculpture that characterize the changes that emerge with the architecture and culture of the Gothic.

THE ROYAL PORTAL

At Chartres, the west "royal" portal was designed and built about 1145–1170. Its sculpture relates closely to that of the portal of St.-Denis (which is lost), but it is more elaborate.

Jamb Sculptures. The figures on the jambs of the portal at Chartres stand in front of the jamb columns. They are tall, elongated columnar figures, but they stand free of the jambs themselves, floating, as it were, in their own space in front of the masonry.

These portal figures at Chartres are interpreted as ancestors of Christ, although they cannot be individually identified. Many wear crowns as kings and queens, reminding the viewer that Christ was a descendant of King David. In later cathedral façades these figures reappear at various levels, often across the whole width of the building.

Above the kings and queens at Chartres, the jamb column capitals display continuous relief sculptures of the Passion of Christ. The story of capture and death is a reminder of Christ's human nature and sacrifice.

Tympanum Sculptures. The jamb columns and the piers behind them support the triad of tympanum sculptures atop their carved lintels and within the surrounding arches of sculptural voussoirs. At this level the emphasis is on Christ's divine nature; the Incarnation is on the right (Virgin's) portal, the Ascension on the left, and the Second Coming of Christ, as the *Majestas Domini,* is in the center.

Each of these subjects is elaborated for the viewer. The Virgin's portal displays a seated Virgin and Child above a double lintel with narrative representation of scenes of Christ's Birth. The voussoirs represent the liberal arts. They remind the knowledgeable viewer that Mary is the *Sedes sapientiae*, the "Throne of Wisdom."

A double lintel in the left doorway shows angels appearing to the Apostles as Christ rises to heaven in the tympanum. In the voussoirs are images of the signs of the zodiac and the labors of the months. These are features that appeared in Romanesque portals as well. The cyclical calendar images are reminders of the passage of earth time until Christ's return. As devotional images, they reappear in illuminated service books such as the *Lectionary* and the *Book of Hours*, in celebration of the liturgical year.

CHARTRES TRANSEPT SCULPTURE

Each of the portals of the north and south transept at Chartres is very large. Each is filled with sculpture, representing, on the north, the prophets and the Virgin Mary. The tympanum of the north central portal represents Mary's Coronation in Heaven. On the south portals are Christ, the Apostles, and Saints. The Last Judgment is the theme of its central tympanum. There are three large doorways on each side with a huge number of individual

figures and combinations. The transept figures were carved in the early thirteenth century (1205–1240) by at least two different workshops.

Among the sculptures of the transepts, the jamb figures are the most interesting and highly developed. Here they are given individuality far in advance of the slender, columnar figures of the royal portal. In addition, the figures display attributes that identify them or enlarge upon the significance of their presence.

The Prophets of the North Transept Porch. The prophets on the left jambs in the central portal of the north transept, for instance, include Melchizedek with chalice and censer, dressed in priestly robes. Next to him is Abraham, turning to hear the angel's words while holding a sacrificial knife and his son Isaac. The angel who stayed Abraham's hand from sacrificing his son is in the capital over Melchizedek's head. Next to Abraham is Moses, who holds a pillar with the brazen serpent as well as the tablets of the law. Samuel follows, holding a sacrificial lamb, and the crowned king David, holding a spear, follows Samuel.

SYMBOLS AND ATTRIBUTES AS A FUNCTION OF VISUAL PROGRAMS

The symbolic values in each of these figures rest in their identifying attributes. Moses' brazen serpent and Abraham's knife raised to sacrifice his son are both symbolic of the Crucifixion. Melchizedek's symbols are of the priesthood and of the sacraments. Samuel's sacrificial lamb bears the same symbolism. David is Jesus' direct ancestor. On the cross, Christ uttered David's words from Psalm 22 (Matthew 27). The attributes carried by these figures are not simply identifiers. They bear thematic resonance for the entire complex of sculpture.

It would take a theologian and intensive study for us to understand many of the complex patterns of meaning worked into programs such as this or any of those myriad portals that the Gothic world created. To the extent that Gothic art represents the climax of medieval art, this symbolic element is the most elaborately interwoven into the imagery of faith.

We will also find such expression in the altarpieces, stained glass, paintings, and manuscript illumination—indeed, all the representational arts of the Gothic period. Writers and philosophers of the twelfth century onward, from Bernard of Clairvaux to Thomas Aquinas, Hugh of St. Victor, and many others, expounded on the meaning of events and elements in the material world as representative of the spiritual.

THE CONCEPT OF A PROGRAM AS IT AFFECTS STYLE

St. Theodore. With this sculpture we find more expressive and, it follows, more detailed imagery in the arts. A tendency to reflect the world as a reference to God introduces a tendency to naturalism. Among the jamb figures on Chartres' south transept portal, for instance, is an image of the

soldier-saint Theodore dressed in chain mail and bearing a pennant-draped spear, a sword, and a shield. The sculptor who carved St. Theodore belonged to a group that worked at Chartres from 1230 to 1240, adding to the earlier, adjacent jamb figures.

St. Theodore stands more naturally than his older companions. The unequal weight on his feet is counterbalanced by a small shift of his body. His head turns slightly in contrast to the strict frontality of the other jamb figures. In stance and expression and in the convincing portrayal of the texture of chain mail draped over the body this sculptor has chosen a method entirely different from that of his predecessors. During the High Gothic period we find increasing numbers of examples of this new, expressive, and observed detail.

Reims Cathedral: Jambs of the Central Portal

At Reims Cathedral other sculptors worked from 1225 to 1290 on assorted sculpture of the façade. Here the sculptured tympanums have been displaced by stained glass; the sculpture has been moved to pinnacles over the portals.

The jamb figures of the central portal are particularly interesting. They are arranged in groups forming scenes of interaction. At the right are two pairs of figures, first Gabriel and Mary, representing the Annunciation, and then Mary and St. Elizabeth, in a scene of the Visitation—the meeting of the mother of St. John the Baptist with the mother of Christ. At the left is a five-figured composition, the Presentation of Christ, with Mary, holding the infant Christ, St. Joseph, Simeon, and Anna. These figures turn and gesture to one another. They stand in clusters before the jamb columns, virtually as complete figures in the round. Age and gender are distinctly modeled as are expressions and individualized features.

The Visitation Master. The four figures to the right of the portal were carved by three masters. The most distinct among them carved the two Visitation statues. His style is nearly Classical in the intricacies of drapery folds and the subtleties of the facial features. An analysis of his sculpture leads back to Late Classical or Byzantine art. We can probably trace it best through "Mosan" metalwork. The style has a resonance with the figures on the Shrine of the Three Kings by Nicholas of Verdun. It appears with variations in a number of Gothic sculptures afterward at Strasbourg, Bamberg, and many other churches.

The Sculptors of the *Annunciation*. The *Annunciation* on the same Reims portal was carved by two different sculptors. The one who carved Mary was among the earliest workers, around 1220–1225. He worked with heavy, rather flat planes of drapery and standardized unexpressive facial features. The angel Gabriel was carved by a member of a workshop active about 1240–1250. This carver used a bolder, more expressive drapery form and carved delicate, smiling features on the head of the angel. In theory this

angel was originally placed elsewhere on Reims' exterior and was later moved here to replace an original, now missing angel of the Annunciation.

High Gothic Sculpture Abroad

STRASBOURG CATHEDRAL: *DEATH OF THE VIRGIN*

On the south portal of Strasbourg cathedral are High Gothic sculptures of the death and Assumption of the Virgin Mary. They were carved about 1230. The tympanum on the left, the *Death of the Virgin,* is an agitated version of the Reims Visitation Master's style. Mary's body undulates across the surface of her bed. Ripples of drapery and bedclothing cover and surround her body. She is attended by the Apostles and Christ who make theatrical gestures of mourning. Mary Magdalene sits at the forefront wringing her hands. This affected, overemotional style is also found in other of the Strasbourg sculptures. The use of a naturalistic style and emotion in figural sculpture requires a subtle balance of dignity and monumentality to be most effective.

THE *BAMBERG RIDER*

At Bamberg Cathedral in Germany, a sculptor who worked in a style also related to Reims sculpture made a large stone sculpture of a royal figure on horseback. The *Bamberg Rider,* as he is called, was carved about 1240. The work is 7 feet 9 inches (2.3 m) high and is on a pier in the cathedral. It probably once stood on a portal of the church. This is the first equestrian statue since at least the time of Charlemagne, and it may thereby reflect Classical influence as an Imperial portrait. The emperor Frederick II (1194–1250), who lived most of his life in Italy, may be the subject of the sculpture. Many other names have also been suggested.

THE CHOIR FIGURES AT NAUMBURG

A series of choir sculptures in Naumburg Cathedral in Germany were made to represent family ancestors of the thirteenth-century benefactors of the church. These secular sculptures show a wonderful array of personalities with very human traits. The best known of the group are the couple Eckehart and Uta, he being authoritarian and rather ebullient, she self-protective and a little overwhelmed by Eckehart. The mastery of figure, drapery, and expression in these figures indicates that living models were used by the artist.

PAINTING AND STAINED GLASS

Painting

The best of the paintings done in the High Gothic period were manuscript illuminations. The *Psalter of St. Louis,* in the Bibliothèque Nationale, Paris, made about 1253–1270 for the king by artists closely associated with

stained-glass work, includes many Old Testament subjects among its full-page illuminations. These are bright, colorful, and patterned in the same coloristic abstraction as stained glass itself. Other court manuscripts include the *Bibles moralisées,* Bible texts illustrated with commentary and instructive passages. These manuscripts, in several libraries today, are rich in illustration. Because of their format, the illustrations are also reminiscent of stained glass.

In the Bibliothèque Nationale in Paris is also a notebook, dating from about 1240, kept by an architect named Villard de Honnecourt. It contains notes and architectural diagrams of many famed cathedrals including Laon and Reims. It also depicts contemporary tools, patterns for sculpture, geometric figures, and even a lion. The artist asserts that he drew the animal from life.

Stained Glass

The great visual art of the Gothic, other than sculpture, was stained glass. On entering a great Gothic cathedral such as Chartres, one senses immediately the importance of light in the Gothic world. Despite its enormous windows, Chartres has a darkened interior. The light filters through the rich colors of its window glass, assuming those colors and glowing softly.

Gothic architecture is the systematic use of interdependent elements of a building to structurally reinforce one another and the whole. This system of building has been compared to the structure of scholastic reasoning propounded by such writers as Thomas Aquinas in his Summa Theologica, *published about 1250.*

The great cathedrals, their sculpture, stained glass, and rich furnishings are the products of a sophisticated and stable society, more harmonious and predictable than the centuries of medieval emergence. As the Gothic style proliferated, it also became more complex and decorative. The Rayonnant and Flamboyant styles of architecture have their parallels in painting and sculpture as well. More important is the insight into natural form and color that begins to make itself felt in sculpture and miniature painting, and that leads such an artist as Villard de Honnecourt to see value in noting that he drew his lion "from life."

Selected Readings

Adams, H. *Mont-Saint-Michel and Chartres*. New York: Doubleday/Anchor, 1959.

Bony, J. *French Gothic Architecture of the XII and XIII Centuries*. Berkeley: University of California Press, 1983.

Branner, R. *Chartres Cathedral*. New York: Norton, 1969.

Duby, G. *The Age of the Cathedrals*. Chicago: University of Chicago Press, 1981.

Frankl, P. *Gothic Architecture*. Baltimore: Penguin, 1963.

_____. *The Gothic: Literary Sources and Interpretations*. Princeton, NJ: Princeton University Press, 1967.

Mâle, E. *The Gothic Image: Religious Art in the Twelfth Century*. rev. ed. Princeton, NJ: Princeton University Press, 1978.

_____. *Religious Art in France: The Thirteenth Century*. Princeton, NJ: Princeton University Press, 1984.

Mark, R. *Experiments in Gothic Structure*. Cambridge, MA: MIT Press, 1982.

Martindale, A. *Gothic Art*. London: Thames and Hudson, 1967.

Panofsky, E. *Abbot Suger on the Abbey Church of St. Denis and Its Art Treasures*. 2d ed. Princeton, NJ: Princeton University Press, 1979.

_____. *Gothic Architecture and Scholasticism*. New York: Meridian Books, 1963.

Sauerländer, W. *Gothic Sculpture in France: 1140–1270*. New York: Abrams, 1973.

Stoddard, W. *Monastery and Cathedral in Medieval France*. Middletown, CT: Wesleyan University Press, 1966.

Von Simson, O. *The Gothic Cathedral*. 3d ed. Princeton, NJ: Princeton University Press, 1988.

13

The Gothic in Italy and the Art of the Fourteenth Century in Europe

Very little of the northern European Gothic style of architecture or of the representational arts associated with this style is to be found in Italian cities of the thirteenth century. Most Italian regions were still producing buildings in the Romanesque style and were also under the sway of a developing Italo-Byzantine mode of painting. This was reinforced by spoils from the Latin conquest of Constantinople after the errant Fourth Crusade. From

1204 to 1261, the Byzantine world was under Western control. During that time most of the interchange between East and West passed through Italy.

The spirit of Gothic scholasticism and Gothic forms of expression made their way variously into Italian art, nonetheless. Combined influences from the whole known world contributed to the artistic development of Venice, Rome, Pisa, and, ultimately, Florence and Siena as centers of the arts. In turn these centers were to exert enormous influence on the arts in Italy at large and northern Europe in the fourteenth to fifteenth centuries.

In Italy the usual term for the thirteenth century is dugento *("duecento," or "200s," short for the 1200s). The transition from the dugento to the* trecento *("300s," or the fourteenth century) is a critical moment for Italian art, particularly the arts of sculpture and painting. In these years Italy became a pacesetter for an international evolution of visual forms. In the first section of this chapter the Italian dugento and trecento are our main concerns. The second section covers the arts of the period in other major European centers.*

THE GOTHIC IN ITALY

Italian Gothic Architecture

There are scholars who would argue that there is no Italian Gothic architecture at all. Fossanova Abbey, although set in Lazio, south of Rome itself, is a French Gothic building, built by French monks. Its most famous resident was St. Thomas Aquinas, who lived out his old age at Fossanova. Aquinas was an Italian, but even he had made his fame as author of the greatest theological work of the age, the *Summa Theologica*, while living in Paris.

FOSSANOVA ABBEY

The Cistercian abbey at Fossanova, south of Rome, was consecrated in 1208. The monks dug a huge ditch (*fossa*) to drain a dreary swamp in preparing to build their abbey. The church is a simple unadorned structure that corresponds to their ascetic way of life. It is unmistakably Gothic even without the refined elegance of more resplendent Gothic churches. The pointed groin vaults have no ribs except for heavy transverse arches reinforcing and separating the bays. No triforium or gallery appears over the aisles, and the apse is simply a squared-off termination of the choir. Little or no carving of capitals and mouldings or other statuary appears in the building. This simplicity echoes that of the the Romanesque Cistercian abbey church at Fontenay in France, built about seventy years earlier to the same austere standards.

FLORENCE, SIENA, AND ORVIETO CATHEDRALS, AND THE CHURCH OF SAN FRANCESCO IN ASSISI

The cathedrals of Florence (built 1296–1436), Siena (begun before 1265), and Orvieto (begun c. 1310) were built in the Gothic period, as were the Franciscan churches of San Francesco in Assisi (built 1228–1253) and Santa Croce in Florence (begun 1295). Aside from the use of *ogival* (pointed) arches, however, there is little of Gothic structural principles in the construction of any of them. There is a discrete advantage to this. The enormous wallspace provided by such traditonal and fundamentally Romanesque structures provided working area for a host of great Italian painters for over two centuries. Their façades and the need for interior furnishings provided a demand for sculptured work as well. From these emerged a whole new sculptural style.

MILAN CATHEDRAL

Milan Cathedral, begun in 1386, is adorned with a great number of Gothic spires and details. The initial impression is of a great Gothic building. The apse and chevet, in flamboyant Gothic style, are the oldest and most authentic Gothic elements in the building. On second look one can tell that it, too, actually remains Romanesque in structure.

Milan Cathedral was commissioned by Gian Galeazzo Visconti, duke of Milan. Gian Galeazzo was brother-in-law to great patrons of the arts: King Charles V of France; Jean, duke of Berry; Philip the Bold, duke of Burgundy; and Louis I, duke of Anjou. His project, Milan Cathedral, was intended to be a masterpiece of Gothic art. Six architects, French and Italian, were successively hired and fired in the first decade of work, however, and though building continued into the fifteenth and sixteenth centuries, the duke's objectives were never realized.

SECULAR GOTHIC IN ITALY

The fortresslike structure of the Palazzo Vecchio (begun 1298) in Florence or the Palazzo Pubblico in Siena (begun 1297) represents the construction style of secular Gothic buildings erected where defensive protection against siege was a realistic consideration. The walls are heavy with moderate-size windows. The roofline is fortified and overhangs the buildings' walls.

Venetian Gothic architecture utilizes larger windows and ornamental tracery in a mixture of oriental and Gothic motifs. Secular buildings are not built with defensive strategies in mind. The latticework on the canal front of the palace known as the Ca' d'Oro ("golden house," built 1422–1440) is a good example of Venetian "Gothic" architecture. There are few interior structural details that denote any of the buildings as Gothic.

Italian Painting and Sculpture

As early as the beginning of the twelfth century, Italian artists began to produce panel paintings, both as altarpieces and as devotional works for processional or private use. The inspiration for these, at least in part, was the Byzantine icon, used for worship in the Eastern church rites on a rotational basis throughout the year.

BONAVENTURA BERLINGHIERI

The paintings by members of the Berlinghieri family of Lucca, a Tuscan city near Pisa, are early examples of this form of panel painting.

The St. Francis Altarpiece. Bonaventura Berlinghieri's St. Francis altarpiece was painted about 1235. It is now in the Church of St. Francis in Pescia. The tall, stark silhouette of the saint is austere and formally frontal. St. Francis displays the *stigmata*, the wounds of Christ's passion, on his hands and feet. Two angels in Byzantine style hover at St. Francis's shoulders. Six scenes of his life appear at either side of his body. The stylized figures and architecture of these scenes are closely comparable to contemporary Byzantine painting. This is a powerful depiction of St. Francis who had captured the imagination of the populace of the time, calling for new devotional intensity and clerical poverty.

NEW PATRONAGE: THE FRANCISCAN AND DOMINICAN ORDERS

St. Francis founded the Franciscan order of monks. They lived in the cities and ministered directly to the people. A second monastic order, the Dominicans, was founded slightly earlier and based on even sterner reform. The founder of the Dominicans was the Spaniard St. Dominic (1170–1221). Their later brethren would spearhead the Inquisition in Europe. The Dominicans, too, lived in monastic houses within the cities. Both orders brought a new sense of active ministry to the life of cloistered monks. Villages, even cities, had grown in the environs of monasteries prior to this, but now the monks undertook spiritual leadership among the laity and envisioned their own lives as examples for piety and faith. The rise of the Franciscan and Dominican orders can be seen as an outgrowth of the Gothic emergence of independent cities. The two orders would soon be flourishing throughout Europe.

Unlike the Cistercians, both Franciscan and Dominican churches would become centers of magnificent expression in art. Ironically, the greatest Cistercian of them all, Bernard of Clairvaux, would provide themes in his writings for many of these paintings.

St. Francis died in 1226. He was sainted in 1228, and the mother church of his order, San Francesco in Assisi, was begun in the same year. A dazzling array of thirteenth- and fourteenth-century artists worked there, painting the walls of the church (it has two naves, one above the other) and its many chapels.

INFLUENCE FROM BYZANTINE CENTERS

In both the East and West, the tradition of mosaic and fresco decoration in churches was kept alive in the thirteenth and fourteenth centuries. There is little question that later Byzantine paintings were part of the inspiration for developing traditions in the West. Scholars have seen parallels between frescoes of the period, preserved in monasteries in Serbia and Macedonia, in present-day Yugoslavia, those in the Kahryie Djami (St. Savior's in Chora) in Constantinople, and contemporary Italian painting. In Venice, the great mosaic programs of San Marco were put in place in the twelfth and thirteenth centuries, in part at least by Byzantine craftsmen. The Norman churches in Sicily were built and decorated in the twelfth century. A huge mosaic combining the lives of John the Baptist and Christ and a Last Judgment, all in strong Italo-Byzantine style, is in the cupola of the Romanesque baptistery in Florence.

PIETRO CAVALLINI OF ROME

One of the best Italian painters of the dugento, also a brilliant mosaicist, was the Roman artist Pietro Cavallini (active from 1273–1308). Cavallini's workshop produced many decorations of old and new buildings in the late years of the thirteenth century.

The Last Judgment, The Church of Santa Cecelia. Cavallini painted a huge composition of the Last Judgment in the Church of Santa Cecelia in Trastevere (the western sector of Rome, across the Tiber River, or *trans Tevere*). The power of the surviving figures of Christ, the Virgin, John the Baptist, and the twelve Apostles intimates that Cavallini's work was known to the great Florentine artist Giotto di Bondone (c. 1266–1337). Cavallini's art is not simply Italo-Byzantine in form. He used stronger shapes and bold modeling in light and shadow in these Last Judgment figures.

Giotto and the Sienese painter Duccio di Buoninsegna (active c. 1278–1318) are often seen as the founders of the Italian Renaissance. This judgment is based on the writings of a later Florentine, Giorgio Vasari, a sixteenth-century artist better known as a founder himself of the writing of art history. There still is much to be said for beginning Renaissance study with these artists, but neither had any sense of the direction that the arts would take, based on what they did and what their descendants would do. We will return to Giotto and Duccio presently.

NICOLA PISANO AND THE DEVELOPMENT OF ITALIAN GOTHIC SCULPTURE

The sculptor Nicola Pisano (Nicolas of Pisa, active in Pisa c. 1258–1278) settled in Pisa shortly after 1250. Earlier references to a sculptor named Nicola Pugliese (Nicolas of Apulia) probably refer to this same man. He worked for Frederick II in the south of Italy until Frederick's death in

1250. His experience in Frederick's unusual court may be the most important factor in Nicola's style. A distinct sense of the Classical world pervades Nicola's works.

The Pulpit of the Baptistery, Pisa. The pulpit he made in 1259–1260 for the baptistery at Pisa is probably Nicola Pisano's best-known work. It is an elevated octagonal structure, made of marble. It consists of a platform supported by columns surrounded by a balustrade. A number of the columns are supported on the backs of carved lions. The pulpit is about 15 feet (5 m) high overall. Each face of the balustrade contains a panel with carved scenes of Christ's life and a Last Judgment. At one corner a carved eagle with spread wings provides a lectern.

Large carved pulpits with sculpture, colored marble decoration, and even mosaic are not uncommon in Romanesque Italian churches. Nicola has produced a telling new element in the baptistery pulpit at Pisa. In scenes such as the reliefs the *Annunciation* and the *Nativity*, Nicola reveals a close aquaintance with Classical sculpture. The manner in which he combines the scenes, elements of costume and hairstyle, even gestures, have been borrowed from antique sources for this work. The proportions of the figures are still medieval, but the sense of Classical order and stability pervades the work.

GIOVANNI PISANO

Giovanni Pisano (c. 1250–1320), Nicola's son, was also a sculptor in Pisa.

The Pulpit of Sant'Andrea, Pistoia. Giovanni Pisano made a pulpit for the Church of Sant'Andrea in Pistoia that is structurally similar to his father's at Pisa. The sculpture, however, is very different. Although there are still evidences of Classical form in features and dress among his figures, the order and stability have vanished. In his panels *Annunciation* and *Nativity*, an energy-charged whorl of figures surrounds the Madonna and her newborn Infant at the center. The scenes are the same, but their expression has been emotionally charged.

ANDREA PISANO

A follower of Nicola and Giovanni Pisano was Andrea Pisano (c. 1270–1348; not related), who worked in Florence.

The Bronze Doors, Baptistery, Florence. Andrea's bronze doors on the south portal of the baptistery in Florence are his best-known works. Bronze doors are another medieval tradition, harking back to St. Michael's at Hildesheim. Andrea's cycle, with fourteen panels on each of the paired doors, relates the stories of John the Baptist and Christ. Each scene, within a Gothic quatrefoil, presents a few figures, the suggestion of a setting on a shallow projecting ground plane. The gentle sway of the interacting figures

speaks of both Late Gothic style and of the artist's own skill at narrational storytelling. This may well be developed in part from the skills of the great Florentine painter, Giotto, who was Andrea's contemporary.

GIOTTO AND THE FLORENTINE PAINTERS IN THE FOURTEENTH CENTURY

The Arena Chapel. Giotto di Bondone, already mentioned, is the most famous and arguably the most important Italian trecento artist. His greatest work is the fresco cycle on the walls of the Arena Chapel, a small chapel built in Padua for Enrico Scrovegni. The family palace stood on the site of an ancient Roman amphitheater, or arena. The chapel was dedicated to the Virgin Mary, traditionally in expiation for the sins of the father of the donor. The elder Scrovegni, a notorious usurer, was placed in a lower circle of hell by the great poet Dante Alighieri (1251–1321) in his epic poem, *The Divine Comedy*.

Giotto's paintings, finished in 1308, include a cycle of the lives of the Virgin Mary and of Christ in three tiers on the north and south walls. There are personifications of the virtues and vices beneath these. On the west wall is a huge and vibrant Last Judgment, and on an arch over the altar on the east end of the church is the Annunciation, befitting the dedication of the chapel and strategically bridging the cycles on the north and south walls.

The frescoes of the two side walls show individually composed scenes as integrated parts of a long narrative. Their simple compositions and concentration on the forms of the figures with volume evoked by light and shade is similar to the open and direct expression of Italian sculpture. Giovanni Pisano, in fact, made statuary for the altar of the Arena Chapel. Other influences on Giotto were the aforementioned Pietro Cavallini of Rome and the Florentine artist Cimabue (active 1272–1302).

A Comparison of Giotto's and Cimabue's Madonna Paintings. According to Giorgio Vasari, Giovanni Cimabue (c. 1240–1302) was Giotto's teacher and mentor. It is useful to compare Cimabue's great *Madonna and Child with Prophets and Angels,* made about 1280–1290, in the Uffizi Gallery in Florence, to Giotto's *Madonna with Saints and Angels,* c. 1310, in the same collection. Cimabue clings to the medieval sense of pattern, color, and design as prime visual material in his work. Giotto builds upon a logic of volume and space. His Madonna is heroic, even statuesque in her graceful setting. Cimabue's work centers on the patterns of colorful figures, the angels stacked one above the other beside Mary and the prophets ensconced under her huge throne, with banners validating her glory with quotations from their own prophecies.

It is easy to see the differences between Giotto's and Cimabue's works and to understand Vasari's eagerness to accord them to Giotto's genius. We should take careful note that they also represent a difference of generations and objectives, similarly changing in the work of sculptors of the same period. These changes are not based on comparative talents.

DUCCIO DI BUONINSEGNA OF SIENA

Giotto's own contemporary, the Sienese painter Duccio di Buoninsegna (c. 1278–1319), perpetuated some of the older, Italo-Byzantine traditions in his best-known works, and his brilliance in design kept elements of this style alive for additional generations.

The Maestà Altarpiece. Duccio made the high altarpiece for the Cathedral of Siena. When it was finished in June 1311, the altarpiece was borne in a great festival procession from his studio to the church. The altarpiece of the Madonna in Majesty, called the *Maestà*, included a large central panel of the Virgin and Child, 7 feet by 13 feet (2.3 by 4.2 m), surrounded by a whole array of saints. There were also many pinnacle and predella paintings of scenes from the Virgin's life and the infancy of Christ attached to the top and bottom of the work. The back of the altarpiece was also covered with many small panels depicting Passion scenes. These smaller panels are now scattered among various museums. Still showing strong signs of Italo-Byzantine traditions in their landscape and architectural detail, they are colorfully and beautifully painted.

As Nicola and Giovanni Pisano's sculptural styles combine to shape that of Andrea Pisano and his followers, the combined styles of Giotto and Duccio emerge in their successors' works in painting. The combination, moreover, is the basis of a wide-ranging artistic style change that was to become international in scope with expanding ripples of influence throughout the whole fourteenth century and beyond.

TADDEO GADDI

Giotto's immediate followers were not prepared to carry their illustrious mentor's work forward. Most of them were imitators without Giotto's strength and originality. One of the best of these, however, was Taddeo Gaddi (c. 1300–1366).

The Baroncelli Chapel Frescoes. Taddeo painted a cycle of frescoes in the Baroncelli Chapel of the Church of Santa Croce, Florence's great Franciscan church. Taddeo Gaddi's paintings were directly inspired by the Arena Chapel paintings of Giotto. His *Meeting of Joachim and St. Anne at the Golden Gate* contains all the details of Giotto's version but fails to focus on the dramatic moment of the event.

The extended city view in Taddeo's work and the deeper landscapes in others of his series of frescoes indicates that a growing love of detail and description became characteristic of later fourteenth-century painting. Balancing the strong, solid monumentality of Giotto's works with this expanded world view may be said to characterize the task of the fourteenth-century artist.

SIMONE MARTINI

The Sienese painter Simone Martini (c. 1285–1344) was a pupil of Duccio, and his paintings display the same engaging love of color and pattern. There is a new sense of vitality and detail in Simone's work that runs parallel to that of Taddeo Gaddi.

The *Annunciation Altarpiece*. While the number of participants in the central scene of his famous *Annunciation Altarpiece* of 1333, in the Uffizi Museum in Florence, is few and the space is uncomplicated, the color and detail are complex. Gabriel wears a leafy crown and bears a branch with similar foliage. He wears a simple tunic covered by a cape woven in a complex tartan pattern. His wings are a vibrant pattern of stripes and dots. His greeting to Mary is written in gold relief against the gold background of the room. Above, the dove of the Holy Spirit descends, surrounded by a ring of winged cherubim. Meanwhile, Mary is silhouetted in a blue robe over her dark red dress. As in Nicola and Giovanni Pisano's *Annunciation* sculptures, Mary seems reluctant to accept Gabriel's message. These artists have chosen to reflect Mary's immediate doubtful response. Prompted by her virtue and supreme humility, Mary was taken aback at the sudden appearance of this radiant and splendiferous being.

During the fourteenth century the commune of Naples was a kingdom of its own, governed by members of the French royal family. Simone Martini worked for the king of Naples. He also worked at San Francesco in Assisi and at Avignon in France, where, for much of the century, the papacy resided in exile from Rome. Among other such international travelers, Simone aided in the establishment of an International style that combined elements of trecento Italian art with the French Gothic style.

PIETRO AND AMBROGIO LORENZETTI

The Lorenzetti brothers were also pupils of Duccio in Siena.

The Birth of the Virgin. Pietro (active 1320–1348) painted a large triptych, *The Birth of the Virgin,* in 1342. It is now in the Museo dell' Opera del Duomo in Siena. The painting is over 6 feet (2 m) high and almost as wide. It is divided into three sections by the frame. The center and right section show the chamber of St. Anne. She reclines on a bed covered with an orange and black tartan. Five attendant midwives are present, two of whom bathe the child in the foreground. This detail seems to deliberately parallel the bathing of the Christ Child in the pulpit carvings of Nicola and Giovanni Pisano. The logical cubicle of space, crowned by groin vaulting in two bays, is accompanied by another cubicle, an antechamber where the anxious father of Mary, Joachim, receives news of the birth.

The Effects of Good Government. Ambrogio Lorenzetti (active from 1319–1348) is best known for his frescoes in the Palazzo Pubblico (Town Hall) in Siena. Large frescoes allegorically and literally depicting the effects

of good government in city and country were painted by Ambroggio in a major hall of the building (there is a poorly preserved allegory of bad government here, too, that has been defaced and is rarely noticed). The painting expands upon the burgeoning love of detail in Italian Gothic art. The landscapes filled with people actively going about their lives reflect a true sense of the Tuscan city and countryside.

THE BLACK DEATH

The disappearance of both Lorenzetti brothers in 1348 is almost surely the result of the outbreak of the plague—known as the *Black Death*—in Italy in that year. The disease spread rapidly and devastated much of Europe within a few years. It was to recur periodically in localized outbreaks for centuries to come. To the Gothic world, enmeshed in the Christian faith and little aware of the causes and care of disease, the plague was seen as a punishment or warning from heaven. It fostered fear and reformers. Treatises on death and dying, themes such as the Triumph of Death and the Dance of Death, and tales of confrontation with personified Death came into the popular lore of the period and made their way into the arts as well. A foreshadowing of these themes is in the *Triumph of Death* frescoes in the Campo Santo in Pisa, the burial ground associated with the great cathedral complex in Pisa. The painter Franceso Traini, working about 1340, shows a rugged landscape with warring angels and devils battling for the souls of the departed in the sky over scenes of human encounters with death.

THE FOURTEENTH CENTURY: LATE GOTHIC IN NORTHERN EUROPE

A contemporary writer, Barbara Tuchman, called her historical book on the fourteenth century *A Distant Mirror* because of the parallels between the trauma of European civilization at that time and those of the twentieth century. The exile of the papacy, the Black Death, and ceaseless warring make up a generous part of the political history of the period. This truly had its effect upon the arts in both positive and negative ways. The most positive for the history of art was the movement it fostered, of artists seeking commissions at distant courts, and the resultant international scope of artists' works.

Flamboyant Gothic Architecture in France

ARCHITECTURE: THE CHURCH OF ST. MACLOU IN ROUEN

The French Gothic style of architecture became more deliberately decorative and elaborate as the fourteenth century began. Already foreshadowed in the Rayonnant style of the later thirteenth century, fourteenth-century Gothic architects invented the style known as Flamboyant Gothic, named for the flame-shaped tracery to be found in large window and screen decoration.

A well-preserved late example is the Church of St. Maclou in Rouen, 1434. Many freestanding tracery patterns in spires and pinnacles are applied to the surface of the structure outside. Five porch bays front the church, projecting in a shallow arc from each side to the center. The two outer bays are blind (without openings); the three innner bays have portals.

SCULPTURE: *THE VIRGIN OF PARIS*

This elaboration of Gothic form also found expression in fourteenth-century French sculpture. The newfound sense of expression and gesture in Gothic sculpture gave way to a heightened and emotional stylization. Drapery took on a swirling and curving life of its own, all but concealing the figures it covered. The crowned statue of the Madonna and Child in the transept of Notre Dame Cathedral in Paris, known as *The Virgin of Paris*, is a good example of this. Here, as in many sculptures of the time, the pronounced curvature of the body, swaying in the shape of a shallow *S*, is more a function of the drapery than of the natural form of a human body.

Late Gothic Mysticism

One outgrowth of the zealous religious reforms preached by the Dominicans and others in the Late Gothic period is the fervid intensity of religious devotion it inspired in sensitive, intelligent, and educated people. A number of these persons had the conviction of personal visions and revelations. Meister Eckehart, Johannes Tauler, and Heinrich Suso are among the most famous, as are Hildegard of Bingen, Birgitta of Sweden, Elizabeth of Hungary, and Catherine of Siena.

The devotional art that surrounded their mysticism includes works that are intensely focused, votive images, intended for intense meditation. Pietà figures, the Virgin Mary with her dead Son, isolated from the scene of the Lamentation with its many figures, were among these works. The form was so compelling, in fact, that it survived to inspire Michelangelo's famous sculpture at St. Peter's in the Vatican. Other works show Christ and St. John, extrapolated from the Last Supper, and a form of the Crucifixion, with the emaciated Christ on a cross carved in the form of a forked, pruned tree trunk. These served to concentrate the viewer's devotions on the suffering Christ and the Tree of Life, which the cross symbolizes.

Mystic visions (the mystic writer Juliana of Norwich, called them "showings") actually had some influence on the artists. Birgitta of Sweden, particularly, described elements of the Nativity of Christ seen in her vision that came to be a part of the scene as painters would depict it.

Bohemia in the Fourteenth Century

With western Europe in the grips of the plague and innumerable wars, with exile and schisms within the papacy, it is perhaps not so surprising that a brilliant central European monarch, Charles IV of Bohemia and Luxembourg, should gain access to the imperial crown. Educated in the

Valois court of France and crowned emperor in 1347, Charles set about to make Prague the glittering capital of Europe and he succeeeded for a time. Architects from France and Germany worked on his great Cathedral of St. Vitus. Sculptors and painters, brought from Germany and Italy, made great works and, more importantly, inspired Bohemian artists Master Theodoric, the master of Trébon, the master of Vyssi Brod, and others to a highly original Bohemian style of painting.

An equivalently inventive group of Bohemian sculptors produced brilliant works. Bohemian sculptors were partly influenced by the works of Peter Parler, a German master architect and sculptor brought to Prague to work on St. Vitus. Parler's sculpture has a robust and naturalistic vigor. His portrait busts in the triforium of St. Vitus Cathedral include a self-portrait, a portrait of Charles IV, and others of members of his court. The Late Gothic sculptural style known as the *soft style* in German lands began in Bohemian art with the creation of a number of sculptures of the Virgin and Child known as *Beautiful Madonnas* (*Schöne Madonnen*). The Krumau Madonna in the Kunsthistorisches Museum, Vienna, is the best known of these Bohemian sculptures.

The Charles University in Prague, the oldest in central Europe, was founded by the emperor on the pattern of the University of Paris. Buildings, bridges, forts, and castles were built to support and defend the imperial city. Much of the art of this era is still preserved, although it did not last long after the death of Charles IV.

Charles' son, Wenceslas IV, was not the leader his father had been. The recovery of western Europe resulted in the shift of the imperial title and capital. The fierce wars of the Hussites, followers of the religious leader and martyr John Hus, kept Bohemia and Moravia unsettled for nearly the entire first half of the fifteenth century.

International Gothic in France

As the fourteenth century progressed, the impact of Italian trecento art was realized in workshops of Europe at large, outside the special influence on Imperial Prague and Bohemia under Charles IV and his successor. In Paris, as early as 1325, the manuscript illuminator Jean Pucelle had been making miniature paintings in prayer books and breviaries. His work demonstrates the superb quality of the art, thriving now in individual workshops rather than monastic scriptoria.

In painted manuscripts he produced, such as the renowned *Belleville Breviary* in the Bibliothèque Nationale in Paris or the *Hours of Jeanne d'Evreux* in the Cloisters Collection of the Metropolitan Museum of Art in New York City, Pucelle shows the influence of the new trecento masters. Figures appear in his miniatures in small, Duccio-like cubicles of space.

THE LIMBOURG BROTHERS

During the century this new awareness of space, love of detail, and observable solidity of figures came alive, at least in the enormously colorful and decorative works of manuscript illumination in the Parisian school. Among the most famous miniaturists were the Limbourg brothers—Jean, Pol, and Hennequin—who worked together for several noble and royal patrons in the late fourteenth and early fifteenth centuries.

The *Très Riches Heures de Jean, Duc de Berry*. Their masterpiece was a large "book of hours," the *Très Riches Heures*, made for John, duke of Berry. Many colorful and surprisingly detailed miniatures grace its pages. Most famed are the calendar pictures that accompany listings of the cycle of annual feast days and saints' days with the labors of the months, a yearly almanac. John of Berry commissioned the labors as a set of landscapes, some depicting royal chateaux in the background. The *Très Riches Heures* mark the end as well as the summit of manuscript painting as the leading painters' art in the lands outside of Italy. Painters almost immediately turned to panel painting as the chosen form and oil paint as the chosen medium. Developed in northern painting at just this time, oil painting provided the most effective way for an artist to depict the colors and textures of the visible world.

THE CHARTREUSE DE CHAMPMOL

The duke of Berry's brother, Philip the Bold, duke of Burgundy, was also a great patron of the arts. Near his capital at Dijon, Philip founded the Chartreuse de Champmol, a Carthusian monastery intended as a sancturary and royal burial site for himself and his successors. The most notable of the artists who worked at the Chartreuse were the sculptor Claus Sluter, Dutch by birth, and the Flemish painter Melchior Broederlam.

Claus Sluter. Claus Sluter (c. 1340–1405/1406) created the sculptures of Philip, Margaret of Flanders, their patron saints, and the Virgin and Child on the portals of the chapel at the Chartreuse; the complex figures for the *Moses Well*; and the tomb of Philip and Margaret. All include figures that are vigorous and monumental in form. Even the carved monks, bearing the duke's recumbent image atop his tomb, weep and gesture with such expression that their sobbing seems almost audible.

At a wellhead in the cloisters of the Chartreuse, Sluter carved a pedestal for a crucifix, with figures of six life-size prophets standing against its hexagonal form. The work took place between 1395 and 1406. The crucifix survives only in detached fragments, but the prophets, dominated by the figure of Moses, are still in place. The sense of natural being that projects from Sluter's sculpture is related to the less well-known contemporary works of Peter Parler and his shop in Prague.

Melchior Broederlam. Melchior Broederlam (active from 1381–1409) lived and worked in Ypres, in present-day Belgium. The dates are those in which he is documented as having worked for Philip the Bold. Broederlam painted a series of scenes on a pair of wings for a great carved altarpiece for the Chartreuse. He finished the work in 1399. The altarpiece and its wings are currently in the Musée des Beaux-Arts in Dijon. Broederlam's paintings are bright and colorful panel paintings of Christ's infancy, expressive in the new medium of oil paint on panels. The proportions of the figures and the architectural style in the paintings are similar to those of Claus Sluter. Simultaneously, they anticipate the enormous strides to be made in painting by the next generation of Flemish panel painters.

*I*t is significant that Italian art maintained an independent course in the Gothic period. Though it could not avoid the influence of this great movement of art and thought in the rest of European countries, the Italians remained truer to the spirit of Classical and Early Christian form in many of their buildings. Monastic connections continued to feed a taste for the Italo-Byzantine style until the fourteenth century. Then more individualistic and autonomous artists, stimulated it is certain by the Gothic movement toward freer and more naturalistic gestures in painting and sculpture, began to change the mode.

With that change, at the hands of Giotto and Duccio and their followers, came the beginnings of an entirely new visual approach to the representation of the world. The artists began to record visual experience rather than conventional forms. Space, proportion, and interaction of represented figures became a concern.

Retroactively, the work of the Italian innovators reflected on artists in France, Germany, Bohemia, and the rest of Europe. By the end of the fourteenth century the colorful, expressive, and decorative mode was widespread in miniature painting, panel painting, sculpture, and in all sorts of decorative arts in a style that is often termed International Gothic.

Selected Readings

Borsook, E. *The Mural Painters of Tuscany*. New York: Oxford University Press, 1981.

Cole, B. *Sienese Painting from Its Origins to the Fifteenth Century*. Bloomington: Indiana University Press, 1985.

Meiss, M. *Painting in Florence and Siena after the Black Death*. New York: Harper & Row, 1973.

Pope-Hennessey, J. *Italian Gothic Sculpture*. 3d ed. New York: Phaidon, 1986.

Smart, A. *The Dawn of Italian Painting*. New York: Cornell University Press, 1978.

White, J. *Art and Architecture in Italy, 1250–1400*. 2d. ed. New York: Viking/Penguin, 1987.

14

European Art of the Fifteenth Century Outside Italy

1364–1404 Reign of Philip the Bold, duke of Burgundy

1404–1419 Reign of John the Fearless, duke of Burgundy

1414–1418 Council of Constance, end of Great Schism of the papacy

1415 Jan Hus burned at the stake for heresy

1419–1467 Reign of Philip the Good, duke of Burgundy

1431 Joan of Arc burned at the stake for heresy

1432 Van Eyck, *The Ghent Altarpiece*

c. 1440–1450 Invention of the printing press, Germany

1453 End of the Hundred Years' War

1453 Fall of Constantinople

1467–1477 Reign of Charles the Bold (Rash, Foolhardy)

1477 Marriage of Mary of Burgundy to Maximilian of Austria (Emperor Maximilian I, 1492–1519), end of Burgundian dominion in the Low Countries

1492 Columbus: the European discovery of America

1505–1510 Bosch, *Garden of Earthly Delights*

*T*he International Gothic style in painting, sculpture, and architecture evolved, outside of Italy, into a late medieval art, rich in descriptive and detailed expression of the visual world. Especially noteworthy were the painters of the Burgundian Netherlands, present-day Belgium and Holland. Sculpture workshops at Tournai and a continuing school of manuscript painting at Bruges and Ghent were also notable arts of the region. Architecture here, as in the rest of Europe beyond Italy, continued in the Flamboyant Gothic mode, becoming, if anything, more delicate and decorative. For most of the century these lands were in the control of the dukes of Burgundy, forming, with the French province of Burgundy itself, a powerful buffer state between France and Germany. The artists working in this region exerted an enormous influence upon the art of neighboring lands, even extending into Renaissance Italy.

In Italy itself a whole new phenomenon, the Renaissance, produced the emergent and eventually dominant art forms, but the northern countries remained particularly resistant to the theoretical and Classical emphases of Renaissance art until practically the end of the century. Much of northern art is religious, still steeped in pious devotional images and expressive of latter-day mysticism. Symbolism and complex, implied meaning also characterize the art, carried forward from the sculpture programs of great Gothic portals and from the structured devotions of illuminated prayer books. This was reinvigorated by movements of contemporary faith, such as that of the "modern devotion" promoted by the Brethren of the Common Life, a lay religious order. The order was founded in early fifteenth-century Holland and soon spread to Belgium, Germany, and France.

THE EARLY NETHERLANDISH MASTERS

The painters who worked for the Burgundian dukes and in the territories under their sway produced an art form that was both new and powerful. Its sources lay in the innovations of the trecento in Italy, in the Internationalism of the late fourteenth and early fifteenth centuries, and in the realization of the full potential of oil painting.

The Founders of Netherlandish Painting

Robert Campin, who worked at Tournai; his pupil, Rogier van der Weyden, who was the city painter of Brussels; and Jan van Eyck of Bruges were the first major artists among the painters. By the end of the third decade of the fifteenth century, the center of painting had shifted from Paris to these Flemish centers and the preferred medium was oil paint on oak panels rather than miniature painting in illuminated manuscripts. It was Erwin Panofsky,

in his major study of these Netherlandish artists (see Selected Readings), who first referred to these artists as the "founders."

ROBERT CAMPIN (THE MASTER OF FLÉMALLE)

We know through documents that the Tournai artist Robert Campin (c. 1375–1444) was a painter of considerable fame and success. Although none of a group of works formerly attributed to the "Master of Flémalle" is signed and dated, they fit the known data about Campin and his times exactly. Most scholars today accept these works as Campin's.

The Mérode Triptych. The best known of his paintings is the triptych of *The Annunciation*, often called *The Mérode Triptych,* today in the Cloisters Collection of the Metropolitan Museum of Art in New York City. It is usually dated about 1426.

The central panel of this triptych shows the archangel Gabriel approaching Mary with his message. She is seated on cushions by a bench in a fifteenth-century house. She reads in the scriptures while the tiny Christ Child, bearing a cross, rides a beam of light toward her. A smoldering candle and a host of other images in this panel and in its two side wings imply an interpretable meaning beyond the event as simple history. Their meaning was no doubt readily accessible to the devout donors, who kneel in the left wing as observers, and to their contemporaries. They are not so easy for our times when such usage has little place in art. In simplest terms Campin's *Annunciation*, like Simone Martini's, has a specific emphasis for its time and place.

St. Joseph in the right wing has made a tiny mousetrap that sits upon his workbench. St. Augustine, a great theologian, had likened the cross of Christ to a mousetrap in which the Devil was caught by deception for not recognizing Christ's true nature. The little Christ image in the triptych, becoming flesh and bringing this device to earth, is parallel to the future triumph of the Lord reincarnate, appearing at the Last Judgment.

To twentieth-century eyes the painting reveals an important step past the International Gothic and toward the art of the fifteenth-century North. Campin has made great strides in representation of the physical world. His rather exaggerated perspective is developed from visual experience rather than Renaissance theory. On closer inspection, the texture and form of individual objects and the carefully observed patterns of light and reflection show the artist's remarkable visual sense of the particular.

The Dijon Nativity. We also find this observed detail in others of Campin's works, such as his painting the *Nativity* in the Musée des Beaux-Arts in Dijon. This painting, dated about 1420, shows Christ's birth in a crude shed set in a rustic landscape. Above distant mountains rises the morning sun. St. Joseph kneels with the Virgin Mary adoring the Child. He holds a tiny candle, shielding its flame from the winter wind. Candle flame

and morning sun are equivalent symbols of Christ. One represents the frail human he has become, protected by his foster father. The other implies that Christ is the "Sun of Justice," arriving as the dawning light of the world's salvation.

JAN VAN EYCK

Jan van Eyck (c. 1380–1441) was the most noteworthy of the first generation of Flemish painters. In his art the visual perspective and spatial order approach that of constructed perspective. At the same time his expressive use of visible detail in textures, colors, and light shows all the skills embodied in Robert Campin's art. Jan van Eyck lived and worked in Bruges in the mature years of his career.

The Ghent Altarpiece. For the city councilman of Ghent, Jodocus Vydt, and his wife, Jan van Eyck completed an altarpiece in 1432 that had evidently been begun by the painter Hubert van Eyck, Jan's brother. We know this from an inscription on the frame of the painting itself. Very little is known about Hubert van Eyck, who appears to have died in 1426. *The Ghent Altarpiece*, as it is known, is a huge complex of painted panels, exhibited today in the same chapel of the Church of St. Bavo in Ghent for which it was made.

The central panel of *The Ghent Altarpiece* is a large painting, *Adoration of the Mystic Lamb*. Approached by angels, Apostles, prophets, and saints, the Lamb of God stands upon an altar at the center of an open landscape. In the foreground is the Fountain of Life. The scene is a kind of paradise, with flowers, fruit trees, and a carpet of grass. In the wings on either side are additional worshipers, saints in the form of just judges and knights, hermits, and pilgrims. A plausible theory is that this part of the ensemble was designed for a picture of "All Saints" by Hubert. Added to this were donor portraits and an *Annunciation* on the outer sides of the wings, along with prophets, sibyls, and saints. With the wings open we see added figures of Adam, Eve, musician angels, John the Baptist, the Virgin Mary, and the Lord enthroned, reigning over all.

The Ghent Altarpiece is an amazing work of great power and colorful detail. The complexity, varieties of figure scale, and the combinations of panels in the altarpiece suggest that Hubert van Eyck's original design played an influential role in the final outcome of this work. We might designate it as the last great masterpiece of International Gothic art in the North.

The Rolin and van der Paele Madonnas. Other paintings of Jan van Eyck surpass the visual continuity, surface details, light, and directness found in Campin's art. With Jan van Eyck's particular skills they achieve a visual totality that is astonishing. This appears in his paintings *Virgin and Child with Nicolas Rolin*, in The Louvre, and *Virgin and Child with Georg*

van der Paele, in the Groenige Museum in Bruges. Rolin, chancellor of Burgundy under Philip the Good and of the distinguished family from Autun, is shown in private audience with the Madonna and Child. They appear in a palace loggia, and a splendid, minutely detailed landscape appears beyond. Van der Paele, a distinguished churchman from Bruges, appears in the Virgin's throne room, introduced to her by his patron, St. George, and the Bruges martyr, St. Donation. The elegant room seems to be a circular oratory with an aisle around it.

The Arnolfini Double Portrait. Others of van Eyck's celebrated works include the double portrait *Giovanni Arnolfini and Jeanne Cenami,* dated 1434, in the National Gallery, London. Many believe this painting to represent a form of marriage portrait. Indeed, much of the symbolic content in the painting can be interpreted that way. There seems hardly any doubt that it represents the mutual concepts of love and trust in marriage between husband and wife.

Man in a Red Turban. Also, *Man in a Red Turban* in the same museum is a notable portrait signed and dated 1434 by the artist. Popular sentiment is that this is a self-portrait by Jan van Eyck. This would make it one of the earliest of such paintings, and is an appealing idea.

Jan van Eyck worked for several noble courts, last and most notably that of Philip the Good of Burgundy. For Philip he is known to have undertaken several diplomatic missions. He anticipates the artist as a respected court official in the Renaissance and Baroque periods.

ROGIER VAN DER WEYDEN

The Brussels painter Rogier van der Weyden (c. 1400–1464) was a pupil of Robert Campin. Elements of his art that relate to the works once attributed to the Master of Flémalle aid in the identification of his teacher with those paintings. His work is individual, however, and at heart more emotional.

Deposition of Christ. This is especially true of his *Deposition of Christ*, in the Prado in Madrid. Painted about 1438, it concentrates on the Virgin Mary's grief and empathy with her dead Son. She has fainted and fallen into a position that echoes Christ's body. John the Evangelist, Nicodemus, Joseph of Arimathea, and Mary Magdalene also show their tearful grief. The scene is constrained within a closely confined enclosure, forming a nearly sculptural tableau, without the profusion of detail for which Campin and van Eyck are best known.

Van der Weyden was the official city painter of Brussels. His fame was international and he headed a large workshop, training many artists.

Portrait of a Woman. As his contemporaries had done, van der Weyden also painted portraits. The elegant *Portrait of a Woman* in the National Gallery, Washington, D.C., is an example of his refined style of portraiture. The features of the subject are silhouetted against her angular, stark white

headdress, whose broad pattern stands out against the dark, undefined background. The reverent sobriety of her expression guards against the sin of pride, a peril for the person commissioning his or her own likeness.

The Second Generation

Several painters of a generation after Rogier van der Weyden took up the artistic evolution begun by their predecessors and added significantly to the development of the art. Two of the most important of these artists were Petrus Christus and Dirk Bouts. There is evidence that both men may have been originally from the northern Netherlands (later Holland) and trained there before moving to Bruges and Louvain, where they established their workshops.

PETRUS CHRISTUS

Petrus Christus (c. 1410–1472) lived and worked in Bruges from 1444. He has sometimes been considered a pupil of Jan van Eyck's, but this theory is no longer prevalent.

Portrait of Edward Grymeston. In portraits such as that of Edward Grymeston, in the National Gallery of London, Christus depicts the interior space of the room, adding an environment for the sitter.

St. Eligius. His painting *St. Eligius*, dated 1449, in the Metropolitan Museum of Art in New York City, shows a goldsmith's shop wherein the saint, patron of goldsmiths, shows his wares to a young couple. They seem intent upon the purchase of a ring. The mirror and other details suggest the marital implications of Jan van Eyck's Arnolfini painting, but the emphasis here is on the saint. Quite possibly the work was done for a goldsmiths' guild.

DIRK BOUTS

Dirk Bouts (1415–1475) was probably born in the northern Netherlands and trained in Haarlem. He lived most of his active life in Louvain (Leuven) in the southern Netherlands (now Belgium).

The *Last Supper Altarpiece*. Bouts's most famous painting is his large *Last Supper Altarpiece*. It is still in the church of St. Peter in Leuven, for which it was commissioned by a lay brotherhood of the church called the Confraternity of the Holy Sacrament. The central panel shows the Apostles and Christ seated about a table in a room that may be a representation of the confraternity's chapter house. Christ is blessing a host; the subject is the institution of the Sacrament, the wafer as the transformed substance of Christ's body. Some members of the confraternity appear as servants and onlookers at the Supper. Bouts himself appears at the right edge of the painting.

The room of the *Last Supper* appears to have been drawn and then painted in constructed perspective, a formula for depicting spatial depth developed in Renaissance Florence. Lines of wall moldings, floor tiles, and

rafters converge, or nearly do, at the top of the fireplace opening over Christ's head. There is little precedence for this in Netherlandish painting, nor is there much further development of the technique outside of Italy before the end of the century.

The Late Fifteenth Century

Petrus Christus does not appear to have had any direct followers in Bruges. Evidence of his style in the art of later artists is less direct than is that of Dirk Bouts. Bouts's colorful, uncomplicated painting style was popular. Two of his sons were painters, and they, together with a number of followers, kept his workshop style alive for most of the latter part of the century. Additionally, some very individualistic artists appear in the late fifteenth century.

HUGO VAN DER GOES

Works by the Ghent artist Hugo van der Goes (c.1440–1482) are quite different from those by the easygoing Dirk Bouts. Hugo painted with an almost relentless intensity. His admiration for Jan van Eyck and Rogier van der Weyden transmuted itself in his work to genuine furthering of their ideas. The combination of intense devotion and highly particularized detail confronts and challenges any attempt to understand his works.

The Portinari Altarpiece. This is very evident in Hugo's best-known painting, *The Portinari Altarpiece,* commissioned by Florentine merchant Tomasso Portinari, now in Florence in the Uffizi Gallery. The altarpiece is a triptych that portrays the Adoration of the Shepherds on its large, 8-foot 3.5-inch-by-10-foot (2.5-m-by-3-m) center panel. The Christ Child lies naked on a sparse bit of hay in the center of the panel. Mary kneels by him and Joseph appears to the left, prayerfully entering the scene. At the upper right are shepherds, coarse outdoor men, clumsy and awestruck at the scene they are witnessing. We gain a sense of Hugo's unabashed observation of the human condition in such work.

Even before finishing *The Portinari Altarpiece,* Hugo van der Goes entered a monastery near Brussels as a lay brother. There he continued to entertain clients and to paint, but he suffered a mental breakdown in the monastery and met an early death in 1482. We know little of Hugo's workshop or students, but his art exerted a wide influence on his own and subsequent generations of painters.

HANS MEMLING

Hans Memling (c. 1430–1494), Hugo's contemporary, worked in Bruges. Memling was born in Germany and may have received early training there. His style has some of the delicacy and intricacy of the Cologne school, exemplified earlier by Stefan Lochner. He may also have been in the workshop of Rogier van der Weyden for some period of time.

In his own day, Memling may have been best known as a portraitist. Many of his portraits survive, though his altarpieces are now the most famous works. They radiate a delicate charm. Graceful saints address a genial Madonna and Child in his paintings. Slender columns, colorful tapestries, carpets, and flowers enhance the palace chambers of the Virgin and Child; rolling landscapes beneath cloudless blue skies back up his foreground scenes.

The St. John Altarpiece. Memling's most popular work is *The St. John Altarpiece,* in the Hospitaal Sint Jan in Bruges, for which it was originally made in 1479. It shows an open, symmetrical architectural space in the foreground of the central panel. In balanced array about the enthroned Madonna are two kneeling saints, Barbara and Catherine; two angels; and John the Baptist and John the Evangelist. Mary reads in a service book held by one of the angels. The Christ Child awards St. Catherine's devotions by placing a marriage ring upon her finger, a "mystic marriage" symbolizing St. Catherine's vows of chastity and faith.

GEERTGEN TOT SINT JANS

Although several of the painters of the Netherlandish fifteenth century were born and received early training in the region that is now Holland, few remained in the North and made their name there. One of those few was Geertgen tot Sint Jans (c. 1460– c. 1490), who lived and worked in Haarlem and may have been trained with Dirk Bouts and Petrus Christus. His art has its own inventive characteristics and style.

The Nativity. A tiny painting, *The Nativity,* in the National Gallery in London, is lit only by the radiance of the Christ Child. Joseph and Mary are shown in the light that reflects off them from the glowing Babe in the manger. On a distant hillside is a bonfire that lights up a few gathered shepherds. Above them a glowing angel announces Christ's birth.

The nighttime ambience of Geertgen's painting can be traced back to the art of the International Gothic, to manuscript illuminators and Gentile da Fabriano's *Nativity* in the predella of the *Adoration of the Magi* altarpiece. Geertgen's work shows greater distinction of depth, using direct and ambient light to differentiate subtly between the locations in space of the persons shown.

HIERONYMUS BOSCH

Hieronymus Bosch (c.1450–1516) lived and worked at 's-Hertogenbosch (Bois le Duc), a town near the border of Holland and Belgium. He was a painter of extraordinary individualism who reveled in the fantasy of emotion and form. Few painters have ever approached the level of visual invention found in the works of Hieronymus Bosch.

Christ Carrying the Cross. His painting *Christ Carrying the Cross*, in the Musée des Beaux-Arts in Ghent, is a frightening look at blind injustice, mob psychology, and isolation. Close to the picture's surface, a host of uncouth-looking men crowd in and pointedly ignore Christ, jeering and gossiping among themselves. St. Veronica in the lower left corner turns away. Is this vanity or repulsion at the blind cruelty that propels the throng forward? In her hands she holds the kerchief with the imprint of Christ's face upon it, miraculously transferred when the saint cleansed Christ's face in a gentle act of mercy during his suffering. It is this hauntinig face of Christ that gazes out intensely at the viewer.

The Garden of Earthly Delights. The most famous and individual of Bosch's paintings is the great triptych *The Garden of Earthly Delights*, in the Prado in Madrid. Although it was certainly not an altarpiece, the painting is another insight into the morality and folly of human life. It appears to present a cycle of scenes. The exterior is a Creation scene of the earth as a great globe, assuming form at the direction of the Lord in the heavens. When the altarpiece is opened, the left wing shows the Lord introducing Adam and Eve in a bizarre earthly paradise that does not yet appear to be fully formed. Strange animals lurk in the foreground and in the distance.

The central panel is an astonishing array of nude figures in all kinds of suggestive diversions: eating, drinking, dancing, swimming, embracing, and tumbling in a puzzling, eroticized landscape of lawns, pools, and strange towers. Oversize birds, fish, and vegetables join with the licentious groups of people.

One gains the certainty here of a moralizing commentary on God's admonition to Adam and Eve. In the central panel the sins emphasized are those of lust and gluttony. The lessons ignored are vested on all the children of Adam and Eve. There is no violence; that is reserved for the flames and blades of hell in the third panel, the right wing where punishment of sin is exacted upon the sinners. Hell is a place of gloom and real terror, exaggerated by Bosch's careful depiction of the impossible.

THE FIFTEENTH CENTURY IN FRANCE AND GERMANY

The fame of the Netherlandish painters spread across northern Europe; the art of the fifteenth century was profoundly affected by Jan van Eyck, Rogier van der Weyden, and their followers. Conversely, the art of the Italian Renaissance had very limited influence outside Italy, mostly in the concept of constructed perspective, until the end of the century.

French Painting

The agony and financial burden of the Hundred Years' War left France weakened and divided in its powers. A few artists, working among the rival duchies of the French lands, came to prominence in the fifteenth century. Most of these artists had turned to panel painting before the middle of the century.

JEAN FOUQUET

Jean Fouquet (c. 1420–1481) is the best known among the French artists of the century. Fouquet worked from 1445 to 1447 in Italy where he learned some principles of Italian painting and the art of constructed perspective. He worked in France for Charles VII and for Etienne Chevalier, the royal finance minister.

Etienne Chevalier and St. Stephen. Fouquet's portrait *Etienne Chevalier and St. Stephen,* in the Dahlem Museum in Berlin, is the left half of a diptych painted about 1450. The minister is in prayerful devotion to the Virgin and Child (they appear in the right wing of the diptych, which is in the Antwerp Museum). The portrait shows Fouquet's Italian training. He used broad surface masses to construct the figures, logical perspective, and even classical moldings of the architecture. Yet there is clear linear description here. This and the use of oil color mark the northern origins of the work.

Hours of Etienne Chevalier. Fouquet was also a prolific miniaturist. His *Hours of Etienne Chevalier,* in the Musée Condé in Chantilly, combines the heritage of French illumination, Netherlandish painting, and Italian art.

THE AVIGNON PIETÀ

The Avignon Pietà. The panel painting of *The Avignon Pietà* in The Louvre, Paris, from Villeneuve-lès-Avignon, is a powerful depiction of the mourning for Christ. It is usually dated about 1455–1460. The Virgin holds her Son's body in her lap. His figure is arched and stiffened in death. St. John the Evangelist and Mary Magdalene flank Mary in grieving poses. The heads of all mourners are silhouetted against a dull gold background. At the left is the donor, a severe figure in white robes. The profile of the city of Jerusalem on the horizon near the donor's head may be taken to indicate that this man has been a pilgrim to the Holy Land.

Additional artists working in various regions of France produced individual works of great interest. Few are known by name, and none presided over longstanding or influential workshops comparable to those of the great Netherlandish masters.

TAPESTRY: A RELATED ART

In France and also in Flemish centers during the fifteenth century, the art of tapestry weaving was very much in evidence. The surviving examples of this art are of remarkable quality and variety. They suggest a far more

widespread practice because of the highly perishable nature of tapestries, used as wall hangings to insulate against the cold.

The Angers Apocalypse Tapestry. The late-fourteenth-century Apocalypse tapestry at Angers in France was woven between 1373 and 1381 for Angers Cathedral by Nicolas de Bataille after designs by the court painter of Charles V, Jean Bondol, and partly based on a book of the Apocalypse in Charles's collection. Sixty-seven of ninety original scenes are preserved in the ducal château at Angers.

The Lady and the Unicorn. A remarkable set of tapestries, *The Lady and the Unicorn* is preserved in the Cluny Museum in Paris. They were woven in the flower-strewn *mille-fleurs* style of the 1490s in France. Five of the six pieces relate to the senses: touch, taste, scent, hearing, and sight; the sixth is a motto, "A mon seul desir," for the unidentified original owner.

The Hunt of the Unicorn. Related in style to the tapestries of *The Lady and the Unicorn* are the *Hunt of the Unicorn* tapestries in the Cloisters' Collection of the Metropolitan Museum of Art in New York City. They were made either in France or Flanders in about 1499, probably for Anne of Brittany in celebration of her marrriage to Louis XII in that year. Colorful, filled with patterns, details, botanical delights, and expressive animals, the *mille-fleurs* tapestries represent a continuance of the love of pattern and design based on the International Gothic style.

Fifteenth-Century German Art

Germany is represented by a number of significant fifteenth-century artists working in regional styles. Nearly all regions were affected by the development of Netherlandish painting, but the strength of German art is concentrated less on the absolute naturalism of form, color, and texture. Pattern, expression, emotion, and design seem at once more vivid and more abstract in German works. A number of active sculptors appear in Germany during the century, some of whom maintained workshops that produced altarpieces combining sculpture and panel painting. The Upper Rhine region of Germany is also a leading region in the early production of graphic art, particularly woodcuts and engravings, which began to be produced in Europe in the early fifteenth century.

KONRAD WITZ

Konrad Witz (c. 1400–c. 1446) worked in Switzerland in the first half of the fifteenth century. He is noted for several multipanel altarpieces.

The Miraculous Draught of Fish. One of these is the altarpiece of St. Peter made for Geneva Cathedral in 1444. Now in the Museum of Art and History in Geneva, it includes a scene of the miraculous draught of fish, a biblical episode (Luke 5:1–8) wherein Christ appeared to the Apostles walking upon the water of the Sea of Gennesareth.

Witz has transferred the event to a very recognizable Lake Geneva, elegantly painted with the reflections and refraction of water closely observed and with an identifiable Alpine landscape in the distance. Christ appears near the foreground shore, dressed in bright red robes that silhouette his form against the blue-green water. Peter is shown in the fishing boat to the left and again foundering in the water between the vessel and Christ. The work is surely influenced by Netherlandish art, particularly by the landscape of Jan van Eyck. Yet it has a more direct, almost naive approach to form that characterizes all of Konrad Witz's work.

STEFAN LOCHNER

Stefan Lochner (c. 1400–1451) lived and worked in Cologne. His style is delicate, almost dainty, in contrast to Witz's. The Cologne artists perpetuated much of the decorative quality of the International Gothic style, using the bright colors, intricacy, and gold backgrounds of the earlier painters. Lochner painted the high altarpiece showing the Adoration of the Kings for the Cathedral of Cologne.

Madonna in a Rose Arbor. Lochner's *Madonna in a Rose Arbor,* in the Wallraf-Richartz Museum in Cologne, shows the influence of Jan van Eyck's paintings of the Madonna but maintains the delicacy of book illumination.

VEIT STOSS

The St. Mary Altarpiece, Krakow. The Nuremberg sculptor Veit Stoss (1447–1533) was commissioned to make an altarpipece for the German community in Krakow, Poland, in 1477. He worked on the sculpture for twelve years, until 1489. His enormous finished work, with figures as high as 9 feet (2.8 m) tall, is still preserved in St. Mary's Church. It shows the death and Assumption of the Virgin in its main section. In the wings and above the main scene up to the peak, 43 feet (13.1 m) high, are many additional figures and scenes.

Stoss's work combines vigorous and expressive emotion in the central figures with a twisting and shifting drapery style that seems independently animated. The Virgin's death, which is often a somber, more peaceful scene, is here the focus of much agitation.

TILMANN RIEMENSCHNEIDER AND MICHAEL PACHER

Two other sculptors of the late fifteenth century were Tilmann Riemenschneider (1460–1533) and Michael Pacher (1435–1498). Riemenschneider produced many carved altarpieces. His work has a lean and powerful dignity within a rich patterning of flamboyant drapery and decorative tracery. Pacher lived in the Tirol, in what is now Italy. He is documented as both sculptor and painter. His proximity to Italian sources

led to a clear understanding of Renaissance perspective in some of his works. The influence of the northern Italian Renaissance master Andrea Mantegna has been singled out in particular.

The Art of Printmaking

Printmaking as an art form began in Europe in the late years of the fourteenth century. Woodcuts were the earliest to be made. These were printed from lines carved in relief on the surface of a piece of wood. The lines were inked and pressed onto a sheet of paper. Among the earliest woodcuts are religious pictures, greeting cards, and playing cards. Such prints were inexpensive, practical, and popular.

THE PRINTING PRESS

The development of relief printing brought along with it the concept of movable type, a relief printing process that would revolutionize book production and costs and ultimately change the course of civilization. Printing books began almost simultaneously in Germany and Holland in the mid-fifteenth century.

A second form of artists' printmaking was developed in the first decades of the fifteenth century. The process, known as *engraving*, began in goldsmith shops. It was quickly taken up by artists as well.

Engraving is an intaglio process. Lines are cut into the surface of a metal plate with a tool called a *burin*. The plate is prepared by rubbing ink into the lines and then cleaning the metal surface. The inked plate is then put through a roller press with dampened paper, which draws the ink from the plate.

MARTIN SCHONGAUER

By the middle of the century, artists in most European countries were producing woodcuts and engravings. The most outstanding master of the art in northern Europe was the German artist Martin Schongauer (c. 1450–1491).

Tribulations of St. Anthony. He made more than a hundred engravings, including the remarkable *Tribulations of St. Anthony.* This print shows the saint carried into the air by a whorl of demons who buffet and torment him. The artist has shown incredible imagination in combining natural forms of animals, birds, reptiles, and insects to create the demons. Legend has it that the young Michelangelo was fascinated by this engraving and made a painted copy of it.

*T*he rich color, love of pattern, and detail that characterize the International Gothic Style of about 1400 continue in the art of northern Europe through the fifteenth century. The transformation of the painters' art to panel painting in oils instead of miniature painting in tempera led to great changes in expres-

sion. The ability to paint color built up in glazes of oils led to an especially rich outpouring in art. It was to be influential in all neighboring countries.

Altarpieces, devotional paintings, and portraits make up most of the painting of the fifteenth-century northern European countries. Within these works the artists drew an extraordinary range of symbolic content. They also depicted space, landscape, and still-life elements with strong linear clarity.

The centers for most of the painting of the fifteenth-century North were in Flanders and Brabant, in what is now Belgium. This leadership found reflection in the arts of France, Germany, and other European countries. Before the end of the century it would be visible among the works of Renaissance artists in Italy.

Sculpture, architecture, and other arts did not evolve as distinctly or as radically in the period. Germany, however, produced some especially distinguished sculptors, some of whom were equally gifted painters. Printmaking, notably woodcut and engraving, developed in all these countries during the fifteenth century, earlier and more rapidly than in Italy. A major by-product of the printmaking epoch was the development of the printing press and movable type.

Selected Readings

Chatelet, A. *Early Dutch Painting*. New York: Rizzoli, 1981.

Cuttler, C. *Northern Painting From Pucelle to Bruegel*. New York: Holt, Rhinehart & Winston, 1968.

Friedländer, M. J. *Early Netherlandish Painting.* 14 vols. New York: Praeger/Phaidon, 1967–1976.

Huizinga, J. *The Waning of the Middle Ages*. New York: St. Martin's Press, 1981.

Meiss, M. *French Painting in the Time of Jean de Berry*. New York: Braziller, 1974.

Panofsky, E. *Early Netherlandish Painting*. Cambridge, MA: Harvard University Press, 1953.

Snyder, J. *Northern Renaissance Art*. New York: Abrams, 1985.

Stechow, W. *Northern Renaissance Art: 1400–1600*. Sources and Documents. Englewood Cliffs, NJ: Prentice-Hall, 1966.

15

The Early Renaissance in Italy

1402	Lorenzo Ghiberti awarded commission for portals of the Baptistery, Florence
1414	Rediscovery of the *Ten Books on Architecture* by Vitruvius
1423	Gentile da Fabriano, *Adoration of the Magi*
c. 1450	Invention of the printing press, Germany
1452	Leon Battista Alberti, *De re aedificatura*
1473–1482	Building and first decoration of the Sistine Chapel
1492	Death of Lorenzo de' Medici; Columbus's discovery of America
1494	French invasion of Tuscany
1498	Savonarola burned for heresy in Florence

The study of art history of the Western Hemisphere evolved around the rebirth of classical antiquity, first evident in Florence in the early decades of the fifteenth century. The Florentine Republic, successful in wars and intellectual advancement, took great national pride in its achievements, finding parallels among its own successes with those of ancient Athenian triumphs over the Persians.

Part of the recovery of Mediterranean Europe from the disasters of the fourteenth century depended upon the banking houses of the Strozzi and Medici families in Florence. The Florentines were also fortunate in fending

off the forces of the dukes of Milan who had sought to annex Tuscany. Venture capital and victory paid off. The Medicis and other powerful houses became, in their turn, lavish patrons of the arts.

The artists did not disappoint; in a brief course of time, an entirely new mode of expression overtook all the arts. This mode was formulated on principles and theories forged from the records and works of the ancient world and from the new humanist philosophers of the fourteenth and fifteenth centuries.

THE ARTS IN THE FIRST HALF OF THE FIFTEENTH CENTURY

Three Florentine artists, Brunelleschi, Donatello, and Masaccio, with a number of contemporaries and close followers, forged ideas that would inaugurate the art of the Renaissance. It was an art structured upon principles and theories. These artists set a standard for their followers in the second half century to build upon. Theirs was a world view built on humanistic principles and on the full participation of the arts in the world of ideas. Much of their work remained religious, but it had an added emphasis on human worth and dignity. From the outset great value was placed on strong individualism in the artist's style.

Early Renaissance Architecture in Italy

Many ancient buildings survived in Italy to the period of the Renaissance. Some were still inhabited; others stood as empty reminders of the abilities and achievements of the Classical past. The size and structure of some of these ancient buildings were beyond the abilities of medieval builders to duplicate. Only in the deliberate and conscious return to the principles and underlying theory of building was a new venture at comparable scale possible.

FILIPPO BRUNELLESCHI

The architect Filippo Brunelleschi (1377–1446) was initially trained as a goldsmith and is recorded as a sculptor. From 1401 to 1402 he was one of several sculptors who took part in a competition for the commission to design a set of bronze doors for the east portals of the Baptistery in Florence. His competiton entry, a relief of the sacrifice of Isaac, and that of the sculptor Lorenzo Ghiberti (1378–1455) are both preserved in the Bargello Museum in Florence.

It is instructive to compare the two works. Both show the same subject and essentially the same moment. Abraham is stopped by an angel from the human sacrifice of his son Isaac to the Lord. Brunelleschi's relief is designed to balance the framework and shape of the quatrefoil border specified by the

competition's regulations. It is rich in detail and pattern, engaging the eye at every point. Ghiberti's panel is focused on the action more specifically. The details are subordinated, and the composition is seen within the framework of the quatrefoil as through a picture plane or window. In principle, Brunelleschi's work is a Late Gothic masterpiece, while the massing of forms and expression in Ghiberti's panel herald a new era and a different critical path. It is a masterpiece but, additionally, one with remarkably advanced compositional elements.

Ghiberti was awarded the prize and the commission. As he was also one of the earliest writers on the history of the Renaissance, he did not hesitate to assure his readers that the vote was unanimous for himself and that all his fellow competitors agreed to his prowess.

As for Brunelleschi, he became known particularly for his enormous achievement in architecture. In this field he was the leading master in the expression of that new era and of the new direction taken by the Italian artists of the fifteenth century.

The Dome of Florence Cathedral. In 1420 Brunelleschi began a project to construct the dome of Florence Cathedral. Arnolfo di Cambio had built the cathedral nave beginning in 1296, but no architect had been able to solve the engineering problems raised by designing a dome for the enormous 140-foot (42.56-m) crossing. The success of Brunelleschi with this project marks the beginning of the Renaissance in no uncertain terms. Brunelleschi had equaled the achievement of the ancients. His dome is just 4 feet (1.2 m) narrower than the span of the Pantheon dome.

Brunelleschi's project required construction of the dome over a space that was too large for the wooden framework, called *centering*. Centering had been used for constructing domes and arches in the Romanesque and Gothic periods. The technology of the ancient Romans was also unavailable to him. Instead, Brunelleschi invented a whole new technique for dome construction and designed the mechanisms to accomplish it.

The result was an enormous double dome, one inside the other, built upon a ribbed system and capped by a lantern at the peak. A sophisticated balance of its parts kept the whole together. Additionally the whole was reinforced by enormous chains surrounding the structure between the inner and outer domes to aid in its stability.

Another result was fierce civic pride in Brunelleschi's accomplishment. Proud Florentines could point to their cathedral dome secure in the knowledge that their city had a monument on a par with the works of antiquity. The Renaissance had become a fact, not a goal.

Brunelleschi traveled to Rome first in 1402 and on several subsequent occasions. There he studied, measured, and drew from ancient buildings. The simple geometrical forms and the proportions became a part of his own repertoire in fashioning the extraordinary number of buildings he designed

in the remainder of the first half of the century. Except for the cathedral dome, Brunelleschi did not work on buildings of huge scale and dramatic technological achievement.

The Pazzi Chapel. Brunelleschi's work has a confident human assertiveness that invigorates it with monumentality even in the relatively small size of the Pazzi Chapel at Santa Croce, begun in 1440. This small chapel has simple domes on pendentives in the narthex, nave, and sanctuary. The space of the nave is amplified by two bays with barrel vaults, one at either side of the center. The architect has used dark marble against white stucco on the interior to demarcate the forms and to add decorative notes using Classical details.

Unlike Gothic architecture, the Renaissance buildings of Brunelleschi and his followers do not reveal their structure. Soaring vaults, networks of ribs, vaults, and buttresses do not play a part in the works. The bold geometrical shapes are faced with decorative marble piers and pilasters. The Classical orders reappear in proportion with one another. They are built with human scale and proportions in mind.

The Ospedale degli Innocenti. The sense of order and unity was imposed on a row of adjoining buildings at the Ospedale degli Innocenti in Florence, begun in 1419. Brunelleschi designed a continuous façade for all the buildings and a colonnade to unite them with a continuous rythmic pattern. Each end is set off by an arch framed by heavy piers as well as columns. The result is a self-contained structural block with a graceful arcade.

The Churches of San Lorenzo and Santo Spirito. San Lorenzo and Santo Spirito, two churches built by Brunelleschi, are both in Florence. Both were begun in the 1420s. Each has a simple, straightfoward basilican form, and each is elegant in the proportions and detailing that define the spaces within them. They each have a simple flat ceiling and truss roof. The vaulted side aisles open to a chapel in the outer wall of each bay. The crossing in both churches is domed and the high altar stands in the choir. Neither church ends in an apse.

In carrying out the construction of these churches, Brunelleschi returned to the Early Christian and Italian Romanesque tradition of basilican form. His use of strict proportional rules and formal Classical design details presents an entirely different appearance to the finished buildings, however.

A comparison of either of these naves with those of Pisa Cathedral and San Miniato al Monte shows the differences and similarities. They are composed of the same elements, but Brunelleschi has coordinated the proportions and design elements, moldings, capitals, and columns to the interior space. The result is unity and harmony quite unlike the medieval composite forms.

MICHELOZZO

Michelozzo di Bartolommeo (1396–1472) was a follower of Brunelleschi and the sculptor Donatello. He was selected by the Medicis to build their palace in Florence. The work began in 1444.

The Medici-Riccardi Palace. Michelozzo's Medici Palace, now known as the Medici-Riccardi Palace, is an early Renaissance architectural project of a secular nature that incorporates the ideas of Brunelleschi's religious works. Medieval palaces were normally large irregular structures built over time and according to needs. They were often fortified and withdrawn from their surroundings, conspicuously defensive in design, in ways similar to town halls such as the Palazzo Vecchio of Florence and Palazzo Pubblico in Siena.

The Medici-Riccardi Palace is visibly a stronghold. This is accentuated by the heavy rustication of its ground-story masonry and the deep drafting of that on the second story. It also has large portals and many windows, however, and these are arranged in a symmetrical pattern over three stories. The pattern unifies the building and interacts with the exterior space. Additional unity is provided at the top by a heavy overhanging cornice that frames the structure. Thus the palace is a strong presence, but it is also harmonious and engaged with its surroundings.

Early Renaissance Sculpture in Italy

We sometimes use the term *Renaissance man* or *woman* to describe a person of many cultivated skills. It seems fitting enough when we consider that Brunelleschi was a goldsmith and a successful sculptor in addition to being an architect, that Michelozzo, the architect, also worked as a sculptor, and that Ghiberti, the sculptor, did significant work as an architect.

LORENZO GHIBERTI

The Baptistery Doors. As victor in the Baptistery competition, Lorenzo Ghiberti went on to complete bronze doors for the east portal of the Florence Baptistery between 1403 and 1425. Andrea Pisano's doors of 1330 to 1335 were moved to their present location in the south doorway to accommodate the new ones.

The doors Ghiberti made do not fully meet the artistic promise of the competition relief. They were moved, in turn, to the north doorway when Ghiberti made a new set of doors in gilt bronze. He worked on them from 1425 to 1452.

The Gates of Paradise. Ghiberti's later doors incorporate much of the new Renaissance concept of space, environment, and perspective within their ten panels and rich surrounding borders. Michelangelo is said to have dubbed them the "Gates of Paradise." Ghiberti's scenes contain high-relief figures, small in proportion to the space of each panel. They apppear in the foreground of a distinctly described world, designed on

the one-point system of Early Renaissance perspective. The distance is indicated in shallow, linear relief.

NANNI DI BANCO

Nanni di Banco (c. 1380–1421), another Florentine sculptor who was active at the start of the fifteenth century, made major strides toward the formation of a more monumental sculpture.

Four Crowned Saints. His *Four Crowned Saints (Quattro Santi Coronati,* 1408–1415), stand in a niche on the exterior of the medieval guild church of Or San Michele (they are patrons of the stonemasons). The niche about them is ornate and decorative in a late Gothic style. It is quite deep and slightly overpowers the four life-size figures that, otherwise, are clearly inspired by antique sculpture and interact in a bold, assertive way with one another.

The *Porta della Mandorla*. A similar vigor is to be found in the unfinished sculpture by Nanni di Banco on one of the north portals of Florence Cathedral, called the *Porta della Mandorla*. The work shows the Assumption of the Virgin. The artist died before its completion.

DONATELLO

The sculptor Donatello (Donato Bardi, 1386–1466) is first encountered in documents as an assistant to Lorenzo Ghiberti, working on the first set of doors for the Baptistery. On his own he began making sculptures for the exterior of Or San Michele. In the second decade of the fifteenth century he worked at Or San Michele along with Nanni di Banco, making statues for its exterior.

St. Mark and *St. George*. His most famous works for this church were *St. Mark* (1411–1413) and *St. George* (1515–1417). Each occupies its space more deliberately than the work of Nanni di Banco. Donatello's statues are dominant over their niches, giving them a bolder, more assertive appearance. Such power revitalizes the Classical mode of expression.

A close friend of Brunelleschi, Donatello traveled with the architect to Rome and also took part in the measurement and drawing of ancient buildings. There, too, he certainly encountered ancient sculpture in relief and freestanding form.

David. Between 1428 and 1432 Donatello made a bronze sculpture of David. It is said to be the first freestanding nude figure since antiquity. Life-size, *David* represents the adolescent youth standing over the severed head of Goliath and rather absentmindedly holding the slain giant's sword in hand. His air of self-confidence clearly sets Donatello's sculpture apart from Roman and Greek statuary.

The theme of David, the shepherd boy victorious over the colossal Goliath, was a favorite in Florence. The city had certainly been an underdog in the confrontation with the armies of the duke of Milan. Donatello had

made an earlier version in marble, and he would be followed by many, including Verocchio and Michelangelo, in treating the subject. The Florentines were also not unmindful that David went on to become a rich and powerful king.

Gattamelata. Donatello's later equestrian statue of the condottiere Erasmo da Narni, called *Gattamelata*, was made from 1445 to 1450. It is in Padua. The sculpture is modeled, in part, on the celebrated Roman statue of Marcus Aurelius. The ancient sculpture stood through the Middle Ages by the Church of St. John in the Lateran. It was identified as a portrait of Constantine, which saved it from recycling, the unfortunate fate of much ancient bronze sculpture. Michelangelo moved it to its present position on the Campidoglio.

Relief Sculptures. Donatello was also a master of relief sculpture. He made panels for the baptismal font of Siena Cathedral, about 1425, and for two pulpits in Brunelleschi's Church of San Lorenzo. These incorporate the careful use of Renaissance perspective in scenes such as the *Feast of Herod* in the earlier work and expressive emotional fervor that discards traditional composition and perspective in the *Lamentation for the Dead Christ*, a panel on one of the San Lorenzo pulpits.

Early Renaissance Painting

GENTILE DA FABRIANO

A sense of design and rich detail similar to that in Brunelleschi's competition relief for the doors of the Baptistery can be seen in the colorful panel paintings made by the painter Gentile da Fabriano (Gentile di Niccolo, c. 1370–1427). Gentile belongs with the International Gothic tradition as one of the later followers of Giotto and Duccio in the decorative, detailed, and descriptive representation of the world. Gentile and his painter contemporaries, working in tempera paint and gold leaf, continued the fourteenth-century traditions of Simone Martini, Lorenzetti, and others, occasionally experimenting with foreshortening, new forms, and colors.

The *Adoration of the Magi* Altarpiece. In 1423 Gentile painted an altarpiece, the *Adoration of the Magi,* for the chapel of Palla Strozzi in the Church of Santa Trinita in Florence, now in the Uffizi Gallery. Its rich, colorful details, exotic costumes and animals, and profuse use of gold leaf attest to the International Gothic tradition, although it also includes new and inventive details not entirely out of keeping with a whole new trend in the representation of space, foreshortening, light, and the effects of perspective that preoccupy his contemporaries.

MASACCIO

The painter Masaccio (Tommaso Guidi, active 1421–1428) worked in new ways to express form and color. His work is rare since he was active for only about six years before his untimely death. He learned and used a

system of perspective in his art and, like the fifteenth-century northern artists, he utilized observed principles of light and shadow to build form in his figures.

There is no doubt that Brunelleschi, Donatello, and Masaccio, among themselves, devised a system of one-point perspective used for visually representing the third dimension on a two-dimensional surface, such as a drawing or painting, or on the basically flat surface of relief sculpture. This type of perspective is dependent upon a restricted view, within a picture plane or a frame of space. An established line of horizon corresponds to the selected eye level of the viewer and any persons in the picture intended to be seen at the same level as the viewer. A vanishing point, or *eye point,* on the horizon fixes the viewer's position, and all horizontal lines perpendicular to the picture plane trace back to this point.

The *Tribute Money*. The painting by Masaccio that best exemplifies this principle is the *Tribute Money,* one of a series of frescoes in the Brancacci Chapel of the Church of Santa Maria del Carmine in Florence. Masaccio worked here along with his teacher, an artist known as Masolino. The *Tribute Money* is a part of the program of miracles related to St. Peter that play an important part in the decoration of the chapel.

In the *Tribute Money,* Masaccio has established a horizon line at the eye level of Christ, whose left eye also represents the vanishing point in the picture. All of the Apostles gathered around share this eye level as do we, looking at the event. The lines leading back from the front of the building at the right all lead to the eye point.

The *Trinity*. In the Dominican Church of Santa Maria Novella, Masaccio painted a large fresco, called *The Trinity*. It shows Christ crucified within an architectural ensemble, more or less like a triumphal arch raised above an altar. With Christ under the coffered barrel vault of the arch are St. John the Evangelist and Mary, flanking the cross, and the Lord standing upon a ledge behind, his arms supporting the cross. Between St. John and the head of Christ is the dove of the Holy Spirit. By the pilasters and columns of the arch are a male and female donor, unidentified. Beneath the foreground altar table is painted a sarcophagus with a skeleton resting upon it. A motto in the wall behind the sarcophagus reads in translation: "I once was as you are; you will be as I am."

In this powerful work, Masaccio has also used principles of perspective to dramatize the message. His image of the Trinity goes far back in medieval tradition, but it is brought dramatically to life when presented within the immediacy of recognizable scale and place.

FRA ANGELICO

The discoveries of Masaccio and his friends were immediately absorbed by a number of painters and their application to humanist principles of art applied with growing vigor through the century. A contemporary of

Masaccio was the Dominican monk-painter Fra Angelico (Guido di Pietro, c. 1387–1455). He worked at Fiesole and Florence in Dominican monasteries. Fra Angelico had been trained in the International Gothic tradition and his love of detail, color, and intricacy continued in his works. He imposed a thoroughly rational, constructed perspective on his paintings as soon as he learned how. The combination at his hands provides a delicate sprituality in such works as the frescoes in the monastery of San Marco, where he and assistants decorated most of the monks' cells and the chapel, and produced altarpieces and other devotional works.

PAOLO UCCELLO

Paolo Uccello (c. 1396–1475) was born before Masaccio and also trained in the International Gothic style. He made a particular study of constructed perspective. Afterward, he did not hesitate to demonstrate his accomplishment in his works. He added odd grid patterns and objects of great complexity drawn in perfect perspective to his landscapes.

The Battle of San Romano. Among Uccello's paintings are three large panels in tempera on wood, each about 6 feet by 10 feet 5 inches (1.8 by 3.2 m), celebrating the victories of San Romano, marking the defeat of the Sienese in 1432. The paintings date from about 1456, and they were made for the Medici Palace. They are now separated. One is in the British Museum in London, one at The Louvre in Paris, and the third in the Uffizi Gallery in Florence. Uccello's rearing horses and heavy, iron-clad knights are wonderfully imaginative. A grid of lances, fallen warriors, and debris from the battle carpets the battlefield.

ANDREA DEL CASTAGNO

Another artist working in Florence during the first half of the century was Andrea del Castagno (1423–1457). His best-known work was for the convent of Sant'Apollonia. There he painted a fresco of the Last Supper for the refectory. He also painted a series *Famous Men and Women* for the Villa Carducci in Legnaia, moved long ago to the refectory of Sant'Apollonia and now in the Uffizi Gallery in Florence.

The *Last Supper*. Castagno's *Last Supper* is a controlled excercise in perspective showing extreme foreshortening of the ceiling, walls, and floor of the square room of the supper itself. Otherwise, it is a relatively static composition, giving prominence only to Judas, who sits apart from the rest of the participants, on the near side of the long table.

Famous Men and Women. The figures in the series *Famous Men and Women* appear as if standing in a loggia, each between piers of a continuous frieze. The isolation individualizes the figures, bringing a more genuine focus to each in turn.

DOMENICO VENEZIANO

Born and trained in Venice, Domenico Veneziano (c. 1420–1461) lived and worked in Florence for most of his active career. His work, too, shows an extensive knowledge of perspective, but his use of color and detail and the decorative way perspective is used in his work suggest the International Gothic style of his early training

The *St. Lucy Madonna*. Domenico's *Madonna and Child With Saints*, known as the *St. Lucy Madonna*, is an early example of a *sacra conversazione*, a painting of the Virgin and Child attended by saints in a formal, balanced arrangement. She and the Child are on a raised dais and are approached from two sides by saints. These saints look to her, read in their service books, or gesture toward her for our benefit in an introductory fashion.

The complicated architectural background to this painting serves to divide the panel into three bays. Its pink and green tones are picked up by the colors in costume and marble detailing of the foreground. Neither the Virgin nor any of the saints appears within this architecture. Its complexity and careful perspective are simply a decorative screen. Thus they are similar to the complex wall and ceiling decorations in Castagno's *Last Supper* and even less functional in the setting. If anything, the division of the panel into these three spaces continues and formalizes a concept seen in Simone Martini's *Annunciation*, Pietro Lorenzetti's *Birth of the Virgin*, and Gentile da Fabriano's *Adoration of the Magi*. Here all the saints are within a continuous space with Mary and one another, wherein they may enter into conversation with her, among themselves, or with us. The background structure replaces the shaped frame in imposing order upon the whole.

FRA FILIPPO LIPPI

The Florentine monk Fra Filippo Lippi (1406–1469) was a magnificent painter, if somewhat of a disgrace to his religious calling. He is said to have seduced a pretty nun, Lucretia Buti. Lucretia was the mother of his son, the painter Filippino Lippi. Understandably, Filippo was defrocked, but his genius at painting earned him the intervention of the Medicis, who saved him from total disgrace and further punishment.

***Madonna and Child with Angels*.** Filippo's best-known painting is the *Madonna and Child with Angels* in the Uffizi Gallery in Florence. It shows Mary as a young, beautiful woman (allegedly his Lucretia) seated and adoring the Christ Child, who is supported by two child-angels. Behind is a landscape with Tuscan features seen through a painted frame as through a window. The concept of a landscape space behind the Virgin and Child finds an earlier parallel in Flemish painting. Jan van Eyck's *Rolin Madonna* in The Louvre is an example.

PIERO DELLA FRANCESCA

The great paintings of Piero della Francesca (c.1420–1492) dominate the art of mid-fifteenth-century Italy. Piero did not work in Florence after a period of early training with Domenico Veneziano. Rather he is associated with such northern Italian cities as Ferrara, Rimini, Arezzo, and Urbino.

The Legend of the True Cross. At Arezzo, in the Church of San Francesco, Piero painted a fresco series, *The Legend of the True Cross*, a medieval tale combining the story of the origins of the cross as a piece of wood preserved from the Tree of Life in paradise and of its rediscovery by St. Helen.

Piero painted these scenes with a dramatic and yet contained flair, carefully constructing the perspective and point of view of each and restraining the figure movements and gestures to a minimum. This restraint is characteristic of Piero's paintings. It sets his style apart from his predecessors and contemporaries.

The Flagellation, **Urbino**. Piero studied and wrote on the theory of perspective. His painting *The Flagellation*, in Urbino, is enigmatic in its unusual view of the subject in the middle distance, beyond a group of conversing figures at the foreground plane. The clear geometry of the space in perspective is, nonetheless, crisp and exact.

The Resurrection of Christ, **Borgo San Sepolcro**. In a later work, one of Piero's best known, *The Resurrection of Christ*, in the Palazzo Communale (Town Hall) in Borgo San Sepolcro, the artist avoids perspective entirely. Instead he bases the powerful composition on the figures themselves, forming a pyramid of the gathered masses of the sleeping soldiers' bodies and the central figure of the resurrected Christ rising from his tomb in the center.

LEON BATTISTA ALBERTI

Leon Battista Alberti (1407–1472) and Piero della Francesca were both working in Rimini for Sigismondo Malatesta around 1450 and doubtless met there. Alberti's mathematical studies and interests in proportions and perspective inspired the studies of Piero in these areas. Both men represent a turning point at mid-century in the arts of the Renaissance. Alberti, in particular, is the ultimate "Renaissance man."

He comes down to us in history as both theoretician and architect; painting and sculpture were also among his skills. Alberti was the first to seriously study the single ancient treatise on architecture that survives, Vitruvius's *Ten Books on Architecture*, written in the first century B.C. and dedicated to Augustus Caesar. The work was rediscovered at Monte Cassino Abbey by the humanist scholar Poggio Bracciolini in 1414.

Alberti wrote his own treatise on architecture, *De re aedificatoria* (1452), along with an earlier treatise on painting, *De pictura* (1435), and one on sculpture, *De statua* (c. 1464–1470). As an architectural designer, Alberti

drew upon sources similar to Brunelleschi. He had been in Rome where he, too, studied and drew the antiquities.

The Church of San Francesco, Rimini. For Sigismondo Malatesta in 1451, Alberti designed a Renaissance form for rebuilding the medieval church of San Francesco in Rimini. The façade is based upon a Roman triumphal arch. A deep arcade on each side is designed to enframe the sarcophagi of Sigismondo, members of his court, his mistress Isotta, and others who shared in the love of things both pagan and Classical. The Tempio Malatestiano ("Malatesta Temple," as it is irreverently called) was never finished. Ironically enough, it looks like a Classical ruin.

The Palazzo Rucellai. In Florence, Alberti designed the Palazzo Rucellai beginning in 1452. Its design derives from the Medici-Riccardi Palace, although its surface is less sculptural. It has a consistent pattern of drafted walls, rather than the sequence of rusticated, drafted, and plain walls that lighten the stories of the Medici-Riccardi Palace.

Through each story of the Palazzo Rucellai, smooth, unfluted piers rise to support entablatures at each of its three-story levels. The orders of pier capitals are progressively lighter, from Tuscan Doric to composite (Ionic and Corinthian combined) to Corinthian in upward succession, corresponding to Vitruvian principles. The windows of the upper two stories are large, within arches as wide as the space between the piers.

Amazingly, nearly all of Alberti's most famous building projects are reconstructions or surface treatments of earlier structures. The Palazzo Rucellai façade unites three earlier buildings behind it.

The Church of Santa Maria Novella. From 1458 to 1470, Alberti worked on the old Dominican Church of Santa Maria Novella, designing a façade for it, inspired by the Tuscan Romanesque design of San Miniato.

Beginning about 1470, Alberti redesigned the Church of St. Andrea in Mantua with an imposing combination of temple façade and triumphal arch superimposed on one another. Here he also designed the interior. It is lavishly and intricately surfaced but remains powerful in the large motifs of the barrel-vaulted nave with barrel-vaulted chapels opening in rows along each side.

All the vaults of Sant'Andrea are coffered and widely separated by massive walls so that a sturdy geometrical space is the overpowering impression. Here a foreshadowing of the colossal architectural order of the High Renaissance is seen in the large pilasters of the nave wall that echo those of the façade and give visual support to the entablature beneath the nave barrel vault.

THE EARLY RENAISSANCE: THE SECOND HALF OF THE FIFTEENTH CENTURY

Donatello and Piero della Francesca lived well into the second half of the fifteenth century, as did Paolo Uccello and Leon Battista Alberti. A younger generation of artists built or designed well on the foundations of these masters. Many of them were in turn to become the teachers of the artists of the High Renaissance at the outset of the sixteenth century.

Architecture of the Late Fifteenth Century

In his treatise on architecture, Leon Battista Alberti had advocated the use of centrally planned structures as ideal church buildings. The geometric symmetry of the forms derived from a circular or regular polygonal structure could be said to express the unity and dynamics of faith. He could cite examples, although not a great many, of Early Christian centrally planned churches and ancient temples. The best was probably the Pantheon, which had served as both a temple for the ancients and a church, Santa Mariá Rotunda, since the Early Middle Ages.

Brunelleschi had begun a centrally planned church, Santa Maria degli Angeli, in Florence, in 1434, although the project was abandoned, unfinished, in 1437. Alberti's own attempt at designing such a structure was the Church of San Sebastiano in Mantua, not completed as planned.

Nonetheless the ideal represented a prophetic judgment on both Brunelleschi's and Alberti's part. By the late fifteenth century many artists and architects were designing centrally planned structures in sketches, paintings, projects, and idealizations. These came into being as an expression of the ideal in the High Renaissance.

GIULIANO DA SANGALLO

Giuliano da Sangallo (c.1445–1516) was a Florentine architect trained early by his architect father. Giuliano also trained in Rome, from 1465 to 1480, where he, too, studied ancient buildings. Many of his notes and sketches of his Roman studies have survived, an important record of the ancient city.

The Church of Santa Maria della Carcere. While one of his principal interests and activities was as a builder of fortifications with his brother Antonio (c. 1455–1534), Giuliano built, beginning in 1485, the centrally planned Church of Santa Maria delle Carcere in Prato. Elements of its structure depend closely on the geometric ideas of Alberti. Many of its details are strongly influenced by Brunelleschi. Its interior is very reminiscent of the Pazzi Chapel. It is built on a Greek cross plan, the short arms of the cross being barrel-vaulted.

The Late–Fifteenth–Century Sculptors

A number of sculptors active in the second half of the fifteenth century combined the art of Donatello and the theory of Alberti to further heights in their attempts at glorification of the ancient arts in updated versions.

BERNARDO ROSSELLINO

Bernardo Rossellino (1409–1464) was a pupil of Alberti. He was both an architect and a sculptor. As an architect he worked for popes Nicolas V and Pius II. For the latter he redesigned the old Tuscan town of Corsignano, planning and designing the cathedral, town hall, bishopric, and the palace of the Piccolomini, Pius II's family. The rebuilt town, renamed Pienza, is a surviving example of Renaissance city planning.

The Tomb of Leonardo Bruni. At Santa Croce in Florence, Bernardo designed the tomb of the great humanist scholar, Vatican secretary, and Florentine councilman Leonardo Bruni. The massive tomb, set into a wall, is over 20 feet (6.5 m) high. The dead humanist is shown on a catafalque supported at each end by Roman Imperial eagles. The bier rests on Bruni's sarcophagus between two piers supporting an entablature and an arch. Above the arch are winged figures holding Bruni's coat of arms. Within the tympanum appear the Madonna and Child with angels.

ANTONIO ROSSELLINO

Bernardo's brother Antonio collaborated with him on many projects. He was primarily a sculptor and best known for his portrait *Matteo Palmieri*, in the Bargello in Florence. The stern, unflattering visage of Palmieri, a noted churchman, has the qualities of an ancient Roman portrait bust.

ANDREA DEL VERROCCHIO

Andrea del Verrocchio (Andrea di Francesco di Cione, 1435–1518) was a goldsmith, sculptor, and painter. He worked mainly in Florence. Lorenzo di Credi, Perugino, and Leonardo da Vinci were all students of Verrocchio.

David. About 1465, Verrocchio made a bronze sculpture of David that is now in the Bargello in Florence. Donatello's bronze *David,* in the same museum, strikes us by his youth and immature reaction to his own deed. Verrochio's *David* is also an adolescent, but he seems more alert and very elated by his action. He looks almost jaunty and seeks approval for his deed.

Colleoni. The equestrian statue of Bartolommeo Colleoni, another condottiere who led Venetian forces to various victories, was made by Verrocchio. Again, it is a portrait more enlivened than the similar *Gattamelata,* by Donatello, in Padua. The horse seems to strain foward, his muscles tensed. The rider stands in his stirrups, alert to his opposition.

ANTONIO POLLAIUOLO

Antonio Pollaiuolo (c. 1431–1498) and his brother Pietro (1443–1496) were both skilled in the arts of painting, sculpture, and goldsmithery. Antonio, the better known of the two, is celebrated in all these arts, especially as painter and sculptor. He painted the large *Martydom of St. Sebastian*, now in the National Gallery, London, and the series *Labors of Hercules*, two panels of which survive in the Uffizi Gallery, Florence. Antonio also painted the *Abduction of Dejanira* in the Yale University Art Gallery, New Haven, Connecticut.

As a sculptor, Antonio is noted for the tombs of Popes Sixtus IV and Innocent VIII in Rome and a vivid *Bust of a Warrior* in the Bargello, Florence. His sculpture is worked in terra cotta or bronze. He did not work in marble.

Hercules and Antaeus. He also made the small, 18-inch (45.7-cm) sculpture, *Hercules and Antaeus*, in the Bargello, in about 1475. The animated action of this work comes from Pollaiuolo's observation of ancient sculpture: small bronzes and reliefs on sarcophagi. As a sculpture in the round, it is carefully designed to be seen from all sides, remaining in balance on a central axis as one turns it or moves around it.

Engraving: The Battle of the Ten Naked Men. Antonio Pollaiuolo made one engraving that has survived. *The Battle of the Ten Naked Men* shows a combative group of figures in fierce combat, progressing from bow and arrow to battle-axes, swords, and daggers. The print is usually dated about 1470. This places it within a few years of Schongauer's *Tribulations of St. Anthony*. It is instructive to compare the action and intentions of these two prints. Schongauer's print comes from the vigorous but devout and superstitious Late Gothic world and represents the triumph of good over evil by the steadfastness of faith. Pollaiuolo's work has no moral tale attached, no sense of burden or triumph. It is intended to intrigue the viewer, to impart the sense of a classical frieze. The subject of his print, a fierce, deadly battle, has never been fully explained, but the action of the figures clearly depends upon ancient reliefs. It presents a theme intended to display figures in action. Several of the fighters represent front and rear views of the same position.

Painting in the Late Fifteenth Century

DOMENICO GHIRLANDAIO

The Florentine painter Domenico Ghirlandaio (1449–1494) was among a select group of Tuscan artists who worked in Rome in 1481–1482 on a series of paintings for the Sistine Chapel. The chapel, newly built and named for Pope Sixtus IV, was first decorated with frescoes on its side walls. Later, Michelangelo would immortalize it with his ceiling frescoes and *Last Judgment*.

Choir Frescoes, Santa Maria Novella. Ghirlandaio is best remembered for various cycles of painting in Florentine churches. He painted two detailed and elegant series of the lives of the Virgin and John the Baptist in the choir of Santa Maria Novella. Among the participants in the scenes of the life of the Virgin are members of the Tornabuoni family, donors of the fresco cycles. His Birth of the Virgin is an updated version of the subject, worth comparing to Pietro Lorenzetti's painting of the same subject done in 1342.

Ghirlandaio's love of rich detail attracted him to Flemish paintings imported into Florence, such as *The Portinari Altarpiece* by Hugo van der Goes. Some of his works display the influence of this exotic art.

SANDRO BOTTICELLI

Sandro Botticelli (Allessandro Filipepi, 1445–1510) also worked on the Sistine Chapel wall frescoes in 1481 and 1482. He had been a pupil of both Fra Filippo Lippi and Verrocchio.

Botticelli painted both religious and secular pictures. His style is vigorous, linear, and decorative; it is compared by some to that of his friend and contemporary, Antonio Pollaiuolo. Botticelli worked for the Medicis in the 1470s and later. His mythological scenes, particularly *Primavera* and *The Birth of Venus*, painted for Pier Francesco de' Medici, are inspired by Renaissance poetry constructed in humanist circles interpreting the ancient myths. The artist's style is itself poetic and inventive, little given to strict ideals of human proportion. Rather, Botticelli uses an invigorated line and color to emphasize the movement and rhythm of his figures.

PERUGINO

The painter Perugino (Pietro Vannucci, c. 1445/1450–1523) lived and worked in several northern Italian cities after his apprenticeship in Florence in the shop of Verrocchio and a sojourn in Rome that began about 1478. His Tuscan contacts found him work with Botticelli, Ghirlandaio, and others at the Sistine Chapel in 1481 and 1482.

Christ Delivering the Keys to St. Peter. One of Perugino's best-known works is the fresco of *Christ Delivering the Keys to St. Peter* in the Sistine Chapel. It is a painting temperamentally opposite to Botticelli's lyrical work. Note Perugino's exacting perspective and rational proportions. The foreground figures are carefully placed in the open space of a large plaza. Behind them the pavement forms a grid that recedes to a domed, centrally planned octagonal temple standing between two triumphal arches. The frieze of figures across the front occupies less than half the height of the fresco, divided vertically by the keys, the portal, and dome of the distant temple. In the narrow band of space that divides the foreground from the background

are figures who run, leap, and play in relaxed contrast to the formalities of the rest of the painting.

ANDREA MANTEGNA

Andrea Mantegna (1431–1506) came from Padua and spent most of his life in northern Italian cities, primarily Padua, Ferrara, and Mantua. He was affected by Donatello's work in his early years, and he took an almost archaeological interest in antiquities.

Frescoes in the Ovetari Chapel. A cycle of frescoes painted by Mantegna in the Ovetari Chapel of the Erimitani Church in Padua (lost) showed the lives of St. James and St. Christopher and the Assumption of the Virgin. Surviving representations of these works show Mantegna's scrupulous attention to perspective and his fascination for ancient costume and architectural detail.

In paintings such as *St. James Led to His Martyrdom*, the artist has worked out a perspective of the scene from below, similar to the upper part of Masaccio's *Trinity*, in which the horizon (our eye level) is below the lower edge of the picture plane.

After 1460, Mantegna worked for the wealthy Gonzaga family of Mantua. His most famous work on their behalf was the fresco decoration of a large salon called *Camera degli Sposi* (*Newlyweds' Chamber*). Its walls and ceiling are richly painted with family scenes, portraits, and illusory architecture. At the center of the vaulted ceiling is a painted oculus showing blue sky, puffy clouds, several cupids, and a few people peering down, supposedly at the marriage bed of the newlyweds. Swags and garlands enliven the illusion.

Mantegna was also a printmaker. Seven engravings by his hand and many from his followers established a graphic art tradition in the late fifteenth century in northern Italy. Some of these were known to the young Albrecht Dürer even before his arrival in northern Italy in 1495.

ANTONELLO DA MESSINA

Both Mantegna and the painter Antonello da Messina (c.1430–1479) were influential artists for Giovanni Bellini, who can be considered the founder of the Venetian school of High Renaissance art. Mantegna was Giovanni Bellini's brother-in-law and early teacher. Antonello, who had learned his art in Palermo and Naples with artists trained in the Franco-Flemish tradition, may be credited with introducing oil painting to Venice.

The Martyrdom of St. Sebastian. Both Mantegna and Antonello made paintings of the martyrdom of St. Sebastian, each bringing the wounded, suffering saint to the foreground. In each case, landscape is visible beyond. Mantegna's is a linear, hard-edged version, strewn with fragments of ancient statuary and architecture. The saint is also statuesque and bound to a column

that is part of a ruined arch of triumph. Antonello's St. Sebastian is modeled in color, light, and shadow. He is at once more monumentalized and larger in proportion to the picture space and seen from a lower vantage point, and more human. He has a true flesh-and-blood appearance enhanced by the richness of oil paint and the building of glazes of color that characterize the medium.

GIOVANNI BELLINI

Giovanni Bellini (c. 1432–1516) was the younger brother of the painter Gentile and son of the painter Jacopo Bellini. Giovanni's contacts with Mantegna and Antonello are essential for the evolution of Venetian painting. Always an international city, with connections to northern Europe and the eastern centers, Venice developed a Renaissance mode of its own as it had earlier assumed Byzantine and Gothic elements into its art.

The San Giobbe Altarpiece. Giovanni Bellini's large altarpiece for the Hospital of San Giobbe in Venice was painted in 1485. It is an enormous painting, 15 feet 4 inches by 8 feet 4 inches (4.67 by 2.54 m). *The San Giobbe Altarpiece* is a form of *sacra coversazione*, the combination of Madonna and saints as in Domenico Veneziano's *St. Lucy Madonna*. Here the figures are brought closer to the picture plane; the architecture, majestic in height above all, surrounds them, and a sense of sanctity and mystery is generated by the gold Byzantine apse fitted into the Brunelleschi-like vault. The enriched color and depth of the oil paint enlivens the figures in this work. It was to be the medium of choice for the great Venetian artists, beginning almost immediately with Giorgione and Titian.

The Italian Renaissance began in the intellectual circles of Petrarch and Boccaccio in the mid-fourteenth century. Its humanist and Neoplatonic theories reached the arts only later, but in the early fifteenth century, artists began to react to humanist thought in a manner of expression entirely counter to the arts of the Middle Ages. Their art, like the philosophy of the humanists, turned back to an analytical view of the Classical past. It was, in fact, to the art that the term Renaissance was first applied.

To justify this "ennobling" of the arts, theorists, such as Leon Battista Alberti, observed that art was built upon theories and that the liberal arts, noblest of humankind's intellectual ventures, were requisite to the making of fine arts. Geometry, mathematics, and history are especially emphasized in this context and brought to the fore in the artists' preoccupation with perspective and with the art, poetry, and mythology of the ancient world.

The result was a change in artistic expression that would revolutionize the practice of all art forms more quickly and dramatically than any other style change. The step marks the bridge from late medieval to early modern Europe.

Selected Readings

Baxandall, M. *Painting and Experience in Fifteenth-Century Italy*. New York: Oxford University Press, 1988.

Gilbert, C. *History of Renaissance Art Throughout Europe*. New York: Abrams, 1973.

_____. *Italian Art: 1400–1500*. Sources and Documents. Englewood Cliffs, NJ: Prentice-Hall, 1987.

Hartt, F. *History of Italian Renaissance Art: Painting, Sculpture, Architecture*. 3d ed. Englewood Cliffs, NJ: Prentice-Hall, 1987.

Murray, P., and L. Murray. *The Art of the Renaissance*. London: Thames and Hudson, 1981.

Panofsky, E. *Renaissance and Renascences in Western Art*. New York: Harper & Row, 1969.

Seymour, C. *Sculpture in Italy, 1400–1500*. Baltimore: Penguin, 1966.

White, J. *The Birth and Rebirth of Pictorial Space*. 3d ed. Boston: Faber & Faber, 1987.

16

Art of the High Renaissance and Mannerism in Italy

1492	Columbus' discovery of America
1492–1503	Pope Alexander VI (Borgia)
1494	Expulsion of the Medicis from Florence
1498	Savonarola burned at the stake for heresy
1503–1513	Pope Julius II (della Rovere)
1508–1512	Michelangelo paints Sistine Chapel ceiling
1512	Restoration of the Medicis to Florence
1513–1519	Pope Leo X (Giovanni de' Medici)
1520–1522	Magellan circumnavigates the globe
1522–1523	Pope Adrian VI
1521–1534	Pope Clement VII (Giulio de' Medici)
1527	Sack of Rome
1534–1549	Pope Paul III (Farnese)
1545–1563	Council of Trent

Any preconception that great art is the product of peace and prosperity ought to be dispelled by a look at the period of the High Renaissance. In this time lived and worked Leonardo da Vinci, Raphael, Michelangelo, and Titian. A host of other artists who might otherwise be recognized for their genius hover in the shadow of these majestic names. Yet the period was one of conflict, uncertainty, and the fall of mighty houses of power. In 1527 Rome itself was sacked and pillaged by mercenaries of the emperor Charles V, much as the Visigoths and Vandals had done at the nadir of Roman history.

It would be difficult, nevertheless, to find any period in history to match the achievements in art of the brief decades that mark the High Renaissance. The focal center moved to Rome and in place of the fallen house of Medici the resources were the seemingly limitless funds of the Roman church. But the Medicis and others had set the pattern, and the sponsors of the projects set forth early in the sixteenth century seem determined to rival the Florentines' earlier successes, also accomplished in the midst of political and religious strife.

Again, the artists responded with magnificent works. The foundations laid by the Early Renaissance artists were formidable. The works produced by the artists of the early sixteenth century are astonishing. This does not mean that the High Renaissance was simply a perfection of the Early Renaissance or that the artists were any more uniform in objective or spirit. If anything they were more diverse. They learned the value of independence as well as the foundations of their art from the men who had created the Renaissance.

THE HIGH RENAISSANCE

Leonardo da Vinci

Leonardo da Vinci (1452–1519) was the earliest-born of the geniuses whose particular talents identify the High Renaissance. He was also one of the most enigmatic, having spent the major part of his productive life in projects that never saw satisfactory completion. He was a theorist who never assembled his theoretical writings for publication. He was an inventor who saw very few of his inventions successfully built or applied. He made models and casts for great sculpture that was never achieved.

Nonetheless, the paintings, the designs, and the fragments of Leonardo's other works that survive exist in the same, central energy field that animates Michelangelo, Raphael, and the small cadre of true High Renaissance artists.

Because he was the eldest and thus the first, it is tempting to thrust the burden of origins upon Leonardo. But Leonardo neither remained in Florence to accept the great commissions he might have expected, nor did he travel to Rome, where, in many respects, the future seemed most opportune.

In 1482, Leonardo withdrew to Milan, where he worked until the end of the fifteenth century for the ducal court of the Sforzas, designing fortifications and military engineering projects.

ADORATION OF THE MAGI

He left behind in Florence an unfinished painting, *Adoration of the Magi,* now in the Uffizi Gallery in that city. It is a painting on panel, worked in mostly monochromatic glazes. The method of painting by defining light and shadow from within, rather than from linear outline, is called *chiaroscuro painting*. It marks a particular awareness of solid form and depth or mass.

THE VIRGIN OF THE ROCKS

In Milan, Leonardo painted *The Virgin of the Rocks,* about 1485. The painting, now in The Louvre, was completed with the chiaroscuro technique apparent in his *Adoration of the Magi*. The soft light and haze (*sfumato*) that appear in the finished work are characteristic of Leonardo's painting. The composition is pyramidal: the near face of the pyramid slopes from the Christ Child in the foreground, through the heads of John the Baptist on the left and the angel on the right, to the Virgin's slightly inclined head at the summit.

THE LAST SUPPER

A decade later, Leonardo painted *The Last Supper* for the refectory of the Monastery of Santa Maria della Grazie in Milan. This magnificent work survives in near ruinous condition, partly because of the artist's experimental use of oil paint on the plaster surface. It is still visible enough, however, to deduce the compositional and expressive power that lifts it past earlier treatments of the theme (by Dirk Bouts and Andrea del Castagno). Leonardo's *Last Supper* is now undergoing an exacting conservation and restoration process that is recapturing some of the lost detail.

In Leonardo's work, the perspective of the room and its darks and lights interplay with the variations in the positions taken by the Apostles. The latter move in waves of reaction to the gesture and expression of Christ as he reveals that one of them will betray him. The radiating lines of perspective and the staccato alternation of light and dark passages contrast with the calm, resigned sorrow of Christ's pose.

MONA LISA

In Florence in 1503, Leonardo painted the *Mona Lisa*, a portrait of the wife of Zanobio del Giacondo, a Florentine banker. It is a half-length portrait fronting a deep, atmospheric landscape beyond the wall of the parapet before which she sits. Much has been made of the indeterminate expression of the sitter, a "sad half-smile," as one writer has expressed it. The rich atmospheric

tonalities that play across the whole picture seem to heighten its mystery, or enigmatic mood. It was one of the paintings with which Leonardo could not bear to part, still in his possession at his death. Her image has become one of the icons of Western art.

Leonardo's intensive concerns in the natural and physical sciences make his notebooks a valuable and fascinating array of visual images. They include studies of the flight of birds, the flow of water, optics, mechanics, anatomy, designs for sculpture, and many architectural projects, none brought to fulfillment. Several of the latter show domed, centrally planned churches.

The last years of Leonardo's life were spent in the court of Francis I of France at the Château de Cloux. He died there in 1519.

Donato Bramante

Donato Bramante (1444–1514) was trained as a painter, probably in his native Urbino and possibly by Piero della Francesca. Between 1481 and 1499 he was in Milan, and during this time his real interest and skill as an architect evolved. In his buildings, the influence of Brunelleschi, Alberti, and Leonardo da Vinci can be seen.

THE TEMPIETTO

The major turning point in High Renaissance architecture has been pinpointed to his tiny Tempietto in the cloister beside the Church of San Pietro in Montorio in Rome, conceptualized and built between 1502 and 1509. The Tempietto is a realization of the central plan idealized by Alberti and already forecast in the plans of Brunelleschi. Probably the concept also indicates Bramante's contact with Leonardo in Milan. The structure is a round temple set on a circular, stepped base with a peristyle in the Doric order. Above the entablature is a balustrade. The cella continues into a second story, forming a drum that supports a semicircular ribbed dome.

The Tempietto was built at a site supposed by some to represent the place of St. Peter's martyrdom. A more traditional view places the event in the circus of Nero, partially beneath St. Peter's in the Vatican. The great Cathedral of St. Peter is centered as was its predecessor, Old St. Peter's, on the site of the burial of the Apostle, in a cemetery across the street from Nero's circus.

ST. PETER'S

Bramante was awarded the first commission to design the new St. Peter's by Pope Julius II in 1505. It was intended to hold Julius's tomb as well. As such, it was designed as a domed, centrally planned, colossal structure. Work was started on the central piers and choir walls but had not progressed far by the time of Julius's death in 1513 and Bramante's in 1514.

Old St. Peter's in the Vatican was founded by Constantine. From the fourth through the fifteenth centuries it stood as a prototypical Early Christian basilica. The decision to replace it is ordinarily explained by its great age and deteriorated condition. Such a rationalization is made for the replacement of buildings throughout history.

The rebuilding of major monuments is usually associated with the names of the donor and the architect. Pope Julius II envisioned a new St. Peter's with his own monumental tomb conspicuously standing within it. The church took over 150 years to build, however, and it is associated with many names. Pope Julius II's tomb is elsewhere.

Rebuilding St. Peter's: A Time Chart. The following timetable will be useful in anticipation of the long period and variety of names associated with the project:

1505	Pope Julius II commissions Bramante to design the new Church of St. Peter
April 18, 1506	Foundation stone laid for the church; work continues under Bramante until 1514
1514	Raphael appointed chief architect of St. Peter's
1514–1520	Work continues under Raphael until the artist's death
1543	Pope Paul III appoints Antonio da Sangallo the Younger to work on the church
1546	Death of da Sangallo; Michelangelo appointed chief architect
1546–1564	Michelangelo works on St. Peter's
1588–1590	Dome built by Giacomo della Porta; centralized plan modified to Latin cross by Carlo Maderna
1608–1615	Maderna builds façade
1623–1644	Gianlorenzo Bernini builds the *Baldacchino* over the high altar
1656–1657	Bernini builds the colonnades around the piazza
1657–1666	Bernini designs the Throne of St. Peter in the apse

Table 16.1

MICHELANGELO BUONAROTTI

While Bramante designed and began work on the new St. Peter's, Pope Julius II summoned the young Florentine artist Michelangelo Buonarotti (1475–1564) to Rome in 1505 in order to design a tomb for himself. As we

noted, it was to have been a monumental, freestanding work, within the new St. Peter's. It was an act of papal self-glorification that was ill-fated since neither the tomb nor the church were more than barely begun at Julius II's death.

Michelangelo was brought up in the household of Lorenzo de' Medici. In that court he had associated early with many of the most brilliant men of the burgeoning Renaissance. He was apprenticed for a period to Domenico Ghirlandaio and also to the sculptor Bertoldo di Giovanni, a leading pupil of Donatello.

THE PIETÀ, 1498–1500

Early attention was drawn to the work of Michelangelo by his earliest sculpture of *The Pietà*. The work was made on his first sojourn in Rome after the death of Lorenzo de' Medici. *The Pietà* shows the Virgin Mary holding the dead body of Christ on her lap. It is a highly finished marble sculpture. *The Pietà* is a deeply religious theme from the mysticism of Late Gothic art. It became a vital theme of religious humanism in the hands of Michelangelo. It can be seen as the artist's personal attempt to reconcile the intensity of Savonarola's Dominican puritanism with the deeply felt Neoplatonism of Renaissance philosophers he learned in the Medici court.

DAVID

On his return to Florence from Rome in 1501, Michelangelo carved a huge statue of David, which was set up in front of the Palazzo della Signoria. At 18 feet (5.5 m), it has been interpreted by some as the Florentine assertion of freedom from Medici power. For the artist it represented an opportunity to demonstrate his skills in carving an immense block of marble, famous for its size and difficult shape, into a rational masterpiece.

As in Donatello's and Verrocchio's versions, Michelangelo has emphasized David's adolescence, in this case by the oversized proportions of his hands, head, and feet. Here David is confronting his enemy rather than triumphantly standing over him. If symbolism is its mode, this should be taken to represent Florentine defiance against any aggressor.

ARCHITECTURE AND THE SCULPTURE AND PAINTINGS WITHIN

For the tomb of Julius II, Michelangelo made myriad sketches, but the project was postponed time and again until after Julius II's death. It was to have been a large complex combining architecture and sculpture within the new St. Peter's. Twenty-eight figures were to have been assembled in a two-storied construction. The work was put off; Michelangelo left Rome again in 1506, to return in 1508 on Julius's commission for him to paint the Sistine Chapel ceiling.

The Sistine Chapel. Working substantially alone over the period from 1508 to 1512, Michelangelo painted the ceiling in true fresco. The walls of the chapel had been painted from 1480 to 1481 by leading Florentine painters, among whom was Domenico Ghirlandaio, Michelangelo's teacher. The enormous task of painting the ceiling was centered upon a Creation cycle. It appears in scenes of the separation of light from darkness and the forming of earth and water, sun and moon. *The Creation of Adam*, by far the best known of all the scenes, is followed by *The Creation of Eve, The Temptation, Expulsion,* and three scenes from the story of Noah.

Surrounding these scenes are prophets, sibyls (prophetesses of the ancient world), and ancestors of Christ. These and others, some purely decorative, are intricately arranged in the painted representation of a complex architectural framework. A recent, and brilliant, restoration of Michelangelo's Sistine ceiling, although controversial, has provided a new and startling idea of the original vividness of the paintings. The conservators removed centuries of grime, candlesmoke, and dust from the plaster surface.

The whole focus of the program, far too intricate to be analyzed here, is in balance with the cycles painted earlier on the walls below and the tapestries designed for the lower walls by the painter Raphael.

Later, in 1534, Michelangelo was commissioned by Pope Paul III to paint *The Last Judgment* on the altar wall of the chapel. Not inauspiciously, the judgment appears beneath the ceiling scenes of the separation of light from darkness.

The Last Judgment. The artist returned to Rome to paint *The Last Judgment* in the Sistine Chapel in 1534. He carried out the work from 1534 to 1541. As already noted, this great project closes the complex program of representational art that includes the walls, ceiling, and altar wall of the Sistine Chapel.

The Last Judgment is a vast, 48-by-44-foot (14.6-by-13.4-m) complicated composition, powerful in its representation of themes that are traditional in Last Judgment iconography but magnified here by the sheer force of Michelangelo's artistry. Christ dominates the fresco, surrounded by the Apostles, the Virgin, John the Baptist, and, above, angels with the instruments of the Passion. The enormous number of resurrected figures, totally nude, above the altar of the chapel, was greeted by considerable objection in the midst of the critical religious strife of the mid-sixteenth century. The fresco was thus modified by many strategically placed bits of drapery at little cost to its power or impact on the viewer.

The Tomb of Julius II. Shortly after Michelangelo completed the cycle of the Sistine ceiling paintings, Julius II died. The artist worked on a revived project for the pope's tomb from 1513 to 1515, carving two figures of slaves and the seated Moses, the latter a powerful expressive figure that eventually found its way to the actual tomb at San Pietro in

Vincoli, in Rome. The slaves, known as *The Dying Slave* and *The Rebellious Slave,* are now in The Louvre, Paris.

The Medici Chapel. The Medici popes had more pressing contracts for Michelangelo than the tomb of Julius II. Leo X (reigned 1513–1519) engaged the artist to produce a funerary chapel for the Medicis. In Florence by 1516, Michelangelo worked on the Medici Chapel at Brunelleschi's Church of San Lorenzo. The structure, to the right of the apse of the church, corresponds to Brunelleschi's sacristy to the left. The new chapel was a funerary memorial to Lorenzo the Magnificent and his brother Giuliano, and a burial chapel for Lorenzo's son Giuliano and grandson Lorenzo.

The tombs of Dukes Giuliano and Lorenzo are architectural constructions facing each other across the chapel. Each duke is represented by a statue in a niche flanked by doubled piers and additional niches. In front of each is his sarcophagus with reclining figures of Night and Day over one, Twilight and Dawn atop the other. Each figure lies in an immobilized pose, turned or twisted, and seeming to struggle against some multiple of the earth's normal gravity field.

The Laurentian Library. In 1524 Michelangelo also designed the library of the Medicis at San Lorenzo and its entrance hall. The latter is famous for its staircase and the apparently contradictory forms of its architectural details. Enormous paired columns are recessed into the wall, appearing to support nothing and seeming to be supported on slender volutes in wall recesses.

The Piazza del Campidoglio. Between 1537 and his death in 1564 Michelangelo worked at the design and execution of the Piazza del Campidoglio, in Rome, uniting the Palazzo del Senatori, the Palazzo del Conservatori, and the newly built Capitoline Museum into a balanced group on three sides of a paved, irregular trapezoidal piazza. Centered here, on an interlocking design of ovals, is the ancient bronze equestrian statue of Marcus Aurelius, brought from the Lateran and now a focal point of the square.

St. Peter's. When Antonio da Sangallo the Younger died in 1546, Michelangelo was appointed chief architect of St. Peter's. He returned to the basic centralized plan originally advocated by Bramante and made slight modifications that strengthened and rationalized the design to a buildable, if huge, structure. The exterior design and much of the plan of the church that was eventually built conform to the designs of Michelangelo. Three bays were added to the nave by Carlo Maderno in the early seventeenth century, and the dome was extended from its hemispherical profile to an ogival shape by Giacomo della Porta when it was built in 1590.

Of the High Renaissance geniuses, Michelangelo was the most accomplished. His art has the deepest philosophical content and takes the greatest number of forms. His descriptive words about his art are few and abrupt.

They mostly concern the execution and technical problems. Not a critic or theoretical writer, Michelangelo allowed his works to speak for themselves.

Raphael

Raffaello Sanzio (1483–1520), called Raphael, was born in Urbino and received early training from his father, the painter Giovanni Sanzio. He also worked for several years in the studio of Perugino. He mastered the style of Perugino, ultimately producing works that outshone the master. One such, the *Marriage of the Virgin*, in the Pinacoteca di Brera, Milan, has a clearly stronger grasp of depth, tonality, and composition than Perugino's own painting of the same subject, now in the Musée des Beaux-Arts in Cannes.

MADONNA WITH THE GOLDFINCH

In 1504, Raphael moved to Florence, where his style rapidly developed from that of his teachers to a solid and powerful form, influenced by both Leonardo and Michelangelo. His *Madonna with the Goldfinch*, in the Uffizi Gallery, Florence, was painted in 1505 and 1506. It combines the pyramidal composition of Leonardo's *Virgin of the Rocks* with a brighter, clearer landscape still reflecting Perugino's style. It is a harmonious and tender image, one of many versions of the Madonna and Child for which Raphael became particularly famous.

THE VATICAN STANZE

By 1508 Raphael had gained such fame and competence that he won a great commission from Pope Julius II in Rome: to decorate the papal apartments of the Vatican. Raphael painted the most famous of the rooms, the Stanza della Segnatura, during the years 1509 to 1511. Its walls are divided thematically; Theology, Philosophy, Law, and Poetry are represented in great murals, representing the branches of human knowledge. One great mural, called *The School of Athens,* depicts Philosophy. The fresco is a large *lunette,* shaped to the curvature of the vaulted room. It centers on the paired figures of Plato and Aristotle amidst a crowd of other figures, many recognizable by their actions or attributes as representatives of classical learning and philosophy.

All the figures appear within the architectural space of an enormous structure, open to the sky in the foreground and at stages intermittently closed by coffered barrel vaults beyond. Plato stands with a copy of his *Timaeus,* pointing to the heavens, the source of the Idea, the Platonic ideal upon which all reality is based. On his side of the composition are the ancient philosophers who relate to the transcendent and metaphysical thought. Aristotle points to the earth. He holds the *Ethics*. On his side are the philosophers and scientists concerned with the world as objective proof of all reality.

Brooding just to the right of the center foreground is the single figure of Heraclitus, his head supported on his hand, his arm resting on a block of stone. This figure is a portrait of Michelangelo. At the right is Pythagorus writing and at the left foreground is Euclid demonstrating a theorem to a group of students. Euclid is said to appear as the aged Bramante, an early sponsor of Raphael. At the edge of the painting to the right is Raphael himself, gazing into the observer's space.

Raphael's work on this painting and the others in the Vatican Stanze corresponds in time to the period when Michelangelo was at work on the Sistine ceiling. Raphael continued to prosper in Rome with commissions from Julius II's successor, the Medici pope Leo X, and the papal court.

GALATEA

In 1513, Agostino Chigi, papal banker to Leo X, commissioned Raphael to decorate the palace he had built, now known as the Farnesina, with mythological themes of the loves of the gods. The fresco *Galatea* shows the sea nymph on a shell drawn by dolphins, surrounded by Tritons and Nereids. Wheeling above are winged cupids aiming arrows in her direction. The weight and musculature of these figures were clearly inspired by Michelangelo.

THE PORTRAIT OF CASTIGLIONE

Count Baldassare Castiglione posed for Raphael. The portrait is now in the Louvre. It is a half-length representation, mostly combining subdued earth tones and black. Castiglione wrote an important book defining the ideal Renaissance courtier by his manner, education, and behavioral standards. Raphael's carefully balanced and vivid representation of the distinguished author seems to evoke those ideals in the sitter.

TRANSFIGURATION

In 1517, Raphael painted the large, 13-foot 4-inch-by-9-foot 2-inch (4-by-2.75-m) *Transfiguration* in the Vatican Museum. The painting combines an upper background scene of Christ's transfigured appearance to Peter, James, and John, with a scene in the foreground below, clearly directed to the presence of Christ by the light and compositional direction of the figures. The near scene represents a possessed youth whom the Apostles could not cure (Matt. 17;14–23) without Christ's presence. This is the occasion of a lesson in faith and a prophecy of the Passion in the Scriptures.

The *Transfiguration* was commissioned by Giulio de' Medici, who was bishop of Narbonne Cathedral, but it was never sent to the church. When he died in 1520, at only thirty-seven years of age, Raphael was buried in the Pantheon. The *Transfiguration* stood above his bier at the funeral ceremonies.

Additional Artists of the High Renaissance

Many artists active in the period of the High Renaissance contributed to the formation and character of its art and architecture.

ANTONIO DA SANGALLO THE YOUNGER

Antonio da Sangallo the Younger (1483–1546) was a protégé of his two uncles, Giuliano and Antonio the Elder, and of Bramante. He designed the Palazzo Farnese for Cardinal Farnese, who succeeded the Medici pope Clement VII as Paul III in 1534. Sangallo, from 1543 to 1546, was also the chief architect of St. Peter's in Rome.

When Sangallo died, Michelangelo finished the upper story and courtyard of the Palazzo Farnese. It was completed by 1548. Michelangelo also succeeded Sangallo as architect of the Vatican basilica of St. Peter's.

ANDREA DEL SARTO

In Florence a major painter of the High Renaissance was Andrea del Sarto. His *Madonna of the Harpies* in the Uffizi Gallery in Florence, so-called by Vasari for the tiny decorative sculptured creatures on the sculptured base on which Mary is standing, is a stable, symmetrical composition. It is a *sacra conversazione* made dramatic by raising the Virgin on a pedestal, giving an exaggerated pyramidal composition enclosed by the flanking figures of St. Francis and St. John the Evangelist.

Andrea del Sarto's painting also shows signs of change in High Renaissance style. The artificial elevation of Mary onto a pedestal and the artful poses of the two saints are at least self-conscious and, in the case of St. John, inexplicable. The phase of sixteenth-century painting called *Mannerism* seems anticipated here. It is not surprising that a new generation of painters, Jacopo da Pontormo, Rosso Fiorentino, and Giorgio Vasari, were all pupils of this master.

For Andrea del Sarto the compositional adjustments are for balance in High Renaissance terms. The result is a pleasing and formal symmetry made effective spatially by a harmony of colors and of solids and voids. His students and others would change all that.

CORREGGIO

The northern Italian painter Correggio (Antonio Allegri, c. 1489–1534) lived and worked in Parma. He was a highly individualistic artist, though aspects of Mantegna, Leonardo, Michelangelo, and Raphael are cited as influential on his style. Notable are his ceiling frescoes in the domes of San Giovanni Evangelistà (1520–1523) and the Cathedral of Parma (1526–1530). Both are painted from a pronounced, illusory *de sotto in su* point of vision, reminiscent of Mantegna's Camera degli Sposi in the ducal palace in Mantua.

Assumption of the Virgin. The cathedral fresco *Assumption of the Virgin* combines painted and illusory architecture. The Apostles look on as rings of celebrating angels throng the composition, bearing Mary heavenward. Correggio's illusionism anticipates Baroque ceiling paintings of the seventeenth century.

Holy Night. His large 8-foot 5-inch-by-6-foot-2-inch (2.7-by-1.9-m) *Holy Night*, in the Gemäldegalerie, Dresden, defies the symmetry of High Renaissance painting. It attains balance by the proportions of light and dark areas and by focusing upon the central area of Virgin and Child through the use of the Infant as light source.

Jupiter and Io. For Federigo Gonzaga, duke of Mantua, Correggio painted a series of the loves of Jupiter. The god assumed many guises to conceal his liaisons from Juno. To Danae he appeared as a shower of gold, to Leda as a swan, and in the *Jupiter and Io*, in the Kunsthistorisches Museum in Vienna, as a vaporous cloud. Here he engulfs the willing and responsive nymph Io in a humid, erotic, and rapturous embrace.

MANNERISM

Leonardo da Vinci died in 1519, when he was sixty-seven years old. Raphael died in the following year at only thirty-seven. For another 44 years, Michelangelo worked through a range of styles and media, surviving to the age of eighty-nine. Leonardo's, Raphael's, and even Michelangelo's pupils, between 1520 and the end of the sixteenth century, practiced a new art, deliberately contrary to the High Renaissance principles that had opened the century with such certain and definable characteristics.

Mannerism, as this new art is called, has been defined in many ways. The term itself is derived from the Italian word *maniera*, translatable as "style." It indicates the deliberate emphasis of style over form. Seen as a negative by earlier critics, Mannerism is now recognized as a genuine art form between the High Renaissance and Baroque, related to both but belonging to neither.

Florentine Mannerist Painting

GIORGIO VASARI

Giorgio Vasari (1511–1574) worked in Florence and Rome. He was a painter, architect, and, more important, a theoretical writer, known particularly for his *Lives of the Artists* (*Le Vite de' piu eccelenti Architetti, Pittori et Scultori Italiani...*), first published in 1550, then in an enlarged edition in 1568. The book is a vastly important source work for the history of Renaissance art and played the formative role in defining the history of art in the

Western Hemisphere. Vasari was a theoretician of art as well. His use of the term *maniera* led to the present usage.

As an architect Vasari is best known as the designer of the Uffizi Palace, now the great Florentine museum. As a painter he was a pupil of Andrea del Sarto and a contemporary of Rosso Fiorentino and Pontormo. Frescoes by Vasari are in the Palazzo Vecchio in Florence, in the Sala Regia in the Vatican, and in the so-called *Fresco of 100 Days* in the Cancelleria in Rome.

ROSSO FIORENTINO

Giovanni Battista Rosso (1494–1540), called Rosso Fiorentino, was also a pupil of Andrea del Sarto and one of the founders of Mannerism. He was active in Florence from 1513 to 1523, during which time he painted the huge *Descent from the Cross*, 11 feet by 6 feet 6 inches (3.35 by 1.98 m), of 1521, in the Pinacoteca Communale in Volterra, and *Moses Defending the Daughters of Jethro,* in the Uffizi Gallery, Florence, done in 1523. In each of these works the figures tower in the foreground, limiting the depth and space that outdoor settings imply. The compositional ancestor of the *Descent From the Cross* is clearly Raphael's great *Transfiguration*, painted only four years earlier. Rosso has brought the upper and lower parts together. Thus the figure eight of Raphael's dual composition is confusing. The figures seem to be placed schematically on and beneath the framework of ladders and cross, in little spatial relationship to one another.

Moses Defending the Daughters of Jethro. Rosso's painting is taken from the story in Exodus (Exod. 2:16–3:1). The painting is incomprehensible as a story of conflict, functioning mainly as a pileup of athletic, muscled figures. A pyramid of fallen and twisting figures dominates the foreground; strident and wrathful forms flank these central characters in the background. Again, the composition reflects Renaissance sources, but it avoids a focal subject at its compositional center. The musculature of the figures was inspired by Michelangelo, no doubt, but the absence of space reduces the work to an abstraction.

There can also be no doubt that such abstraction was the objective. Rosso's contemporaries worked in the same way to the same ends. We can readily see that the most inventive artists of the generation after the High Renaissance masters were acutely aware of the importance of individual style as it emerges beyond the great compositional discoveries and principles among the masters of High Renaissance art. It is natural that style, or manner, became the focus of their effort. Once seen as rebellious and deliberately dissonant because of the political and religious upheavals of the sixteenth century, Mannerism is more reasonably a reaction to be expected of artists who wished to achieve more than repetitious restatements of their teachers' art.

Rosso worked in Rome after 1523 until the sack of the city in 1527. Later he worked briefly in Venice, and from 1530 in France, at Fontainebleau for Francis I, where he collaborated with Francesco Primaticcio as one of the founders of the Fontainebleau style. The harsh and agitated quality of his earlier works had moderated by then.

JACOPO PONTORMO

Jacopo Carrucci da Pontormo (1494–1557) was also a pupil of Andrea del Sarto. He worked in Florence for most of his life and with Rosso was one of the founders of Mannerism. His *Entombment* (or *Descent from the Cross*) in the Capponi Chapel, St. Felicità, Florence, is one of the key works of Mannerist art. As in Rosso's paintings, the concept of space seems to be lost to expression and a circular swirl of figures among whom are Mary and the deposed Christ. We are given no idea of the location of the event or what will happen next.

The painting is bright and colorful, emphatically using a startling palette of yellow, pink, red, purple, and green against the slate blue worn by several of the figures. Color plays an important role in Mannerist art. It was as deliberately considered and as sharply contrasted with High Renaissance color as were the antithetical compositions.

BRONZINO

Agnolo Tori (1503–1572), called Bronzino, was Pontormo's pupil. His development as a painter is still very much in the realm of Mannerism. He was employed by Cosimo I de' Medici, grand duke of Tuscany.

Venus, Cupid, Folly, and Time. For the duke, Bronzino painted *Venus, Cupid, Folly, and Time,* also called the *Exposure of Luxury,* now in the National Gallery, London. The painting was given by Cosimo to Francis I of France. It shows Time exposing the sensual embrace of Venus and Cupid in the presence of Truth, in the upper left, Envy and Inconstancy, in the background, and a laughing infant who pelts the lascivious couple with roses.

This curious painting retains the improbable composition and uncertain space of earlier Mannerist works. Its allegorical meaning, never fully explained, is augmented by the eroticism probably designed to please the court of Francis I.

Portrait of a Young Man. Bronzino was also an excellent portraitist in the Mannerist idiom. His *Portrait of a Young Man,* in the Metropolitan Museum of Art (H. O. Havermeyer Coll.), is a characteristic example. The three-quarter length figure in an architectural interior is a haughty, self-conscious person. Furniture and molding details and the complex costume vie with the subject for the attention of the viewer. He holds his place in a book, obviously impatient to return to it. None of *Mona Lisa*'s serenity or *Baldassare Castiglione*'s engaged attention appears here.

PARMIGIANINO

Girolamo Francesco Maria Mazzola (1503–1540), called Parmigianino, led an active, strange life that is reflected in his art. He was a painter influenced early on by his fellow Parmesan, Correggio, who may have been his teacher. Before he was twenty years old he had commissions to work in the cathedral of Parma and the Church of San Giovanni Evangelistà. By 1523 he was working in Rome. He was captured in the sack of Rome but escaped, returning to Parma by 1530. In the last decade of his short life, he turned from painting to alchemy, living as a virtual hermit, according to Vasari.

The Madonna with the Long Neck. The most famous of Parmigianino's surviving paintings, *The Madonna with the Long Neck*, of 1535, is a large, 7-foot 1-inch-by-4-foot 4-inch (2.15-by-1.32-m) panel painting in the Uffizi Gallery, Florence. Although it is less harsh and angular than Rosso's and Pontormo's works, Parmigianino has not returned to a representational or proportional mode. His Madonna is an elongated figure, seated in an indeterminate open space.

The Christ Child, asleep, is sprawled across her lap in imitation of the dead Christ in the lap of the Virgin in Michelangelo's early *Pietà*. Mary's long neck is but a symptom of the vertical elongation of the ensemble. Curious features, such as the long bare leg of the foreground angel on the left and the tiny, distant prophet in the lower right, add further mystery to the painting. His work entails a purposeful, designed use of space more evident but no more naturalistic than that of the earlier Mannerists.

Self-Portrait. Parmigianino's *Self-Portrait* in the Kunsthistorisches Museum in Vienna represents a deliberate spatial game. Here the artist portrays his reflection in a convex mirror on a canvas, 9⅝ inches (24.5 cm) in diameter, made convex to duplicate the effect. Across the base of the painting is the artist's right (or left?) hand enlarged as observed in such a mirror.

Printmaking. Parmigianino was also a printmaker. He was one of the first Italian artists to make use of the printmaking technique of *etching*, developed in Germany early in the sixteenth century. The most famous of his etchings was the *Entombment of Christ*, copied by several artists and widely circulated in his time. He also made designs for printing chiaroscuro woodcuts. His print work probably inspired Primaticcio, Rosso Fiorentino, and other artists of the Fontainebleau school in France.

Mannerist Sculpture

A large number of sculptors also worked in the Mannerist idiom. The most famous of them were Benvenuto Cellini and Giovanni da Bologna.

BENVENUTO CELLINI

Benvenuto Cellini (1500–1571) is well known for his *Autobiography* as well as for his works. He was a Florentine, trained as a goldsmith and sculptor. His life makes exciting reading.

Saltcellar of Francis I. Among the most entrancing of his surviving works in gold is the large (for its genre), 10¼-by-13⅛-inch (26-by-33.3-cm) *Saltcellar of Francis I*, in the Kunsthistorisches Museum in Vienna. Figures in gold of the Earth and Neptune recline on an encrusted base. Neptune guards a tiny boat-shaped salt cellar. The personified Earth governs a small triumphal arch designed to hold ground pepper. The languid figures possibly relate to the personified times of day in Michelangelo's Medici Chapel, as has been suggested, but their proportions are closer to the Mannerist ideal.

Perseus with the Head of Medusa. Cellini's full-scale sculpture *Perseus with the Head of Medusa*, 18 feet (5.48 m) high overall, stands in the Loggia dei Lanzi in the Piazza della Signoria in Florence. The figure of Perseus ripples with muscles more reminiscent of Signorelli or Pollaiuolo than the broader-muscled Michelangelo figures usually compared with it. Perseus holds aloft the severed head of the slain Gorgon. Her body lies at his feet. The blood gushing from her neck and head has frozen into twisted gobbets of coral.

GIOVANNI DA BOLOGNA

Jean Bologne (1529–1608) was a Flemish sculptor known in Florence, where he lived and worked as Giovanni Bologna, or Giambologna. He made the sculpture *Abduction of the Sabine Women* in 1583. It stands in the Loggia dei Lanzi near Cellini's *Perseus*. The title was applied after the work was complete. Its important feature is the multidirectional or continuous vantage point for the viewer to observe the work. The turning, varied positions of the three figures allow this, but they leave us a three-dimensional version of the puzzle in Pontormo's *Entombment*. We cannot determine what action will follow or what stage in the narrative animates the figures.

Mannerist Architecture

There is much diversity in architecture just as there is in painting and sculpture in the sixteenth century after the High Renaissance. In Florence the aforementioned Giorgio Vasari worked at about the same time as Bartolommeo Ammanati, sculptor and architect (1511–1592). Ammanati built the Palazzo Pitti from 1558 to 1560. The building is also an important museum today. The Pitti Palace is decorated with extensive *rustication* across its walls and columns. These give it a look of excessive decoration at the expense of the apparent strength of the order.

GIULIO ROMANO

Raphael's pupil, Giulio Romano (c. 1492–1546), was both painter and architect. In Rome he had assisted Raphael in painting the Stanze and the Loggie nearby in the Vatican Palace.

Palazzo del Te. Giulio Romano's most famous building is the Palazzo del Te, built 1525–1535. It was a commission from Federigo Gonzaga the Mantuan duke, for a summer retreat and stud farm. A brief look at the façades on the north side and in the court reveals a wholly deliberate anti-Classical irregularity of almost every element. On the north side the pilasters are unevenly spaced, the entrance is off center, and it is unclear whether the building has one or two stories inside. Looking at the building from the court, one sees slipped sections of architrave, unsettled keystones, and disproportionate elements of the Doric order.

With his painter's skills, Giulio Romano decorated one room, the Sala del Giganti, with frescoes showing an entire architectural collapse.

THE VENETIAN SCHOOL

The art of Venice emerged in the fifteenth and sixteenth centuries at a different pace and with differing ideals from those of Florence and Rome. Venice's long history of interaction with northern Europe and with the Byzantine East fostered a different development. There is no question that Venice shared in High Renaissance triumph, however. The masters who painted here in the sixteenth century produced works that were as widely influential as any from central Italy, and many artists from afar honed their skills in Venice at some point in their lives.

Venetian Painting

THE BELLINIS

Among the best contributions to the art of the Renaissance in Venice were those of the Bellini family of artists, active from the late fifteenth century into the sixteenth century. Jacopo (c. 1396?–1470), scion of the family, had been a pupil of Gentile da Fabriano. Little of his work remains. He was interested in Renaissance perspective and in the return to antiquity. Two of his sketchbooks are preserved. Gentile Bellini (c. 1429–1507) painted portraits and Venetian architectural landscapes and historical narratives. Giovanni Bellini (c. 1430–1516), whom we discussed in chapter 12, was a pupil of his father and brother. A new style of style of painting appears in his large *San Zaccaria Altarpiece* of 1505. The changes introduced into this work in comparison to the *San Giobbe Altarpiece* of 1490 are substantial. The artist has reduced the number of figures and clarified the space. The early Renaissance emphasis on perspective is relaxed, and a breathable atmosphere of light and shadow permeates the pictorial space.

Feast of the Gods. Giovanni Bellini painted the Feast of the Gods, now in the National Gallery, Washington, D.C., in 1514, a pastoral representation of the Olympian gods in a mildly bawdy picnic in a subtly colorful,

idyllic setting. The painting was made after the death of Bellini's pupil, Giorgione, and its landscape background is thought to be by Titian, another Bellini pupil.

GIORGIONE

Giovanni Bellini's pupil, Giorgio da Castelfranco (1478–1510), called Giorgione, had a major influence on Venetian art despite his very short career. His paintings include *Venus Asleep,* in the Gemäldegalerie, Dresden; the *Three Philosophers,* in the Kunsthistorisches Museum, Vienna; the *Tempest,* in the Accademia, Venice; and the *Castelfranco Madonna,* in the Cathedral, Castelfranco. All incorporate a special approach to space, color, and form closely related to both Bellini and Titian.

The Tempest. Around 1505 Giorgione painted *The Tempest,* an enigmatic landscape with figures. The subject, if indeed the figures present relate to some particular story or event, is unknown.

The whole painting is beautifully modulated. Foreground sunlight contrasts with the background of an approaching thunderstorm. In a glade by some ruins and a spring is a young woman, nude but for a mantle on her shoulders, nursing an infant. A young man standing in the left foreground with a tall staff glances in her direction. Buildings and trees appear in the distance along a riverbank with a rustic bridge. A flash of lightning in the sky reflected in the stream provides the drama.

TITIAN

Tiziano Veccelli (c. 1488–1576), called Titian, was also a pupil of Giovanni Bellini. He is the best known of all Venetian artists, and his painting style, which developed early and is close to that of Giorgione, continued to develop during a long, rich career.

Madonna of the Pesaro Family. Titian's paintings include mythologies, great altarpieces, and portraits. His power is found early in the *Madonna of the Pesaro Family,* 1519–1526, in Santa Maria dei Frari in Venice. The large 16-by-9-foot (4.87-by-2.74 m) painting commemorates a victory on behalf of the papacy against the Turkish forces in the Venetian-Turkish war. Thus the victor, Jacopo Pesaro, kneels at the foot of a podium in adoration of the Virgin and Child enthroned. St. Peter introduces him and a soldier saint, most probably St. James, Jacopo's patron saint and himself a victor over the forces of Islam, holds the papal banner and leads a turbanned captive to the throne.

Unlike any previous altarpieces, the Virgin appears near the right edge of the painting and the podium recedes diagonally into the space to the left. This visual depth corresponds to the angle that the viewer comes upon this painting to the left of the nave of the church. The result is an almost startling continuation of real space into the picture itself. The pyramidal form of a Renaissance *sacra conversazione* has been modified, though not lost, in this

inventive approach. To the right and below the Virgin are two additional saints and other members of the Pesaro family.

The Venus of Urbino. Titian's mythological paintings, an early *Bacchanal,* of 1514 in the Prado, Madrid, and *Sacred and Profane Love*, in the Borghese Gallery in Rome, painted in 1515, adopt Giorgione's serene Arcadian spirit. His painting of a reclining Venus, known as *The Venus of Urbino*, was painted for the duke of Urbino in 1538. It reflects the *Sleeping Venus* of Giorgione. These paintings validate an extensive tradition in the art of Europe for representation of the reclining nude figure.

Titian's Venus reposes on a couch in an interior. Two satiny white pillows support her head and shoulders. She reclines in a shallow, diagonal slope across the width of the picture, languidly returning the viewer's gaze. Past a drapery that half conceals the background we see into greater depth. Two servants, one rummaging in a great *cassone,* are at the far side of the room near a window. A silhouetted plant and tree appear against a lowering sky. Subtle patterns of light and color make a serene balance in the painting. Gone are the pastoral, rustic, or Arcadian implications of Giorgione's Classicism. This is a luxuriant Venus, a goddess of love quite literally incarnate.

TINTORETTO

Jacopo Robusti (1518–1594), called Tintoretto, was the leading Mannerist painter of Venice. He was an prodigious painter of great inventive ability. Many of his works are densely populated with very active figures. He always seems to be in greater control of space and depth than the Florentine Mannerists, but light color and motion play across the surface of his works ceaselessly. He is noted for holding the color of Titian and the design of Michelangelo as ideals for himself. His use of them was intensely personal. Tintoretto painted many cycles of works in the Scuola Grande de San Marco, the Scuola Grande di San Rocco, and others.

The Last Supper. Tintoretto painted several versions of the Last Supper, particularly one in the church of San Giorgio Maggiore, in 1594. Here color and design are controlled by the light sources, a single lamp to the left and the radiant halo of Christ in the center background. Ghostly angels circle the lamp and hover near the ceiling as the Apostles are served at a long diagonally receding table. Judas is once again isolated to the wrong side of the long table as in Andrea del Castagno's painting in Florence. Here the diagonal perspective, the flurry of servants, and the gloomy atmospheric darkness invigorate the scene. We sense the intensity of the moment.

VERONESE

Paolo Caliare (1528–1588), called Veronese, was an assistant of Titian for a period. His art centers around a rich pageantry enveloping scenes in colossal architectural settings, splendid color, and a surfeit of detail.

Christ in the House of Levi. One of Veronese's paintings was commissioned as a Last Supper. It shows the event taking place in an arcaded loggia with a vast array of figures in addition to Christ and his Apostles. They include noblemen, German soldiers, servants, clowns, dwarfs, dogs, and others.

In answer to a complaint, Veronese had to testify to the Holy Inquisition in defense of his painting. Rather than alter it, he renamed it *Christ in the House of Levi*. His honest and cantankerous testimony survives:

Q.: Who do you really believe was present at that Supper?

A.: I believe one would find Christ and His Apostles. But if in a picture there is some space to spare I enrich it with figures according to the stories.

Q.: Did anyone commission you to paint Germans, buffoons, and similar things in that picture?

A.: No, milords, but I received the commission to decorate the picture as I saw fit. It is large and, it seemed to me, it could hold many figures.

Q.: Are not the decorations which you painters are accustomed to add to paintings . . . supposed to be suitable and proper to the subject . . . ?

A.: I paint pictures as I see fit and as well as my talent permits. ... (Holt, 1957).

High Renaissance Architecture in Venice

JACOPO SANSOVINO

Jacopo Tatti (1486–1573), who took his teacher Andrea Sansovino's name, was trained as a sculptor, but in Rome, influenced by Bramante's followers, he turned to architecture as a major interest. In Venice, to which he fled after the sack of Rome in 1527, he became the city's leading architect.

There he built the Zecca (Mint) and the State Library of San Marco across the Piazetta from the Gothic Doge's Palace on the Canale di San Marco. The buildings were begun in 1535 and 1536 and introduce High Renaissance architecture into Venice. The Zecca, with its three stories of heavy rustication and heavy cornices, seems a fortified Renaissance palace. The library is more delicate in its open two-story elevation with rich columns and a decorative balustrade atop its upper story.

PALLADIO

Andrea Palladio (1508–1580) succeeded Sansovino as chief architect of the Venetian Republic. He was also an architectural theorist who wrote his own treatise on architecture, *The Four Books on Architecture,* first published in 1570. He had studied ancient buildings at first hand in Rome

and illustrated an edition of Vitruvius. Palladio was second only to Michelangelo among architects of the sixteenth century as the most influential on subsequentarchitecturalhistory.

Villa Rotonda. Palladio's most famous, though not most typical, secular building is the Villa Rotonda, near Vicenza, built between 1566 and 1570. It was built as a retreat for social events rather than a residence. As such, its symmetrical plan provides engaging landscape views in four directions from four colonnaded porticoes. They front a square, domed structure. Symmetrical divisions of rooms around a central, round hall grace the main floor of the villa.

The Church of San Giorgio Maggiore. In 1565 work began on the Church of San Giorgio Maggiore in Venice, opposite San Marco across the Canale di San Marco. This domed basilican church has groin vaulting in nave and choir. The high nave is fronted by a tall narrow Classical porch, its columns set on high *plinths*. This is superimposed on a lower, wide temple façade that fronts the aisles on either side of the nave. The combined forms, richly embellished with sculpture and architectural detail, work effectively to conform traditional church form with Classical detail.

*I*t *is only natural, perhaps, to think of the High Renaissance as a high point, if not* the *high point, in the history of art. The time was, after all, shared by Leonardo, Michelangelo, Raphael, and Titian. Moreover, traditional art history grows from* The Lives of the Artists *by Giorgio Vasari, whose writing is based on that premise. At least until recently Vasari's assertions have patterned art historical approaches.*

Certainly we see the antecedents of these masters in the artists of the fifteenth century. Just as certainly we see that their followers, Vasari among them, changed the concepts of art so drastically as to indicate a crisis of confidence. It takes a hard look to realize that it was not a crisis of self-confidence but a much braver attempt to redefine artistic objectives. The change was necessary and inevitable; the genius in it has been obscured by the achievements of those High Renaissance titans.

There is further no question that the masters of the High Renaissance had a lasting impact upon successive generations of followers and changes of style. It is likely that this period, which created so many icons of Western civilization, will continue to be an intensely admired resolution of the Renaissance, an integration of the arts of Classical antiquity with the Christian humanism of early modern Europe.

Selected Readings

Ackerman, J. S., and J. Newman. *The Architecture of Michelangelo.* Harmondsworth, Baltimore: Penguin, 1971.

Beck, J. H. *Raphael.* New York: Abrams, 1976.

Clark, K. M. *Leonardo da Vinci.* rev. ed. Baltimore: Penguin, 1967.

Freedburg, S. J. *Painting in Italy: 1500–1600.* rev. ed. Harmondsworth, Baltimore: Penguin, 1975.

Holt, E. G., ed. *A Documentary History of Art.* vol. 2, *Michelangelo and the Mannerists.* 2d ed. Garden City, NY: Doubleday, 1957.

Klein, R., and H. Zerner. *Italian Art, 1500–1600: Sources and Documents.* Englewood Cliffs, NJ: Prentice-Hall, 1966.

Levey, M. *High Renaissance: Style and Civilization.* Baltimore: Penguin, 1975.

Murray, L. *The High Renaissance and Mannerism: Italy, the North, and Spain, 1500–1600.* New York: Oxford University Press, 1977.

Pope-Hennessey, J. *Italian High Renaissance and Baroque Sculpture.* 3 vols. London: Phaidon, 1963.

Shearman, J. K. G. *Mannerism: Style and Civilization.* Baltimore: Penguin, 1967.

Smyth, C. H. *Mannerism and Maniera.* Locust Valley, NY: Augustin, 1963.

Wethey, H. E. *The Paintings of Titian.* 2 vols. London: Phaidon, 1969–1971.

17

The Art of the High Renaissance in Northern Europe

For most of the fifteenth century little of the movement that swept through Italy made itself felt in other European centers. The Renaissance remained a particular Italian phenomenon until it was well defined and theoretically stabilized by its great fifteenth-century practitioners. The Late Gothic world in Germany, France, the Netherlands, England, and Spain only gradually received these new art forms with responsive results.

The art of the Renaissance, when it finally took hold outside of Italy, never had quite the same objectives or identification with Classical antiquity. Artists were still accustomed to the ideals and concepts of their own culture. They became more Italianate only as they came to live and work in Italian centers. This became a trend in the sixteenth century.

In particular, Venice and Rome attracted northerners, the former for its long-standing trade and cross-cultural connections, the latter for its fame and reputation as a High Renaissance center. The art that these visitors and emulators of Renaissance principles produced has its own traditions and values and its own legacy in succeeding generations.

SIXTEENTH-CENTURY GERMAN ART

Germany produced a number of significant artists in the fifteenth century, from the Parler family, active mostly in Bohemia, to Konrad Witz, Michael Pacher, and Martin Schongauer. In the sixteenth century a new and especially vigorous art proceeded from a variety of intensely individualistic, productive, and inventive masters, particularly in painting and the graphic arts.

Painting and Graphic Arts

ALBRECHT DÜRER

Albrecht Dürer (1471–1528) of Nuremberg was the son of a goldsmith. He was apprenticed to a Nuremberg artist, Michael Wolgemut, whose shop produced everything from book illustrations in woodcut to complex altarpieces. Dürer's training at home and in Wolgemut's shop prepared him for practice in the graphic techniques, for which he is particularly famous, and as a painter. Of all the German artists of the period, he is the best known and the most prolific.

Early in his life, Dürer discovered Italian art through engravings made by Pollaiuolo and Mantegna. Their influence and his acquaintance with the new humanism of Renaissance Italy introduced to him by his contemporary and friend, the German humanist Wilibald Pirckheimer, were to inspire him to seek out Renaissance concepts and theory. As Dürer himself saw it, his special mission in life was to bring this new concept of art to his fellow artists in German lands.

Dürer visited Italy as early as 1495. His direct contact with artists of Italy, especially Giovanni Bellini in Venice and possibly Mantegna at Mantua, had a profound effect upon his art. Because one of the chief ways that Dürer chose to work in was printmaking, his work circulated rapidly and widely. By 1500, work from his Nuremberg studio was known and studied in almost every part of Europe.

Apocalypse. In 1498 Dürer published a series of woodcuts that visualized the text of the Apocalypse in fourteen prints. These appeared in a bound set with text on the reverse of the prints and a frontispiece showing one of the torments of St. John the Evangelist, the author. The power of

Dürer's interpretation of St. John's vision transformed the concept of wood-cut into a wholly recognized art form. Dürer's *Apocalypse* appeared in two editions, one in Latin and one in German. The Latin version was republished in 1511.

The Four Horsemen, the best known of these woodcuts, follows the textual description (Rev. 6:2–8) and converts it to a vivid image through the controlled and contrasted use of light and dark by the power of linear design alone. The riders, grouped and sinister, gallop across a turbulent sky. Nearest is Death upon his pale horse followed closely by the devouring mouth of Hell.

The theme reflects Gothic visualizations of the Last Judgment, but its power comes from the artist's clear study of Mantegna's art and his own ability to transform verbal description into visual images as immediate as if drawn from direct experience.

The Fall of Man. Dürer began making engravings as early as he made woodcuts. In Venice he had drawn exact copies of Mantegna engravings, and during his early period he created a number of prints with Classical- or Renaissance-inspired themes. In 1504 he produced the engraving *The Fall of Man,* which follows Renaissance ideals, showing the figures of Adam and Eve as proportional studies modeled after the antique. Adam is modeled on a figure of Apollo, and Eve is derived from a Venus. They stand frontally, side by side. Each is more an example of Classical form than a participant in a human drama.

Even the animals, suggestive of the Creation, have been chosen for symbolic reasons. The four main creatures—cat, rabbit, ox, and elk—represent the four humors. These were believed in ancient times and even in the Renaissance to represent the characteristics of all persons, variously dominant in people of differing natures. The humors were in balance before the Fall, just as the first humans were perfect, but the actions of Adam and Eve cost them and all their descendants this stability and this perfection of form.

The Master Prints. In 1513 and 1514 Dürer made three engravings often called his master prints. They include the *Knight, Death and the Devil; St. Jerome in His Study;* and *Melancolia I.* Each is the same size, 9.5 inches by 7.5 inches (24.13 by 19.05 cm). They probably symbolize the moral, religious, and intellectual virtues, respectively. They show an incomparable mastery of the engraving process.

Dürer also has the capacity to astonish us with the fresh brightness of his watercolors, the descriptive intricacy in his drawings, and the insights and depth of perception in oil portraits of himself and his contemporaries. He painted altarpieces and religious works and drew everything one could think of, from a few blades of grass with some wildflowers to maps of the heavens.

MATTHIAS GRÜNEWALD

Albrecht Dürer's great contemporary was Mathis Gotthart Neithart, known as Grünewald. Very little biographical information survives about this rare artist. He appears to have lived at just the same time as Dürer; his death was also in 1528. He was not a printmaker and his reaction to the Renaissance could not have been more different from Dürer's.

Grünewald lived in a series of German cities, longest perhaps in Mainz, where he was court painter to a series of electors of Mainz between 1508 and 1526. His most famous work is the assortment of paintings he did for a great altarpiece at the monastery at Isenheim.

The Isenheim Altarpiece. *The Isenheim Altarpiece* was finished in 1515. At its core was a sculpture of St. Anthony, patron saint of the monastery, carved by Niklaus Hagenower. A *predella* beneath, two pairs of folding wings, and another fixed pair of wings, all with paintings, were all added to the work by Grünewald.

Closed, the altarpiece displays *The Crucifixion of Christ*, one of the most powerful, discomforting representations of this scene ever painted. Christ appears in it, dead of unspeakable suffering, flanked by mourners and by John the Baptist.

Other brilliant paintings of Christ's life and two scenes from the legend of St. Anthony appear as the altarpiece is opened. In each of its stages it was designed to remind the viewer of his faith. The monastery was a hospital for sufferers of skin diseases from which St. Anthony and St. Sebastian, who also appears, were protectors.

Grünewald's color, composition, and expression are brilliant and powerful in this work. Its religious intensity confirms the description of Grünewald as a mystic. The composition and color have been designated "expressionistic," "Late Gothic," and "Mannerist" by assorted authors, terms that would each have to be redefined to accommodate the artist comfortably. Renaissance principles apply to his composition but not to the irregular proportion and intense gestures. The Late Gothic artists could not combine balance and form so successfully, and the Mannerists might well have learned from this work. It anticipates theirs by at least half a decade. A few other paintings and a few drawings also survive from Matthias Grünewald's hand. They are all powerful works, sufficient to remind us what has been lost from the hand of this master.

ALBRECHT ALTDORFER

Albrecht Altdorfer (c. 1480–1538) lived and worked in Regensburg. He was a painter and architect. He also served as a city councillor. Altdorfer was a leading exponent of landscape painting and is often credited with having painted the first true landscapes in Europe. With Lucas Cranach and Wolf Huber, among others, he is counted as an artist of the *Danube School*,

artists who drew and painted using the characteristic landscape along the Danube River in their works. Also a significant master of the graphic arts, Altdorfer made woodcuts and engravings. He also made a number of landscape etchings using this new graphic medium with great skill and control.

Altdorfer's major works are *The St. Florian Altarpiece*, finished in 1518 for the collegiate Church of St. Florian, near Linz, and the large, engaging *Battle of Alexander*, painted from 1528 to 1529, discussed in the Introduction.

LUCAS CRANACH THE ELDER

Lucas Cranach (1472–1553) lived and worked primarily in Wittenberg after an early start in Vienna. He was court painter to the electors of Saxony, but he also met and befriended Martin Luther, for whom he made propaganda woodcuts. His use of landscape in early paintings and prints links him to the Danube School with Altdorfer and others (though these artists never worked together).

Many of the court paintings he made are of mythological or Classical subjects such as the *Judgment of Paris* of 1530, in the Staatliche Kunsthalle in Karlsruhe. They are highly stylized paintings, little influenced by Classical proportions or ideals. The stylized nudes are naïve and quite innocent. His gods and heroes often wear German parade armor.

Cranach was a good portraitist. Martin Luther, Philip Melancthon, and many members of the Saxon court sat for him. His sons, Hans and Lucas the Younger, continued his workshop.

HANS HOLBEIN

The painter Hans Holbein the Younger (c. 1497–1543) was the son of an Augsburg painter. Hans the Younger was a printmaker, illustrator, and painter. He worked in Basel and particularly in London, where he painted for the English court headed by Henry VIII and Thomas More, the court chancellor. Holbein's most famous works are portraits, particularly those of Henry VIII, some of his prospective wives, Thomas More, and others of the court.

The French Ambassadors. Holbein painted *The French Ambassadors*, depicting Jean de Dinteville and Georges de Selve, in 1453. The work is now in the National Gallery, London. It is a large balanced composition of the two full-length figures, nearly 7 feet (2.3 m) square. Dinteville wears an ornate court costume; de Selve, a churchman, wears dark and somber rich velvet. Both were humanists and their interests and occupations are symbolized by the array of still-life objects arranged on a table between them. Globes, scientific instruments, a lute, and religious treatises are distributed in exacting detail on the tabletop and a lower shelf. Heavy green drapery hangs behind them, and the patterned tile floor suggests a noble chamber.

Across the bottom foreground is an anamorphic (deliberately distorted) representation of a skull, ostensibly a *memento mori,* a caution against the sin of vainglory. Neither man can see it properly from his own position. It is visible by looking at the picture at close range from the lower left corner.

Sculpture

Both Tilmann Riemenschneider and Veit Stoss lived well into the sixteenth century and continued to produce great works. The effects of the Renaissance were limited on their works, though an increased monumentality, perhaps based on influence from Dürer, can be seen. An extremely rich and decorative style evolved in early sixteenth-century Germany, given the contradictory name of Late Gothic Baroque. An unknown artist, called the Master H. L., was the virtuoso of this style.

SIXTEENTH-CENTURY ART OF THE NETHERLANDS

After the death of his patron, Maximilian I, Albrecht Dürer traveled to the Netherlands to seek continued support from Charles of Burgundy. There he was shown works by Roger van der Weyden, Jan van Eyck, Hugo van der Goes, and other fifteenth-century masters. He met the painters Barent van Orly, Joos van Cleve, Joachim Patenir, and many other artists. He was shown Quentin Massys's studio.

He also saw and admired treasures sent back to the emperor from newly conquered Mexico by Hernando Cortez. Antwerp, where he based his visit, was a newly important city, its harbor the best of the Netherlands, filled with foreign trading ships. Antwerp became the cultural center of the arts of the sixteenth-century Netherlands.

Quentin Massys

The painter Quentin Massys (c. 1465–1530) was the leading artist in Antwerp at the time of Dürer's visit. His *St. Anne Altarpiece* is a triptych painted in 1509 for the Leuven Brotherhood of St. Anne. It is in the Musée Royaux des Beaux-Arts in Antwerp.

The central panel shows a *Holy Kinship,* the traditional extended family of Mary and Joseph. It is composed within a fantasy of architecture, inspired by Renaissance models. The symmetrical arrangement of the figures is also based on Renaissance models. The perspective, color, and tonalities have been compared to Venetian paintings by Giovanni Bellini and his contemporaries. These comparisons have led to speculation that Massys may have visited Venice, not an unlikely event.

Later, Quentin Massys would encounter works by Leonardo da Vinci and Raphael. These would give his work even stronger association with the Renaissance. The magnificent *Lamentation Altarpiece* in the Musée Royale des Beaux-Arts in Antwerp, with its powerful arrangement of mourning figure, behind the prostrate dead Christ, is an early example. It was finished in 1511, just three years after the St. Anne triptych.

Joachim Patinir

Joachim Patinir (c. 1485–1524) also worked in Antwerp. He was a painter who emphasized landscape in almost all of his works. Indeed, on occasion he was employed to paint the landscape backgrounds in paintings by Massys. After Altdorfer and the German Danube school artists, landscape began to find emphasis in the work of many painters in northern Europe. Patinir was one of the best of these. Small-scale figures appear in his paintings before great rock outcroppings, vistas of fields and farms, villages, and distant blue mountains.

ST. JEROME IN A LANDSCAPE

Several versions of *St. Jerome in a Landscape* were painted by the artist, more as an excuse for a wilderness landscape than to focus on the saint's penance, meditations, or ministrations to an injured lion. They reveal a fanciful and stylized world view and deeper lowlands space than one encounters in hilly Germany.

They also retain the northern appetite for detail; atmospheric effect does not diminish the paths, buildings, flora, and fauna in his wildernesses; and the elevated viewpoint gives one a different perspective from the Venetian landscapes in works by Giorgione and Titian.

Jan Gossaert (Mabuse)

Jan Gossaert (c. 1478–1535) signed himself "Mabuse" after his hometown. He visited Italy in 1508 and 1509 and was credited by Vasari with being the first Netherlands artist to compose with nude figures in the Italian fashion. He is one of the first *Romanists*, the term used for Flemish artists who visited Italy and fell under the spell of Michelangelo and Raphael. The influence of his predecessors from the Netherlands and of Dürer is also present in his works.

NEPTUNE AND AMPHITRITE

Jan Gossaert's painting *Neptune and Amphitrite*, in the Staatliche Museen, in Berlin, is composed of nude figures in a Renaissance architectural setting. Neptune holds a great trident, his hair is waved in great billows, and a seashell held in place by seaweed replaces a fig leaf. Gossaert's figures of the maritime deities, nonetheless, are derived from Dürer's *Fall of Man* engraving, though they have been inflated and stiffened somewhat.

Pieter Bruegel the Elder

Pieter Bruegel (c. 1525–1569) was the greatest Flemish sixteenth-century artist. He painted village and peasant life, biblical scenes, parables, and landscapes with a remarkable vitality. He was able to see through human nature to find its serious and comic sides without belittling or romanticizing it. In this his acumen is similar to that of Rembrandt in the next century. He shares nearly universal admiration with Rembrandt.

HUNTERS IN THE SNOW

One of a series of seasonal paintings Bruegel made in 1465 is *Hunters in the Snow,* in the Kunsthistorisches Museum in Vienna. It shows a characteristically bleak, cold day at evening with a small group of hunters and their tired hounds trudging homeward down a hillside to the village sprawled below. Snow blankets the whole deep landscape, back across the town to the fields and Alpine mountains that rise in the distance. Silhouetted with the hunters against the snowy land is a line of winter-bare trees marking their homeward progress.

THE PEASANT WEDDING

Bruegel painted many scenes in which ordinary, rustic, and simple villagers or farmers are the protagonists. These peasant dances, festivals, and ceremonials can be interpreted on many levels, yet they have an immediacy and guileless honesty that appeals to all. *The Peasant Wedding* is also in the Kunsthistorisches Museum. Here a feast takes place within a huge barn. Twenty-odd people sit at a great table that recedes diagonally from the right. More than twenty others serve, play music, or crowd in through the doors in the left background. In the subdued interior light we still see bright colorful costumes and can isolate the bride. She wears a ceremonial crown and sits before a special cloth of honor that hangs in front of the neatly stacked hay in the chambered haymow behind her. The groom is not identified.

We see a hungry musician, a tipsy guest, and a cheerful gathering of friends. A crude old shutter is used as a serving tray; huge earthenware winepots supply the feast. The idyll is of an honest and moral society, secure in its own traditions and lifeways, seeking neither change nor redress.

SIXTEENTH-CENTURY FRENCH ART

Francis I, king of France from 1515 to 1547, made a conscious effort to bring the Renaissance to his country. France had held Milan since 1499, and both Leonardo da Vinci and Andrea del Sarto had responded to offers of work in France. The court of Francis I was even more successful with the Mannerists. Rosso Fiorentino, Francesco Primaticcio, and Benvenuto Cellini all worked for Francis at Fontainebleau.

The School of Fontainebleau

Rosso and Primaticcio were responsible for the stucco and painted decorations of the gallery of Francis I at Fontainebleau with mythological scenes. The style, known as the School of Fontainebleau, produced a number of French followers. The Mannerist features of this style included "suave, artificial, elegant, and erotic art." It appears in painting, sculpture, and graphic arts.

Renaissance Architecture

CHÂTEAU DE CHAMBORD

A follower of Giuliano da Sangallo provided designs for the construction of the Château de Chambord, begun in 1519. Chambord was built like many older countryside fortified retreats for French nobility, except to a regularized plan. It is square with round towers at the corners. The main buildings are three-storied, with Classical piers and entablatures, pediments, and other Renaissance features. The roofline is still a forest of pinnacles, chimneys, dormers, and lanterns, much like the medieval châteaux that preceded it.

PIERRE LESCOT

The Louvre. The architect Pierre Lescot (1510–1578) began a project to rebuild the old Louvre in Paris for Francis I in 1546. Francis died in the following year and his successor, Henry II, maintained the project. The old Louvre, originally built at the end of the twelfth century as a fort to defend the west side of Paris against invaders, was modified as a royal residence by Charles V of France late in the fourteenth century. Now it was to be successively torn down and replaced, eventually, by the enormous complex that is found there now.

Lescot planned a more modest reconstruction. He wished to tear down the old circular *keep* and to replace the four sides that surrounded it with a more spacious, Classically inspired square around an open court. The west section of this project was built, and still stands, incorporated into the whole. As work progressed the court size was quadrupled and the square court would represent only the southwest quarter of the whole. In form Lescot's design stands for French, and essentially northern European, Renaissance architecture. There are three clearly demarcated stories. An arcade flanked by piers is on the first level, large windows with pediments alternately triangular and arched are on the main floor, and the smaller third story is topped by a sloping roof. The façade is accented by vertical pavilions in the center and at each end. Paired columns framing a niche form the dominant motif of the pavilions.

JEAN GOUJON

The façade of The Louvre designed by Lescot is enhanced by sculpture, another feature that will be richly incorporated into northern European Renaissance building. The sculptor for Lescot was Jean Goujon (c.

1510–1565), who had learned his style at Fontainebleau from Primaticcio and Cellini. His own style is delicate yet strong, elongate but not disproportionate.

The Fountain of the Innocents. Goujon's reliefs of nymphs on the Fountain of the Innocents in Paris are good examples of his style. They were done in 1549. Their light flowing drapery is Classical in style, their gestures graceful and elegant.

GERMAIN PILON

Germain Pilon (c. 1535–1590) was the most accomplished French sculptor of the sixteenth century. His art progressed from a Mannerism generated by the Fontainebleau sculptors to a far more profound realism in his masterpieces, the tombs of Francis I (1559) and Henry II (1564–1583), at St.-Denis on the outskirts of Paris.

SPANISH RENAISSANCE ART

Charles V became emperor on the death of his grandfather, Maximilian I, in 1519. His lands included Holland and Spain, much of Germany, Austria, and Bohemia, and a great portion of the New World in South and Central America and Mexico. He and his successor son, Philip II, ruled a vast portion of the world.

Spanish interests in particular dictated much of European history in the sixteenth century. Spanish influence spurred the Counter Reformation and church reform at the Council of Trent. These reforms of the church were enforced by the Inquisition and by the Jesuit order, founded by the Spaniard St. Ignatius Loyola. Spain's power was backed by enormous treasure ransacked from the Americas during the sixteenth century.

During the fifteenth century, Spanish art had been little influenced by Italy. Spain's own Late Gothic architectural style, the *plateresque,* combines Flamboyant Gothic elements with a particular love for small-scale detail. *Platero* in Spanish is a "silversmith," and the style seems to reflect the metalworkers' craft. Painting was profoundly influenced by the Flemish artists in this period.

Renaissance Architecture

The sixteenth century saw the introduction of a new architectural style to Spain. Both Charles V and Philip II ordered buildings that reflected a wider scope and an interest in the Renaissance. Charles had been a patron of Titian. In 1526 he employed the painter-architect Pedro Machucha (active 1520–1550) to build his palace in Grenada. It used the Classical orders and a simple, cubical form for its structure, elaborated by a circular, two-storied

colonnade on its interior court. The construction of the palace never was completed.

Philip II employed architects, chiefly Juan de Herrera (1530–1597), to build the Escorial palace near Madrid. Construction continued from 1563 to 1584. The complex is dominated by the dome and towers of a huge church. Square towers mark the corners of the large rectangular complex, 625 by 520 feet (190.5 by 158.5 m). It was built as a residence, mausoleum, and palace for the Spanish monarchy.

The Classicism of the building is predominantly Doric and little decorated. The gray-granite stone increases the severe appearance of the structure. It was within these walls, however, that the art collections begun by Charles V and enlarged enormously by Philip II were kept. They formed the nucleus, eventually, of the Prado Museum collections in Madrid.

El Greco

The leading Spanish artist of the late sixteenth century was actually a Greek, born on Crete and trained in Venice, where both Titian and Tintoretto affected his style. Called El Greco ("The Greek"), Domenikos Theotokopoulos (1541–1614) is also reported to have visited Rome. Some contact with Mannerism of the Roman and Florentine varieties is said to be discernible in his work.

THE BURIAL OF COUNT ORGAZ

The masterpiece of El Greco's middle phase of painting, from about 1580 to 1604, is *The Burial of Count Orgaz,* in the church of Santo Tomé in Toledo, where the artist settled. The huge canvas, 16 feet by 12 feet (4.87 by 3.65 m) shows the miraculous appearance of St. Stephen and St. Augustine at the burial of the church's benefactor in 1323.

The two saints lower the dead count reverently into his tomb. A solemn row of black-clad witnesses stands behind the group, while churchmen, a monk on the left and priests at the right, celebrate the Mass of the Dead. Overhead, an angel bears the soul of the count toward the heavens between the narrow opening of clouds. On the clouds appear the Virgin Mary and John the Baptist, who intercede for him. The Lord and his saints in great numbers appear at the upper level.

VIEW OF TOLEDO

El Greco's late works are more animated and abstract, called "mystical" by some authors. One of these is a landscape, *View of Toledo,* painted in 1610 and now in the Metropolitan Museum of Art in New York City. The recognizable buildings, towers, and walls have been painted on an exaggerated hillside (Toledo is on a low, sloping hill) and with a luminosity that radiates from a stormy sky with broken clouds, dramatically contrasting sunlight and shadow. It is a skillful and evocative landscape painting as

dramatic in its almost uninhabited isolation as the infinitely crowded land-scape of Altdorfer's great *Battle of Alexander*.

There is no doubt that the enormous artistic movement of the high Renaissance in Italy had a tremendous effect on European art at large. At the same time there are great individuals in other European lands whose art is of similar power. Dürer, Grünewald, Bruegel, and El Greco are such persons.

In the sixteenth century the Protestant split with the Roman church represents one distancing element. Various regional revolts and an increasing awareness of the plight of the common people represent trends that will change patronage, subject matter, and emphasis in the art of the northern Europeans in this and subsequent centuries.

The changes are dramatic, and by the end of the century they affect all kinds of artistic expression. The next generation of artists, working at the beginning of the seventeenth century, finds an entirely new way to combine the energy of Mannerism with the power and logic of the High Renaissance. The internationalism of that age, called the Baroque, has its origins in the diversity of the sixteenth century.

Selected Readings

Baxandall, M. *The Limewood Sculptors of Renaissance Germany*. New Haven, CT/London: Yale University Press, 1980.

Benesch, O. *The Art of the Renaissance in Northern Europe*. rev. ed. London: Phaidon, 1965.

Blunt, A. *Art and Architecture in France, 1500–1700*. 4th ed. Harmondsworth: Penguin, 1981.

Gibson, W. S. *Bruegel*. New York: Oxford University Press, 1977.

Panofsky, E. *The Life and Art of Albrecht Dürer*. 4th ed. Princeton, NJ: Princeton University Press, 1955.

Von der Osten, G., and H. Vey. *Painting and Sculpture in Germany and the Netherlands, 1500–1600*. Baltimore: Penguin, 1969.

18

Baroque Art in Italy and Spain

In art history the term Baroque *is used to define the period from about 1600 to 1750 in Europe. The word derives from the Portuguese* barocco, *which is said to have originally described the irregular shape of pearls. As with Gothic,* Baroque *originated as a derogatory term in art criticism.*

The styles of Baroque are many, although the period itself is short. It is an international phenomenon with strong regional characteristics. There are definite personalities in the Baroque period whose individuality, like that of High Renaissance masters, puts a regional or personal stamp on

the art Baroque art is dynamic, sometimes theatrical, and in some instances tends to combine media more elaborately than either the Gothic or Renaissance periods, though the inspiration comes from both. Increasingly, the patronage of art turns to the secular, aristocratic world, away from the patronage of the Church.

Italy, where our outline survey starts, produced many Baroque artists and lent certain inspiration abroad. The Baroque is not a simple outgrowth of Italian Renaissance art, however; many elements are to be factored into it.

BAROQUE ART IN ITALY

Architecture

Between 1588 and 1590, Michelangelo's pupil, Giacomo della Porta (1533–1602), completed the dome that Michelangelo had designed for St. Peter's in the Vatican. He modified the design by extending the dome's profile upward from the semicircular shape designed by Michelangelo. The drum retains the Classical elements—columns, entablature, and pedimented windows—of the original design, but the curved, ribbed dome is non-Classical in shape. It is a form that will frequently recur in Baroque art and architecture.

IL GESÙ

Della Porta had also completed the façade of Il Gesù, the Jesuit mother church in Rome, in 1584. Il Gesù had been built, beginning in 1568, in a severe Renaissance style conforming to the reform movement of the Jesuit order. The architect was Giacomo Vignola (1507–1573), another of della Porta's teachers. In the façade, della Porta also used some of Michelangelo's motifs in a new combination that would contribute to the formulation of Baroque architecture. The façade is two-storied with a podiumlike space separating the stories.

Wide consoles extend the lower sides of Il Gesù to mask the side chapels flanking the nave. On the ground level the façade is divided by paired pilasters at the outer sides; paired pilasters and an added half pilaster that sets the architrave forward appear at the vertical nave divisions. Pairs of pilasters with columns in the round further accent the center and entrance to the church.

CARLO MADERNO

Elements derived from Michelangelo's architecture but used in ways that Michelangelo never attempted form some of the initial impetus of Baroque architecture. They can also be seen in the work of Carlo Maderno (1556–1629), nephew of the Mannerist architect Domenico Fontana. Fon-

tana had moved the ancient obelisk from Nero's Circus, where St. Peter had been martyred, to the middle of St. Peter's Square.

The Church of Santa Susanna. Carlo Maderno designed the façade of Santa Susanna in Rome in 1597–1604. The façade clearly was inspired by della Porta's Gesù but has been made even more sculptural by increasing the central projection and by great emphasis on the vertical in its narrower, higher proportions. These changes have led many archtectural historians to designate Santa Susanna as the first truly Baroque church.

St. Peter's Basilica. Carlo Maderno was also awarded the task of completing construction of St. Peter's. Here he faced problems that were, perhaps, insurmountable. He was instructed to add three nave bays to the church on the entrance side of Michelangelo's central symmetrical design, and he was also commissioned to design the façade.

With the height and elevation of the dome already established for a centrally planned structure, no maneuvering could adjust the relationship between dome and façade at the increased distance from one another imposed by the addition of length to the nave. Maderno's design was actually never completed as he intended. This accentuates the distancing and disproportion between dome and façade of St. Peter's.

Michelangelo had planned a raised colonnaded porch at the entrance. Maderno placed the pattern of these columns against the façade and planned towers over the outer bays. These would have set dome and entrance in a more comprehensible proportion and affected the proportions of the façade itself, but they were not built. Today, the façade remains a wide screen over which the distant dome seems diminished in scale.

GIANLORENZO BERNINI

Gianlorenzo Bernini (1598–1680), architect and sculptor, was the last major contributor to lend his talents to the building of St. Peter's. His designs remain an important factor in our impression of the final form taken by the church.

The Baldacchino, St. Peter's Basilica. Between 1624 and 1633 Bernini designed the *baldacchino,* a huge bronze canopy over the high altar of the church. It is approximately 100 feet (30.5 m) high and richly sculptural, repeating the spiral shape of columns in Old St. Peter's baldachin, said to have come from Solomon's temple.

The Cathedra Petri, St. Peter's Basilica. From 1656 to 1666, Bernini worked on the Cathedra Petri, an altar at the apse of the church celebrating the throne of St. Peter, using a window and natural daylight for visual focus of the piece. The throne, surrounded by billowing clouds and angels, is supported by Augustine and Ambrose, doctors of the Western or Latin church, and Athanasius and Chrysostom, learned representatives of the Greek church of the East.

The Scala Regia, St. Peter's Basilica. Bernini was also the designer of the Scala Regia, a monumental stair connecting the narthex of St. Peter's with the papal apartments. The Scala Regia rises between the cathedral and the Sistine Chapel in two flights. It diminishes in size as it ascends and a dramatic, proportionally scaled colonnade flanks the stairs. The distant landing is flooded with natural light providing a goal and end to the passage.

The Piazza, St. Peter's Basilica. Finally, in 1657, Bernini gave form to the huge space in front of St. Peter's. The Piazza San Pietro is dominated by an enormous oval centered on the obelisk, its long proportion punctuated by fountains on a north-south axis across the front of the church. The oval is closed on its narrow ends by two curved, double ranks of huge Tuscan Doric columns. The passages angle back to the ends of the narthex in two diverging rows from the oval. They demarcate a vast space, imposing in power yet opening gracefully to the visitor on a religious or cultural pilgrimage.

David. Bernini was an incomparable sculptor as well as architect. His *David,* in the Borghese Gallery, Rome, done in 1623, demonstrates well the evolution from Renaissance to Baroque. It shows David during, rather than before or after, his battle with Goliath. His face is worked up with the effort and tension of attack and his body is a coiled spring about to unwind in action. The energy expands outward in contrast to Giambologna's *Rape of the Sabine Women*.

Sculpture by Bernini, in monumental form or in conjunction with architectural complexes, includes some well-known pieces, such as *Apollo and Daphne*, in which the desirous Apollo in pursuit of the chaste nymph, Daphne, catches her just as she is transformed into a laurel tree by her father, the river god Peneus. Bernini also designed the extraordinary Fountain of the Four Rivers, supporting an ancient Egyptian obelisk in the midpoint of Rome's Piazza Navona, one of many fountains in Rome that he designed.

The Cornaro Chapel, Santa Maria della Vittoria, Rome. A full spectrum of the arts merges in the Cornaro Chapel, which was designed by Bernini in 1645 and completed in 1652. It combines architecture, painting, and sculpture to depict the dramatic ecstasy of St. Teresa, a mystical visionary saint of the sixteenth century. The scene, above the altar, becomes the focus of the entire space of the chapel. Sculptures of the members of the Cornaro family appear at the sides of the chapel in theater boxes; the barrel-vaulted ceiling is concealed by a painted angel host surrounding the dove of the Holy Spirit. The marble group of St. Teresa and an angel with the golden arrow with which he repeatedly pierced her heart is lit by a concealed window, focusing the attention on her moment of religious rapture.

Bernini was the most influential of Roman Baroque artists. His fame was international. Louis XIV of France summoned him to Paris for a proposed redesign of The Louvre in 1665, although his project was rejected as too radical. It would have involved a nearly complete rebuilding of the work already accomplished by Lescot and others.

FRANCESCO BORROMINI

Bernini's great rival in architecture was Francesco Borromini (1559–1667). The churches built by Borromini are magnificent in the precision and elegant use of elliptical and contrasting forms.

The Church of San Carlo alle Quattro Fontane. The small monastery Church of San Carlo alle Quattro Fontane was designed and built from 1638 to 1641, the façade added after 1656. San Carlo's revolutionary, complicated plan is an extended oval between the entry and altar, with walls that undulate, alternately curving inward and outward. The result is two deep recesses at the ends and two shallow recesses along the sides of the church that form chapels.

The later façade of San Carlo is also of great significance because it, too, utilizes a sophisticated curvature combining concave and convex surfaces. Small as it is, San Carlo stands upon a street corner named for the fountains on each corner. Incorporated into the church is a second façade that frames the fountain on its corner at a 45-degree angle from the entrance.

The Chapel of St. Ivo. The chapel of St. Ivo in the courtyard of the College of the Sapienza in Rome was begun in 1642. The façade continues the design of the courtyard by Giacomo della Porta in a connecting exedra. The interior is a complex, six-lobed plan carried upward into a dome in which six piers divide three lobes and three counter spaces aloft. A high lantern and a spiral spire rise above the dome.

The Church of Sant'Agnese. At midpoint on the east long side of Piazza Navona, Borromini began the Church of Sant'Agnese in 1653. It rises just in front of Bernini's Fountain of the Four Rivers. It combines a shallow concave façade with an imposing dome in clear and harmonious relationship along with flanking towers that also are balanced with the whole. The success of this organization of elements is a realization of the intentions never achieved at St. Peter's.

GUARINO GUARINI

Among additional Baroque buildings in Italy are works by Guarino Guarini (1624–1683), who worked primarily in Turin. Guarini was a Theatine priest who had become familiar with Baroque architecture in Rome during his novitiate. After working in Messina and in Paris, Guarini worked for the prince of Savoy in Turin. There he built the Theatine Church of San

Lorenzo with a remarkable dome created of eight intersecting crossing arches opening between their intersection to an octagonal drum.

Guarini's two most famous works in Turin include the Palazzo Carignano, built from 1679 to 1692, and the small dome over the Chapel of the Holy Shroud (Sacra Sindone) in the cathedral, built from 1667 to 1694. The palazzo, entirely of brick construction, is divided into a central convex pavilion separated by two concave sections from lateral pavilions at the corners. Borromini's influence is clear. The Chapel of the Holy Shroud is covered by Guarini's dome, made up of segmental arches staggered to support each other in diminishing spans to a 12-segmented lantern at the top.

BALDASSARE LONGHENA

In Venice, the chief Baroque addition to the city's monuments was the Church of Santa Maria della Salute, designed by Baldassare Longhena (1598–1682) and built over the long period from 1631 to 1687. It stands at the opening of the Grand Canal, not far from San Giorgio Maggiore. The larger section of Santa Maria della Salute is its nave, a large domed octagon, aligned with a choir behind it that is crowned with a smaller dome flanked by bell towers.

The design of the façade resembles a pedimented triumphal arch. The six sides repeat the pattern. Each face of the octagon supports great scroll buttresses, paired at each angle and merging with the drum. These are repeated in miniature in the domed lantern over each dome. Statuary is everywhere, over the pediments, atop the scroll buttresses, in niches, and crowning the lantern domes.

Painting

The brothers Annibale and Antonio Carracci and their cousin Lodovico were Bolognese artists instrumental in the founding, about 1580, of the Bolognese Academy. The academy was based on the principle that art could be taught formally, that exercises in life drawing, perspective, and other disciplined study could impart structure upon the arts. The works of Michelangelo, Raphael, and Titian were held up as models for an anti-Mannerist renewal of the idealization of nature on high Renaissance principles. The Bolognese Academy would become the principal model for academies in Rome, Paris, and ultimately throughout Europe.

ANNIBALE CARRACCI

Annibale (1560–1609) was the most distinguished of the Carracci family of artists. Early study in Parma and Venice in addition to Bologna widened his skills. In Rome, between 1597 and 1604, he supervised and painted the Farnese Gallery in the Palazzo Farnese in Rome for Cardinal Odoardo Farnese, grandson of Pope Paul III.

The Farnese Gallery. The subject of the Farnese Gallery paintings is the loves of the Classical gods. The frescoes encompass the upper walls and ceiling of the reception hall in the palace. They are painted as scenes within a complicated architectural framework that is decoratively ensconced by simulated statuary, reliefs, bronze medallions, and stuccos. The mythologies appear as framed easel pictures in this complex.

The Flight into Egypt. Annibale Carracci painted a variety of works, altarpieces and genre paintings among them. His painting *The Flight into Egypt*, in the Galleria Doria Pamphili in Rome, is one of a series of biblical paintings from his shop. It was painted in 1603 as an overdoor painting. The landscape is the dominant element in this scene, a deep, controlled, idealized combination of woods, river, sea, and stately Classical walled city. Gentle trees and shepherds inhabit the brightly lit fields. Mary and Joseph toil up from a riverbank with their mule as their ferryman pulls back into the stream. Such idealized landscape, developed from Giorgione and Titian, reflects Annibale's Venetian experience. Its broadened and opened form appears in increased numbers of Baroque paintings.

GUIDO RENI

Guido Reni (1575–1642) was a Bolognese artist, a pupil of the academy, who worked in Rome and ultimately became an enormously popular master on his own.

Aurora. Reni's works include altarpieces, mythological paintings, and ceiling frescoes such as the *Aurora*, painted in 1613, in the Casino Rospigliosi in Rome. Reni's version shows the progress of Apollo's chariot across the sky preceded by Aurora (the dawn) and surrounded by the Hours. The strong influence of Raphael is seen in this work, yet its dramatic play with light is clearly beyond the even naturalism of the *Galatea* in the Farnesina.

GUERCINO

Giovanni Francesco Barbieri, called Guercino (1581–1641), a Bolognese painter working in Rome from 1621 to 1623, painted the ceiling in the garden house of the Casino Ludovisi with another version of *Aurora*.

Guercino's *Aurora*. Guercino was a rival of Guido Reni, who eventually took over the latter's studio. His version of *Aurora* shows the goddess herself in a chariot strewing flowers as she soars overhead. The artist has painted the architecture illusionistically into the ceiling. He has shown the undersides of horses, chariot, and flying figures canted at an angle.

PIETRO DA CORTONA

Pietro da Cortona (1596–1669) was an architect and painter active mostly in Rome. He worked with Bernini on several projects and was particularly favored by Urban VIII and the Barberini family of the pope.

The Triumph of Divine Providence. Pietro's huge allegorical ceiling in the Barberini Palace, ostensibly *The Triumph of Divine Providence,* is mostly a glorification of the reign of Urban VIII. The Barberini arms with papal tiara, crossed keys, and three bees, the family symbol, is carried heavenward in the center of this huge composition. The illusionism of architecture and heavenly space, sculpture, medallions, and flight combines all the array of spatial and pictorial invention characteristic of the period.

CARAVAGGIO

Michelangelo Merisi (1573–1610), called Caravaggio after his hometown near Milan, lived in Rome from about 1593 to 1606. He fled the city after killing a man in a brawl and spent the rest of his short life moving about from Naples to Sicily. He died in 1610 at the age of thirty-seven, either of wounds from another brawl or of malaria.

Caravaggio's paintings are in an entirely different mode from the formal anti-Mannerism of the Carraccis and their followers. His naturalism is a more direct treatment of linear form and emphatic chiaroscuro treatment of light. The figures are naturalistic rather than idealized.

The Conversion of St. Paul. Caravaggio's *The Conversion of St. Paul* is in a small chapel to the left of the high altar in Santa Maria del Popolo in Rome. The work was done in 1601. The fallen Saul lies on the ground in the foreground, knocked from his horse and blinded by the power of God's light. The painting shows the saint, his horse, and a servant in such close-up view that no further detail is possible. The dark aura against which the light gleams from the horse's flanks and on the saint's outstretched body conceals any view of deeper space.

The Calling of St. Matthew. Caravaggio painted *The Calling of St. Matthew* in 1599 and 1600 for the Contarelli Chapel in the Roman Church of San Luigi del Francesi. In this painting, too, the artist used dramatic light and limited visibility to emphasize the subject.

It shows the simple interior of a plain room with five figures seated around a table. There are coins, a purse, and a notebook on the table. Light streams in from the upper right, catching the faces and some details of the seated figures and falling on two figures in the doorway. Christ, with halo, is at the far right gesturing past his Apostle Peter. Matthew sits at the table in the center of the group, pointing to himself in response to Christ's beckoning.

The large painting is just over 11 feet (3.35 m) square. It is one of three paintings concerning St. Matthew in the chapel. Its strong simplicity is again made arresting by the dramatic use of light. Here the light is inexplicable. It streams at a shallow angle, selectively lighting the figures and gestures.

***The Death of the Virgin*.** On occasion the directness of Caravaggio's imagery was deemed too strong or too shocking for the shrines at which it was to have been placed. The first version of the portrait of Matthew for the chapel at San Luigi del Francesi was thought to be too direct a representation of a clumsy elderly man, and insufficiently pious for an Evangelist.

The Death of the Virgin, in The Louvre, painted in 1605 and 1606 for the Church of Santa Maria della Scala, was rejected because of the "irreverent" directness of the image. Mary lies quite dead upon a low bed. Grieving figures stand or sit around her bier. Light filters into the scene, glowing on the bald heads of three Apostles, a grieving woman's bowed shoulders, and the swollen body of Mary herself, one arm flung out and her bare feet overhanging the couch. A large drapery hangs above, inexplicable in spatial or functional relation to the whole.

Caravaggio's art was immediately and profoundly influential on other painters. The impact of his work was in fact widespread, as we shall see.

ARTEMESIA GENTILESCHI

There has been almost no mention of women artists in this text, nor is there much in any of the general histories of art until the Baroque period. Few women are documented in antiquity, the Middle Ages, or the Renaissance as practicing artists. Even more rare are known works. There are traditional and ritual answers for this lack, mostly acknowledgment that the fine arts were restrictive and too often closed to women as practitioners.

Thus a pioneer in the establishment of women's abilities and their distinction as artists is Artemesia Gentileschi (1597–1652), daughter and pupil of the painter Orazio Gentileschi. She worked at Florence, Rome, and Naples. She was a follower of Caravaggio and noted for her versions of Old Testament heroines. These she painted with power and grace using dramatic Caravaggesque lighting to strong effect.

***Judith with Her Maidservant and the Head of Holofernes*.** The painting in Detroit's Institute of Arts, *Judith with Her Maidservant and the Head of Holofernes*, of about 1625, is a frequently illustrated version of one of her subjects. It shows the event within the darkened space of Holofernes's tent, lit by the glow of a single candle that casts eerie, moody shadows over the two women's forms. Judith holds her hand in front of the candle and a shadow is cast on her face. The Assyrian general's head is placed in a fabric bag by the maidservant kneeling in the foreground. Each woman has stopped to listen, distracted by some sound in the sleeping encampment. The spirit of the painting is in close keeping with the Baroque sense of drama.

SALVATOR ROSA

Salvator Rosa (1615–1673) was a painter, etcher, poet, and musician. He was born in Naples and worked in Rome and Florence. His paintings often incorporate landscape of a wild, savage composition, with cliffs, blasted trees, and ragged skies. Figures of wilderness saints, battles, even of brigands and bandits appear in his landscapes. These features and these characters infuse a Romanticism and a "poetic" nature into the Baroque, quite opposite to the Classical landscapes of Annibale Carracci.

FRA ANDREA POZZO

Fra Andrea Pozzo (1642–1709) was a Jesuit lay brother and a painter. He developed an expertise on perspective and wrote a treatise on it, which he published. Between 1691 and 1694 he painted the ceiling of the Church of Sant'Ignazio in Rome.

The Glorification of St. Ignatius. St. Ignatius of Loyola was the founder of the Jesuit order in 1534. The church named for him was built in the mid-seventeenth century. Fra Andrea Pozzo's ceiling shows the glorification of St. Ignatius, the saint being received in heaven. It is a complete combination of painted illusion that mixes architecture, painting, and sculpture in such fashion as to create the illusion of a junction of heaven and earth through the open vaults of the church.

BAROQUE ART IN SPAIN

The dark side of the religious reform of the Counter Reformation was the harsh reality of asceticism, suffering, and the sanctioning of torture as a route to salvation. We associate these with the extremes of the Spanish Inquisition and the Jesuits in their zeal. It also haunts our image of conquest in the Americas. Elements of this somber exercise of raw power appear in Spanish painting in the Baroque period.

Painting

Contrasted to the wealth and glory of the Church in the Baroque period were the sufferings and tortures of the early martyrs. The representation of these found expression in art particularly with the simplicity and naturalistic directness of Spanish painters who worked in Caravaggio's style, mingling it with their own heritage and the lingering influence of Flemish linear realism. Spanish baroque is strongest in the realm of painting. Religious art predominates, but there are some particularly strong still-life painters and portraitists.

JOSÉ DE RIBERA

Among the artists to adopt a style related to Caravaggio was José de Ribera (1591–1652), who settled in Naples. Ribera traveled in Italy and also was influenced by the idealism of the Carraccis. His own style combines that of the two Baroque masters with a personal style inherently Spanish. The strong chiaroscuro in many of his works enhances their power. Ribera was also an influential printmaker. His etchings impressed many and motivated the development of the medium.

Martyrdom of St. Bartholomew. Ribera's painting *Martyrdom of St. Bartholomew,* of 1639, is a work of somber implications. It depicts the saint being prepared for his torture, raised against a mast to be flayed. There are straining tormentors and a few dispassionate onlookers. Little nobility or solace softens the outlook. Again, a close-range abruptness emphasizes the shock we feel on realizing the circumstances.

FRANCESCO DE ZURBURAN

Francesco de Zurburan (1598–1664) concentrated on images of single saints in devotional, prayerful, solemn, and mystical discourse with the Lord or as martyred saints left lifeless in prayerful attitudes. Zurburan used light and shadow to effect a mystic relation between his subjects and the object of their prayers. In his painting *St. Francis in Prayer*, the saint holds a skull as a *memento mori.* In the painting *St. Serapaion*, the martyr is slumped in death, head bowed and hands held aloft by ropes in the position of an ancient *orans* figure.

DIEGO VELÁZQUEZ

By far the greatest master of Spanish Baroque art is Diego Velázquez (1599–1660). Velázquez began his work in Seville, but by his mid-twenties he was appointed a court painter to Philip IV and spent most of his life in Madrid. He traveled to Italy in 1629 and again in 1650 when he painted *Pope Innocent X* in the Galleria Doria Pamphili, Rome. The painting shows Velázquez's knowledge of the art of Titian, whose work he studied both in Italy and in the Spanish royal collections.

The Water Carrier of Seville. When only twenty, Velázquez painted *The Water Carrier of Seville,* a scene that combines the careful observations of portraiture, a sensitivity to the everyday life of the streets, and a mastery of textures of the rough pottery, glazed ceramic, clear glass, and various fabrics. The painting shows his enormous skills.

Las Meninas. Velázquez made many portraits of the king and of the royal family and court personages. The most remarkable, from many points of view, is *Las Meninas* (*The Maids of Honor*), of 1656. The large, 10-foot 6-inch-by-9-foot (3.2-by-2.75-m) painting shows the little Princess Margarita at the center, two maids in waiting, a dwarf, a playmate, and a large dog.

A governess and her escort are in the background, while at the back of the room a man stands on a staircase outside the room. To the left, in shadows behind a large canvas, stands the artist with palette and brushes in his hands.

Nearly everyone's attention is riveted on the place where the viewer stands. This seems to be explained by the reflection in the mirror on the far wall of the royal couple, the king and queen. A simple conclusion is that the artist is painting the royal couple. Their daughter, her playmates, and assorted royal guardians entertain the sitters. With an almost mischievous facility, Velázquez paints what the king and queen view as they sit, the innermost private circle of family.

The Baroque period is not a single movement, nor is it primarily Italian in its character and objectives. It is usual to begin surveys of the Baroque in Rome because some of the earliest work really definable as Baroque can be found here. Rome in the late sixteenth century had increasingly become an international city. Artists from Bologna, Milan, Venice, Antwerp, and various German cities who lived and worked in Rome brought the skills and influences of their early training to bear on the region.

One aspect of the Baroque, certainly, is anti-Mannerism, a return to nature, some of it as seen through the eyes of Raphael and Michelangelo, some of it restoring the color and nuance of Titian's art. Beyond that there is a treatment of light and shadow, texture and emotion that represents northern European influence. Caravaggio's art is partially grounded in the North.

Thus the varieties of Baroque in all the arts can never be seen as simply a Renaissance revival. The combinations of elements in Italian works led to new expressive paths and to an art very identifiable by the compositional balance of color and composition in angle and depth rather than by geometrical stasis.

Selected Readings

Argan, G. C. *The Baroque Age.* New York: Rizzoli, 1989.

Engass, R., and J. Brown. *Italy and Spain: 1600–1750.* Sources and Documents. Englewood Cliffs, NJ: Prentice-Hall, 1970.

Freedberg, S. J. *Circa 1600: A Revolution of Style in Italian Painting.* Cambridge, MA: Harvard University Press, 1983.

Kubler, J. A., and M. Soria. *Art and Architecture in Spain and Portugal and Their American Dominions: 1500–1800.* Baltimore: Pelican History of Art, 1959.

Millon, H. A. *Baroque and Rococco Architecture.* New York: Braziller, 1961.

Wittkower, R. *Art and Architecture in Italy: 1600–1750.* 3d rev. ed. Harmondsworth: Penguin, 1980.

19

Baroque Art in Flanders and Holland

1556–1598 Reign of Philip II

1568 Netherlands revolts against Spain

1581 Holland declares its independence

1598–1621 Reign of Philip III

1602 Dutch East India Company founded

*T*he marriage of Mary of Burgundy to the emperor Maximilian of Austria in 1477 put the Lowlands territories in Habsburg-Spanish possession from that time to the reign of Philip II (1556–1598).

 Philip II, in his religious zeal, took harsh repressive measures against the Protestant Reformation in the Low Countries. In response, the northern provinces under the House of Orange broke away from Spain and set up the Dutch Republic in 1581. The boundaries of present-day Catholic Belgium and Protestant Holland are based on this split.

 In part for these reasons, Flemish and Dutch art are differentiated more in the Baroque period than in earlier centuries. The southern provinces, which continued under Habsburg control, did not particularly flourish. One artist, Peter Paul Rubens, dominates the period. This marks a strong contrast to the rich history of the southern Netherlands in the fifteenth and sixteenth centuries. By tradition, the terms Flanders *and* Flemish *are used for the art of all*

ten of the southern provinces of the Netherlands prior to the establishment of the present-day kingdom of Belgium in 1830.

Holland developed as a republic and acquired a great trade empire in the Baroque era, especially in the East and West Indies. A variety of extraordinary artists worked in the seventeenth century in Holland. In both Holland and Flanders, painting continued as the dominant art form.

FLEMISH PAINTING IN THE SEVENTEENTH CENTURY

The sons and grandsons of Pieter Bruegel the Elder (c. 1525–1569) became artists. His elder son, Pieter the Younger (1564–1630), was famed and popular as a copyist of his father's works. He also was the teacher of Frans Snyders, who was a principal painter in the shop of Peter Paul Rubens. The younger son, Jan Bruegel (1568–1625), was a still-life and landscape painter who also found work in Rubens's shop. Jan was sometimes called "Velvet" Bruegel because of the fine rendering of his subjects.

By the end of the sixteenth century the Romanist tradition and the Antwerp Mannerists were no longer a dynamic force in Flemish art. Several Flemish artists of significant talent worked in Italy, but the repressive Spanish actions of the late sixteenth century exhausted the spirit of Antwerp in contrast to its great years earlier in the sixteenth century.

Peter Paul Rubens

Peter Paul Rubens (1577–1640) was born in Germany, where his family lived in exile from the Catholic repression of the Protestant movement. After his father's death in 1589, Rubens and his family returned to Antwerp. The artist was raised as a Catholic. He traveled to Italy as a journeyman artist in 1600. There he became court painter to Vincenzo Gonzaga, duke of Mantua. Rubens traveled in Italy and visited Spain before returning to Antwerp in 1608 when his mother became ill and died.

In Italy Rubens studied the works of antiquity and of Leonardo, Raphael, Michelangelo, and Titian. In Rome he encountered the work of the Carraccis and Caravaggio. In Spain he found additional opportunity to study Titian in the royal collections.

In Antwerp, just before returning to Mantua, Rubens was appointed court painter to the Spanish governor. He retained this official court status and undertook assorted diplomatic missions for the rest of his life. He settled in Antwerp, married, and thereafter headed a large and prolific workshop. His enormous skills and facility in assimilating the Italian tradition, together with his official status, assured him of commissions and widespread recognition.

Rubens was a bold, incredibly energetic man. One writer reported on a visit to his studio that he found the artist simultaneously painting, listening to a reading from Tacitus, and dictating a letter. As the visitor entered the studio, Rubens engaged him in conversation without giving up his dictation, stopping the reader, or hesitating from continuing to paint.

RAISING OF THE CROSS

Among Rubens' earliest commissions in Antwerp was an altarpiece for the cathedral. The central panel, the *Raising of the Cross*, is an Italianate painting that shows many influences blended into Rubens's style. The painting, made in 1610, is huge, 15 feet by 11 feet 2 inches (4.6 by 3.4 m). Its lighting is rich in Caravaggesque chiaroscuro. The composition is powerful in the vertical thrust of the figures. The heavy muscular figures show Michelangelo's influence.

What is important, however, is not the isolation of influences but Rubens' control of them. His admiration for Renaissance and Baroque artists led to his intensive study of their techniques, but the result was a style of Rubens' own. It earned him immense international fame and commissions from all the noble houses of Europe. From 1621 to 1624 he painted a cycle of twenty-two paintings for Marie de' Medici for the decoration of the Palais de Luxembourg. They are now in The Louvre, in Paris. In 1635 he painted the ceiling of the Banqueting House in London's Whitehall. King Charles I knighted Rubens for his services. At the end of his life he was working on the decorations for the Torre de Parada, in Madrid, for Philip IV of Spain.

THE ABDUCTION OF THE DAUGHTERS OF LEUCIPPOS

A frequently cited example of Rubens' mature style is his version of the myth of the abduction of the daughters of Leucippos. The twins, Castor and Pollux, called the Dioscouri, were born of Jupiter's liaison with Leda. Enamored of the two women, the twins are shown carrying them off in a robust composition that glorifies the flesh in Rubens' most spectacular fashion, presenting a mythological allegory as its justification.

Though all the figures are in dynamic action, the placement of them balances the composition. Form, light, shadow, color, and Rubens' own spectacular ability with brushwork harmonize all the disparate elements into a concerted whole.

PORTRAITURE

Rubens was a great portraitist, as was Titian, the artist he most admired. A great many of the famous and powerful heads of state and aristocracy sat for him. He was well acquainted in these circles, and his patrons were in endless supply.

He also made portraits of himself and his wife and children. These, too, have flair and brilliance. It can clearly be seen that Rubens' skills with brush and with color bespeak an exuberant craftsman and inventive genius. The level of his expression is remarkably constant, nearly always lighthearted. Unlike most of his High Renaissance idols and nearly all of his contemporaries, Rubens had no dark or brooding dimension, not, at least, in his art.

Anthony van Dyck

Rubens' most famous assistant was Anthony van Dyck (1599–1641). A man of great talents himself, van Dyck left Rubens's shop and worked for a time in Genoa before going to England, where he was appointed court painter to Charles I. He is most well known as a portraitist and is considered the founder of the English School of portraiture. Thomas Gainsborough and Joshua Reynolds each owe much to van Dyck's style.

PORTRAIT OF CHARLES I, DISMOUNTED

Among the portraits of Charles I painted by van Dyck, the *Portrait of Charles I, Dismounted,* of 1635, now in The Louvre, Paris, is one of the best. It is a full-length portrait of the king with attendants and a favorite horse in the background. The king stands to the left, his body directed toward a river landscape on that side. There are woods behind him to the right. He casts a glance in our direction, which establishes the balance of the painting.

No doubt intended as an informal representation of the ruler, the painting is anything but casual. The king is highlighted, his stance every bit as regal as if he were in royal chambers. The landscape is adapted to his will and presence.

Anthony van Dyck was also a superb printmaker. He designed etched portraits of famed artists and others of his day. Trained engravers in the shop of Rubens finished some of these with a burin.

BAROQUE ART IN HOLLAND

The seventeenth-century Dutch School involved a variety of artists and approaches. In Holland the sweep of Protestantism led to the general prohibition of religious, mythological, and characteristic Renaissance History painting. A new iconoclasm had led to the destruction of religious art in churches. The allowable new subject matter was portraiture, genre, still-life, and landscape. Through these the Dutch seventeenth-century artists built a magnificent tradition.

The Caravaggists

Late sixteenth-century Dutch art continued to be powerfully influenced by Italian Mannerism in its late phases. For almost the whole century Dutch artists had been in Italy as a nearly mandatory part of their training and some had made their influence felt strongly on the Italian scene.

There were two painters from Utrecht whose return to Holland in the seventeenth century brought new momentum to Dutch painting from the early Baroque in Italy, where they had studied and worked. Their names were Hendrick Terbrugghen and Gerrit van Honthorst. Each had been particularly affected by the art of Caravaggio.

HENDRICK TERBRUGGHEN

The Utrecht painter Hendrick Terbrugghen (1588–1629) worked in Rome from 1604 to 1614. Upon his return to Utrecht he painted scenes that repeated Caravaggio themes: the *Calling of St. Matthew* and the *Incredulity of St. Thomas,* among others. He tended to paint close-up, half-length compositions. His work is thus different from and his emphasis on color more pronounced than Caravaggio's. The chiaroscuro effects are still strong, nonetheless. Terbrugghen's effect on the art of Holland stems from this. Judith Leyster, particularly, worked in this style.

GERRIT VAN HONTHORST

Gerrit van Honthorst (1590–1656) was also from Utrecht and traveled to Rome, where he remained from 1610 to 1620. His return to his native city and his subsequent art were also responsible for the dispersal in Holland of Caravaggesque effects in chiaroscuro in painting. Later, Honthorst also worked in England and Denmark as a court painter.

The Supper Party. Paintings like *The Supper Party* of 1620, in the Uffizi Gallery in Florence, are characteristic of Honthorst's work. A gathering of unidealized figures sits about a table. The scene is dark, presumably nocturnal. The light sources are concealed; in this case there is a single candle on the table hidden behind a foreground reveler at the left and another, handheld, at the right. A musician plays, and some coarse tidbit is fed to one of the party by another. Here we have a genre scene focused, as many are, on the five senses. The light and shadow are dramatic and intricate.

JUDITH LEYSTER

Judith Leyster (1609–1660) was a painter of Haarlem. She was the most important pupil of Frans Hals. Rather than follow the inimitable style of her teacher, Leyster painted scenes in the Caravaggist style, in which she excelled. Her work, such as the *Boy Playing a Flute* of 1630 to 1635, in the National Museum, Stockholm, is close to similar works by Hendrick Terbrugghen. A half-length youth, playing the flute, appears in the foreground looking up to the left, from where the source of the light comes. He is seated,

and his shadow falls on the wall behind him where a violin and recorder are hanging from nails. The light and shadow and the rapt, alert youth making music make a strong, pleasing composition.

The Major Dutch Painters

Three Dutch artists stand out particularly among the many in the Baroque period. They are Frans Hals, Rembrandt van Rijn, and Jan Vermeer. Aside from the fact that two were noted portraitists, there is little to connect these three individuals in their style or the objectives of their art. All three lived the greater part of their lives in poverty, although Hals and Rembrandt had periods of success and recognition. Vermeer is thought not to have sold a single painting of his own. What living he made was as an art and antiques dealer.

FRANS HALS

Frans Hals (c. 1580–1666) lived and worked in Haarlem. He was a portrait painter who excelled in clearly and quickly capturing the character of his sitters using spare, precise, and loaded brush strokes. He could do this well enough to capture the character of as many as a dozen persons in one group portrait. The influence of Caravaggio, mostly through Terbrugghen since Hals never went to Rome himself, is visible in the play of light and dark in his works.

A Group Portrait. *The Banquet of the Officers of the St. George Guard Company* was painted in Haarlem in 1616. This jovial group of men is sitting around a table, mostly looking toward the artist. Each is individualized, yet the painting has compositional integrity. Hals was particularly successful with such group portraits and made many of them.

Two Individual Portraits. The fresh, vigorous quality of rapid brushstrokes carefully placed for maximum effect is even more distinctly visible in Hals's portraits of individuals. As subjects, perhaps no two individuals could be more different from one another than the *Laughing Cavalier* and *Malle Babbe,* who are among the subjects of famed Hals portraits. Amazingly, the same techniques of painting bring out the character of each person despite the stark differences.

The *Laughing Cavalier,* in the Wallace Collection in London, is a dashing, elegantly dressed, and self-confident person, twenty-six years old in 1624, when the painting was made. The light and shadow and the profusion of detail in the costume are all painted with apparent ease, though rigorous work is required to achieve such an effect.

The same appearance of rapid and effortless brushwork was used to define the image of *Malle Babbe,* painted about 1630 and now in the Staatliche Museen in Berlin. This is a painting of a drunken woman seated with an owl, here a symbol of evil or foolishness, on her shoulder. Her right hand clutches a giant tankard, its lid open and reflecting out toward us. Her

laugh is a slurred sneer delivered as a coarse aside. Her solitude suggests isolation; thus her mirth appears unfriendly, her reason blurred by drink. Here Hals, the portraitist who could so deftly express the character of his sitters, is working at an extreme of the spectrum of human behavior no doubt to enhance his own vision of the center.

REMBRANDT VAN RIJN

Rembrandt van Rijn (1606–1669) was the single greatest Dutch Baroque artist and remains one of the most universally acclaimed painters of all art history. In painting, drawing, and etching Rembrandt was a master of incomparable achievement.

Rembrandt was born near Leiden, where he first trained. Further training in Amsterdam led him to open his own workshop in Leiden in 1626. He moved to Amsterdam in 1631 to 1632.

The Anatomy Lesson of Dr. Tulp. Rembrandt gained early success in Amsterdam. In 1632 he painted the group portrait of Dr. Nicolaes Tulp and his associates in the form of *The Anatomy Lesson*, showing Tulp demonstrating the anatomy of a human hand as an element of the dissection of a corpse. As Hals had done, Rembrandt clarified the figures, here gathering them about the operating table. Dramatic light spills in from above and behind the viewer's left.

Such dissections were learned and social events in seventeenth-century Holland and elsewhere. The corpses were often of executed criminals. The participants were distinguished members of the college of surgeons.

The Night Watch. Rembrandt's early success was such that he received many commissions. He painted portraits and Old Testament stories. The large 11-foot 6-inch-by-14-foot 5-inch (3.5-by-4.4-m) group painting of the company of Captain Frans Banning Cocq, called *The Night Watch,* was painted in 1642. It is now in the Rijksmuseum, Amsterdam. Though it was not initially intended to be a night scene, the eerie and unusual spotlight effect of the light is not explicable in usual daylight terms. An air of mystery surrounds the group. It is probably Rembrandt's best-known work. Despite legends about disgruntled members of the company, the painting was well received in its time.

When his wife, Saskia, died in the same year, Rembrandt's fortunes went into decline. For the remainder of his life, Rembrandt was usually destitute. Even so, he continued an important output of works. In his art, even more than in that of Rubens and Hals, the importance of brushwork and paint begin to challenge the importance of subject matter.

Self-Portraits. Rembrandt, more than any artist since Albrecht Dürer, painted and drew his self-portrait at all ages to enormous effect. These show us Rembrandt in a variety of moods. In them we can trace his insights. The depth of expression that they came to represent is clear from the solemnity

of his self-portraits at an advanced age in contrast to the earlier, playful costume studies and casual sketches.

Graphic Art. Among his earliest efforts, Rembrandt produced etchings. He continued as a printmaker for his whole life, working in all the subject matter of his paintings and experimenting with processes, particularly the combination of etching with dry point, a form of engraving done by scratching rough lines into the plate rather than carving the surface with an engraver's burin or etching the lines with acid.

Especially in his later works, Rembrandt worked vigorously on the surface of his plates, often reworking them and then inking them, leaving *plate tone* (thin washes of ink) on the surface of the plate for additional effect. His influence on printmaking, in turn, was enormous.

JAN VERMEER

Jan Vermeer is a third major Dutch seventeenth-century artist. Vermeer began as a Caravaggist, but his most developed work is as a painter of interior genre scenes, carefully designed and painted with a clear, rational light. He lived and worked in Delft. Two landscapes, a Delft street scene and the *View of Delft*, in the Mauritshuis, the Hague, in Holland, are by his hand.

The Kitchen Maid. The painting *The Kitchen Maid*, in the Rijksmuseum, Amsterdam, is one of many simple interiors by Vermeer. It shows the woman in a brightly lit interior as light gleams, modeling her face and hands, the coarse textures of basket, bread, and earthenware, and the tiny stream of milk poured from a pitcher to a bowl. The simplicity of the act, the setting, and the materials are a harmony enhanced by the judicious choice of colors. The patterns of brick red, yellow, and blue-purple intertwine against the gray-and-white background. As uncomplicated as this seems, the artist has worked with incredible subtlety to achieve that appearance.

Vermeer's work has such power within its very small format and limited subject matter that we grant him major status here. There is much in his Baroque mastery that we recognize as the result of his individual strength despite the tiny number of surviving works and the relatively small scale.

"Little Masters"

Among the artists of seventeenth-century Holland are landscape, genre, and still-life painters traditionally if inaccurately called "Little Masters."

LANDSCAPISTS

The facility for landscape painting in the Netherlands goes back to fifteenth-century origins. It flourishes in the sixteenth century and triumphs in the seventeenth with the work of Jan van Goyen, Meindert Hobbema, Jacob van Ruysdael, and others. Each of these has his own style, yet their art characterizes the Dutch landscape most particularly. Open skies, low

horizons, distant views, river- and seascapes, dunes, and city views all characterize the topics undertaken by these painters.

Ruysdael's *View of Haarlem*. Jacob van Ruysdael's several paintings of Haarlem from a distance are one characteristic type. The *View of Haarlem from the Dunes at Overveen*, in the Mauritshuis, the Hague, is typical. It shows the distant Groot Kerk (Great Church) and the low roofs of the city with a few spires and windmills. A great billowing mass of cumulus clouds with patches of blue sky and reflected sunlight occupies more than the upper two-thirds of the canvas, giving emphasis to the shape of the land and its breadth. In the foreground is a small village. Tiny figures work in the fields where linen is laid out to bleach.

STILL-LIFE PAINTERS

Some artists—Willem Claesz. Heda, Willem Kalf, Rachel Ruysch, and others—painted elegant and precise still-life paintings, usually close-up portrayals of tabletop arrangements. Food, drink, their utensils, and flowers are typical subjects. As Caravaggists like Honthorst had done, the still-life painters appealed to the senses. The remnants of a meal were often shown in these paintings.

The Flemish and Dutch painters of the Baroque, with a common heritage, went very separate ways in the art of the Baroque. Though painting is still the major art in both cases, the Dutch turned away from the Classical tradition. Peter Paul Rubens, who was the single greatest Flemish master, managed to restate the Classical tradition in his own powerful and extraordinary way.

Rubens was, in fact, the pivotal character in Flemish Baroque art. His pupils, Van Dyck and the painter Jacob Jordaens, were very much subject to his style. The enormous output of Rubens, to all effects, was the Flemish Baroque.

Holland had many painters in the seventeenth century. If most were amateurs who painted only on Sunday and made their living in other ways, an astonishing number were very good at what they did and more than a few became famous indeed. In the work of Holland's great Baroque masters we see new subjects or older, tentative ones suddenly flourish as powerful statements.

Selected Readings

Baudouin, F. *Pietro Paolo Rubens*. New York: Abrams, 1977.

Gerson, H., and E. H. Ter Kuile. *Art and Architecture in Belgium: 1600–1800*. Baltimore: Penguin, 1978.

Haak, B. *The Golden Age: Dutch Painters of the Seventeenth Century*. New York: Abrams, 1984.

Nash, J. M. *The Age of Rembrandt and Vermeer: Dutch Painting in the Seventeenth Century*. New York: Holt, Rinehart & Winston, 1972.

Rosenberg, J., S. Slive, and E. H. Ter Kuile. *Dutch Art and Architecture: 1600–1800*. 3d ed. Harmondsworth: Penguin, 1977.

Slatkes, L. J. *Vermeer and His Contemporaries*. New York: Abbeville, 1981.

Stechow, W. *Dutch Landscape Painting of the Seventeenth Century*. New York: Cornell University Press, 1980.

20

The Baroque in France, England, and Germany

1589–1610	Reign of Henry IV of France
1603–1625	Reign of James I of England
1610–1643	Reign of Louis XIII of France
1618–1648	Thirty Years' War
1620	Plymouth Colony founded in Massachusetts
1643–1715	Reign of Louis XIV of France
1648–1658	England under Cromwell
1660–1685	Reign of Charles II of England
1666	Great Fire of London
1685–1688	Reign of James II of England
1689–1702	Reign of William and Mary of England
1715–1774	Reign of Louis XV of France

*F*rance did not take the lead in art until the late nineteenth century after the Gothic period. In the Renaissance and Baroque eras, French art remained subordinate to Italy, Germany, and the Low Countries, although it is fair to add that the art of France was not imitative of these other countries at any time. French borrowing from the masters of the Renaissance in Italy or the northern Renaissance masters in Antwerp led to an expressive French

form of the art. The same is true in the Baroque, though in the case of Nicolas Poussin there emerges a genuinely original and major master.

English Baroque art is dominated by its citizens' efforts in architecture. Works by Inigo Jones and Christopher Wren are justly renowned. Little Baroque sculpture exists, and the main painters of seventeenth-century England are Flemish and German artists invited to work in the court.

In Germany the Baroque took hold late, but German and Germanic artists managed to create a recognizable style. The prominent artist is the architect Johann Fischer von Erlach.

BAROQUE ART IN FRANCE

Architecture

French architects of the Baroque period continued to use some of the elements introduced by Pierre Lescot in the first redesign of The Louvre in 1543. The steep roofline above the three-story façade appears again in François Mansart's work and in the early buildings of Louis Le Vau, although it will vanish in large building projects of the second half of the century. French Baroque architects continued to focus upon the central section of their buildings and to close the ends of façades with pavilions.

FRANÇOIS MANSART

François Mansart (1598–1666) built the Orléans Wing of the Château de Blois from 1635 to 1638. The duke of Orléans, who ordered the work, was the brother of King Louis XIII. The façade of the Orléans Wing is centered upon a pavilion more dramatically emphasized than that of Lescot at The Louvre. Mansart's design utilizes doubled pilasters, three bays, and emphasized cornices with pediments and sculpture for focus. Mansart used a classical sequence of Doric, Ionic, and Corinthian orders. The pavilions at the sides project forward, flanked at ground level by two quarter-circles of paired Doric columns that recede to the intermediate spaces.

Mansart was made royal architect in 1636. The Château de Maisons at Maisons-Lafitte, built from 1642 to c. 1650, is his major work. The architect Jules Hardouin-Mansart was his grandnephew and pupil.

LOUIS LE VAU

Louis Le Vau (1612–1670) worked for the court of Louis XIV. In 1655 he was named premier architect, councillor, and secretary to the king. His first undertaking after this appointment was the design of a château for the king's finance minister, Nicolas Fouquet. It was a grandiose structure, landscaped by André Le Nôtre (1613–1700) and decorated by Charles Le Brun (1619–1690).

Vaux-le-Vicomte. The château called Vaux-le-Vicomte was built from 1657 to 1661. Among its features, the Garden Façade is the most striking. The central pavilion is domed, fronted by a two-storied, pedimented temple façade. Le Vau converted the first (ground) floor into a podium. The side pavilions have a giant Ionic order that rises through the upper two stories. These are Italianate ideas, though the building remains particularly French, with high sloping roofs and a towering lantern over the dome. The dome is oval, surmounting an oval ballroom. Its profile is lower than its breadth. François Mansart lent his name to the *mansard roof,* a roof with two slopes, the lower steeper than the upper.

The building proved bad luck for Nicolas Fouquet. Court jealousy led to accusations of embezzlement, and the royal financier was arrested and convicted, his properties stripped from him. The architects, conversely, were promoted.

CLAUDE PERRAULT

Claude Perrault (1613–1688) was the architect selected by Louis XIV to build the east front of The Louvre. In 1665, Louis had summoned Bernini to Paris to make new designs for the building but these had proven far too ambitious for the king's desires. Perrault, an amateur, was probably assisted by Le Vau and Le Brun at this task.

The East Façade of The Louvre. Since its reconstruction in the sixteenth century, The Louvre Palace had been enlarged. The original square court had quadrupled in size, and the surrounding structures with variations repeated Lescot's original designs. Unifying the exterior of this building toward the east was the king's first chosen priority. The imposing east façade was built between 1667 and 1670. Standing upon a heavy windowless base, the east façade is three-storied. The bottom story is fashioned as a podium for the upper two. The upper two are united behind a large colonnade. There is a pedimented central pavilion and a balustrade at the roofline. No visible roof rises above the cornice. Two corner pavilions close the ends of the colonnade.

THE BUILDING OF VERSAILLES

Even as The Louvre was being reconstructed, Louis XIV chose to move his court to Versailles, a short distance from Paris. The space, woodland, and opportunity to build on an even larger scale appear to have influenced his choice.

The château at Vaux-le-Vicomte may have inspired the move. At any rate, Louis chose the same architects, adding Jules Hardouin-Mansart (1646–1708), grandnephew of François Mansart.

A Versailles Time Line. The building of the Palace of Versailles took a long period. Following are some significant dates in the sequence of events:

1624	Louis XIII builds a hunting pavilion at Versailles
1634	The hunting pavilion is converted to a château
1661	Louis Le Vau and Charles Le Brun are contracted to build a new château in place of the older one; André Le Nôtre is in charge of landscape design of park
1670	Death of Le Vau; Jules Hardouin-Mansart is appointed
1678–1684	Jules Hardouin-Mansart constructs the Hall of Mirrors; decoration by Charles Le Brun
1687	The Grand Trianon is built by Jules Hardouin-Mansart
1698–1710	Chapel at Versailles is built by Jules Hardouin-Mansart, finished by Robert de Cotte (1656–1735), his pupil

Table 20.1

JULES HARDOUIN-MANSART

The architectural masterpiece of Jules Hardouin-Mansart on his own is the Church of the Invalides in Paris. Otherwise, he worked extensively in concert with other designers and architects.

Church of the Invalides. In Paris, the magnificent Church of the Invalides is predominantly a centrally planned, Greek-cross structure with chapels in each corner. The plan relates to Michelangelo's St. Peter's. Added to the Invalides, however, are an oval choir and a much larger proportional scale for the dome that soars overhead.

Within the central dome, Hardouin-Mansart created a dramatic, Baroque lighting effect that illuminated the frescoes on the inner of the two outer domes where an apotheosis of St. Louis, the nation's patron, is painted. An inner, partial third dome conceals windows that penetrate the outer domes to provide light. Because the interior is comparatively dark, the burst of light above makes an impressive effect.

Painting

France is the northernmost Latin country. As in the Medieval and Renaissance periods, Baroque painters derived their art from their northern neighbors as well as Italy. The French Caravaggists, in fact, appear to have drawn upon the influence of the Italian master through the Dutch painters of Utrecht. Also, as in those earlier periods, the art emerges as French, with its own qualities and expression.

GEORGES DE LA TOUR

Georges de La Tour (1593–1652) lived and worked all his life in the province of Lorraine. Despite this, he won recognition and patronage from the duke of Lorraine and from King Louis XIII. He painted scenes similar in lighting to those of Gerrit Honthorst and is usually said to have been influenced by the Utrecht Caravaggists. His range of colors through yellow, reds, and browns is his own choice, however, and he did not hide the light sources.

Lamentation over St. Sebastian. The light in La Tour's *Lamentation over St. Sebastian*, of c. 1630, in the Staatliche Museen in Berlin, comes from a single, unconcealed torch held by a servant who takes the saint's pulse. The torch molds a stark form across the surface of the picture. St. Irene bemoans the saint in the upper right. Two other women weep behind her. Sebastian lies near death in the foreground at the foot of the column to which he was bound. A single feathered arrow has pierced his body just beneath the breastbone. The surrounding darkness and raking light heighten the tension.

LOUIS LE NAIN

Three brothers, Louis, Antoine, and Matthieu Le Nain, were all inducted into the French Académie des Beaux-Arts in 1648. It is not certain, but the paintings of rustic country life are attributed to Louis Le Nain. They are clearly influenced by Dutch genre painters, but they have a stoic virtue unlike the revelry and animation of the Dutch works. There is still a Caravaggesque light in the work of Le Nain, but it is used to emphasize the virtues and crises of peasant life in strife-torn France.

JACQUES CALLOT

Jacques Callot (1592/3–1635), from Nancy in the province of Lorraine, was a printmaker who mastered techniques of etching, first in Rome and by 1611 in Florence, where he worked for the late Medici court until 1621. Thereafter he worked at his native Nancy. Jacques Callot made as many as 1,500 etchings and used inventive techniques for linear expression. He worked on prints of fairs and festivals in Florence. His hunchbacks and beggars inspired Rembrandt.

Misères de la Guerre. Callot's greatest work was a series of etchings, the *Misères de la Guerre* (*Miseries of War*) of 1633. Its directness in recording the brutality of the Thirty Years' War is frequently compared to Goya's *Disasters of War* of 1810 to 1813.

NICOLAS POUSSIN

The greatest of the French Baroque painters was Nicolas Poussin (1594–1665). His style of Classicism is a major factor in Baroque art and in theoretical discussion long afterward. Poussin lived most of his active life

in Rome, but he did not adopt the exuberant Italian Baroque styles of either the Carraccis or of Caravaggio. Rather, his work depended more consistently on Titian and Raphael. Its calm and stable elegance is bound up with a sense of Classical art and the concept of beautifying nature. Art historians tend to call it *academic* for its systematic approach to the Classical. The term is not negative in this context, for Poussin was a theorist, concerned with academic themes and "modes" of painting. He enjoined great artists to choose great subjects, as history paintings, battles, heroic actions, and religious themes.

Landscape with the Burial of Phocion. In imposing such ideals upon artists, it is possible to assume Poussin was also expressing the hardships of his times through the moral and stoic lesson of the ancients. He had no sympathy for genre painting such as that by Louis Le Nain and would not have considered the prints of Callot as art.

Poussin's landscape paintings are painted as theoretically as his mythologies. He often combines them. Their idealism as landscape is reminiscent of that in Annibale Carracci's *Landscape with the Flight into Egypt*. As myth it takes deeper significance. The narrative event does not seem casually chosen.

Poussin's painting *Landscape with the Burial of Phocion* is one of his best. It shows a deep, stabilized landscape with carefully placed groves of trees, ancient buildings, sky and clouds, and a distribution of figures including two men in the foreground who carry the dead hero on his litter. The deep, carefully balanced, and quiet scene makes a thoughtful setting for its solemn subject and the moral wisdom of its ancient lesson of honor.

CLAUDE LORRAIN

Claude Gellée (1600–1682), called Claude Lorraine or simply Claude, was also a landscapist. As did Georges de La Tour and Jacques Callot, Claude came from the province of Lorraine. As did Poussin, he traveled in Italy, working in Naples and Rome, where he settled.

Claude's landscapes are not moralizing. His figures, usually quite small, often enact scenes from myth and history but in miniature, minimalized fashion. They detract little from the effects of atmospheric perspective, filtered sunlight, and gentle breezes.

Sculpture

PIERRE PUGET

Pierre Puget (1620–1694) has been called the most original French sculptor of his time. Despite this he did not find favor early at the court of Louis XIV. He was a pupil of Pietro da Cortona's and was powerfully influenced by Bernini. His expressive Italian Baroque style conflicted with court Classicism controlled by Charles Le Brun.

Milo of Crotona. Puget's sculpture *Milo of Crotona*, made between 1671 and 1683, was finally acquired by the court and later much admired by artists such as Delacroix. It is a highly finished sculpture of the hero, his

hand caught in a tree stump, attacked by a lion. The unreserved agony is reminiscent of the Laocoön group from the Hellenistic period.

ANTOINE COYSEVOX

Antoine Coysevox (1640–1720) was a portrait sculptor in the court. His portraits of Louis XIV are less exuberant than Bernini's, yet they remain expressive character studies. He was also responsible for decorations in the Galérie des Glaces and other chambers at Versailles.

FRANÇOIS GIRARDON

François Girardon (1628–1715) also worked as a sculptor at Versailles and also was an exponent of Classicism. He made sculptural groups and relief sculptures at the Palace of Versailles. He also designed the tomb of Richelieu at the church of the Sorbonne and the *Equestrian Louis XIV* in the Place Vendôme, destroyed in the Revolution.

Apollo Tended by the Nymphs. The most well-known sculptural group by Girardon is *Apollo Tended by the Nymphs,* begun in 1666, in the Grotto of Thetis at Versailles. The composition, though somewhat altered when the group was moved, refers to Poussin's painted figural groups. The subject is clearly a reference to Louis XIV, who was known as the Sun King, and the figure of Apollo is based on the Hellenistic sculpture of Apollo in the Vatican, *The Apollo Belvedere*. Its theme of Apollo's rest after his day in the sky stands in strong contrast to the intensity of Puget's *Milo of Crotona*.

BAROQUE ART IN ENGLAND

England's tradition in painting and sculpture really begins in the eighteenth century. During the Baroque period, painters such as Rubens, Van Dyck, and others continued the tradition of Holbein in the sixteenth century. They visited England for commissions or promises of longer employment.

Architecture

In architecture there are two major individuals who generated an English tradition and stand out among all English artists of the Baroque. They are Inigo Jones and Christopher Wren.

INIGO JONES

Inigo Jones (1573–1652) traveled in Italy between 1613 and 1614 with the entourage of Thomas Howard, earl of Arundel. There he encountered the work and style of Palladio. Palladio's architecture and theory became the basis of his own style. The combination was to remain a powerful influence on English architecture for generations.

The Banqueting House, Whitehall, London. Inigo Jones designed the Queen's House at Greenwich in 1616 and many other buildings using the Palladian style. The most often cited of his works is the Banqueting House at Whitehall, built from 1619 to 1622. It is a simple geometrical, rectangular structure with two stories in the Ionic and Corinthian orders. The elevation uses a balanced combination of engaged piers and columns, each indicated by the cornice above it but with an unbroken balustrade at the roofline.

Inigo Jones worked in the courts of James I and Charles I. He also did theatrical designs and costumes for theater productions of his contemporary, the poet laureate of England, Ben Jonson.

CHRISTOPHER WREN

Christopher Wren (1632–1723) was the most successful and famous of English architects. He began a career as a recognized scientist, having distinguished himself in physics and astronomy. His great opportunity as an architect came when the Great Fire of London in 1666 destroyed the old St. Paul's Cathedral in London for which he was already working on new designs. The fire led to a royal commission to rebuild the city. Many of London's churches were rebuilt to Wren's designs.

St. Paul's Cathedral, London. Wren's design for St. Paul's Cathedral, built from 1675 to 1710, was a combination of elements drawn from sources he had seen and studied. Everything from Bramante's Tempietto in Rome, St. Peter's dome, and Perrault's Louvre façade to Palladio's books and Borromini's St. Agnese has been cited in relation to St. Paul's Cathedral. Despite this eclecticism, however, the whole is still greater than the sum of its parts.

Painting

Most of the celebrated painting in England in the Baroque period was done by visitors such as Peter Paul Rubens and Antony Van Dyck. An engraver of great historical interest was the Bohemian Vaclav (Wenceslaus) Hollar (1607–1677), who worked in England for most of his life after 1636. His views of London, costume studies, and portraits form valuable records. The Dutch-born Sir Peter Lely (1618–1680) lived and worked in England after 1641, and became the chief court portraitist after Van Dyck's death. He was principal painter to Charles II of England.

BAROQUE ART IN GERMAN LANDS

South Germany and Austria were overwhelmed by the ravages of the Thirty Years' War. Little of the Baroque movement in art is to be found there until late in the era.

JOHANN FISCHER VON ERLACH

Johann Fischer von Erlach (1656–1723) was an Austrian who studied sculpture in Rome and Naples before turning to architecture.

Karlskirche. Fischer von Erlach's greatest building is the Church of St. Charles Borromeo (Karlskirche) in Vienna, built from 1716 to 1737. The church was a thank-offering of the emperor Charles VI for the deliverance of Vienna from the Plague and is dedicated to the imperial namesake. Its exterior owes much to Borromini and to Roman history. From antiquity it borrows the portico scheme of the Pantheon and flanking columns patterned on the Column of Trajan. The dome, close to the forefront, and flanking pavilions with short towers are reminiscent of Borromini's St. Agnese.

Baroque art is no single style, nor is it the contribution of any single center. It emerges in a truly international variety of expressions and at the hands of artists of many different personalities and persuasions.

The achievements of the Renaissance had brought about the ability of artists to depict the visual world as they chose. The choice, in many instances, was the theatrical or dramatic moment. Styles of the past were also beginning to be seen as historically significant. The experience of the senses was also to be exploited.

The differences in Baroque styles were no longer regional on a provincial basis. Artists frequently worked for long periods in lands far from their homes. Graphic arts, easily transported, brought replicas of the great works of leading masters to opposite ends of the world. The ravages of political and religious wars still continued. Baroque artists and their patrons began to use art as a form of social-consciousness raising.

Selected Readings

Bazin, G. *Baroque and Rococo Art*. New York: Praeger, 1974.

Blunt, A. *Art and Architecture in France: 1500–1700*. 2d ed. Harmondsworth: Penguin, 1970.

_____. *Baroque and Rococo: Architecture and Decoration*. Cambridge, MA: Harper & Row, 1982.

Chatelet, A., and J. Thullier. *French Painting from Fouquet to Poussin*. Geneva: Skira, 1973.

_____. *French Painting from Le Nain to Fragonard*. Geneva: Skira, 1964.

Hempel, E. *Baroque Art and Architecture in Central Europe*. Baltimore, MD: Penguin, 1965.

Powell, N. *From Baroque to Rococo: An Introduction to Austrian and German Architecture from 1580 to 1790*. London: Faber & Faber, 1959.

Waterhouse, E. *Painting in Britain: 1530–1790*. New York: Penguin, 1978.

21

Late Baroque and Rococo Art

1704 English victory over French at Blenheim

1715 Death of Louis XIV

1715–1774 Reign of Louis XV

1756–1763 Seven Years' War (French and Indian War); England and Prussia against France and Austria

1759 Battle of Québec

1775–1785 American Revolution

1789–1797 French Revolution

We have seen the enormous variety of Baroque seventeenth-century art that contrasts Bernini with Lebrun; Caravaggio with Velázquez, Rubens, Rembrandt, and Poussin. In the eighteenth century these artists' styles will persevere and be modified by followers. But the eighteenth century further represents a series of changing patterns in art. These are reflective of particularly important changes in nations and alliances of nations. They also represent the increasing concept that art bears political symbolism and can reflect social consciousness. The first half century begins with a continuation of the Baroque and its evolution to the lighter, more delicate art of the Rococo.

The death of Louis XIV in 1715 marks a turning point. In the age of Louis XV the focus returned to Paris, and there was a distinct reaction against the weighty pomp and ceremony of Versailles court life. The Rococo style marks this change. The word derives from the French rocaille *("rock work") and pertains extensively to decorative arts, though it has come, by extension, to include architecture, painting, and sculpture.*

In France the Rococo did not outlast the first half of the eighteenth century. The most outstanding monuments of the style, in fact, are in Austria and South Germany. The English painter Hogarth, the Italians Guardi and Tiepolo, and the Spanish Goya are all considered Rococo masters, but the art of the Rococo did not become predominant in England, Italy, or Spain.

LATE BAROQUE ART

The eighteenth century opens with a continuation of Baroque art in European countries. Most of the acknowledged great masters of Baroque art died before 1700. A number of artists seem to bridge the century successfully, and to continue in the weighty, pompous fashion that Late Baroque had become. Others would be quick to produce a new art that rapidly evolved to a lighter more fanciful style termed *Rococo*.

Architecture

FILIPPO JUVARA

Filippo Juvara (1678–1736) was a Sicilian architect who made his best works in Turin during the period when Sicily fell under the reign of the duke of Savoy and Piedmont in 1706.

La Superga. On a high hill over the city of Turin, Juvara built the basilica and monastery of La Superga for Vittore-Amadeo II, duke of Savoy. The church is basically a centrally planned circular structure with a dome and a temple-like portico. Wings extended to the sides support campaniles. The central dome compares to the Church of the Invalides in Paris. It is still Baroque, but its overall effect is lighter. The high drum supporting the dome, the balustrade over the portico and extending around the whole structure, and the open campanile towers produce this lighter effect.

The Royal Hunting Lodge, Stupinigi. From 1729 to 1733 Juvara worked on the huge royal hunting lodge known as Stupinigi for the House of Savoy. It is situated near Turin on large landscaped grounds. Two wings extend forward on diagonal angles from a large oval central hall. These branch out to additional wings. The whole is reminiscent of the plans of Versailles, though not built on the severe rectangular plan. The Classical order is reduced in emphasis.

SIR JOHN VANBRUGH

Sir John Vanbrugh (1664–1726) was commissioned to build Blenheim Palace, in Oxfordshire, northwest of London. The palace, a vast structure, was Queen Anne's award to John Churchill, duke of Marlborough, for his victory over the French at Blenheim. Vanbrugh, an amateur architect at best, had been a theater designer and dramatist.

Blenheim Palace. Blenheim Palace was built between 1705 and 1724. Its size is particularly impressive, but as a Baroque work it sits uncomfortably in its country setting. The use of colossal orders, projecting pavilions, and encompassing colonnades flanking a huge forecourt drew scorn from Vanbrugh's contemporaries. So did impractical design matters, such as placing the kitchen 400 yards (375 m) from the dining hall.

JACQUES-GERMAIN SOUFFLOT

Jacques-Germain Soufflot (1713–1780) was a French architect trained in Italy, principally in Rome. He lived and worked in Lyon. Soufflot traveled in a French royal entourage to Italy, particularly Paestum, where he studied the Doric temples. In 1755 he was named supervisor of the royal constructions for Paris and director of works at The Louvre.

The Panthéon, Paris. Shortly after, from 1757 to 1790, Soufflot built the Church of Ste.-Geneviève, known since the French Revolution as the Panthéon. His church is often cited as an example of Neoclassicism and as a reaction against the Rococo. Very few Rococo churches were built in France to react against, however, and Soufflot's sources combine his experience with archaeological study and his training in Italy.

The dome for the Panthéon is closely modeled on the dome of St. Paul's Cathedral in London. The rather severe outer walls of the Panthéon are the result of walled-up windows. This was done after the Revolution when the church was converted to a memorial to French heroes. Its interior is far more elaborate. There are domes over nave and choir and transept wings. It is claimed that Soufflot built his vaults using Gothic principles of construction, a technology he is known to have admired and praised.

As a result, while it may be premature to call this work Neoclassical and it may be an exaggeration to seek Gothic principles in its construction, the Panthéon is a harbinger of both trends, each of which will emerge as the second half of the eighteenth century progresses. Fundamentally, it is still a building of the Baroque era.

Painting

HYACINTHE RIGAUD

Hyacinthe Rigaud (1659–1743) was court painter to Louis XIV after 1682, and to Louis XV after 1715. His style was patterned after the French Baroque painter Philippe de Champagne. Though his state portraits of Louis

XIV, for which he is best known, are filled with the pompousness of the Sun King's court, Rigaud also admired and collected Rembrandt paintings.

Rigaud had a large active studio that produced his official works. By one account his studio produced an average of thirty-five portraits a year for sixty-two years (over 2,100 canvases).

JEAN-BAPTISTE SIMÉON CHARDIN

The painter Jean-Baptiste Siméon Chardin (1699–1779) is not easy to classify, should one try to distinguish between Baroque and Rococo in an exacting way. His paintings are simple scenes of commonplace interiors, kitchen still lifes, and unpretentious events. The sense of Dutch and Spanish Baroque pervades his works, yet the results are less harsh than Spanish paintings and less minutely finished than the Dutch. Chardin gives them a quiet, collected mood.

Grace at Table. The painting *Grace at Table*, in The Louvre, shows a mother and two small children in a simple dining room. They are about to partake of a meal. The furnishings are modest, yet carefully painted by the artist. The light is limited, and the color is nearly a monochromatic variation of reddish browns, with some subdued green added for balance. The interaction is gentle and human. The art of Vermeer comes to mind in comparison, though here we have no bright window spilling light into the room.

ROCOCO ART

Architecture ### GABRIEL-GERMAIN BOFFRAND

Gabriel-Germain Boffrand (1667–1754) was one of the architect-decorators whose work was popular in the early eighteenth century in Paris. Boffrand was a pupil of François Mansart. He redesigned and built town houses for the aristocracy in Paris particularly concentrating on elaborate decorative interiors in the Rococo style.

Salon de la Princesse, Hôtel de Soubise. A frequently cited example of this rich, rather frothy style is the oval Salon de la Princesse, a reception room in an elegant private town house, the Hôtel de Soubise in Paris, designed in 1732. Windows, mirrors, and wall panels alternate around the room, extending the space and fracturing the light. Gilt moldings and floral decorations enhance the surfaces, and paintings over the panels conceal the separation of wall from ceiling. The vaulted ceiling supports a huge chandelier fashioned to echo the room's shape.

JAKOB PRANDTAUER

Jakob Prandtauer (1660–1726), a German architect, made his best work in Melk.

Benedictine Abbey, Melk. The monastery at Melk, on a rock promontory over the Danube in Austria, is a dramatic element in its landscape. The elevated height emphasizes the dome with its broken curvature and the bell towers, which have onion domes. The interior of the church is an undulating nave, and it is particularly rich in decoration to impress noble visitors to the abbey.

BALTHASAR NEUMANN

Johann Balthasar Neumann (1687–1753) was a German architect who worked for the prince-bishops of Würzburg. Their palace, called the Residenz, is Neumann's best work.

Residenz, Würzburg. The large palace is best known for its interior staircase and the great Kaisersaal (Emperor's Hall), both grandly conceived and enriched by the paintings of Tiepolo.

Church of Vierzehnheiligen, near Bamberg. Balthasar Neumann also designed the Church of Vierzehnheiligen (Fourteen Saints), built from 1743 to 1772 near Bamberg in Germany. Here the façade is bowed outward in the center. The whole front rises in two stories. Bell towers top the sides.

The interior of the Vierzehnheiligen is a complicated interplay of ovals and circles in its plan. Above it is an intricate working of vaulted spaces united in several great ceiling paintings. The walls are white with gilt molding and trim. The columns are painted to simulate pink marble. Thus the interior is bright, and the curvature of all its surfaces makes a rich interplay of light and shadow.

Painting

Even more than in the Baroque, Rococo painting mixes with architecture and sculpture to dissolve the clear lines between each medium. The works are often a collaboration of various masters.

GIAMBATTISTA TIEPOLO

Giovanni Battista Tiepolo (1696–1770), for instance, worked from 1750 to 1753 with Balthasar Neumann at the Residenz in Würzburg to create the spectacular effects of the painting and architecture in the great stairhall and the Kaisersaal.

Tiepolo was a Venetian artist and has been called the greatest painter of the eighteenth century. The paintings at the Würzburg Residenz may be his most successful, but he worked in Venice and northern Italy, and for Charles III of Spain at the Royal Palace in Madrid as well. He employed both of his sons and many assistants who worked up his designs from small sketches and models. Both Tiepolo and his older son Giovanni Domenico Tiepolo

(1727–1804) were celebrated printmakers. They worked in etching. Giovanni Domenico's series of twenty-seven etchings called *Picturesque Ideas on the Flight into Egypt* (1750–1752) is his most famous work.

FRANCESCO GUARDI

Giambattista Tiepolo's brother-in-law was the painter Francesco Guardi (1712–1793). Guardi represents the painting of landscape "views," a category of painting in which the Italians excelled in the eighteenth century. The paintings rank more or less as souvenirs of the famed vistas of Venice.

Guardi's views of the Lagoon, the Piazzetta, San Marco, Palladio's San Giorgio Maggiore, and Longhena's Santa Maria della Salute depict these famous monuments with quick, deft touches playing on the surface. His brushstrokes mimic the play of reflected light in the watery atmosphere of the city.

JEAN-ANTOINE WATTEAU

Jean-Antoine Watteau (1684–1721) was of Flemish descent. He was from Valenciennes but traveled to Paris by 1702 and remained there for almost the rest of his life. He professed admiration for Rubens and showed an affinity for that master in his works. He was also affected by the Venetian school.

Watteau painted figures of the characters in the Comédie Française and the Italian Commedia dell'arte. His masterpiece is *A Pilgrimage to Cythera,* a painting made in 1717 as a submission piece for the French Academy.

A Pilgrimage to Cythera. Watteau's painting *A Pilgrimage to Cythera,* the mythical isle of Love, exists in two versions, the original in The Louvre and a second version in Berlin. The composition shows the languorous departure from the island. A late afternoon glow and frothy clouds and sky pervade the air. *Putti* circle and hover about as the couples converse and slowly wend their way toward the shore, leaving the garlanded statue of Venus at the right. The academy was forced to devise a term, *fête galante,* for such paintings. Many others of Watteau's works fit this nomenclature.

FRANÇOIS BOUCHER

François Boucher (1703–1770) was a follower of Watteau who worked for Madame de Pompadour and in elevated court circles. Boucher is best known for allegorical classical scenes featuring shepherds, nymphs, and goddesses in Arcadian grottoes and glens. Pink robes and warm flesh tones contrast with green leafy foliage, colorful bouquets, and light blue skies.

JEAN HONORÉ FRAGONARD

Jean Honoré Fragonard (1732–1806) was Boucher's student after having briefly studied with Chardin. He was an excellent landscape painter but became better known and popular for painted situations or intrigues.

The Swing. Such an intrigue is *The Swing,* a remarkable representation of a pink-clad young lady in frothy garments swooping forward on a velvet swing and kicking off a slipper toward a little statue of Discretion. This taunts the little figure and her lover concealed in the bushes who may glimpse her legs in more detail than he is accustomed. Her aerial display is aided by an elderly vicar who guides and propels her motion with a harness of guy ropes. The damsel is a pinkish glow in the center of a cool green maelstrom of foliage around her and a blue-green backdrop of misty trees.

WILLIAM HOGARTH

William Hogarth (1697–1764) was the real founder of the English school of painting. He knew the basics of composition and brushwork and had a sense of the Rococo palette and style, though his subject matter was a truly English attempt to report on morality and the foibles of his time. His art is in no way academic or idealized. Rather, he set out to make series of paintings as narrative examples of moralizing satires. Series such as the *Rake's Progress*, *The Harlot's Progress*, *Marriage à la Mode,* and others were painted with great virtuosity and humor.

Hogarth began his career as a trained engraver. He published engraved versions of his painting series. He also wrote and illustrated a book, *The Analysis of Beauty,* demonstrating that a curved line is of greater beauty than an angular one.

The Breakfast Scene of Marriage à la Mode. The series called *Marriage à la Mode* is a comment on the social custom of marriages arranged for social position and money. *The Breakfast Scene* shows the morning after a revelry in the newlywed couple's house. The pair has collapsed unceremoniously into chairs. Overturned furniture, books, and musical instruments lie on the floor. A yawning guest seems to have just come to in the dining room, and a steward gestures in disbelief, holding a ledger under his arm and a handful of unpaid bills.

Here, as in all his series, Hogarth has a keen eye for English taste and pretense. His scenes are filled with details that ring true, echoing the writing of Fielding and Smollett, his friends and contemporaries.

FRANCISCO GOYA

The Spanish painter Francisco de Goya y Lucientes (1746–1828) began his career in Madrid in 1763 after early training in his native Saragossa. After traveling in Italy in 1770–1771, and a period in Saragossa, he worked for the rest of his life in Madrid, first producing tapestry cartoons for the royal factory and eventually rising to the position of principal painter to the king, Charles IV. For this part of his life, Goya was primarily working in a

late Rococo style, inspired in part at least by Tiepolo, who spent his last years in Madrid.

Goya made an intense study of Velázquez and was also influenced, in his portraiture, by Anton Raffael Mengs, a Neoclassical artist in the Spanish court in the late 1760s. His portraits of Spanish royalty are an ironic combination of the lightness and colors of the Rococo and the arrogant, moronic stupidity of the royals, Charles IV, Ferdinand VII, and their wives and children.

Goya's intensity changed in the works of his later years. This is partly an outgrowth of his own experiences and observations of the world changes going on around him and partly an observation of court indifference. It may also reflect an introspectiveness forced on him by deafness, the result of an illness in 1792. At any rate, his etching series *Los Caprichos,* produced from 1796 to 1798, is a critical attack on the customs and manners of his times. Later, his *Disasters of War*, another etching series, of 1810 to 1813, records atrocities he saw or heard of in the time of the Napoleonic invasion of Spain in 1808.

The Family of Charles IV. Goya's late style of painting is termed Neobaroque by some art historians. *The Family of Charles IV* certainly reflects Velázquez's *Las Meninas*. Light and shadow play across the space of the group portrait. Goya himself is at work on a canvas in shadow to the left. In the center is the queen and in the right foreground, the king. Eleven other gaudily dressed royals stand in attendance around the king and queen.

It is still inexplicable that Goya seems to have found royal approval for this portrait. The insufferable and fatuous group seems incapable of detecting the scorn it represents.

The Third of May, 1808. Goya's painting *The Third of May, 1808* represents the reason for that scorn of the royal family. The Spanish throne had joined with others at war with the new republic of France, bringing atrocities and privation to Spain. The painting shows the execution of Madrid's citizens after the fall of the city. It is painted as the bleakest of disasters, taking place at night in acid-white lamplight beside which a faceless row of soldiers fires point-blank at terrified captives. Others lie slaughtered on the ground and more are being marched into the place. Light, shadow, and dramatic effect echo the Baroque here, but we are also cast into the modern world by the sense of the all-too-real horror at the event. This pivotal role is characteristic of Goya's genius.

Sculpture

As with painting, the sculpture of the Rococo is closely associated with architecture. In Austria and Germany particularly, large-scale sculpture is incorporated into Rococo churches.

EGID QUIRIN ASAM

Egid Quirin Asam (1692–1750) frequently worked with his architect brother Cosmas Damien Asam (1686–1739) to decorate the interior of churches and chapels and to add altarpieces to these locations.

Assumption of the Virgin. The sculpture *Assumption of the Virgin,* above the altar at the abbey church at Rohr in Germany, is a larger than life-size grouping of marble figures with gilt trim. The Virgin soars heavenward, borne up by angels beneath her, while the Apostles are gathered in awe about her tomb, watching. Carved billowing clouds surround a glowing window suggestive of heavenly glory overhead.

CLODION

Claude Michel (1738–1814), called Clodion, was a characteristic French Rococo sculptor, though he worked later in the century than many other Rococo artists of France. Clodion tended toward small-scale sculpture of figural groups.

Nymph and Satyr. His *Nymph and Satyr,* of terra cotta, in the Metropolitan Museum of Art in New York City, dates about 1775. It suggests works of Boucher and Fragonard in the active erotic play between the figures. Delicate and fragile details enhance it. It is a small work, approximately 2 feet (59 cm) high.

The eighteenth century is far too complicated to be defined by period designations. Clearly the Baroque came to an end here, and the Rococo belongs to the eighteenth century alone. It is also the age of new discoveries of all sorts and of changes that will further define the modern world.

The roots of Romanticism, the Gothic Revival, and the Neoclassical world are found in the eighteenth century. In this period the age of exploration turns to the age of exploitation, and to explosion on a worldwide stage. Revolutions in America and France stand at the beginnings of a modern world, entirely changed from the imperial past. These are the directions we must follow next.

Selected Readings

Conisbee, P. *Painting in Eighteenth-Century France.* Ithaca, NY: Cornell University Press, 1981.

Hitchcock, H. R. *Rococo Architecture in Southern Germany.* London: Phaidon, 1968.

Kimball, S. F. *The Creation of the Rococo.* New York: Norton, 1964.

Rosenblum, R. *Transformations in Late Eighteenth Century Art.* Princeton, NJ: Princeton University Press, 1970.

Whinney, M., and O. Millar. *English Art, 1720–1830.* London: H.M. Stationary Office, 1971.

22

The Arts of Asia:
India, China, Japan

*T*he many connections of the West with India, China, and Japan—through war, trade, and cultural contacts—have profound consequences for the arts of the East and West. New ideas have been carried across ever-changing international borders by way of art objects and aesthetic ideals since antiquity.

Artistic contacts of the West with Asia began in the Ancient Near East when Mesopotamia traded with the Indus Civilization (c. 2300–1750 B.C.) in Pakistan. In the early centuries of our era the Silk Route—from the Mediterranean, across Central Asia, into North India, Tibet, and China—was an avenue for the exchange of art objects and styles among these cultures. Beginning in the sixteenth century, extensive sea and land travel promoted vigorous interchanges between artists and patrons of the West and East. Chinese paintings and ceramics were the first of these non-Western arts to be studied academically in Europe.

To a greater degree than in the West, Asian arts developed in conjunction with the religious and philosophical ideas of their period and location. Often the arts of Asia were the necessary expression and vehicle of religious forces, either doctrinal or popular. We will see that the many forms of Buddhism have promoted a strong artistic link throughout Asia.

Baroque and Rococo artists in Europe were especially influenced by motifs and materials from China and Japan, sometimes using Asian settings or objects. Later, the painting and architecture of Romanticism took up Asian themes. The Royal Pavilion in Brighton, England (1818–1821), built by John Nash for the royal family, is a romanticized conglomerate of East and South Asian styles and techniques.

THE ART OF INDIA

c. 2300–1750 B.C.	Indus or Harappa civilization
c. 1500–450 B.C.	Aryan Vedic and Upanishadic periods
c. 563–483 B.C.	Life of Shakyamuni Buddha
327 B.C.	Alexander the Great in India
c. 322–184 B.C.	Maurya period
c. 272–232 B.C.	Ashoka's reign
c. 185–70 B.C.	Shunga period
c. 70 B.C.–30 A.D.	Regional developments
c. 30–320	Kushan period (North India)
c. 100–300	Satavahana period (Deccan*)
c. 320–550	Gupta period (North)
c. 320–750	Chalukya period (Deccan)
c. 600–800	Pallava period (South)
c. 750–1000	Hindu kingdoms (North)
846–1173	Chola dynasty (South)
1022–1342	Hoysala dynasty (Deccan)
1206–1526	Delhi Sultanate (North)
1336–1565	Vijayanagara dynasty (Deccan)
1420–1736	Nayaka dynasty (South)
1526–1707	Mughal empire (North, Deccan)
1707–1858	Colonial period
1858–1947	British rule and Indian nationalism
1947	Independence

*The Deccan is the central plateau of India separated from the north by the Vindhya Mountains, from the south roughly by the Krishna river.

Indus Civilization (c. 2300–1750 B.C.)

The Indus civilization planned its cities in grid patterns, used sophisticated materials and designs for water and sewer systems, and built multistoried housing. Its many agricultural centers boast the earliest long-term city planning. The Indus civilization is also called the Harappa culture, after one of its largest sites. Its artistic achievements include small stone sculptures that illustrate some qualities of later Indian sculpture: swelling volumes that seem to breathe and a monumentality that denies their small size. Contemporary with the cylinder seals of Mesopotamia, the Indus peoples used rectangular steatite seals with intaglio carvings of animals and mythical beings (many were found at Mohenjo-Daro). An enigmatic script on all of these seals has not yet been deciphered. However, some of the motifs—gods in yogic postures, tridents, sacrificial altars—foreshadow iconography used in the mature religious arts of India. These seals show early evidence of the acute sensitivity in portraying animal forms displayed in Indian arts to the present.

Aryan Migrations (c. 1500–450 B.C.)

Indo-Europeans called Aryans ("Nobles") moved into northwestern India and the plain of the Ganges River beginning in about 1500 B.C. They developed the Vedic culture that produced a wealth of literary works but few extant artifacts. At the end of Aryan dominance in the fifth century B.C., the Shakyamuni ("Sage of the Shaka clan") Buddha was born in the hills of present-day Nepal. The religion he inaugurated fostered some of the greatest religious art of Asia for one thousand years after the third century B.C.

Early Buddhist Sculpture and Architecture

ASHOKAN PILLARS

A convert to Buddhism, Emperor Ashoka (c. 272–232 B.C.) of the Mauryan period built some of the most well known Indian images. The emblem on the modern Indian national flag copies the lion capital of a free-standing column from Sarnath near the capital of the Mauryan kingdom (mid-third century B.C.). Its polished, powerfully stylized, and linear surface claims hegemony over the directions faced by the four *addorsed* lions. Monolithic pillars with lotus-petal capitals and emblematic animals were erected all over the Mauryan kingdom. Political edicts and Buddhist precepts were engraved on the sides of the pillars, crucial documents of India's ancient history.

BUDDHIST STUPAS

Ashoka had *stupas,* or monumental reliquary mounds, built in India, Sri Lanka, and Nepal to honor the Buddha and to serve as worship and teaching centers. The Great Stupa at Sanchi, first built during Ashoka's reign, was completed and elaborated in the mid-first century A.D. with railings, balustrades, and gates (*toranas*) covered with narrative relief carvings. Reliefs of city scenes describe the sophisticated urban culture of ancient India. Many

of the relief panels were sponsored by a guild of ivory carvers and indeed the precise, lively scenes emulate the ivory arts. Other important stupa sites are Bharhut in the northeast (first century B.C.) and Amaravati in the eastern Deccan, the broad central plateau of India (from the second century B.C. to the second century A.D.); each used a distinctive style of architectural decoration and iconography.

BUDDHIST ROCK-CUT ARCHITECTURE

Also begun in the Mauryan period were rock-cut "cave" temples that carefully imitated wooden architectural forms of the day. In the centuries around the beginning of our era the rock-cut worship hall (*chaitya*) and monastery (*vihara*) became established forms in northern and central India. The largest example is at Karli, built in about A.D. 120 near Bombay. It has a nave-like form, is 125 feet long, including apse and colonnade, and has a palatial façade and a free-standing lion pillar in front. Karli is carved into a stone cliff (called "living rock"). Its imitation of wooden constructions includes the use of curved wood beams in the hall's barrel ceiling; wooden architectural sculpture and balconies once adorned the front as well. An enormous horseshoe-shaped window with lattice screens filters light into the hall, illuminating the monolithic stupa at the apse end of the hall. This window shape and lattice decoration characterize Indian façades to this day.

Kushan Era
(c. 30–320 A.D.)

FOREIGN INFLUENCES AND INDIGENOUS IMAGES

The Buddha Image: Gandhara and Mathura. The beginning of anthropomorphic sculpture in India is a controversial and intriguing study of the motives for image making as well as the development of both indigenous and borrowed styles. Two sites sponsored parallel versions of Buddha images and narrative reliefs at least as early as the second century A.D.: Gandhara, in Pakistan, and Mathura in northern India. The Gandharan images resemble Hellenistic figural and relief traditions first imported with Alexander the Great when he occupied northwestern India in 327 B.C. The Gandharan Buddha looks like a perfect, sensuous human being, like Apollo. The Mathuran images follow indigenous forms: geometric, full volumes with attributes (called *lakshanas*) signifying a spiritual being. The Mathuran Buddha intimates the solid power of a village deity, definitely apart from this world. These disparate styles blended into an eloquent compromise in the fifth century A.D. during the reign of the famous Gupta clan.

"Classical"
Gupta and
Post-Gupta Art
(c. 4th–6th
centuries A.D.)

INTERNATIONAL BUDDHIST ART

Gupta Buddha Image. The Gupta, "Classical" style became the prototype for Buddha images throughout Asia. A sandstone stele found at Sarnath, the site of the first sermon by the Buddha, exemplifies this style: sensuous volumes combined with abstract religious symbolism. The ornamental fi-

nesse of this style was to be admired and imitated throughout India, Nepal, and Southeast Asia for centuries. It also provided the visual vocabulary for much of the religious art in China, Korea, and Japan.

Culmination of Rock-Cut Architecture. New rock-cut architecture was excavated during this period, serving both Buddhist and Hindu worship needs. The most well known group of Buddhist chaitya halls and viharas is at Ajanta, on the eastern Deccan (latter half of the fifth century). Dry-fresco murals on many of the walls portray the previous lives (*jatakas*) of the Buddha as well as Buddhist saints and divine beings; figures seem to glow in the dark interior. Although the images use courtly, sophisticated compositions, they evoke a strong spiritual presence. Remarkable for their rich modeling and palatial imagery, these paintings also provided models for designs in Sri Lanka and especially for the murals of rock-cut halls in Central Asia and China for the next three centuries. Architectural sculpture at Ajanta also carried forward the Gupta opulence into ever more elaborate displays. The style and skill of this work continued to flourish in India, even though the religion did not.

Buddhism Leaves India. Buddhism faded completely from India by about the eleventh century, lasting longest in the northeastern states; however, it grew and continues to this day in parts of China, Southeast Asia, and Japan. Small contingents of Buddhism exist today in the United States and Europe, and it is regaining adherents in India as well.

HINDU ROCK-CUT ARCHITECTURE

The Hindu site at Udayagiri in north-central India (early fifth century) used the rock-cut medium for its worship needs, also producing a series of monumental, high-relief images. On an island called Elephanta near Bombay, a Shiva temple almost 100 feet square was excavated in the living rock. More than life-size, deeply undercut relief sculptures enliven the walls of Elephanta (mid-sixth century). Shiva as Maheshvara, the "Great Lord," is portrayed by a gigantic bust with three heads: the right face and headdress has a sensuous, feminine demeanor; the central one a meditative, quiescent presence; the left one a fierce, masculine grimace. The omnipresent Indian theme of combining opposites into composite images is well illustrated by the iconographic examples at Elephanta.

CONSTRUCTED STONE ARCHITECTURE

Early Sites. At the site of Sanchi where the Great Stupa was built are the remains of the earliest extant free-standing temple. Here begin the fundamentals of India architecture: a central square sanctum, a pillared front porch, and architectural sculpture of auspicious symbols. Many examples of this formative period in temple architecture show innovations and additions to these essential elements. The temple to the incarnations of the god

Vishnu at Deogarh (c. 500–525) in north central India is a prototype for the medieval temples to come. On its east side is a highly decorated doorway that signifies the threshold of a divine precinct. The entrance displays both symbols of the blessings of this world and the many beings who share the divine realm with the gods. At the other cardinal directions are high-relief panels illustrating deeds performed by Vishnu.

Meaning of the Hindu Temple. The Hindu temple plan is based on a diagram of the creation of the universe called a *mandala*. The temple is a three-dimensional map of the cosmogony as envisioned by ancient Indian people. Every portion is ruled by a deity; every element and design has some purpose, some role—narrative or cosmological—in the unified scheme. A major difference between Hindu temples and Western churches is that Indian temples are not built for congregational worship; individual prayer and rituals performed by priests are the daily rule at the temple. The symbolic presence of the gods and goddesses, not the acts of worshipers, is paramount. Porches were added, however, for circumambulation rituals (walking around the sanctuary), for shelter of waiting devotees, for recitation of teachings and stories by the temple priests and clerics, and for sacred dances and dramas.

Medieval India (c. 7th–12th centuries)

HINDU ARCHITECTURE

Structural Architecture. Beginning in the sixth century A.D. a resurgence of Hindu devotional beliefs (*bhakti*) meant the proliferation of images to illustrate the mythology of the many sects. Strongest at first in north and central India (the Deccan), the building of structural temples in stone has left many monuments through which may be read the political and religious movements from the seventh to the twelfth centuries. Although fairly plain in the early stages, sculpture eventually covered the temple's exterior, projecting the power of the deity or deities in the inner sanctum outward. The governing iconography of these temples was to imitate, or rather to create, an abode for the gods that could take different forms: the mountain at the center of the cosmos, a palace fit for the greatest king, a mandala of the cosmos itself with its divine inhabitants displayed on the surface. Theories about space-enclosing architecture do not work well with Indian architecture: there is so much displayed on the exterior, so much only implied in the interior, that it may seem more like sculpture than architecture to the Western eye.

Rock-Cut Architecture. Buddhist and Hindu rulers excavated the long cliff at Ellora on the Deccan from the seventh to the ninth centuries. The world's largest monolithic temple at Ellora (late eighth century) is called Kailasa after the sacred mountain where Shiva lives. Excavated from the top down into a cliff, Kailasa imitates a constructed temple whose central, three-story tower is 100 feet high.

HINDU KINGDOMS

Styles of Hindu architecture were largely regional. Patronage depended on trade routes and on feudal lords whose realms fluctuated in extent and influence. On the Deccan were the Western Chalukya temple complexes at Badami, Aihole, Alampur, and Pattadakal (sixth to eighth centuries). In the south were the Pallava cities of Mamallapuram and Kanchipuram. In the north were a number of Hindu kingdoms, from the Pratiharas in Gujarat to the Palas in Bengal.

MEDIEVAL BUDDHIST ART

Buddhist architecture and sculpture continued in India until the twelfth century. The major sites were Aurangabad and Nagarjunakonda on the Deccan plateau, and Nalanda in the northeast. Both rock-cut and structural complexes served as universities for Buddhist scholars from all over Asia and as monasteries for disciples. Buddhist stone and metal-cast sculptures of the Pala and Sena dynasties in northeastern India (eighth to twelfth centuries) are well known for their supreme elegance and fine detail. Pala-Sena sculptural style and technique penetrated Nepal, Burma, Tibet, and China in service of esoteric Buddhist traditions.

SOUTH INDIAN STYLE

Mamallapuram. A complex of five monolithic shrines at Mamallapuram, in Tamil Nadu, offers a unique sampling of the varieties of South Indian Hindu architecture in close proximity. The shrines were sculpted out of a long granite ridge during the Pallava dynasty (c. 600–800). Each displays a different tower and sanctum design (called the *vimana* in the south), perhaps built as architectural models. The common Indian practice of having many levels of cornices made up of miniature shrines adorning the temple tower is played out on two shrines. A thatch roof and wooden barrel-vaulted roof are imitated on another two. Interspersed among the shrines are remarkable animal sculptures that reaffirm the Indian sensitivity to animals noticed as early as the Indus civilization: a bull seems about to rise; an elephant has a grace that denies his bulk.

South Indian Hindu Kingdoms. Although the Moslem invasions of North India began in about 1000, South India flourished with the Hindu kingdoms of the Cholas (846–1173), the Hoysalas (1022–1342), the Vijayanagaras (1336–1565), and the Nayakas (1420–1736). These dynasties continued and elaborated Indian arts in their different regions of the Deccan and far south. In architecture, enormous religious compounds of many acres, enclosed within a series of walls punctuated at the cardinal directions with high-towered gateways (*gopurams*), grew at the centers of southern cities. Multiple temples, "thousand-pillared" halls, and large temple tanks for ritual bathing became required parts of the temple city. The Minakshi temple

complex at Madurai in Tamil Nadu is still famous for its processional festivals and colorful images of the Indian pantheon.

South Indian Sculpture. South Indian sculpture became more and more elaborate, completely covering temple exteriors during the Hoysala period. Bronze sculpture, especially of the Chola dynasty, achieved technical and aesthetic perfection by the eleventh century. Examples of Chola bronzes are highly prized by museums all over the world. Made using the *ciré-perdu,* or lost-wax, casting method, these sculptures have a grace of implied movement, a precision of iconographic detail, and a subtlety of composition appreciated by connoisseurs and devotees alike. Painting also flourished, but few examples remain intact. The paintings were mythological murals narrating the mythology of the gods and goddesses on the interior walls of temples, similar to those painted on modern temple walls.

SPREAD OF INDIAN ARTS TO SOUTHEAST ASIA

Sri Lanka (Ceylon), Burma, Thailand, Kampuchea (Cambodia), Malaysia, and Indonesia (especially Java) received the religions and arts of India through active mercantile trade. Early missionary groups also brought Buddhist and later Hindu mythology, epic stories, and images to Southeast Asia. Each country and region established its own artistic idiom, building upon different Indian ideas and styles. Most remarkable are the huge temple complexes that create elaborate microcosms of Buddhist and Hindu cosmologies. The earliest is the multitiered stupa of Borobudur on Java (c. 800), which honors the emerging *Mahayana* teachings of Buddhism. A Hindu corollary is the compound at Angkor Wat, Kampuchea, built in the twelfth and thirteenth centuries. The overall plans of these temples are derived from Indian designs, but the sculptural detail and iconographic choices are distinctly Southeast Asian.

NORTH INDIAN STYLE

The evolution of North Indian temples saw a multiplication of elements and a trend toward higher and higher towers (called the *shikhara* in the north). In the tenth and eleventh centuries, this style culminated at Khajuraho in modern Madhya Pradesh: more than twenty immense temples on high plinths, each with as many as four stepped towers and four porches (called *mandapas*), form a city of temples of monumental proportions. Well known for their erotic relief sculpture on the exterior walls, the Khajuraho temples celebrate a devotional type of Hinduism that puts to use all levels of human experience, from sensual pleasure to spiritual self-control. Aesthetically, these temples demonstrate an impressive integration of sculptural detail and monumental architectural design rarely accomplished by any culture; multiple horizontal and vertical registers create a dynamic rhythm of visual complexity that shimmers in the glaring light. The towers and

porches cascade toward the worshiper from a mountainous pinnacle symbolic of spiritual power.

Indian Miniature Painting

Moslem incursions stopped the active evolution of Hindu architecture and sculpture in the north after the thirteenth century. Painting continued to develop, however, not only in the Moslem courts but also in the isolated Hindu kingdoms of the Deccan and western India. The format is generally small, on paper or linen, in albums made for royal patrons. Persian techniques of fine detail and complex coloring were introduced through the Moslem courts to the traditional Indian artists. Most well known are the seventeenth- and eighteenth-century paintings that combine indigenous and foreign modes in exquisite miniatures. Not only Islamic themes and portraits but also illustrations of natural phenomena and historical events are common.

In the western and so-called "hill" schools (in the Himalayan foothills) of Hindu painting, isolated feudal courts developed their own styles and subjects. Most unusual are the striking portraits of musical modes (*ragamalas*), depicting figures and landscapes that personify the taste, or *rasa,* of a melodic theme. Cults who worshipped Krishna, an incarnation of Vishnu, had their own erotic and religious poetic literature (for example, the *Gita-Govinda*). They had their favorite stories of Krishna's life and loves illustrated in highly refined but also lush and sensual miniature paintings.

Indo-Islamic Architecture

Islamic buildings in India began in the twelfth century, the century before the Delhi sultanate (1206–1526) was established in North India. The Moslem mosque (*masjid*), necessary for the congregational aspects of Islamic practice, provided an enclosed hall, usually pillared, and a large courtyard for worship. The direction of Mecca is noted by the *qibla*, in India along the west wall of the mosque. Indian mosques are noted for the variety and ornamentation of their façades, and for the number and location of their *minars,* the towers from which calls to prayer are made. Indian Islamic builders were especially adept at elaborate bases for the mosque's grand domes, such as arcades and sculpted squinches, and for monumental gateways that are often magnificently domed buildings in their own right. True arches are the hallmark of Indo-Islamic architecture, usually of the "four-pointed" variety.

Qutb Mosque and Minar. The Qutb mosque in Delhi is the earliest extant Islamic ruin (c. 1200). As with other early mosques, materials pillaged from Hindu structures were used to build the galleries and niches. Some of the carved stonework was recut. Pillars were left intact but with components rearranged or defaced. Vegetal decoration and ornamental Arabic script of verses from the Quran are the dominant surface features. Here, and in subsequent Indo-Islamic architecture, indigenous craftsmen and traditions determined the techniques and materials used for these masonry structures.

The Qutb Minar, a monument of victory rather than a religious minar, is 238 feet high (73 m). Its fluted height is "dressed" in richly carved inscriptions and elaborate brackets under its four balconies.

Taj Mahal. During the Mughal period (1526–1707) the most well-known Indo-Islamic monuments were built: the tomb of Humayun in Delhi (c. 1565), the palace in Fatehpur Sikri (1572), the Red Fort in Delhi (1639–1648), and the Taj Mahal in Agra (1634). The Taj Mahal incorporates all of the dramatic and rich elements of Mughal architecture. Its white marble is delicately carved and inlaid with semiprecious stones; the design is so well balanced and proportioned that the building seems self-sufficient, the air, water, and land around it superfluous. Although it is the tomb of Shah Jahan and his favorite wife, Mumtaz Mahal, it celebrates the opulent life and vision of paradise espoused by the Moslem faith.

Qualities of Indian Art

The sensual quality of Indian art persists throughout its long history. An example is the naturalism, sympathy, and reverence displayed by the treatment of animals, especially in sculpture. Although the artist remains nameless because of the predominantly religious purposes of Indian art, distinct personal styles are present in sensual contours and skilled compositions. Nature is keenly appreciated. Even where the subject is ethereal and spiritual, an earthiness dominates the style.

THE ART OF CHINA

c. 3500–1766 B.C.	Neolithic period
1994–1523 B.C.	Xia* (Hsia) dynasty
1766–1045 B.C.	Shang dynasty
1045–256 B.C.	Zhou (Chou) dynasty
1045–771 B.C.	Western Zhou dynasty
771–256 B.C.	Eastern Zhou dynasty
221–206 B.C.	Qin (Ch'in) dynasty
206 B.C.–220 A.D.	Han dynasty
220–589	Six Dynasties
317–581	Northern Dynasties

*The *pinyin* transliteration system of Chinese characters was officially recognized in 1979; when the previously used romanized spelling is different, it is given in parentheses, e.g., Beijing (Peking).

420–589	Southern Dynasties
618–906	Tang (T'ang) dynasty
906–960	Five Dynasties
936–1125	Liao kingdom, Manchuria
960–1279	Song (Sung) dynasty
960–1127	Northern Song dynasty
1127–1279	Southern Song dynasty
1280–1368	Yuan dynasty
1368–1644	Ming dynasty
1644–1912	Qing (Ch'ing) dynasty, Manchus
1912–1949	Republic of China
1949–	People's Republic of China

Ancient art in China is known from prehistoric ceramics dated to the fourth millennium B.C. A surprising continuity of styles and taste exists from these early arts through the nineteenth century A.D., especially for so large an area with such diverse cultural groups and languages. For example, an emphasis on modulated linear expression is evident in the neolithic painted pots as well as in seventeenth-century brush paintings. Chinese art also shows a strong appreciation of the limits and potentials of materials by utilizing such media as bronze, paper and ink, and porcelain, all to their best advantage. The substances themselves are prepared ritually, with great reverence.

Secular arts were important in China from early times. The role of nature in Chinese secular styles is not subverted; people are part of nature, not purveyors over nature, so the human figure, for example, is not emphasized. Art is seen as a revelation of the world rather than as a re-creation or representation of it; perspective is not utilized to replicate appearances but to create a convincing world for the mind's-eye.

Shang and Zhou Dynasties (1766–265 B.C.)

SHANG DYNASTY ART

Archaeological finds have verified that the Shang dynasty was a large kingdom centered around Anyang, northern China, from 1766 to 1045 B.C. Inscribed bones and shells, used for divination, have been found attesting to the early, pictographic roots of Chinese script. The feudal organization of Shang society is shown by the large royal tombs containing human and animal sacrifices. High-quality bronze ritual vessels are the hallmark of Shang fine arts. Made using elaborate piece molds, these bronzes are by far the most sophisticated in design and technique in the world at this time. The

enigmatic decoration on Shang vessels is composed of composite creatures, imagined in abstract, symmetrical line patterns. Squared and round spirals are the most common elements. These designs appear to be important symbols in the Shang sacrificial ritual system, but their exact iconography is unknown. It is clear, however, that they point to an ancient Chinese world view based on the reverence for ancestors and the manipulation of the powers of nature. The shape of these vessels was widely imitated in later ceramics when antiquarian sentiments were strong, as in the Song dynasty period.

ZHOU DYNASTY ART

Bronze Vessels. The succeeding dynasty, called Zhou (Chou), emerged in c. 1045 B.C. The art forms of this era carried forward the styles and media used by the Shang. Bronze vessels became larger and spiked with pieces of metal or animal shapes at the mold joints (flanges). The vessel silhouette changes from the subtle surface variations of intertwining creatures of the Shang to bold projections and distinct patterns. Zhou vessels are sometimes called "explosive" in contrast to the more "compact" forms of the Shang. A tendency toward ornament without overt symbolic content occurred toward the end of the period (the Eastern Zhou). This may reflect the emergence of the philosophies of Confucius and Lao Zi (Lao-tzu) of the sixth century B.C.; Confucianism emphasized ethics, and Daoism (Taoism) cultivated harmony with nature.

Jade and Other Luxury Goods. The opulence of the late Zhou is reflected in the jade and lacquer artworks made for the royal court. In addition, gold and silver inlay decorated bronze sculptures and vessels. In the fourth century B.C., narrative scenes—hunting and war scenes, rituals to the ancestors—became popular. Goods for the dead nobility became a prevalent artistic focus; jade and precious-metal ritual objects and jewelry were buried in royal tombs. Jade is highly valued throughout Chinese art history. Many poems and commentaries extol its virtues and allegorical attributes. Jade "is endowed with five virtues: charity is typified by its luster, bright yet warm; rectitude by its translucency, revealing the color and markings within; wisdom by the purity and penetrating quality of its note when the stone is struck; courage, in that it may be broken but cannot be bent; equity, in that it has sharp angles, which yet injure none" (from a Han dynasty dictionary, Michael Sullivan, *The Arts of China,* 1977).

Qin and Han Sculpture (221 B.C.– A.D. 220)

QIN DYNASTY TERRACOTTA ARMY AND GREAT WALL

The famous emperor Qin Shi Huang Di (Ch'in Shih Huang Ti) (221–206 B.C.) commissioned the more than 6,000-piece terracotta army discovered in 1974 in Shenxi (Shensi). This life-size battalion of soldiers, calvary, and court entourage was interred with the emperor as his "immortal bodyguard." An extraordinary combination of Archaic stylization and real-

ism is used in these sculptures. The figures are set pieces, identical except for their portraitlike, expressive faces. Huang Di's reign signaled the beginning of China as a country ("China" from Ch'in); he built the Great Wall and tried to destroy all past culture. Upon his death, the Chinese people rebelled and began the long dynasty of the Han (206 B.C. to A.D. 220).

HAN FUNERARY ART

The country expanded and had a strong central government during the turbulent Han period. Expansion included trade along the Silk Route, at its furthest extent with imperial Rome. Noted mostly for its special pictorial style, the Han produced a rich literary and visual history. Fluid, modulated lines characterize Han style: figures move and interact; horses gallop and birds soar. The well-known bronze sculpture of the so-called *Flying Horse* (second century A.D.), poised on only one leg, was found in a tomb at Wuwei in Gansu (Kansu). The horse, highly revered for its strength and grace, is a frequent theme in Chinese art. A new tradition of funerary pillars displays mythological animals and royal emblems on simulated guard towers sculpted in stone. Dragons, lions, and animal masks guard the way to the tombs. As in India at the same time, directional animals and dynastic emblems mark the domain of the ruler.

Bronze sculptures and mirrors, as well as sophisticated ceramics, were also found in Han tombs. The circular mirrors were ritual objects with cosmological diagrams and directional animals cast on the backs. Jade continued to be an important tomb accouterment. In 1968 two funeral suits made entirely of more than 2,000 squares of jade sewn together with gold wire were found on the bodies of a prince and princess in Hebei (Hopei), Mancheng (late second century B.C.). The firm belief in the protective, magical qualities of jade sponsored these unique and extravagant coffins.

Some paintings and many stone reliefs have been found in the continuing tomb-art tradition; ceramic tiles were stamped with dynamic patterns and emblems. The stone reliefs of the Wu family shrines (c. 147–A.D. 151) depict mythological scenes in conceptual space, showing distance by overlapping planes, and important figures by hierarchical scale (more important figures are larger). Using continuous narrative in registers, the reliefs capture the subtle juxtaposition of abstract shapes and realistic detail that characterizes later Chinese pictorial art.

Six Dynasties Buddhist Art (A.D. 220–589)

BUDDHISM IN CHINA

Buddhism was introduced into China by the first century A.D. It had traveled along the Silk Routes, from northern India to Central Asia and into northern China, where most of the early Chinese Buddhist art originated. Art during the Six Dynasties period was exceptional for China in its almost exclusively religious orientation. As an alternative to Confucianism and

Daoism, Buddhism offered hope of escape from worldly strife to the people and a sophisticated system of logic developed in Indian Buddhist universities to the intellectual elite. The Northern and Southern Dynasties (A.D. 220–589) sponsored much painting and sculpture in service of the Buddhist faith.

ROCK-CUT BUDDHIST TEMPLES

In its first few centuries, Chinese Buddhist art imitated Central Asian and Indian styles, iconography, and materials, including excavating rock-cut temples. In Central Asia a new practice of carving colossal Buddha images, sitting and standing, came into vogue. The Chinese emulated this practice in Yungang, Shanxi province (Yunkang, Shansi; c. 460), where a 45-foot (13.7 m) high, seated Buddha is carved into the sandstone cliff. Other figures were excavated at places such as Lungmen. The important site of Dunhuang (Tunhuang), Gansu, at the western gate of the Silk Route into China, has more than 300 rock-cut shrines. The Central Asian style of fresco painting, combined with architectural sculpture adapted to Chinese taste, dominates the Dunhuang sanctuaries. The iconography is respectfully copied from Indian Buddhist images, but the details and shapes begin to be distinctly Chinese: columnar body parts, elongated halos, and robes with exaggerated rippling hems.

BUDDHA IMAGE

The earliest known Buddhist sculpture, a small Shakyamuni Buddha in gilt bronze, dates from 338. Its style closely follows the string drapery and naturalistic features of the contemporary Gandharan prototypes in northern India. Later Six Dynasties Buddha images wear a soft smile, often called the "Archaic smile" in comparison with Archaic Greek sculpture (sixth century B.C.). Just as in the Gupta Buddhist images contemporary with the Northern and Southern Dynasty images, the artists combine human qualities with divine ideals and symbols. As objects of worship they are approachable as well as awe-inspiring. The newest Buddhist sects in China looked to deities as personal saviors who could grant a new existence in paradise; hence their images reflected human warmth and the promise of a happy life. By mid-sixth century, Central Asian influences decreased, and elongated, rhythmic, sumptuous Buddhist painting and sculpture emerged. Naturalism and grace were the dominant motives.

BUDDHIST PAGODA

Buddhist *pagoda* architecture in China began before the sixth century. These multistoried towers with dramatic, winged eaves are specific to Nepal, China, and Japan, and are believed to have developed from the Indian stupa mound. Miniature pagoda-like stupas have been found from as early

as the second century in northwestern India. By way of the Silk Route this characteristic design traveled along with the Buddhist faith into China and spread from there especially to Japan in the seventh and eighth centuries. An ancient example in Canton, China, is the Pagoda of the Temple of the Six Banyon Trees, first built in 537 and rebuilt in 1098. It has seven stories, receding slightly in size from the lowest to the highest, and is hexagonal in plan.

SOUTHERN DYNASTIES PAINTING

Xie He's Canons. The courts of the Southern Dynasties (420–589) saw the earliest dominance of painting in China. Texts describe in detail many scrolls of landscapes that no longer exist, although some were copied. Nature was represented, or rather re-created, as a place for imagined wanderings. The earliest Chinese treatise on painting was written during this time; the six canons of Xie He (Hsieh Ho) governed aesthetic ideas about painting for centuries. Especially the first, "sympathetic responsiveness of the vital spirit," and the last, "transmission of experience of the past in making copies," have determined the course of Chinese painting. Each dynasty interpreted the first maxim according to the prevailing aesthetic philosophy. The instruction to make exact copies has helped art historians in that a record of the great painters is guaranteed, but it has also made authenticity difficult to verify.

Gu Kaizhi and Wang Wei. The painters of the Southern Dynasties period are known to us mostly through historical records and copies. Gu Kaizhi (Ku K'ai-chih; c. 344 – 406) was a court painter, best known for his horizontal scroll painting (ink and colors on silk) *Admonitions of the Instructress to the Court Ladies,* which has explanatory text between scenes. It narrates events of court life and rules of behavior for the emperor's wives using only interacting figures and minimal furniture or landscape on a plain ground. Wang Wei was a fifth-century landscape painter who also wrote about the art of painting. In both styles of painting, court and landscape, the expressive medium is the modulated flowing line put down by the special brush made of different types of hairs layered over a dense core that holds the ink. Skill in manipulating the multiple resiliencies of the brush makes possible the expressive lines of varied width and density associated with Chinese art.

Tang Dynasty Art (618–906)

THE COSMOPOLITAN AGE OF CHINA: TANG EXPANSION

The Chinese empire broadened its borders toward the west and north during the Tang dynasty. Three centuries of extensive cultural, religious, and artistic exchanges among China, Japan, Central Asia, and India began in 618. The Tang is well known for being the most cosmopolitan era of Chinese art history and religion. Buddhism flourished, including the new esoteric sect

of Chan Buddhism (known as Zen in Japan), and the popular paradise cults. By the Tang period the iconography and basic forms of the Indian Gupta style of sculpture and painting had been adopted throughout South, Southeast, Central, and East Asia. Adaptation to Chinese taste and cosmology is the theme of Tang arts, as well as an enthusiasm for foreign things, exotic patterns, and the accidents of the creative process. Images with many arms or heads became popular, for example, and the random dripping patterns of colored ceramic glazes were highly prized. Tang Buddhism had complex doctrines and visions of paradise that required ritual implements and sculptures, as well as minutely detailed pictorial paintings.

BUDDHIST ART

Later in the Tang dynasty, a persecution of Buddhism eliminated most of the Buddhist art in China (845). The government revived Confucianism to lessen the accumulated power and property of the Buddhist monasteries. It is through the Buddhist arts of Japan, which closely imitated or imported the Chinese styles, that we know about Tang religious arts. A storehouse called the Shoso-in, sealed after the death of the Japanese Emperor Shomu in 756, contained numerous Chinese objects of the Tang era.

The fleshy appearance of the Buddhas and *bodhisattvas*, broader and denser than the Indian models, is the most notable Tang Chinese characteristic. In addition, the western rock-cut temples under the rulership of Tibet provide a wealth of wall paintings and architectural sculpture that give a vivid picture of what the art must have been like in Chinese cities. A mural in a Dunhuang cave shows the *Paradise of Amitabha* (ninth century), set in an elaborate architectural setting with some landscape elements as well.

TOMB ART

Tomb wall paintings and ceramic figurines paralleled the developments in religious art. Tomb paintings produced in the capital city of Changan (modern Xian) are viewed by Chinese historians as the classic "golden age" of figure painting. The tomb murals of the Princess Yongtai (Yung-t'ai; 706) show courtly men and women interacting on a shallow stage. Full-face and three-quarter views are common, with elegant poses suggesting movement and contour lines suggesting pliant volumes. The fleshy and robust character of contemporary Buddhist figures is also found in paintings on paper and silk. Most museums have examples of the whimsical performers, domesticated animals, and fantastic creatures that were made by potters for the royal tombs. Some of the foreign visitors to the Tang court are depicted, especially troupes of entertainers, acrobats, and traders. The colored lead glazes and superb designs of moving figures make the Tang figurines unmatched by any other ceramic arts.

PAINTING AND COURT ARTS

The *Scroll of the Emperors* (known from a copy of a work attributed to Yan Liben [Yen Li-pen], who died in 673), superbly drawn in ink and colored washes on a plain ground, illustrates the corpulent emperors in hierarchical scale compared to their attendants. Horses again received special attention from the Tang court painters and sculptors. Album leaves by Han Gan (Han Kan; active 742–756, ink on paper) display the royal horses, sometimes with their grooms (especially interesting because the grooms are usually West Asian). Poems and seals on these paintings show the revered position both the artworks and the horses enjoyed from the Tang period on.

Landscape painting continued to develop. *The Emperor Ming Huang's Journey to Shu,* a color-on-silk copy after Li Zhaodao (Li Chao-tao; c. 670–730), belongs to the Tang dynasty, the prototype for later monumental mountain landscapes. The Tang painter Wang Wei (same name as the Southern Dynasties painter; 699–759) is legendary for his intimate, "literary" style monochrome scenes, often depicted in winter with an "artless" tenor; both ink and white paint on a middleground of silk produce a dramatic "reverse" technique.

Inlaid bronze vessels and sculptures also graced the Tang court, continuing the Han dynasty style of luxury goods in addition to imported items. No architecture remains, but ceramic models and drawings illustrate the elaborate wooden structures of the urban centers. Also, Japanese Buddhist architecture of this time is thought to have been built in exact imitation of Tang models, often supervised by Chinese architects.

Five Dynasties and Song Dynasty China (906–1279)

The fall of the Tang empire in 906 left several rival states in China called the Five Dynasties (906–960). This period is important in Chinese art history for the development of landscape painting. The Five Dynasties are comparable to the Southern Dynasties of the fifth and sixth centuries when artists and scholars also turned to nonpolitical, nonreligious ventures and themes. From this time on, a remarkable continuity of ideas and techniques underlies landscape painting in Chinese art history. The northern part of China was reunited under the Northern Song (Sung) dynasty in 960; the south then gained dominance in 1127 (the Southern Song dynasty, 1127–1279).

MONUMENTAL STYLE

Dong Yuan and Wei Xian. Two Five Dynasties painters are well known: Dong Yuan (Tung Yuan; active late tenth century) and Wei Xian (Wei Hsien; active 937–975). Hanging scrolls of the "monumental" style characterize this period; incidental decoration is minimal and the landscape is the dominant subject of the painting, with figures playing a literally tiny role. Even when the title of the painting is *A Noble Scholar,*

by Wei Xian, the minute scholar is shown in an open structure in the midst of a tangled wild forest beneath towering mountains.

Fan Kuan. The Northern Song style carried this monumental tendency forward. Fan Kuan (Fan K'uan; active c. 990–1030) is famous for his *Travelers Among Mountains and Streams*, a much-copied hanging scroll (ink on silk, 6 feet 9 inches by 2 feet 5 inches). Above the misty middleground, mountain peaks dwarf the craggy scene below. Narrow ribbons of water fall from the mountains, flow beneath the mist, and cascade into the stream below. A minuscule train of horses and people emerges out of the forest. The means of creating perspective here is special to Chinese landscape painting; no single point draws the viewer into the work—the eyes travel freely over the surface, enjoying the lines and washes as if moving through them. A distinct fore-, middle-, and background cleanly divide the distances in the painting, using as few perspective devices as possible to make the scene sensible.

Mi Fei and Guo Xi. Another important painter of this style is Mi Fei (1051–1107), who painted in wet dashes and dots of ink that could be compared with the much later Impressionist technique practiced in nineteenth-century Europe. In a nearly opposite technique of dry, scratchy strokes, Guo Xi (Kuo Hsi, c. 1020–1090) painted hanging scrolls like *Early Spring,* which has been dated to 1072. The dramatic, spiky trees are barely separate from the cracked rocks in the raw landscape; they appear to be actively rending the mountain apart.

Handscrolls. Another format for monumental painting at this time was the handscroll, which could measure as long as fifty feet, and was unrolled to show small sections at a time for leisurely contemplation. A sequence of moods, changes in seasons, and movement over great distances were the themes developed by the handscroll. Many included narrative poetry as commentary on the unfolding views. This style, often defined as a visual symphony, remained popular in the courts and universities through the Qing (Ch'ing) dynasty (1644–1912).

LITERAL STYLE

The scholar-gentleman was the persona of the Chinese painter. The major exponent of the literal style was the highly educated Emperor Hui Zong (Hui Tsung; ruled 1101–1125, Northern Song). He painted precise representations of birds, animals, flowers, and plants. Each feather, each petal was sharply defined, and a descriptive poem usually framed the drawing. The format for these small works was often an album leaf or fan. Li Gonglin (c. 1049–1106), a court painter, continued the Tang tradition of horse portraits, now on handscrolls; study, for example, *Five Tribute Horses,* Northern Song dynasty (unfortunately destroyed during World War II but known from photographs).

LYRIC STYLE

Ma Yuan. In 1127 the hegemony of Hui Zong fell to the "barbarian" Mongols and Tartars from the north and west. The court moved south and remained in power there as the Southern Song dynasty until 1279. A new "lyrical" style of painting began in response against the sensuous leisure arts of the capital. In landscape art the monumental format of scrolls was retained, but the compositions were asymmetrical, cut off, not rational. The roles of intuition and spontaneity became significant for the first time. The most famous proponent of this style is Ma Yuan (active c. 1190–1225), known for his compositions that leave one corner empty (hence called "one-corner" Ma). *Bare Willows and Distant Mountains,* an album leaf in the Boston Museum of Fine Arts, illustrates the spidery, unbalanced trees and hazy background characteristic of Ma Yuan.

Xia Gui. Long handscrolls became poetic ramblings over landscapes with little or no definition; much was left to the imagination. *Clear and Distant Views of Streams and Hills* by Xia Gui (Hsia Kuei; c. 1180–1230) alternates between nearly blank sections and bold sketches of shores, and outlines of distant hills. It is peopled with a few tiny boats, bent stick figures guiding their course, moving slowly along the stream. Brush strokes are quick, more suggestive than literal, in contrast to the "realistic" nature paintings of the Northern Song. In *Twelve Views from a Thatched Hut* (Nelson Gallery in the Atkins Museum, Kansas City), Xia Gui continues this less controlled brush style in a handscroll format.

SPONTANEOUS STYLE

Two types of the so-called spontaneous style developed during the Southern Song dynasty. The first emerged from popular ink paintings of bamboo and related subjects; the second emerged from the calligraphic arts of Chan Buddhism and native Daoism. Both were greatly influenced by the lyric style painters, extending Ma Yuan's free technique to its limits and Xia Gui's free evocative mood to its extremes. Examples of the spontaneous style were influential in turn on later Chinese and Japanese Zen painting. Modern Expressionist art has also taken inspiration from these innovative painters.

Mu Qi. Mu-Qi (Mu-ch'i; c. early thirteenth century to after 1279) is perhaps the best known in both the East and West. *Six Persimmons,* a small ink painting on paper, is exemplary of the spontaneous style. It is a simple, enigmatic, and quick study of six fruits set upon a completely plain background that has inspired lengthy interpretation among Chan Buddhists and aesthetic theorists alike. While quick, it also displays great skill and subtlety in the handling of ink washes and opaque brushwork; calligraphic, modulating lines are complemented by modeling of the fruit with incredibly terse shading. Another remarkable work by Mu-Qi is the Buddhist triptych *Crane*

in a Bamboo Grove, White-Robed Guanyin (a bodhisattva), and *Monkey with Her Baby on a Pine Branch,* whose main subjects, unlike the *Six Persimmons,* are precisely defined in the midst of foggy, freely drawn settings. He combined the spontaneous style with literal details to striking effect.

Liang Kai. The spontaneous style was the favorite vehicle for Buddhist artists. *Hui Neng, The Sixth Chan Patriarch, Chopping Bamboo at the Moment of Enlightenment,* painted by Liang Kai (Liang K'ai; died after 1246), is a hanging scroll that narrates the attitude of Chan Buddhism toward doctrine: it is not decorous piety that accompanies wisdom but the rough, spontaneous, and yet meaningful act; direct personal experience, not ritual and study, is the key to becoming like the Buddha. Hui Neng crouches on a bare ledge hacking the stems from a long stalk of bamboo with a sharp blade. In Chan this is an appropriate visual metaphor for the moment of enlightenment.

CERAMICS

The celadon vessels that China is famous for developed during the Southern Song era. This special gray-green glazing process originated in northern China and was applied to the gracious shapes of porcelain ceramics. Many other types were perfected in the thirteenth century: *ci zhou* (tz'u-chou) stoneware, *ding* (ting) porcelain, and *jun* (chun) porcelaneous stoneware are among the most well known. The skillful and intricate designs, shapes, and colors on these vessels, whether bold in high-contrast patterns or subtle in delicately incised lines, became the epitome of ceramic glazes looked to by potters to this day.

Yuan Dynasty (1279–1368)

PERIOD OF FOREIGN DOMINATION: PAINTING

Huang Gonwang. Kublai Khan overran China in 1279 and a dynasty of Mongol rulers dominated China until 1368. Painting was the most affected art form of this "barbarian" phase. Most scholar-painters chose exile rather than serve the new court, and their subject matter was often their life in the wilderness. The landscape had been a scene to be viewed with distant, philosophical pleasure, but now it became the immediate and threatening environment. Mi Fei's soft mists changed to splintered trees and massive mountains. The monumental-style painter Huang Gongwang (Huang Kung-wang; 1269–1354) painted scrolls of tiny rough dwellings amidst the mountainous wilderness of China, viewed from the inside out rather than from the outside in.

Yuan Spontaneous Style. The spontaneous style of painting flourished during the Yuan because the new court patronized many forms of Buddhism, including Chan, as well as Daoism. In addition, the exiled painters Li Kan (Li K'an; 1245–1320), Ni Zan (Ni Tsan; 1301–1374), and Wu Zhen (Wu Chen; 1280–1354) painted asymmetrical studies of bamboo trees and leaves,

often including verses in stylized calligraphy that was becoming an art form in itself. Bamboo is a symbol of the scholar-gentleman; in adverse conditions it may bend, but it will not break. The saints of Buddhism and Daoism were common subjects of such painters as Yan Hui (Yen Hui; c. fourteenth century) and Yintuole (Yin-t'o-lo; active second half of the thirteenth century). A wide variety of individual styles of spontaneous landscapes emerged, from the archaizing, "primitive" handscrolls of Zhao Mengfu (Chao Mengfu; 1254–1322), to the dense, coarse hanging scrolls of Wang Meng (1308–1385).

Yuan Literal Style. Zhao Mengfu, who was among the few painters who did work in the Yuan court, also painted in the literal style but with the particular stylization characteristic of the Yuan. The well-known scroll *Sheep and Goat*, in the Freer Gallery of Art, Smithsonian Institution, is cursive and decorative, a departure from the labored detail of the Tang. Ren Renfa (Jen Jen-fa; 1254–1327) continued the tradition of horse and groom paintings, here with Mongol trappings and features.

ARCHITECTURE

Yuan rulers especially favored building elaborate, walled palaces, inspiring the later Forbidden City of the Ming dynasty. Many Buddhist pagodas were built, some as the gateways to major trade and military routes. Imperial ceremonial hall architecture was adapted to Buddhist worship purposes, including enormous murals depicting scenes of paradise presided over by the Buddha and bodhisattvas.

Ming and Qing Dynasties (1368–1912)

PAINTING

In 1368 the last of the Mongol overlords was driven out by native leaders. The indigenous Ming dynasty then ruled until 1644. Song dynasty painting styles were revived with innovations such as touches of vivid color on hanging scrolls and handscrolls. Many "in the style of" paintings remain from this three-century period because painters exercised the ancient practice of imitating the works of older artists. After 1450, however, a new, creative school of scholar-painters who looked to either the "southern" trends of conservative, learned painting or the "northern" trends of romantic, professional painting, dominated. The older styles were transformed in order to express contemporary issues and ideals.

Ming Painters. Dong Qichang (Tung Ch'i-ch'ang; 1555–1636) painted handscrolls such as *Rivers and Mountains on a Clear Autumn Day* as if the land was tilted, that is, from a bird's-eye perspective. He is considered to be the preeminent painter of the Ming dynasty. A much-admired painting called *Poet on a Mountaintop,* by the prolific painter Shen Zhou (Shen Chou; 1427–1509), represents the amateur-scholar ideal pictured in solitary contemplation. The craggy style of *Early Spring* by

Guo Xi is carried further by Wen Zhengming (Wen Cheng-ming; 1470–1559) in *Old Cypress and Rock* which is a close-in, frank portrait of aged nature, grotesque in its gnarled contortions. A hanging scroll by Qiu Ying (Ch'iu Ying; active c. 1522–60), *Emperor Guang Wu of the Western Han Dynasty Fording a River,* is an imitation of the early Southern Song monumental paintings with the addition of brilliant color and new perspective devices; mountains tinged with azure blue rise in near and far ranges separated by heavy mists. Figures in the foreground are larger than earlier scrolls, recognizable and highly detailed, and an elegant pavilion in the center is drawn in careful perspective.

Qing Painters. Another foreign power called the Qing dynasty dominated China after 1644; the Manchus (from Manchuria) took over military control but readily embraced Chinese cultural traditions as their own and became great collectors of art. Chinese artists were successfully recruited to work for the new court. An innovative painter of the Qing dynasty was Zhu Da (Chu Ta; 1624–1705), a Chan Buddhist who followed the spontaneous style. *Fish and Rocks* is a section of a handscroll that sketches the fish and rocks as if under water—the style is quick and yet suggestive like Mu-Qi's *Six Persimmons*. An example of the more traditional monumental handscroll is *Ten Thousand Miles of the Yangzi* by Wang Hui (1632–1717), which shows great competence in technique and a consistent composition throughout the painting's fifty-three-foot length. By the Qing period, the traditional painting styles had become somewhat rigid, more decorative and academic than in the innovative days of the early Song dynasty.

New Painting Styles in the Qing. The calligraphic quality of some of the more spontaneous arts extended to Qing narrative paintings of folk themes and religious stories. Hanging scrolls like *Zhong Kui Supported by Ghosts*, by Luo Ping (Lo P'ing; 1733–1799), showing an incident in a legend about a "demon-queller," depict the scenes with modulated brush strokes alone, put down with spirited energy and a wry sense of humor. Another development of the Qing was the introduction of Western techniques of perspective and shading. The Italian Jesuit Giuseppe Castiglione (active in Beijing 1715–1766), named Lang Shi-ning by the Chinese, brought French painting techniques to the court and became a painter himself in a composite Chinese-European technique.

CERAMICS

Ming and Qing potters excelled in the technical aspects of ceramics, favoring fine, translucent porcelain as the base for elaborate decorations. Many experiments with colored glazes produced new categories of wares: for example, "five-color" vessels, "blue-and-white" porcelains (using imported cobalt pigments), and "secret" ware, with faint decorations incised

into extremely thin porcelain. The Manchus patronized many kiln sites. Monochrome glazes were also perfected in competition with polychrome ceramics. Extreme subtlety was sought in a pale, silver-blue glaze, for example, known today as *clair de lune*. In addition, porcelain sculpture called Fukien ware, in the early Qing period (seventeenth and eighteenth centuries), became popular especially for small votive bodhisattvas, almost completely human in appearance.

MING ARCHITECTURE, THE FORBIDDEN CITY

The Ming dynasty is especially important in the history of Chinese architecture and city planning. In general, architecture is an extremely conservative art throughout Chinese history, with the basic building profile changing very little from ancient times. The fabled Forbidden City, known today as the Imperial City, in Beijing, was laid out during the early Ming dynasty on the ruins of the Mongol capital. Characteristic features of both governmental and sacred structures are visible in the highly symbolic buildings of the Imperial City. Ancient cosmological ideals are invoked in the central square with entrances and buildings facing the south along a north-south axis; a succession of ceremonial gates, halls, and palaces is enclosed by the high protective wall. The surrounding wall is itself a dominant Chinese architectural element, important from the smallest family enclosure to the Great Wall built in the ancient Qin dynasty.

The most common postcard of the Imperial City shows the Gate of Supreme Harmony (Tai-he Men), the long entrance pavilion with five gateways joined by covered walks, with multiple overhanging eaves and elaborate bracketing beneath the pitched-roof wings. Glazed-tile roofs, decorative brackets, stone platforms, and modular bays of wood all characterize the Imperial city and Chinese monumental architecture in general.

Republic of China (1912–1949) and the People's Republic of China (1949–)

Social realism, diametrically opposed to traditional Chinese art, is the motive for most Republic painting and sculpture. Some painters continue work after the old styles, but the majority of sponsored art must serve the modern purposes of the cultural revolution. An example is *The Rent Collection Courtyard* (1965), a sculptural tableau made by an anonymous team of artists. The theme is the severe oppression of the peasants by the landed nobility, a situation that the revolution has eliminated. As art is given over to collective ideals, the artist becomes a figure from the distant past.

THE ART OF JAPAN

c. 8000–250 B.C.	Jomon period
c. 250 B.C.–250 A.D.	Yayoi period
c. 200–552	Kofun period, Haniwa culture
552–645	Asuka, Suiko period
552	Buddhism begins in Japan
645–794	Nara period
645	Taika reform
645–710	Early Nara, Hakuho period
710–794	Late Nara, Tempyo period
794–1185	Heian period
794–897	Early Heian, Jogan period
897–1185	Late Heian, Fujiwara period
1185–1333	Kamakura period
1392–1573	Ashikaga, Muromachi period
1573–1615	Momoyama period
1615–1868	Tokugawa, Edo period
1853–1854	Perry comes to Japan
1868	Modern Japan begins

Indigenous Arts: Jomon, Yayoi, and Kofun Periods (c. 8,000 B.C.–A.D. 552)

JOMON PERIOD

Japanese arts are generally products of the adaptation of foreign models with a vigorous infusion of Japanese taste and skill in manipulating native materials. Evidence of Chinese, Korean, and Southeast Asian influences dates from the early centuries A.D. However, the earliest known artifacts of the Jomon culture (c. 8,000–250 B.C.), pottery and figurines, are distinctly indigenous. As part of Japanese neolithic culture, these ceramics come in fantastic shapes and bold patterns. *Jomon* means "rope," naming the winding cord motif that covers the hand-built pottery vessels. Equally fantastic figurines of earthenware date to the early and middle Jomon period, possibly designed to be fertility emblems.

YAYOI PERIOD

The succeeding Yayoi period advanced to a bronze-iron culture. The major remains of this period are bell-shaped bronze plaques called *dotaku* with fine linear relief patterns and pictographs of animals, people, boats, and houses. Contact with Southeast Asia is evident in the boat and house designs.

HANIWA CULTURE, KOFUN PERIOD

Haniwa means "circle of clay," the given label of cylindrical clay pickets planted around the grave mounds of Kofun emperors and nobles. The tops of these posts were often sculpted in whimsical forms of people, horses, monkeys, and miniature architecture. Museums around the world prize these Haniwa figures (mostly from the fifth and sixth centuries A.D.) as enchanting examples of native Japanese art. The largest mound belonged to Emperor Nintoku near Osaka (fifth century A.D.). The central tomb is a keyhole-shaped island surrounded by three moats, the whole mound nearly half a mile long.

NATIVE SHINTO ARCHITECTURE: ISE AND IZUMO

Because wood is the predominant building medium in Japan, no remains from proto-historic times are extant. However, the Shinto shrine complexes at Ise and Izumo are believed to faithfully reflect their original form from the early Kofun period. Shinto is the indigenous religion of the Japanese. Part of Shinto ritual is the exact rebuilding every twenty years of the main ceremonial shrine (for the Ise shrine, the most recent rebuilding was in 1973, and the current rebuilding will be complete in 1993).

Well-known for their clean, rustic simplicity and superb use of burnished cypress wood and brass fittings, these houses for Shinto deities (called *kami*) probably resemble domestic dwellings of the Kofun era. They are raised on stilted platforms with steeply pitched thatch roofs, and a narrow balcony surrounding the wooden walls. As in China, the surrounding enclosure is of utmost importance. At Ise four concentric fences delineate the hallowed ground within, broken only by unadorned *torii* gateways.

The incorporation of natural materials, showing off their best aspects, is a prominent characteristic of Japanese sacred architecture, beginning with the Shinto ceremonial precinct. The dominant sentiments of Shinto, reflected beautifully in its architecture, are purity and dignity. Most of the *kami* are deified places or aspects of nature thought to have extraordinary power in ancient Japan. Shinto ceremonial practices are centered around the imperial family, who are believed to be descendants from the *kami* who created the earth and humankind.

Buddhist Art of the Asuka Period (552–645)

IMPORTANCE OF KOREAN ART

As the peninsula between China and Japan, Korea served as a transmitter of arts between the two great cultures. It had its own special styles, however. Stoneware and celadon ceramics were perfected in the many kilns of the Korean countryside, including highly individual tomb figurines. Buddhist architecture was similar to Chinese ceremonial buildings, but the eave decorations and brightly painted dentils and brackets are specifically Korean. Many of the distinctive Buddhist sculpture designs of Japan first appeared in Korea. Versions of the seated *Miroku* (Maitreya, the future Buddha, in Sanskrit), for example, were invented in Korea and were then imported to or adapted by the Japanese. Note especially the *Miroku* of the Asuka period (mid-seventh century), made of gilt wood at the Chugu-ji Nunnery, Horyu-ji, Nara; a gilt bronze sculpture (sixth to seventh century) with similar iconography and composition is now located at the National Museum of Korea, Seoul.

ASUKA SCULPTURE

Buddhism itself was introduced to Japan by way of Korea, traditionally in 552. The ruler of Paekche (a kingdom in Korea) sent a gilt bronze Buddha image and devotional texts to the emperor of Japan. Later, the Japanese Prince Shotoku (572–622) established Buddhism as the state religion, sponsoring many building and sculpture projects. In sculpture, the dominant style exactly recalls the Six Dynasties columnar figures of northern China during the sixth century. An early example is the *Shaka Triad* (623; Shaka is the Japanese name for Shakyamuni Buddha) at the Horyu-ji Temple in Nara. The sculptor was Tori Busshi, a Korean by descent, who looked back to mid-sixth-century Chinese art, the style of the legendary first Buddha image to arrive on Japanese soil.

Later in the Asuka period (also called the Suiko after the empress from 593–628), the newer Chinese Sui dynasty styles prevailed in Japan. In addition, here began the synthesis of the various aesthetic tastes—Indian, Chinese, Korean, Japanese. In the above-mentioned *Miroku* is seen a softening of features and a childlike countenance unknown in India, China, or Korea, while other characteristics are clearly imitated.

ASUKA PAINTING

The *Tamamushi Shrine,* now located at the Horyu-ji, is dated to the Asuka period. It is elaborately decorated with scenes of jataka tales of the Buddha's lives painted in colored lacquer over a dramatic black lacquer ground. (*Tamamushi* means "beetle-wing"; the base of the shrine is decorated with iridescent wings of beetles.) It is a wooden cabinet resembling a small pagoda (7 feet 8 inches high) that opens up to reveal paintings and small sculptures within. The style of painting is like that at the Dunhuang rock-cut temples in China from the fifth century; it is bold,

stylized, and uses continuous narrative. The Japanese character of the piece is shown in the highly skilled use of lacquer, a time-consuming and difficult medium, and in the obvious pleasure in surface texture and in areas of decorative pattern.

Nara Period Architecture and Sculpture (645–794)

BUDDHIST TEMPLE ARCHITECTURE, HORYU-JI

The mature Chinese Tang style of architecture (sometimes called the "international" Tang style) was directly adopted by Japanese Buddhists. The Horyu-ji (the suffix *ji* means "temple") and Todai-ji complexes represent the only surviving examples of Tang-style architecture. The Kondo (Golden Hall) at Horyu-ji (c. 670) at Nara, one of the oldest wooden buildings in the world, is a large, two-storied pagoda with curved eaves on its tiled roofs. It is on a stone platform, has elaborate tiered brackets beneath the eaves, and uses the modular bay system, like Chinese post-and-lintel constructions of the time. A five-storied pagoda that has a single cypress pole rising from beneath the foundation all the way to the top was also built at Horyu-ji.

BUDDHIST SCULPTURE

A gilt bronze sculpture that exemplifies the Nara-Tang style is the *Amida Triad* enshrined at the Horyu-ji (early eighth century). (Amida is the Japanese name for Amitabha, the Sanskrit name of an important Buddha who presides over one of the Buddhist paradises.) The largest image in the center is seated on a full lotus bloom rising above the water's surface on a twisted stalk, elegantly depicted below on a bronze platform. The pristine lotus rising above the muddy waters is an important Buddhist symbol for pure enlightenment rising above the suffering drudgery of life, although still rooted in that nourishing mud. Flanking Amida are two smaller bodhisattvas standing on lotuses. Behind the triad is an elaborately decorated bronze screen with attendant deities seated on lotuses in relief and a radiant halo behind Amida's head. The style of this pond in Amida's paradise is like Tang painting and sculpture combined with its deft, linear character and the body type used for the figures.

Heian Period (794–1185)

INDIGENOUS ADAPTATIONS OF FOREIGN STYLES

Esoteric forms of Buddhism emerged as important forces in the sectarian arts, and a native spirit emerged to change the Tang Chinese domination of Japanese art during the ninth century. Two sects arose at about the same time: Shingon and Tendai, begun by two Japanese Buddhist monks who had studied in China. Images created during the early Heian period were meant to be kept secret in mountain retreats. Their style experimented with the Tang idiom and came up with chunky, off-balance sculptures. The early Heian type did not last.

HEIAN PAINTING

Early Heian, Jogan Period. Early Heian painting came in the form of elaborate mandalas, symmetrical diagrams of esoteric Buddhist cosmology. Two are especially important, the *Taizo-kai* (Garbha-dhatu in Sanskrit), or womb-realm, and the *Kongo-kai* (Vajra-dhatu), or diamond-realm, mandalas. These showed all the deities who ruled the basic doctrines of Buddhism in a combination of representation (seated human figures) and extreme symbolism (colors, geometric shapes and emblems, all with specific meanings), in complex relationships. Individual paintings of deities, especially the fierce protectors and the bodhisattvas, were also painted on silk banners. During the late Heian period a new subject known as the *raigo* was painted. It shows Amida heading a group of bodhisattvas, sometimes as enormous figures hovering over known Japanese landmarks, ready to lead believers to paradise.

Late Heian, Fujiwara Period—Yamato-e. Literature, illustrated books, and theater were patronized by the Heian court. In the late Heian or Fujiwara period (twelfth century), a set of scrolls was painted to illustrate *The Tale of Genji* written by Lady Murasaki. The scrolls are attributed to a court artist named Takayoshi. Sections of text alternate with the pictures. The picture plane is tilted up with the line of a high horizon, and the roofs of structures are removed to reveal the action inside. This is distinctly a Japanese innovation. The faces of the characters are like the masks of Japanese theater performers, and the costumes and settings also seem theatrical—bold shapes in bold patterns, accented with flat areas of contrasting textures, the action supported by strong diagonal lines. This style, called *Yamato-e* ("Japanese painting" in contrast to Chinese painting style), is a purely Japanese creation. Specific brush strokes are specified for each facial feature and prop in the action. The Fujiwara were great supporters of the arts, favoring decorative, dramatic art forms. Gold leaf and mica filings were often sprinkled on the paintings of this courtly style.

HEIAN PRINTS AND SCROLLS

Folk art, especially in the form of woodblock prints of mythological stories about folk heroes or villains, paralleled the court arts. The drawing was similarly stylized and the action exaggerated for effect. These were the earliest comic strips of Asia. Folk taste has influenced even the high arts of Japan throughout its history, providing a fluid, energetic tenor to either religious themes or stories of courtly intrigue. Even the *Lotus Sutra* (Kokke-kyo), the main text of the Amida cult, was illlustrated on paper fans sprinkled with gold dust during the Fujiwara reign.

Another type of text illustrated on handscrolls is the *engi,* or legend, usually associated with famous places. The *Shigisan Engi* (Legends of Mount Shigi) shows in dramatic caricature the fantastic events of the

monastery on the mountain. An episode called *The Flying Storehouse* shows just that, a hut flying through the air with figures gesturing wildly below it. The special brand of Japanese satiric humor was also active during the Fujiwara; four scrolls of animal caricatures satirize the active rivalry between religious sects (c. late twelfth century). All these drawing and painting formats exploited the Japanese artist's superlative skill in decorative line and patterning.

FUJIWARA ARCHITECTURE

The royal family of the Heian period built the *Ho-o-do* (Phoenix Hall) at the Byodo-in, Ujiyamada (eleventh century). It combines a garden setting and palace pavilions in the midst of an artificial lake, with an elaborate Buddhist shrine to Amida. The plan resembles a bird in flight, hence the name. The sculptor Jocho (died 1057) made the shrine images in gilt wood with the same grace and refined dignity as the architecture. The walls and ceiling are lined with decor suitable to Amida's paradise—sumptuous and elegant.

Kamakura Art (1185–1333)

Rulers of the late Fujiwara were overthrown in civil wars, and the successful leaders set up their capital in Kamakura. Fujiwara arts were seen as decadent and effete; a new emphasis on bold realism emerged. Three distinct types of art were developed during the Kamakura: Buddhist, secular, and aesthetic. In all the changing arts of the Kamakura, fine detail, beautiful patterns, and skilled manipulation of materials remain as the foremost concerns.

BUDDHIST KAMAKURA ART: CONTEMPLATIVE AND POPULAR

Contemplative Sculpture. Buddhist artists of the Kamakura looked back to the Nara period for their inspiration. Sectarian forms continued, but with a renewed reliance on the physical iconography of Tang China. However, the artist Unkei (died 1223) started a dramatic new tradition of lacquered wood sculptures of both priests and divine Buddhist figures. Life-size portrait sculptures, like the one of the *Priest Seshin* by Unkei (c. 1208), are more realistic than any earlier arts; Seshin is recognizable as an individual personality.

Popular Sculpture. The demands of popular worship sponsored the exaggerated "realism" of grotesquely muscled temple guardians and a colossal bronze Buddha in Kamakura (1253) that is more than thirty-seven feet high. Unkei also carved out of wood the twenty-six-foot-high fierce guardians at the gate of the Todai-ji in Nara (1203). A remarkable example of Kamakura realism is *The Sage Kuya Invoking the Amida Buddha* of painted wood (thirteenth century); the main worship ritual of the Amida cult is the repetition in sincere faith of the name Amida: the *Kuya* sculpture has a string of tiny Amida images emerging from its mouth, literally showing the invocation of Amida by speech.

Painting. Views of esoteric cosmology and its horrific inhabitants dominate the paintings of Kamakura Buddhism. The popular guardian named Fudo, who has fangs (one pointing up, one down) and is surrounded by flames, is frequently drawn or painted on scrolls. Long handscrolls depicting the monsters and tortures of hell are common—for example, the *Jogoku Zoshi* painted in about 1200. The style is still calligraphic, using dramatic caricatures colored in with brilliant hues, further developing the Yamato-e style.

Architecture. Along with the colossal Buddhas, Kamakura temples and gateways became larger and even more monumental than the Nara buildings at Horyu-ji. Temples resembled palatial architecture, continuing practices of the Fujiwara royal patrons.

SECULAR KAMAKURA ART

The emerging ideal of the military life encouraged portraits of great leaders and paintings of great battles. The best-known sculpted portrait is of the nobleman Uesugi Shigefusa (second half of the thirteenth century); he wears a high black cone for a hat and is seated rather dramatically in enormous, billowing trousers. The painting *Minamoto no Yoritomo,* named for the "Great Barbarian-Subduing General" who established the capital at Kamakura (attributed to Fujiwara Takanobu, 1142–1205), is a striking visage in flat geometrical shapes. The general is clothed in a stiff black robe, seated as if receiving an audience in stern three-quarter profile, and has his sword mostly hidden beneath the robe—overall, an image of potential, menacing power.

Narrative paintings of the Kamakura period are well represented by *The Burning of the Sanjo Palace,* a horizontal scroll of the thirteenth century. It illustrates in vivid, colorful detail the Heiji insurrection, culminating in a great fire. Each scene is crowded with warriors in full regalia, storming cavalry, and the destructive violence of a powerful army.

AESTHETIC KAMAKURA ART, DECORATIVE AND THEATRICAL

Toward the end of the Kamakura period, as the expensive military campaigns took their toll, a retreat into courtly styles ensued. These mostly decorative and literary arts had not ceased after the Fujiwara but had become dormant. An example of the aesthetic rebirth is the *Portrait of the Poetess Saigu Nyogo Yoshiko,* one in a set of thirty-six portraits (attributed to Fujiwara Nobuzane, 1176-1268). The pattern of her costume is by far the dominant element. Following a Kamakura trend of wearing as many layers of colored cloth as possible, Saigu is a tiny figure buried beneath a peacock-spread of yards and yards of fabric, coquettishly seated behind a decorated screen.

The dance drama called *bugaku* was formalized in the Kamakura period to become the still-performed *no* theater. The character masks of the respective styles show the differences between the *bugaku* magical caricatures of powerful forces and the *no* aesthetic caricatures of emotional states.

Ashikaga Art (1392–1573)

Kamakura rule ended in 1333, but civil wars continued until 1392 when the first Ashikaga shogunate emerged. The shoguns were dictators of the Ashikaga family who held power, usually for brief periods, over forces attached to the emperor's entourage. Nearly continuous wars among the various feudal states lasted until the complete fall of the shoguns in 1573. As was the case in equally anarchic periods in China, the arts flourished. When we think of Japanese art, it is usually Ashikaga styles that come to mind. Conservative styles persisted, but importation of both Chinese painting trends and religious ideas sparked new art in Japan.

KANO SCHOOL OF YAMATO-E

Traditionally begun by Kano Masanobu (1434–1530), the so-called Kano school followed a decorative style derived from Chinese Song dynasty painting. Areas of pattern and stylized settings for animal and tree drawings became the norm for aristocratic decor in Japan. Usually hanging scrolls or screens, Kano arts were intended to adorn palatial chambers. The main exponent of this style in the Ashikaga period was Kano Motonobu (1476–1559, possibly Masanobu's grandson) who excelled in *Cranes and Pines* landscape screens.

ZEN BUDDHISM AND OTHER CHINESE IMPORTS

Chan Buddhism, "Zen" in Japanese, came to Japan from China in the twelfth century and was readily adopted by the Kamakura warrior elite. By the Ashikaga period, it was deeply entrenched in the ideals of the established powers. Chinese-style painting, especially monochrome landscapes, became the aesthetic ideal that accompanied the religious ideal. Both were viewed as supremely direct and pragmatic, perfect expressions of intuitive perception, the goal of Zen Buddhism and of brush painting. Also valued were the ceramics, poetry, and philosophic literature (not all of them specifically Chan Buddhist) then available from China. Sculpture became less and less important. The new caste of *samurai* professional warriors became fast adherents of Zen self-reliance in their way of life and art. Following are three of the many artists who painted in one or another of the Southern Song painting styles.

Shobun. The thirteenth-century lyric style of Ma Yuan and Xia Gui (Hsia Kuei) was adopted by Shubun (c. 1390–1464), a priest who painted for the shoguns. He painted room screens as if they were handscrolls, as well as hanging scrolls and album paintings. His landscapes combine the many

types of Southern Song dynasty brush strokes into a distinctively Japanese landscape, responding in quick but precise gestures to the much-revered sacred earth of Japan itself.

Sesshu. *Winter Landscape* by Sesshu (1420–1506) is a hanging scroll that adapts the sketchy spontaneous style of Chinese Chan painters to Japanese taste. The effect of this work differs from Shubun's in the same way that the spontaneous style differs from the lyric: a wry temperament emerges in quickly slashed shapes, random patterns, and ambiguous spaces. Sesshu displays extreme agility in manipulating the angular strokes that Shubun also uses, but here with exaggerated simplicity. Sesshu also painted imaginative portraits of Zen patriarchs, such as *Daruma* (the first Chan Buddhist in China, known as Bodhidharma in Sanskrit), and beautiful folded screens of flowers and cranes amidst scraggy woods.

Josetsu. The combination of quixotic Zen poetry and painting is found in Josetsu's (active c. 1400) *Catching a Catfish with a Gourd*. This hanging scroll has a sketch of a swimming catfish in a small stream and a bedraggled man apparently trying to catch the fish with a tiny gourd. The absurdity of the scene is the subject of innumerable poems that cover the top half of the scroll. By this time the calligraphy of the poetry has become an integral part of the artwork.

TEA CEREMONY ART

The tea ceremony is a unique custom that became an institution among the aristocracy of Japan. It is an important part of art history because it cultivates and perpetuates fundamentally indigenous aesthetic ideals of the Japanese people, combining ancient Shinto attitudes with Buddhist insights. Associated initially with the Zen samurai, it soon took on a form and life of its own. Special teahouses provide the setting; rustic, solitary, plain, but of specific proportions, the teahouse built in a rugged garden (albeit carefully planted) is designed to be the ideal spot for purely intuitive moments. Inside the small house is a shallow alcove where a painting and a flower arrangement are displayed for contemplation. The tea bowls become the cult objects of tea-masters. Typically the prized bowls are rough, much-used stoneware with heavy glazes, often cracked and misshapen. A slow, intense ritual beginning with the way the participants enter the teahouse, the tea ceremony is essentially a performance art. It is particular to no artist or time, and is still performed.

ASHIKAGA LANDSCAPE AND PAVILION ARCHITECTURE

Zen Pavilions. Chinese temple styles became the prototype for pavilions, usually located near a frequented teahouse. However, they were roughed up, stripped to their wooden bones, to suit Japanese taste in the Ashikaga world. They are light and serene, with sliding walls and unadorned eaves, in contrast to the heavily tiled roofs and bracketing of Chinese temples. Two pavilions remain: the Kinkaku (Golden Pavilion; 1394 –1427,

burned in 1950, recently rebuilt) and the Ginkaku (Silver Pavilion; c. 1500), both in Kyoto, capital of the shoguns. They are both adjacent to artificial ponds and planted woods made to look naturally overgrown and spontaneous. Used for Zen meditation practices and recreations, these pavilions are an engaging innovation of Japanese architects, and have served as models even for modern Japanese architecture.

Landscape Architecture. The famous dry gardens that serve as meditation supports in the Zen monasteries of Japan were first designed in the Ashikaga period. Soami (died 1525) designed the racked gravel and rock garden of the Daisen-in of the Daitoku-ji, Kyoto. This garden is like a monochrome landscape painting spilled out into the monastery yard. The rooms and decks surrounding the dry gardens are hung with lyric- or spontaneous-style scrolls, but are otherwise plain.

Momoyama and Tokugawa Periods (1573–1868)

MOMOYAMA CASTLES AND DECORATIVE ARTS

Following the embattled Ashikaga shogunates, a series of three leaders enforced peace in Japan. The Momoyama period (1573–1615) boasts of palaces that must be called fortified castles. The Himeji Castle (begun in 1581 by Hideyoshi), built largely of ashlar masonry with towers rising sixty feet above its moat, nonetheless has a pagoda-like profile that lightens this rock fortress.

Hundreds of decorated screens lined the chamber walls of these palaces and castles. Rich materials, especially gold leaf, were used as backgrounds for many of these paintings. One now in the Tokyo National Museum called *Uji Bridge* (sixteenth to seventeenth century) was covered in gold leaf and then painted with wavy patterns to form a water wheel, stylized ripples of water, a picturesque bridge, and then dramatic, dark willow branches that were added in the foreground. These screens are flat sections of the "spontaneous" gardens so carefully cultivated on the palace grounds. However, some chambers were home to painted screens after the spontaneous monochrome style of Mu-Qi by Hasegawa Tohaku (1537–1610); the viewer is irresistibly drawn into the wet, misty forest of *Pine Trees*.

THE TOKUGAWA PALACE AT KATSURA

Tokugawa Ieyasu was the last of the Momoyama leaders and established himself as shogun of Edo (modern Tokyo) in 1615. Hence this period, from 1615 until 1868, is called the Tokugawa, or Edo, period. The shoguns during this period supported the imperial arts in an effort to legitimize their already tentative right to rule. Under Tokugawa's patronage, the palace and grounds at Katsura near Kyoto were built for the imperial family over a period of about fifty years (c. 1615–1663). They established the standard for gardens and architecture to the present.

The basic module for the palace buildings was the teahouse. The tasteful subtlety, straight rooflines, and striking contrasts of tea ceremony architecture were all superbly combined in the buildings that make up the palace. The function of the structures is expressed with utter simplicity. Darks and lights, planes and volumes, verticals and horizontals are juxtaposed with astonishing artfulness. The gardens follow the cultivated roughness, albeit trimmed at the edges, that characterizes Zen dry landscape architecture and the teahouse setting.

DECORATIVE PAINTING

The Kano school of Yamato-e painting continued in the Tokugawa era with Kano Sanraku (1561–1635). New schools started up, however, which took the pictorial screen painting art to its limits. Ogata Korin (1658–1716) is especially well known as the painter of the screens named *White Plum Blossoms in the Spring* (color on gold paper, late seventeenth to early eighteenth century), now in the Tokyo National Museum. The water is a swirling pattern of golden arabesques, and the plum branches are fine gestures of iridescent greens and dense browns. The delicate white flowers are like drops of bright light illuminating the flat gold earth below.

REALISTIC AND SATIRICAL PAINTING

Along with the decorative styles, literal- and lyric-style painting flourished. Maruyama Okyo (1733–1795) painted naturalistic or realistic studies of animals, plants, and insects with a new, almost Western, objectivity. It has been speculated that this type of nature study was inspired by the Portuguese missionaries and traders that visited Japan in the mid-sixteenth century. Maruyama's brush stroke, however, never loses its own mode of expression and remains visible, not hidden away, to create the illusion of an insect or a leaf. The Nanga painters borrowed the techniques of the Chinese lyric brushwork and added a decorative flair and a sense of humor. Yaso Buson's (1716–1783) *The Ten Conveniences and the Ten Enjoyments of Country Life* is a series of album leaves painted in 1771. Each scene includes a caricature of an urban gentleman "enjoying" the wet wilds of the forest, but the sarcasm is subtle, expressed in small visual puns and playful brush strokes.

PRINTMAKING AND THE UKIYO-E STYLE

Japan's version of genre painting is the Tokugawa art of *Ukiyo-e*, "pictures of the floating world," that emerged from the entertainment quarter of Kyoto in about 1600. The "floating world" is the shadowy realm of fleeting pleasures and escape. The difficult art of woodblock printmaking was embraced and perfected by the many artists of this style. The teahouse pleasures and Kabuki theater of the bourgeoisie provided both subjects

and buyers for these reproduced souvenirs and guidebooks. The artists entered the publishing business and worked in collaboration with cutters and printers.

Hishikawa Moronobu and the Torii School. The first to use the woodblock medium for genre subjects was Hishikawa Moronobu (c. 1625–1694). Using only black outlines on white paper, his designs were bold and vital. The Torii School also stayed with black-and-white prints, specializing in action shots of Kabuki actors in their flamboyant, patterned costumes. Often the buyers of these prints would hand-color them.

Okumura Masanobu and Suzuki Harunobu. During the eighteenth century the printmaking process was refined and experimentation with multicolored blocks began. Okumura Masanobu (1686–1764) used lustrous inks and tried a two-color method of pink and green contrasting areas. Later, the development of the "brocade picture" (*Nishiki-e*), which could have small areas of color and even delicate shading, enabled the incomparable polychrome prints that so inspired the Impressionist and Post-Impressionist painters of nineteenth-century Europe. Suzuki Harunobu (1725–1770) was well known for fine drawings of lovely women in simple but dynamic compositions.

Kitagawa Utamaro and Toshusai Sharaku. Extremes in style were the norm after the death of Harunobu. Kitagawa Utamaro (1753–1806) made elongated figures and half-length portraits in extremely delicate nuances of color and line. Toshusai Sharaku (active 1794–1795) specialized in powerful caricatures of actors and the other entertainers of the floating world. His portraits are disturbing, acidic commentary.

Katsushika Hokusai and Ando Hiroshige. The two most popular printmakers of the nineteenth century brought the colored woodblock style to its highest expression. Katsushika Hokusai (1760–1849) is the author of the ever-present *Great Wave*, just one of his series of *Thirty-Six Views of Mt. Fuji* (c. 1823–1829). Hokusai and Ando Hiroshige (1797–1858), who also did prints in series, exploited the medium to display the best design skills and decorative sense of Japanese art. Pleasing rhythms, perfectly "random" patterns, graceful juxtaposition of contrasting colors, and the meticulous balance of line, areas of flat color, and pattern make the polychrome prints of the Tokugawa period outstanding examples of Japanese artistic genius.

Qualities of Japanese Art

After the clearly indigenous arts of the Jomon and Haniwa eras, the dominant force in Japanese art history is the importing and assimilating of continental art forms. Through trade relations, religious conversion, and military conquest, Japanese artists repeatedly took over foreign styles and then transformed them into distinctly Japanese creations. Fluid and expressive lines dominate the personality of Japanese painting and printmaking. Incorporation of nature into Shinto and Buddhist sacred spaces characterizes

the architecture and landscape arts of Japan. The raw and asymmetrical forms of nature are also revered in Japanese ceramic design as well as in ink painting. The extreme elegance and skill in handling diverse materials remain the hallmark of Japanese art.

*O*nly in our time has the wide variety of world arts become available for appreciation and study. It is an opportunity that can only enrich our appreciation and study of Western arts, and an opportunity that we would be irresponsible to ignore. Not only have East and South Asian art styles influenced European and American artistic trends throughout the history of art, but the apparent "otherness" of Asian art and thought is perhaps one of the major factors in the artificial separation of East from West. Our planet has become too small and too troubled to tolerate barriers to mutual understanding and help. Enjoying and celebrating the enormous wealth of Asian art is a good first step toward crossing one threshold into greater compassion for those "others."

This chapter has been an overview of the arts of Asia that became especially potent in the developments of Neoclassicism and Romanticism of the eighteenth and nineteenth centuries. Political imperialism, religious pluralism, and scientific advances in archaeology and transportation combined to provide an international pool of imagery for artists.

Selected Readings

THE ART OF INDIA

Craven, R. C. *A Concise History of Indian Art.* New York and Toronto: Oxford University Press, 1976.

Eck, D. L. *Darshan, Seeing the Divine Image in India.* 2d ed. Chambersburg, PA.: Anima Books, 1985.

Harle, J. C. *The Art and Architecture of the Indian Subcontinent.* New York: Penguin Books, 1986.

Huntington, S. L. *The Art of Ancient India: Buddhist, Hindu, Jain.* New York: Weatherhill, 1985.

Kramrisch, S. *The Art of India, Traditions of Indian, Painting and Architecture.* 2d ed. London: Phaidon, 1955.

Michell, G. *The Hindu Temple: An Introduction to Its Meaning and Forms.* New York: Harper & Row, 1977.

Rawson, P. *The Art of Southeast Asia: Cambodia, Vietnam, Thailand, Laos, Burma, Java, Bali.* New York: Praeger, 1967.

Zimmer, H. *Myths and Symbols of Indian Art and Civilization.* Ed. by Joseph Campbell. New York: Harper & Row, 1962.

THE ART OF CHINA

Lee, S. E. *A History of Far Eastern Art.* 4th ed. New York: Abrams, 1982.

Sickman, L., and A. Soper. *The Art and Architecture of China.* Baltimore, MD: Penguin Books, 1971.

Sullivan, M. *The Arts of China*. rev. ed. Berkeley: University of California Press, 1977.

_____ . *The Meeting of Eastern and Western Art: From the Sixteenth Century to the Present Day*. Berkeley: University of California Press, 1989.

Willetts, W. *Foundations of Chinese Art from Neolithic Pottery to Modern Architecture*. New York: McGraw-Hill, 1965.

THE ART OF JAPAN

Kidder, J. E. *Japanese Temples: Sculpture, Paintings, Gardens and Architecture*. London: Thames and Hudson, 1964.

_____ . *The Art of Japan*. New York: Crown, 1985.

Lee, S. E. *A History of Far Eastern Art*. 4th ed. New York: Abrams, 1982.

Paine, R. T., and A. Soper. *The Art and Architecture of Japan*. 3d ed. Baltimore, MD: Penguin Books, 1981.

Stanley-Baker, J. *Japanese Art*. London: Thames and Hudson, 1984.

23

Neoclassicism and Romanticism

1748	Excavations begin at Pompeii
1775–1785	American Revolution
1789–1797	French Revolution
1792	First French Republic
1804	Napoleon crowned emperor
1814	Napoleon abdicates
1837	Coronation of Queen Victoria

*T*raditionally, the Baroque period is considered to have lasted from about 1600 to 1750. From this standpoint the Baroque ends with the evolution of the Rococo as its last phase. The events of the latter half of the eighteenth century quite naturally led to changes in artistic expression. Among the important changes are deliberate revivals of past styles. These are in the more general category of Romanticism. In addition to a Gothic Revival, there is a Neoclassical movement that reverts to ancient art itself without particular Renaissance reinterpretation. These revivals of past styles are, at least partially, a reaction against the lavish extravagance of the Rococo.

There may never be agreement on the definition of Romanticism. Some argue that all aspects of art from the mid-eighteenth century to the present fall in this category, and some see Romanticism as separate from the Neoclassical.

These latter see Romanticism as a movement of its own, dating from about 1800, after Neoclassical art and before the Realism of the mid-nineteenth century.

For our part, the definition of Romanticism includes Neoclassicism. We would consider that Romanticism is the conscious awareness and sometimes emulation of a past or a different culture seen selectively as a useful, often escapist, alternative to one's own. The Neoclassicists were not seeking a renaissance of Antiquity. Their admiration for the art was much inspired by archaeological studies. The monuments of ancient Athens, Pompeii, Baalbek, and Palmyra and Diocletian's palace at Spalato were all being excavated, and the accounts of the excavations published at the time. This brought a closer contact with the apparent purity and clarity of an ancient age; hence, it encouraged the emulation of the historical wisdom and behavior of ancient heroes.

NEOCLASSICISM

Johann Joachim Winckelmann (1717–1768) is considered a theoretical founder of the Neoclassical movement. Winckelmann was a German art critic and writer who lived in Rome during this period. His influential studies also proclaimed the aesthetic dominance of Greek art (though he never visited Greece). His books, *On the Imitation of Greek Works* and *History of Ancient Art*, were among the key critical works in the development of Neoclassicism.

It is clear that the change from Late Baroque to the art of the Romantic and Neoclassical was a process over time. Chiswick House, in Middlesex, England, near London, was designed in 1725 by Lord Burlington (1695–1753) and William Kent (1685–1748). It is a villa in the Palladian style, imitating the Villa Rotunda, and based on Palladio's books on architecture. The villa was built just three years after the completion of the very Baroque Blenheim Palace. No longer Baroque and not Rococo, Chiswick House anticipates much of the severe Neoclassicism of the second half of the century.

In contrast, Germain Soufflot's Panthéon in Paris was built after 1755. The Panthéon retains a great many Baroque ideals, such as the form of its dome, and adds elements of Neoclassical taste through closely imitated Classical details incorporated into its structure, especially the portico, which is modeled closely on the *pronaos* of a Roman temple.

The sculpture and painting of Neoclassical art is also an emulation of the Classical age. Themes based on ancient heroes or modern men seen in the guise of ancient heroes reflect the moral stance of changing European values. This is also reflected in the revolutionary spirit of Americans and

their architecture and representational arts of the late eighteenth and early nineteenth centuries.

Architecture

JAMES STUART

James Stuart (1713–1788) was an archaeologist and architect. With Nicholas Revett (1720–1804), Stuart published a monumental illustrated work, *Antiquities of Athens,* in four volumes beginning in 1762. This was one of the first studies to demonstrate that Greek architecture was the original source of Roman forms rather than a provincial derivation of the latter, as was the prevalent viewpoint during the Renaissance. Its engraved illustrations were based on careful measurements made at the Classical Athenian sites.

Doric Portico, Hagley Park. The garden pavilion in the form of a Doric portico that Stuart built at Hagley Park in 1758 is a reconstruction of a Greek temple front. Its severity, even as an ornamental structure, is apparent. That it is an ornamental structure, meant for contemplation, is also a part of its Romantic Neoclassicism. It belongs to the park in the same sense as the Sham Gothic Ruin built there by Sanderson Miller in 1747. Both are of styles consciously and deliberately chosen from the past.

THOMAS JEFFERSON

In addition to being an American patriot and third president of the United States, Thomas Jefferson (1743–1826) was an amateur architect familiar with European and British tradition. His buildings express the same stirrings of stoic and heroic morality that inspired European Neoclassicism.

Monticello. From 1770 to 1806, Jefferson worked on the building on his own estate, Monticello. A private villa, it retains much of the Palladian design found at Chiswick House.

The State House, Richmond, Virginia. Jefferson is also associated with public building projects, including designs for the buildings of the University of Virginia at Charlottesville and the Virginia State House, at Richmond, built between 1785 and 1789. These buildings are more strictly Classical than Monticello. The State House was modeled upon a Classical Roman temple similar to the Maison Carrée at Nîmes.

BENJAMIN LATROBE

Other architects in the New World include Benjamin Latrobe (1764–1820), who left a post as superintendent of public works in London to work in America as protégé of Thomas Jefferson at the building of the Virginia State House. Later Latrobe worked as superintendent of the building of the Capitol in Washington, D.C. (begun 1801). He built the Bank of Pennsylvania in Philadelphia (1798–1801) and was the designer of the Catholic Cathedral in Baltimore, Maryland.

Catholic Cathedral, Baltimore. From 1805 to 1818 Latrobe built the Catholic Cathedral in Baltimore to Neoclassical specifications. Latrobe made projected designs for the same building in the Gothic style. The finished building is simplified and extended, a practical version of the Roman Pantheon with a low dome and colonnaded porch before a nave. There are towers over the narthex that resemble towers added to the Pantheon by Bernini. These were still standing at the beginning of the nineteenth century. They have been taken down since.

ÉTIENNE-LOUIS BOULLÉE

Étienne-Louis Boullée (1728–1799) was a French architect and theoretician. He taught and wrote more than he built. His unpublished *Essay on the Art of Architecture* in the Bibliothèque Nationale in Paris contains projects for monuments designed on simple geometrical forms.

Boullée's teaching probably brought some concept of the simple geometrical, Neoclassical ideal to his students. His projects were rediscovered and studied in the twentieth century by architects who admired them for their simplicity and purity of form. They seemed prophetic of the modern movement.

Cenotaph for Newton. The most impressive project in his manuscript is a design for a cenotaph (tomb) for Isaac Newton. Designed in 1784, the tomb would have consisted of an enormous sphere, partially ringed by cylindrical walls supporting groves of trees. The exposed upper half of the dome would have been lit on the interior by thousands of tiny openings to give the illusion of the stars.

PIERRE VIGNON

The Parisian architect Pierre Barthelmy Vignon (1762–1828) was commissioned to build the present Church of the Madeleine (Mary Magdalene) in the Place de la Concorde. His design for the building was submitted to a competition sponsored by Napoleon, who had designated that the structure should be designed as a "temple of glory" to the honor of his victorious troops. It was converted to a church before it was completed.

La Madeleine, Paris. La Madeleine was built from 1806 to 1843. The exterior design is that of a Roman Corinthian temple. It is *peripteral* (the colonnade surrounds the building) and stands on a podium. Its severe, imitation Classical form has no exterior features of a church. The interior is vaulted with a procession of three skylighted domes in the nave.

KARL GOTTHARD LANGHANS

Neoclassicism was an international movement. One of its German architects was Karl Langhans (1732–1808), who worked in Wroclau (Breslau) and traveled in Italy, France, Holland, and England before settling in Berlin, where he is famed as the designer of the Brandenburg Gate.

The Brandenburg Gate. The Prussian king Friedrich Wilhelm II was the patron of the Brandenburg Gate in Berlin, built from 1789 to 1794. The architect Karl Langhans used the *Propylea* on the Acropolis at Athens as a model for the city gate. The simple and powerful Doric order is used throughout. A passageway opens in widened space between the middle columns, and pedimented wings flank the central passageway. The passage is topped by a sculpture podium, supporting a four-horse chariot (*quadriga*), and decorated in suggestion of a pediment.

Painting

In Paris, France, beginning in the year 1667, the Royal Academy held exhibitions, occasionally at first, then biennially (every other year on the odd numbers, from 1737) and, after 1789, annually. They were held in the Louvre Palace, first in the Salon d'Apollon. From this was derived the name Salon for the exhibitions. Judges for the exhibitions were the members of the academy, the teachers of the École des Beaux-Arts. Paintings were normally judged by standards according to academic category: history painting, portraiture, still life, and so on. Acceptance meant fame and fortune for the artists. They received commissions for portraits and other works from the aristocracy who flocked, with all of Paris, to view the Salons each year.

JACQUES–LOUIS DAVID

The painter Jacques-Louis David (1748–1825), trained in the Rococo, won the Prix-de-Rome in 1774, traveled to the French Academy in Rome, and quickly changed his style to the new Neoclassicism. Little of his art survives from this period. It is said that the influence of Caravaggio also made a strong impact on the artist in Rome. He returned to Paris in 1781. Soon after, he was elected to the Royal Academy and in 1785 submitted a large painting to the Salon.

The Oath of the Horatii. The painting David submitted was *The Oath of the Horatii*, painted from 1784 to 1785. It is a huge canvas, 10 feet 8¼ inches by 14 feet (3.25 by 4.27 m), representing an incident from Roman history. The Horatii, three brothers, vowed to defend Rome against the three Curatii brothers. Their vow, sworn upon the swords held by their father, was an irrevocable act of patriotism undertaken even though their sister, Camilla, was betrothed to one of the Curatii. Five of the six opponents were slain in the ensuing battle. The survivor, one of the Horatii, saved Rome but slew his sister for mourning her lost love. Of such stern stuff are the stoicism and pride of duty formed in the Neoclassical mind.

The painting shows the oath and the despairing women of the family in a shallow stagelike setting, backed by a heavy Doric colonnade. The subject, told by the Classical author Livy, had been dramatized on the Parisian stage shortly before David painted it. Its simple directness and

stern message became a kind of emblem for the French Revolution even though the work was originally painted by royal commission for Louis XVI.

The Death of Marat. David became the most admired of the painters of the Revolution. The dramatic intimations of sacrifice in *The Oath of the Horatii* are changed to the full realization of mortality in his *Death of Marat*, painted in 1793. Marat was a friend of David and a revolutionary radical. He was murdered in his bath by a political enemy, Charlotte Corday.

David's painting, dramatically posed and lit, recalls Caravaggio's limited color and use of space for effect. The upper half of the work is a dark, earth-tone void. Marat, to the lower left, is seated in his tub, head back. The murderer's knife, Marat's pens, the bloodstained towel, and Corday's letter of betrayal are noteworthy details in the spare composition.

Coronation of Napoleon and Josephine. After the fall of Robespierre, Jacques-Louis David was briefly imprisoned. He had been a deputy of the Revolution. After his release he became an advocate of Napoleon and painter in his court. To him was assigned the official painting of the coronation of Napoleon and Josephine. He painted the work from 1805 to 1807. It is in The Louvre in Paris, an enormous canvas 20 feet by 30 feet 6 inches (6.1 by 9.3 m) that is rich in color, pomp, and circumstance. If the *Coronation* does not quite represent a return to Baroque, neither is it a Neoclassical work in David's former style.

JEAN-AUGUSTE DOMINIQUE INGRES

Jean-Auguste Dominique Ingres (1780–1867) was a pupil of Jacques-Louis David. In 1801 he was awarded the Prix de Rome and traveled there in 1806. Ingres's advocacy of the linear contour and simplicity of figures broke with the naturalism infused into the later works of David. At first criticized for this, he was later seen as the chief preserver of the Neoclassical style in contrast to his archrival, Eugène Delacroix.

Bather. Ingres' paintings often seem very direct and simple. The *Bather*, in The Louvre, Paris, of 1808, is a painting of a single seated figure, nude and facing away from the viewer. It is a study of the contours, planes, and textures of the figure against those of a variety of fabrics that surround her. Ingres makes the most of the slight tonal changes that model the form of the woman's back as a large uninterrupted surface modeled within simple contours.

Grande Odalisque. The *Grande Odalisque*, of 1814, also in The Louvre, is another of Ingres' works to turn to the nude figure for contour and planar study. The painting is again an especially fine study of the contours and forms of the figure. Here the artist has used color in an expressive way as well, in jewelry, an ostrich-feather fan, and patterned silk draperies.

Odalisque is a Turkish term for a female slave or harem woman, and the use of such figures is clearly not associated with the Neoclassical ideal of David's moralized and stern, revolutionary stance. The nude is a well-established subject for the artist, but the exotic Oriental splendor is a clear response to the Romantic aspect of the style. This is no longer a goddess or personification of some Classical ideal. The work was much criticized in its own time for its lack of proportion, though Ingres made many careful preparatory drawings for it.

Comtesse d'Haussonville. Ingres was most rewarded in his lifetime as a portraitist. His *Comtesse d'Haussonville,* in the Frick Collection in New York City, was painted in 1845. It is clearly an elegant statement in color and form showing the reason for his success. The comtesse stands before a mantel, dressed in pale blue silk. She looks pensively out at the viewer, her chin partly supported by her left hand. A mirror reflects her head and shoulders and some of the vases and flowers arrayed on the mantel. The whole painting is a subtly balanced arrangement of colors and forms. Particularly effective is the contrast between the tilt of her head and shoulders and the angle of the manteltop and her reflected shoulders. These animate the picture, countering the quiet stability of the vertical mirror frame, corner molding, and the folds of the comtesse's gown.

Sculpture

It has been observed that there are no sculptors of the Neoclassical period whose talents are the equivalent of the painters David and Ingres. One might expect sculpture to reign supreme in an era that looks so reverently to the Classical past.

If we recall that the painters were developing a highly qualified kind of Classicism this may not be so hard to understand. It is therefore possible to see Jean-Antoine Houdon in the role of Neoclassical sculptor and to award him the preeminence he deserves.

JEAN-ANTOINE HOUDON

Though he may not represent full-blown Neoclassicism in many of his works, Jean-Antoine Houdon (1741–1828) is certainly no longer a Baroque or Rococo artist. His sculpture depicts too honest and direct a representation for the extravagances of either. Houdon worked in Rome from 1764 to 1768, in his mid-twenties. There he studied anatomy and received several important commissions. In Paris after that he succeeded best at portraiture.

Seated Voltaire. Houdon made several sculptural portraits of the philosopher Voltaire. The marble *Seated Voltaire,* of 1781, now in the Hermitage, St. Petersburg, was a triumph in the Salon of that year. It is a vigorous portrait of the old, yet still vital, sage. He wears a dressing gown in togalike drapery and is seated in a Classical armchair. The chair, it should be noted, is made

authentically antique by reference to Pompeian relics in the same manner that architects turned to ancient temples for their buildings.

George Washington. Houdon was friend to both Benjamin Franklin and Thomas Jefferson. Through them he was invited to America in 1785 to create a portrait of George Washington. Houdon spent two weeks at Mount Vernon, making his sketches and models. His sculpture of the president, a standing figure in contemporary dress, is now in Jefferson's Virginia State House at Richmond. It was completed in 1791. George Washington appears in his general's uniform. He holds his baton of command in his right hand and rests his left upon a *fasces,* a symbolic bundle of rods carried in ancient Roman processions to signify authority and the strength in unity. A sword and ploughshare, symbols of leadership in war and peace, are attached to the fasces.

ANTONIO CANOVA

Antonio Canova (1757–1822) was the most directly Neoclassical sculptor of the period. Trained in Venice, he spent most of his active career in Rome, with travels to Vienna, Paris, and London.

Maria Paulina Borghese as Venus Victrix. Canova's sculpture *Maria Paulina Borghese as Venus Victrix*, done from 1805 to 1807 and now in the Borghese Gallery, Rome, is his most famous work. Madame Borghese was the sister of Napoleon who also posed for several works by Canova. The emperor's sister appears as the victorious Venus, holding the apple awarded her by Paris in the myth of the Judgment of Paris.

ROMANTICISM: OTHER TRENDS

Romanticism has no single, identifiable Romantic style. Neoclassicism became the official style of the academies in Rome, Paris, and London. It is predominantly a secular style, evoking the supposed purity and cohesion of the early republics in Athens and Rome. It proclaimed the virtues of European empire and American democracy.

As was said before, Neoclassicism is a part of Romanticism. Yet its popularity and official recognition as a definable style appear to give it status of a special order. The only comparable movement in the Romantic period that takes a historical period style unto itself is the Gothic Revival.

The Gothic Revival

The eighteenth century saw the beginning of a revival of taste for the medieval world and the building styles that had preceded the Renaissance. Prevalent among the medieval styles was Gothic architecture.

HORACE WALPOLE

Horace Walpole (1717–1797) can be credited with establishing the Gothic as a style for the English country house. He was the son of the first prime minister of England, a writer, and an amateur architect.

Strawberry Hill. Between 1750 and 1775, Walpole built his country house, Strawberry Hill in Twickenham, in the Gothic style, resembling a medieval castle. Unlike the measured, exact, and archaeological fitness of the Classical Revival, the Gothic Revival started out with little actual reference to Gothic building practices.

It was the beginning, however, of a medieval revival that saw reconstruction and research. Jacques-Germain Soufflot, builder of the Panthéon in Paris, beginning in 1755, expressed his admiration for Gothic structural elegance. In 1805, when Benjamin Latrobe began the construction of the Catholic Cathedral in Baltimore, he had submitted a design in Gothic style along with the Neoclassical plan that was chosen.

AUGUSTUS WELBY PUGIN

One of the leading exponents of Gothic architecture in England was Augustus Welby Pugin (1812–1852). An architect and theoretician, Pugin worked with his architect father on the restoration of Windsor Castle. He designed several Gothic Revival churches.

Houses of Parliament. In 1836, after the houses of Parliament had burned in a great fire, the present building of Parliament was begun. The government had called for the structure to be built in a national style, deemed to be Tudor Gothic. The architects chosen were Sir Charles Barry (1795–1860), who actually preferred the Classical and Italian styles, and Augustus Welby Pugin. Pugin supplied almost all the Gothic details of the building's exterior and interior. The building is still essentially Classical in form with Gothicizing details, as Pugin himself would admit. But it is a monument to a trend that would lead to more and more accurate restorations and buildings in the Gothic Revival.

EUGÈNE VIOLLET-LE-DUC

Pugin's contemporary was Eugène Viollet-le-Duc, the Parisian architect, engineer, and writer who would do more than anyone to restore the popularity of medieval art with his reconstructions of Romanesque and Gothic French monuments and his monumental *Dictionnaire raisonné de l'architecture française du XI^e au XVI^e siècle* (*Comprehensive Dictionary of French Architecture from the Eleventh to Sixteenth Century*) of 1864 to 1868.

The British Romantic School

Closely following the highly individualistic William Hogarth in time and place, a number of native and foreign-born artists in the late eighteenth century managed to develop a British school of painting. Some of

these artists trained in Italy and are considered Neoclassicists. But somehow the title doesn't quite work for Reynolds, West, and Kauffmann, to whom it is often applied, at least not to the same degree we see in David and Ingres. The British school remains apart and partially affected by what a couple of Americans and two extraordinary Swiss artists bring to it.

JOSHUA REYNOLDS

Sir Joshua Reynolds (1723–1792) was the theorist and academician of the school of British painting when it emerged in the eighteenth century. Reynolds traveled in Europe and remained in Rome learning the academic theory. He elaborated at length on art theory in his *Discourses*, published while he was president of the Royal Academy in London, of which he was a cofounder. He was an extremely successful portraitist.

Lord Heathfield. Among his many portraits, the representation of Lord Heathfield, painted in 1787 and now in the National Gallery of London, is a representative example. Lord Heathfield was the English general who defended Gibraltar at the time of the American Revolution. The smoke of battle and angled cannon at the edge of the precipice behind the officer express his heroic occupation and set off his formal stance. He clasps the well-defended key to the fortress and gazes steadfastly at the horizon. The influence of Van Dyck is apparent, along with that of Titian and the Renaissance tradition.

THOMAS GAINSBOROUGH

Thomas Gainsborough (1727–1788) was the contemporary of Reynolds. He was a nonacademic who studied in London but spent most of his active life away from the city. Gainsborough aspired mostly to painting landscapes but sold few of them. He was an extremely successful portraitist, rivaling Reynolds and similarly influenced by Van Dyck.

Mrs. Richard Brinsley. Gainsborough painted *Mrs. Richard Brinsley* in 1785. The painting is in the National Gallery, Washington, D.C. Typically, the sitter is shown outdoors with some extended landscape beyond her.

Van Dyck and Titian had set precedents by painting portrait figures in landscapes. Thus both Gainsborough, who is usually considered a Romantic, and Reynolds, whom some designate as a Neoclassicist or even Neobaroque, use landscapes for some of their portrait work. For Reynolds, as the portrait of Lord Heathfield demonstrates, the landscape is a part of the sitter's *iconography*. That is, it symbolizes the strength and achievement of the sitter. Gainsborough has dressed Mrs. Brinsley for a day in the country. She is part of the scene, neither claiming nor defending it.

BENJAMIN WEST

Benjamin West (1738–1820) was an American painter who spent most of his active career in England. He was cofounder, with Sir Joshua Reynolds, of the Royal Academy and its second president. Like Reynolds, West studied in Rome and learned Baroque theory there. More than either Reynolds or Gainsborough, West succeeded with history painting. He became a painter in George III's court and remained in England through the Revolutionary War.

Death of General Wolfe. One of West's most effective paintings is *Death of General Wolfe,* painted in 1771. The painting is in the National Gallery of Canada, Ottawa. The general, surrounded by his staff, sinks mortally wounded in an open space. The smoke of battle rises behind his despairing friends, who announce the bittersweet news that Québec has fallen to Wolfe's army. Canada will henceforth be British.

For the academic tradition in Britain, the novelty of a history painting in modern dress turned out to be a startling innovation that was gradually to be accepted by the academy and eventually to become acceptable in European academies as well.

JOHN SINGLETON COPLEY

Mostly self-taught in Boston, where he grew up, John Singleton Copley (1738–1815) painted portraits of New Englanders before moving to England in 1775, just before the Revolutionary War.

Paul Revere. Copley's portrait of Paul Revere is in the Museum of Fine Arts, Boston. Revere, who would become a hero of the Revolution, was a craftsman, silversmith, and printmaker and appears holding a shining silver teapot. The strength of light and shadow treatment in the painting suggests the Dutch Caravaggists rather than the English portrait tradition.

Watson and the Shark. In England, in 1778, Copley was engaged to execute a history painting showing a youthful misadventure of his friend Brook Watson. *Watson and the Shark* is also in the Museum of Fine Arts, Boston. Watson had been attacked by a shark while swimming in Havana Harbor. His narrow escape is made doubtful in the dramatic painting, and indeed Watson lost a leg in the encounter.

While it has the form and heroics of an academic Neoclassical history painting, Copley's *Watson and the Shark* is an anecdotal, if terrifying, personal narrative of Romantic recollection. Watson was a successful merchant and in time became Lord Mayor of London.

ANGELICA KAUFFMANN

Angelica Kauffmann (1741–1807) was born in Switzerland and trained in Rome. There she was a disciple of Anton Mengs, a German painter in the circle of Winckelmann, theorist of Neoclassicism. Kauffmann met Reynolds

and West in Rome and afterwards spent fourteen years in London. She was also a cofounder of the Royal Academy. Her association with Winckelmann and Mengs led to greater Neoclassicism in her work.

Cornelia, Mother of the Gracchi. Angelica Kauffmann made many self-portraits, often in the role of painter or the guise of Painting personified. For this, naturally and properly, she gets credit for advancing the cause of women's rights in the world of the arts. She also used her own image as heroine in such works as *Cornelia, Mother of the Gracchi,* in the Museum of Fine Arts in Richmond, Virginia. The painting was made about 1785 and is a moralizing theme, a "soft" parallel to David's *The Oath of the Horatii,* in which a mother of the Republican age of Rome identifies her two sons, future heroes, as her "jewels." The severe architectural setting, unlike David's harsh light, is bathed in warm sunlight and almost exclusively warm colors.

HENRY FUSELI

Henry Fuseli (born Johann Heinrich Füssli, 1741–1825) was a Swiss who came to London in 1764. He was in Rome in the 1770s, having been encouraged to take up painting by Reynolds. In Rome he learned painting mostly on his own by copying Michelangelo's Sistine Ceiling figures. Fuseli returned to England in 1778. His works were highly individualistic, with an immense power of expression. Fuseli was admitted to the Royal Academy and made a professor there. His work, often charged with a kind of Romantic horror, is visionary and eccentric.

The Nightmare. Fuseli made several versions of a painting called *The Nightmare.* Examples are in the Detroit Institute of the Arts and Goëthe Museum, Frankfurt. In it there is a woman dreaming. Her arms and head cascade over the end of the bed. On her ribs perches a menacing devil, and the horrifying, wild-eyed head of a luminescent horse with tangled, flying mane parts the curtains behind her bed.

WILLIAM BLAKE

William Blake (1757–1827) was a friend of Fuseli's. He was a visionary poet, engraver, and painter. Blake studied briefly at the academy but was primarily a reclusive visionary, writing and producing his own books, engraving the text, and hand-coloring the illustrations. Blake was powerfully influenced by medieval illumination and by Michelangelo. He studied Michelangelo mostly through engraved copies of his works. Blake produced his own versions of medieval themes and Michelangelesque figures with astonishing originality and power.

The Ancient of Days. Blake illustrated his books with a variety of print techniques, some of which he invented himself. Many of them were elaborated with hand-colored tones. *The Ancient of Days,* a powerful illustration

to his poem *Europe, a Prophecy,* shows the nude figure of an old man kneeling in the midst of a radiant sun surrounded by cloud and reaching far downward with a large pair of dividers extended at ninety degrees toward the baseline of the picture. The combination of geometrical shapes and expressive forms is an arresting image.

The French Romantic School

The followers of Jacques-Louis David in France did not return to David's Neoclassicism. David himself abandoned the style with his grandiose Napoleonic works and after Napoleon's fall spent the rest of his life in exile in Brussels.

ANTOINE-JEAN GROS

Antoine-Jean Gros (1771–1835) was David's leading pupil. He also made Napoleonic images in a style that is sometimes referred to as a Baroque Revival. It is quite opposite to the cool linearity of David's Neoclassicism. Gros used vigorous brushwork and a developed sense of color. His work was never quite successful, and Gros committed suicide in disappointment.

The Pest House at Jaffa. One of the most important paintings by Antoine-Jean Gros is *The Pest House at Jaffa* in The Louvre, Paris, painted in 1804. It shows Napoleon visiting the sick and dying among his plague-stricken troops after the retreat from the Egyptian campaign. Using dramatic lighting, Gros picks out the heroic general in the midst of this exotic setting, reassuring and comforting the weak and dying soldiers. The Moorish architecture and Eastern costumes and the acrid yellow light emphasize the distant setting on the Palestinian coast.

THEODORE GÉRICAULT

Theodore Géricault (1791–1824) is noted for the careful and analytical study of nature in his works, and the preparations for his great compositions were detailed and careful. His art was strongly influenced by Gros. He also studied in Italy, in 1816, and spent two years in England from 1820 to 1822, exhibiting his *The Raft of the Medusa*. Géricault died two years later, having exhibited only three major paintings. His greatest influence was on Eugène Delacroix.

The Raft of the Medusa. Géricault's masterpiece is *The Raft of the Medusa,* painted in 1818 and 1819, now in The Louvre, Paris. This is the record of a scandalous contemporary event; a raft crowded with passengers from a shipwreck was cut adrift from the boats of the ship's officers. Géricault studied accounts of the event and made paintings and preparatory drawings of dead and dying men for the finished version.

The event was a political scandal, but Géricault has concentrated on the drama of rescue, when a few of the struggling survivors strain to see and signal a distant ship. A diagonal pyramid rises toward the right, culminating

in two figures who wave their shirts to signal the distant vessel. Corpses and the near dead appear in the foreground. They lie on the raft like the victims in the foreground of Gros's *The Pest House at Jaffa*.

EUGÈNE DELACROIX

Eugène Delacroix (1798–1863) was the foremost Romantic painter of France. He was a pupil of Baron Guérin, Géricault's teacher, and an admirer of Géricault as well. Delacroix also drew inspiration from Antoine-Jean Gros and from Rubens and Veronese. Delacroix is frequently contrasted with Ingres, his major contemporary, in discussions of Romanticism versus Neoclassicism (or "Rubénistes" versus "Poussinistes," as antagonists of the late seventeenth century had defined themselves). The Rubénistes, followers of Rubens, held that color was the most important aspect of a painting, having a wider appeal than drawing. Drawing was held by the Poussinistes, defenders of academism, to be more intellectual and thus superior to color.

In fact, Ingres was no more an academician than Delacroix. Both men represent two sides of the same Romantic coin. Each found followers and admirers, and each drew his share of criticism.

The Massacre at Chios. Delacroix's painting *The Massacre at Chios*, inspired by an episode in the Greek war of independence from the Turks, is more a tableau than the representation of an event. Greek citizens of all ages and gender are shown awaiting death or slavery. They are dominated by menacing Turkish soldiers who approach from the middleground.

Liberty Leading the People. Delacroix drew inspiration from many sources. His *Liberty Leading the People,* of 1830, represents his interest in popular struggles for freedom and has become a symbol of uprising. Liberty, a towering, seminude woman holds the French tricolor aloft at the top center of the painting. Citizens of all types brandish weapons, pistols, muskets, and cutlasses as they advance with Liberty over the dead and dying in the foreground. Strong light from the left illuminates some figures, silhouettes others, and reflects off the great pall of smoke in the background. In the distance at the right are the towers of Notre Dame Cathedral.

Landscape Painting in England

Romanticism in the eighteenth century made the landscape popular again. Two of its most extraordinary practitioners were English painters, successors, in a manner of speaking, to Gainsborough.

JOSEPH MALLORD WILLIAM TURNER

Joseph Mallord William Turner (1775–1851) painted landscapes that reflect the qualities of air, light, and atmosphere through which we see the subject matter, a ship at sea, or a train racing across a trestle-bridge. The Romantic preference for color finds fulfillment in such works.

Among them, taken from notes and studies made during the event, are paintings of the *Burning of the Houses of Parliament*, a nocturnal drama of enormous impact.

The Slave Ship. In 1840, Turner exhibited *The Slave Ship*, now in the Museum of Fine Arts, Boston. More than a match for Géricault's *The Raft of the Medusa,* which had been exhibited in England in 1820, Turner's painting condemns the evil practices of the slave trade, of sea captains lightening ships by casting human cargo overboard in the event of a storm or dispatching diseased slaves over the side to prevent epidemics.

The ghastly subject, affirmed by the hands and manacled leg rising from the surface of the tossing sea in the foreground, circling gannets, and frenzied fishes, is balanced by a garish low sun, fused with orange and red clouds, and the ship itself, appearing to broach to as an enormous wave breaks against it.

With Turner, color and surface in the paint express the subject to an extent that will have enormous response in modern painting. His art was much criticized and yet much appreciated in his own time. He made hundreds of landscape paintings and traveled far in search of material.

JOHN CONSTABLE

John Constable (1776–1837) was Turner's contemporary and another consummate landscapist. His paintings are serene and extraordinary views of nature as defined by the light of day. But to Constable the light appears as definition of the form, recording rather than obscuring the surfaces of fields and ponds. His sunlit clouds, studied meticulously for shape and type, do not threaten. Constable acknowledged his admiration for Gainsborough among other sources of influence. The Dutch seventeenth-century landscapists are also included.

The Hay Wain. Constable's *The Hay Wain,* exhibited in Paris in the Salon of 1824, was profoundly influential on Delacroix, who praised it. Its impact on the Barbizon painters, on Manet and the Impressionists, has been noted variously by critics and by the artists themselves in their own writings.

Romantic Painting Elsewhere

German Romantic painting was initiated by Philip Otto Runge (1777–1810), who worked in Dresden for most of his brief, active life. His work was influenced by Blake and was part mystic, part naive. Runge was noted for a series of four paintings of the times of day that mix flower, color, and religious symbolism in an expression that is highly personal. His work influenced the most important of nineteenth-century German Romantic painters, Caspar David Friedrich.

CASPAR DAVID FRIEDRICH

Caspar David Friedrich (1774–1840) painted landscapes that conveyed mood through coloration and subject. He lived and worked primarily in Dresden, as did Runge.

Cloister Graveyard in the Snow. Friedrich's lost painting *Cloister Graveyard in the Snow* (formerly in Dresden) showed a funeral procession in an evening woods in winter entering a ruined Gothic cemetery chapel. The ruins, the tilted crosses in the graveyard, and the dead, leafless, blasted trees imply that the procession is some ghostly visitation. Friedrich also made landscapes of bleak mountaintops and the Arctic ice.

Romantic painters everywhere turned to the landscape as an expression of mood, the power of nature, and people's varying view of themselves in relation to it. Most effectively it played a part in American nineteenth-century painting as well. Here the landscape was new, the forms untried.

THOMAS COLE

English-born Thomas Cole (1801–1848) became the principal painter of the American Hudson River school of highly Romantic painters active in New York. The group included Washington Allston and Asher B. Durand. Cole was one of the founders of the National Academy of Design. His work as a landscapist includes dramatic lighting and wilderness. He also created a Romantic series called *Course of Empire* that echoes, in its way, the Romantic poetry of the day. The *Course of Empire* paintings showed a landscape through several centuries of time, from its first settlement and flourishing years to the last scene, *Desolation*. *Desolation* shows the ruins of the city overgrown by wild nature. Broken, weathered stones, and ruinous colonnades are all that remains.

Cole was influenced by Claude Lorraine and Turner. His non-allegorical landscapes are visually direct and powerful in themselves.

The years from 1750 to 1850 were marked by revolutions in France and the United States and by smaller wars and changes in all of Europe. The bold ventures of people seeking liberty and the vision of self-government led artists to seek parallels in the great ventures of the past. Art turned to the sources it knew best, the ideal past of the Classical world, for models of behavior.

Neoclassicism was the name given to the official style of art that flourished in the academies in Rome, Paris, and London and made its way to the provincial schools through their graduates. It was Classicism with a didactic and moralistic bent.

Neoclassical architecture and sculpture, as well as painting, proclaimed the virtues of European empire and American democracy. The style is predominantly secular, though J. M. Soufflot's Church of St. Geneviève of the late eighteenth century is one of Neoclassicism's finest monuments.

We see Neoclassical art as a major style within the broader category of Romanticism. Romanticism has no separate indentifiable style of its own. Rather, it represents a frame of mind that seeks to experience a richer reality. Some artists, believing Neoclassical art to be soulless and formalistic, found subject matter in landscapes, myths, legends, and exotic settings. But they sought more vivid themes than the fêtes gallantes or the dalliances of nymphs and satyrs so popular in Rococo art.

Selected Readings

Boime, A. *The Academy and French Painting in the Nineteenth Century*. New York: Phaidon, 1970.

Brown, M. *American Art to 1900*. New York: Abrams, 1977.

Clark, K. M. *The Gothic Revival*. New York: Humanities Press, 1970.

_____. *The Romantic Rebellion: Romantic Versus Classical*. New York: Harper & Row, 1974.

Eitner, L. *Neoclassicism and Romanticism, 1750–1850*. Sources and Documents. 2 vols. Englewood Cliffs, NJ: Prentice-Hall, 1970.

Friedlaender, W. F. *From David to Delacroix*. Cambridge, MA: Harvard University Press, 1952.

Honour, H. *Neoclassicism, Style and Civilization*. Baltimore, MD: Penguin, 1968.

_____. *Romanticism.* New York: Harper & Row, 1979.

McCoubrey, J. *American Art, 1700–1960*. Sources and Documents. Englewood Cliffs, NJ: Prentice-Hall, 1965.

Middleton, R., and D. Watkin. *Neoclassical and Nineteenth Century Architecture*. New York: Abrams, 1980.

Novotny, F. *Painting and Sculpture in Europe, 1780–1880*. Baltimore, MD: Penguin, 1970.

Rosenblum, R. *Transformations in Late Eighteenth Century Art*. Princeton, NJ: Princeton University Press, 1967.

24

Realism, Impressionism, Post-Impressionism

1839	Invention of photography
1854	Commodore Perry forces Japanese ports to open to foreign traders
1860–1865	American Civil War
1863	Salon des Refusés in Paris
1867	End of the Edo period in Japan (which began in 1615)
1870–1871	Franco-Prussian War
1874	First Impressionist Exhibition (others in 1876, 1877, 1879, 1880, 1881, 1882, 1886)

The second half of the nineteenth century is as complex as any period in the history of art. Artists had to change their expectations of support almost completely. The patronage of great royal houses disappeared with the houses themselves. The fantasies of Romanticism, escapist and unrealistic as they were, could not survive the needs of a changing and unsettled society, a condition common to America and almost every European nation. A patron middle class, not yet sure of its identity, sought its own image reflected in art. But, as in a mirror, no flattery is reflected. In fact, the artists often focused upon the lower classes and on squalor. Field laborers, factory workers, and the lurid night life of the city captured their attention.

The Realist movement was a literary phenomenon as well. Balzac, Stendahl, and Dickens shared Realistic elements, as did Flaubert and Tolstoy, the masters of the genre. Realism coincided with the emerging Industrial Revolution and the corrosive effect of factory work on the labor force.

Romanticism's lost worlds and distant climes belonged to the era when there was time for escapism. Moreover, the battle between Neoclassicism and Romanticism had no meaning to the emerging Realists. They sought out naturalism in past artists—Vermeer was rediscovered; Le Nain and Chardin caught their attention. The Realists stood against Classical ideals and for justice for the common man. They were avid participants in the social movements of the time.

The naturalism that the Realists sought led them to search within painting for what might be termed the "nature of truth-to-nature." It led to study of the properties of light and optical effects of light, and to optical consideration of the ways vision works in contradistinction to Renaissance perspective. Instead of following traditional academic concepts of painting the artists looked for scientific concepts of vision. The Impressionists and Post-Impressionists set free the boundaries of traditional color and perspective for additional, new visual approaches.

REALISM

Realist Painting in France

In France the art of the mid-nineteenth century includes an identifiable movement called Realism. The Realists concentrated on social and sensory experience and rejected Romanticism's various idealistic tendencies. Corot and the Barbizon painters went about their Realistic painting without adamancy, yet their work had effective results. Among the leaders of the Realists were the more bombastic Gustave Courbet and the highly independent Édouard Manet.

JEAN-BAPTISTE CAMILLE COROT

Jean-Baptiste Camille Corot (1796–1875) is one of the first identifiable Realists. Corot was primarily a landscapist who took up painting at twenty-six after a modest career in his family's business. He worked in Italy and France, in two landscape styles. In his early work Corot painted in planes of color that ignored strict descriptive drawing. His paintings show bright noontime sunlight and shadow falling upon the earth, the walls, and roofs of buildings. These paintings attracted both Cézanne and the Cubists in later years. Corot painted studies in the open air—small oil paintings done on the spot. Unlike earlier artists who had occasionally made such oil sketches, Corot treated these as finished artworks.

The Island of San Bartolomeo. *The Island of San Bartolomeo,* the Tiber island in Rome, was painted in 1825, on Corot's first journey to Italy. It is in the Boston Museum of Fine Arts. Corot's strong use of light and color to define the complex planes of the river, the bridges, and the buildings shows his awareness of a landscape tradition traceable to Ingres and to Poussin. It also directs us to the visual breakup of closely defined, exact edges in favor of a visual sensation of light as it shimmers on the church and hospital buildings on the island.

Ville d'Avray. Corot's later landscape paintings, such as the *Ville d'Avray,* of 1870, in the Metropolitan Museum of Art in New York City, were painted in the studio. They are quite different from his earlier works. These works present a misty or filmy veil of foliage and light through which distant buildings or bridges are seen. Touches of bright color highlight a generally subdued, gray-and-olive color scheme in these works. These later paintings were often copied and very popular, but the Realists and Impressionists found them disappointing. On careful study they are visually challenging studies of space and form.

THE BARBIZON SCHOOL

Corot painted in association with the painters of the *Barbizon School,* a group of French painters who settled in the village of Barbizon in the forest of Fontainebleau. Their paintings opposed academic conventions and focused on undramatic details of countryside and peasant life. The leaders of the school were Jean-François Millet (1814–1875) and Theodore Rousseau (1812–1867).

Jean-François Millet. Millet, who had studied in Paris, worked at Barbizon after 1848. He concentrated on scenes of peasants' simple lives in the realm of nature. *The Gleaners,* of 1857, in The Louvre, is a work that characteristically shows its subjects, here peasant women, as monumental figures though they are actually performing the meanest of tasks—gathering leftover edibles from the earth behind the harvesters.

Millet painted the *Sower,* now in the Boston Museum of Fine Arts, in 1850. It shows a rural peasant scattering seed against the darkening sky of evening. He appears as a heroic figure working against time and toiling in a mode unchanged throughout all the millennia of humankind's settling on arable soil.

Other Barbizon Painters. Theodore Rousseau and Narcisse-Vergille Diaz were the other major Barbizon painters. Their works were predominantly landscapes of woods and meadows, painted on the site. The Dutch landscapists and, to a degree, the Englishman John Constable, who had exhibited in Paris in the 1821 and 1824 Salons, were influential on the Barbizon artists. Their work was of real importance to the Impressionists because of its careful and direct study of light and color within the most simple of settings.

HONORÉ DAUMIER

Honoré Daumier (1808–1879) is a different kind of Realist. He is best known for his prints, which are powerful commentaries, often with biting satire, on the social circumstances and political scandals of his day.

Daumier worked in *lithography,* a printmaking process in which the drawn image was made on Bavarian limestone and transferred by a press to paper. It was a useful medium for journal illustration, though Goya, Géricault, Delacroix, and other artists had made lithographic prints. The process of lithography was invented in 1798 by Alois Senefelder, a German. In modern usage lithography has many variants and commercial applications.

Daumier made lithographs for the journals *La Caricature* and *Charivai,* in the 1830s. He was imprisoned in 1832 for his representation of King Louis-Philippe as Gargantua. He also made paintings. More than 4,000 lithographs by Daumier survive, many of which are witty, often forceful, social satires.

Rue Transnonain, 24 April 1834. One of Daumier's most powerful lithographs, the *Rue Transnonain, 24 April 1834*, is a portrayal of government overreaction. Soldiers, who had been fired upon from a building, entered and massacred all the inhabitants. The deaths of innocent citizens in such brutal reprisals shown with such candor are an effective counter to the atrocity of the attackers.

The print media enable an artist to produce multiple images quickly and cheaply. As we have already seen with Goya and Hogarth, printmaking provides a means of protest in critical response to social injustice in any period. All three of these artists share in the development of this art form.

Third-Class Carriage. Daumier's *Third-Class Carriage,* in the Metropolitan Museum of Art in New York City, dating from about 1862, is a representative painting. It shows a crowd of people in a railway car. They are a stifled group of travelers, isolated even in their crowded space. The scene is lit harshly by the limited window area and low overhead space of the carriage.

GUSTAVE COURBET

The leader of the Realist movement was Gustave Courbet (1819–1877). He was born at Ornans in the Franche-Comté, and painted there and in Paris. Courbet claimed to paint what he saw, rejecting the Neoclassical and Romantic schools for an uncompromising pictorial realism. His works include landscapes, simple ceremonies, laborers, nudes, studies of animals, and still-life paintings. His unsentimental and intentionally unaesthetic painting expressed realities of everyday life.

The Stone Breakers. Courbet's painting *The Stone Breakers,* formerly in Dresden, was painted in 1849. It shows a young boy and an old man at work doing the hard physical work of road mending. It is an unrelenting

look at thankless labor. The graceless positions of the figures clash even with the timeless moralities implied by Millet's heroic peasants. The painting was exhibited at the Salon of 1850 where it shocked and puzzled the critics.

A Burial at Ornans. Gustave Courbet set out to generate shock by the stark, nonheroic factuality of his works. *A Burial at Ornans,* of 1850, was shown in the same salon as *The Stone Breakers.* It is a huge canvas, 10 feet 3 inches by 21 feet 9 inches (3.12 by 6.63 m). It shows a simple country funeral. The foreground is filled with about forty life-size people of Courbet's hometown. A dignified, matter-of-fact event is taking place in the midst of ordinary life. At the feet of this gathering is the open grave of one of their own. Behind them rise the bold-faced cliffs of the land about Ornans. Tied to the land and to village life, the cycle of these people is brought full circle in the painting.

Studio. In 1855, Courbet publicly refused to submit his works for prior approval and was rejected by the Salon. He responded by constructing a special shed, which he called the Pavilion of Realism, for an exhibition of his works. Among the works he showed was *A Burial at Ornans* and a new work called *Interior of My Studio: A Real Allegory Summing Up Seven Years of My Life as an Artist.*

The *Studio* is now in the Musée d'Orsay in Paris. This painting is similar in size to the *Burial.* In the *Studio* the artist sits at the center with palette and brush, painting a landscape. A nude model (symbol of Truth?) stands at his shoulder. A child (an innocent eye?) gazes at the landscape. At the left are Courbet's models, ordinary figures and mannequins. At the right Courbet's friends are gathered: George Sand, Baudelaire, and others are recognizable.

The *Studio* is an especially powerful restatement of the artist's position. In ways it is foreshadowed by Velázquez in *Las Meninas* and Goya in the *Family of Charles IV.* Yet the artist's place in his society is here different. He is part of the group of figures assembled. *They* are the visitors in his environment. He speaks for them in his language as the writers do in theirs. He is not a court retainer.

In 1863, when the judges of the Salon were so reactionary as to refuse the majority of submitted works, the emperor Napoleon III ordered a special exhibition for the rejected. It was called the *Salon des Refusés.* Courbet had the distinction of refusal from both Salons because of a radical anticlerical painting that he submitted. In 1871 he was imprisoned and heavily fined for his political activism. He had taken part in destroying the Napoleon column in Place Vendôme. Courbet fled to Switzerland, where he lived the last years of his life.

ÉDOUARD MANET

The painter Édouard Manet (1823–1883) was a Parisian, trained by the painter Thomas Couture from 1850 to 1856. His art is linked to that of the Impressionists, most of whom he knew. But Manet did not exhibit as an

Impressionist or study light and color in the same way they did until late in his career. Manet was influenced by Velázquez and Goya, and he was spellbound by the paintings of Constable. He practiced direct painting from the model, and he adopted Realist subject matter. Manet's work differs from Courbet's, and he did not have the revolutionary adamancy of his contemporary.

Luncheon on the Grass. In the *Salon des Refusés* of 1863, Manet exhibited one of his best-known paintings, *Luncheon on the Grass* (*Déjeuner sur l'herbe*), presently in the Musée d'Orsay, Paris. It caused a great scandal because of the grouping of two male figures in modern dress, seated with a wholly nude female. Manet had titled the work *The Bath*, apparently with reference to a second, partially nude figure bathing in the middle-distant stream. The model of Titian's *Pastoral Symphony* was probably on Manet's mind when he made the painting. His composition was also drawn from Renaissance sources.

Manet's painting is without any apparent allegorical content. Its Realist assertion is without the protective guise of Classical meaning. The foreground group is composed from an engraving by a Raphael pupil, Marcantonio Raimondi, but nothing of its Renaissance derivation is left to the viewer. It is also painted with a direct, saturated light that flattens the figures, especially that of the seated woman, negating form and volume in the work.

Some critics would date the beginning of the modern period in art to this work. Manet continued to paint subjects as baffling, as free of developed form and depth as this, choosing his own subject matter. His was not a deliberate attempt to offend the public or the academic artists of his time, though we can sense a deliberate attempt to create a controversy with *Luncheon on the Grass*. Manet painted with assurance and selectivity according to his own view and claimed to be perplexed by the reaction of his contemporaries and critics.

Bar at the Folies-Bergère. Manet's *Bar at the Folies-Bergère*, in the Courtauld Institute Galleries in London, was painted in 1882. This is an interior, entirely lit by artificial light, partially reflected in the mirror that forms the backdrop for the painting. At a bar stands a barmaid looking directly at the viewer. Behind her is a mirror, and we see the reflection of a crowded balcony, great chandeliers, wall lamps, and the legs and feet of a trapeze artist on a slender swing in motion to the left. At the right is the reflection of the barmaid and a customer. Their reflections are mysteriously misaligned with the apparent surface of the mirror. The *Bar at the Folies-Bergère* is a fleeting scene. The subject has no special importance. It is engaging only in its strident familiarity and colorful surface.

Realism in Other Countries

The art of Realism found resonance in many places beyond France. It was never such a formal movement abroad, yet it met with critical, similarly resistant barriers.

THE PRE-RAPHAELITE BROTHERHOOD

In England, the artists John Everett Millais (1829–1896), William Holman Hunt (1827–1910), Dante-Gabriel Rossetti (1828–1882), and others founded the Pre-Raphaelite Brotherhood in 1848. The Pre-Raphaelites sought a truth to nature opposed to Reynolds, the academic tradition, and the "Raphaelites" —imitators of Raphael among Bolognese Baroque artists. The Pre-Raphaelite artists used great care in the details of their paintings, depicting the character of landscape down to the individual weeds, soil, and rock types, and studying costume and historical detail for their paintings of events and people.

WILHELM LEIBL

Wilhelm Leibl (1844–1900), Adolph von Menzel (1815–1905), and Hans Thoma (1839–1934) were all Realist painters in Germany. Of them, Wilhem Leibl of Cologne, influenced strongly by both Courbet and Manet, was probably the most true to form. Leibl had spent time in Paris just before the outbreak of the Franco-Prussian War. He made paintings of the working class and peasant life in Germany.

Three Women in a Village Church. Wilhelm Leibl's painting of *Three Women in a Village Church* is usually cited as his masterpiece. He went to live in villages in Bavaria and used peasant models and buildings to achieve the exacting linearity and true types of people in his images. The strong, personal image of these women in a simple, country church interior is painted with scrupulous attention to detail in fabric, pattern, expressive hands, and faces. Leibl was also clearly aware of German historical traditions, especially the strong linear and descriptive art of Dürer and Holbein.

Realism in America

WINSLOW HOMER

Winslow Homer (1836–1910) was both a painter and illustrator, noted for his coverage of the Civil War for *Harper's Weekly*. His best-known works are of rural America, life at sea, coastal scenes, and landscapes. He also painted vigorous watercolors of hunting and fishing in the northern woods and the tropical coast of the Gulf of Mexico.

THOMAS EAKINS

Thomas Eakins was, with Homer, a Realist painter of great influence in American art. In 1866–1870 he trained in Paris with Gérome and Bonnat. He was also influenced by Courbet and Velázquez. In America by 1871, he worked in both academic and Realist modes. Eakins was interested in

photography and anatomy, and was a compelling portraitist. His advocacy of nude models in life-drawing classes at the Pennsylvania Academy of Fine Arts caused enormous controversy and cost him his teaching position.

William Rush Carving His Allegorical Figure of the Schuylkill River. In 1877, Eakins painted *William Rush Carving His Allegory of the Schuylkill River.* Two versions and several oil studies were made of the subject. The paintings are in the Brooklyn Museum and the Philadelphia Museum of Art. The artist felt that this subject was a supportive argument for life study. The sculptor Rush, making statuary for the Philadelphia Water Works in 1809, had depended upon the nude figure for his draped sculpture.

Eakins shows, in both paintings, the sculptor at work in his cluttered studio. The model stands at the center of the more finished Philadelphia version. Seated by her, knitting, is a chaperone. In shadow to the left is the sculptor at work on his wooden figure. Light falls on the standing model and a chair on which her clothing is draped. The painting is a conscientious study of an artist at work. Comparison with Courbet's *Studio* is inevitable. Rather than a "real allegory" Eakins has made a painting of an allegorical subject in the making.

Eakins' figure of Truth, as Rush's model, does not gaze approvingly at the work. She participates in its creation.

Architecture in the Mid-Nineteenth Century

The beginnings of the Industrial Revolution brought about changes in all aspects of life including the arts. Architecture, most of all, experienced changes in form and substance. Metal, long used to reinforce, strengthen, or tie architectural elments together, was suddenly a substance for the major framework of buildings. Iron and steel became factors in a new technology that enabled buildings of a kind and size heretofore impossible.

HENRI LABROUSTE

Henri Labrouste (1801–1875) built the Bibliothèque Ste.-Geneviève in Paris in 1843–1850. In its construction he used thin cast-iron columns and arches of openwork iron for the large second-story reading room. The space is divided into two parallel barrel-vaulted areas divided by the columns and supported by the arches. Labrouste went on the build the Bibliothèque Nationale in Paris, begun in 1868.

SIR JOSEPH PAXTON

Sir Joseph Paxton (1803–1865) designed and built the Crystal Palace in Hyde Park, London, in 1851. It was a five-aisled building, constructed of prefabricated parts, 1870 feet (570 m) long, and designed specifically as an exhibition hall for London's Great Exhibition of 1851. The Crystal Palace displayed the structural possibilities of new materials, but it was itself designed and used only as a temporary structure.

IMPRESSIONISM

The French Impressionists

Impressionism surely arises from Realism and may be termed its last stage. As a movement it began in France, and most of the painters we associate with Impressionism are indeed French. They comprise a group who participated in a series of eight independent exhibitions in Paris from 1874 to 1886. Their interest was in light and its effects upon surfaces.

Not all the Impressionists worked alike, and though interactive, they did not form a specific manifesto or set of rules. From Manet, who in turn had observed innovations in the art of Constable, the Impressionists learned to paint upon canvases primed with white rather than the academic middle tone, usually brown. This gives almost all of their work the brighter color and immediacy that is the directly appealing charm of Impressionism.

Their interest in color included scientific theory of optical effects. They tried to imitate natural light by using small brush strokes of prismatic colors that would blend optically when seen at a distance. They painted out-of-doors subjects on the spot, as Corot and the Barbizon painters did, in order to assure the freshness of the impression. Two additional factors are to be counted into the formation of Impressionist painting. They are *Japonisme* and the invention of *photography*.

Japonisme. Most of the Impressionists' paintings are landscapes, genre scenes, and figure and portrait studies. Academic subject matter—myth and history—was of no interest to them. An especially important factor in their art was the newly available supply of Japanese prints. These were to affect the whole history of Western art. Their unorthodox (to Western eyes) viewpoint, bright color, and vitality of form affected all of the Impressionists.

Japonisme, as this nineteenth century phenomenon is termed, was newly available for study after 1854 when the United States reopened Japan to international trade. The country had been closed, save for a Dutch trading station at Nagasaki, since 1634. *Japonisme* differed from the earlier oriental styles applied to seventeenth and eighteenth century art. The prints had a profound structural effect on composition and surface. Japanese prints were free of the constraints of academic perspective and composition. They lent extraordinary new approaches to composition. Their vivid and unusual colors gave impetus to Impressionist color theories.

Photography. Louis Jacques Mandé Daguerre declared in 1839 that he had invented the photograph. For a considerable time the process of making images on light-sensitive material received through a lens was limited mostly to portraits. As Impressionism developed, photography advanced with portable cameras to make snapshots become available and popular. It provided a new way of seeing for artists.

The history of photography as a visual art is still in the making. No doubt will be expressed here regarding the independent importance of the medium as it continues to the present. There is also no doubt that its invention had a critical impact on modern art from the outset. We do not propose to treat the subject here per se, but reference books are listed in the bibliography at the end of this chapter and the next for this most important topic.

CLAUDE MONET

Claude Monet (1840–1926) was the original and most consistent Impressionist. He, Renoir, and Pissarro, among others, had been working in the 1860s on the ideas of light and color in landscape painting. Monet's individual studies of subjects under differing light conditions and times of day evoke the objectives of the Impressionists clearly.

Impression—Sunrise. The term *Impressionism* comes from the title *Impression—Sunrise,* given by Claude Monet to one of his works painted in 1872 and exhibited in 1874. It is a scene of the smoke-and-mist-clouded harbor at Le Havre with a few small vessels silhouetted against the murky red-orange disk of the low, rising sun. The sun casts a broken reflection in the water, where the rippling waves make a pattern of shadows.

Rouen Cathedral. Among the subjects Monet painted in many variations was *Rouen Cathedral.* About forty paintings of the façade, painted in heavy impasto, are preserved. Monet's care to paint the light and shadows, concentrating on the colors in each, is very clear in these paintings. At various times of day, the sun casts different shapes of shadows across the sculptural form of the façade. In some of these paintings we find that it is neccessary to adjust our perception from the paint surface, its colors, and patterns to visualize the cathedral.

In similar fashion, Monet painted series of the Gare Saint-Lazare in Paris, Waterloo Bridge in London, haystacks in a field, and water lilies in his own Japanese-style garden pond at Giverny. All remain astonishingly fresh through the repetition of form.

CAMILLE PISSARRO

Camille Pissarro (1831–1903) was born in the West Indies and came to Paris in 1855. Courbet, Manet, and Corot were all early influences on his art. He exhibited in the Salon des Refusés in 1863. He worked at Pontoise and in Paris, painting landscapes.

Place du Théâtre Français. In later life, in poor health, Pissarro painted scenes of Paris from windows. Paintings like *Place du Théâtre Français,* in the Los Angeles County Museum, of 1895, still comprise bright Impressionist observation. They are composed almost as if by accident, capturing the vitality of the city at the end of the century with myriad figures streaming in all directions.

BERTHE MORISOT

Berthe Morisot was one of two women in the Impressionist group. She had been encouraged in her painting by Corot. Her work was admired by Manet, whose brother she married. It was she who later convinced Manet to paint in the Impressionist style, abandoning his use of black paint for the perceived color of refracted and reflected light within the shadows.

View of Paris from the Trocadero. Morisot painted remarkably effective landscapes in addition to intimate, household pictures. Her *View of Paris from the Trocadero,* in the Santa Barbara Museum of Art, looks across the city from a high point, embracing a sweeping view of the park and a curving Seine, to the distant towers and spires of the city. It is painted with a fresh, colorful, yet controlled atmospheric perspective.

PIERRE-AUGUSTE RENOIR

Pierre-Auguste Renoir (1841–1919) was instrumental in developing the ideas of Impressionism early, while painting with Monet at Bougival in the late 1860s. Renoir exhibited in four of the Impressionist exhibitions. His paintings of the period are brilliantly infused with color and light. His palette probably included more colors than any of the other Impressionists. Later, Renoir turned to other coloristic concerns. His late paintings are mostly of nudes, using a controlled, non-Impressionist color scheme.

Le Moulin de La Galette. Renoir's painting *Le Moulin de la Galette*, in The Louvre, Paris, was painted in 1876. The subject is a Sunday afternoon crowd at a popular gathering spot for dancing and mixing. A great number of young men and women are shown in a social setting, dancing and conversing. The color of lanterns and dappled daylight play over all the figures.

In color and light, *Le Moulin de la Galette* is a fully Impressionist painting. Furthermore, the oblique view into the space and the arbitrary cutting off of details at the sides and base of the picture plane suggest compositional innovations used by the Impressionists. These elements develop from the invention of photography and the revelations of Japanese prints.

EDGAR DEGAS

Edgar Degas (1834–1917) was the greatest virtuoso among the Impressionist painters. His range of subject matter did not stop at the traditional, and he was more inspired by Japanese prints than all the other Impressionists except for Mary Cassatt. His interests also ranged to photography and a wide variety of printmaking techniques. He also worked in sculpture to great effect, but he exhibited little of it in his own lifetime.

More than the other Impressionists, Degas was interested in the subject matter of his paintings. This involved the tensions between couples, in bars and bedrooms; the attitude of a ballet master observing a rehearsal; the

working and resting attitudes of dancers; and the unposed, wholly un-eroticized nude.

The Glass of Absinthe. In *The Glass of Absinthe,* two figures, a man and woman, sit in silence, tired and expressionless, at a bar table. They are seen as if we are glancing at them from our own table. Degas has keyed the color of the painting to the pale, yellow-green of the woman's drink. The floor, tabletops, and wall, even the woman's blouse, hat, and the pattern in the draperies, are muted resonances of this color. The lighting seems indirect and artificial, providing the tonality overall and lending a mood almost of menace to the inexplicable shadows behind the silent pair.

The Morning Bath. Late in his life, Degas made countless studies, many in pastel, of bathers. *The Morning Bath,* a pastel study in the Art Institute of Chicago, shows an oblique view of a woman stepping into the tub. The foreground shows a bed and several pillows. Brightly patterned curtains enhance the simple domesticity of the subject. Degas expressed the desire to paint such nudes as if seen through a keyhole—not voyeuristically but simply as if they were totally unconcerned with being observed.

Two Laundresses. *Two Laundresses,* a painting in the Musée d'Orsay in Paris, done about 1884, expresses the everyday weight and boredom of hard physical work in the contrasted, Millet-like intensity of two women at work, one stretching and yawning, the other pressing clothing with a weary intensity.

MARY CASSATT

The second woman to join the Impressionist painters was the American Mary Cassatt (1845–1926), who went to Paris in 1868 after study at the Pennsylvania Academy. In Paris she became attracted to the Impressionists' work. Cassatt met Degas in 1877, beginning a long association with him. She exhibited with the Impressionists in 1879, 1880, 1881, and 1886. Like Degas, Cassatt was particularly affected by Japanese prints. She made an especially fine series of colored etchings that were profoundly influenced by Japanese woodcuts in color and composition.

The Bath. Many of Cassatt's paintings are strong, unsentimentalized domestic scenes, often with the theme of mother and child. *The Bath,* in the collection of the Art Institute of Chicago, was painted in 1891. It is one of Mary Cassatt's mature works, simple, expressive, and direct. The oblique composition and contrasted patterns of fabric, along with their bright colors, all portray assured and confident work.

Impressionism Elsewhere

There could be little doubt that the Impressionists would have an impact on painting in both Europe and America, as indeed they did. A number of artists, such as the Americans Childe Hassam (1859–1935) and Maurice Prendergast (1859–1924), are noted for their development of the style in individual directions after encountering it during their Parisian studies.

JAMES ABBOTT MCNEILL WHISTLER

James Abbott McNeill Whistler (1834–1903) was an American who lived in London after 1859. He had met Degas and Courbet in Paris, where he went to study in 1855 in time to see and admire Courbet's Pavilion of Realism. Whistler exhibited in the Salon des Refusés in 1863. One of the first artists of the Western Hemisphere to be affected by *Japonisme,* he collected all kinds of Oriental art and applied its principles to his works. Whistler painted color harmonies and studied color and tonal relationships.

Arrangement in Grey and Black: Portrait of the Artist's Mother. Whistler's best-known work and an enormously popular painting is the portrait of his mother which he called *Arrangement in Grey and Black.* The painting is in the Musée d'Orsay, Paris. It was made in 1871. Entirely painted in the subdued tones suggested by its title, the image shows the artist's mother seated. Dark draperies, Mrs. Whistler's gown, and the baseboard form simple large patterns in muted contrast to the lighter head and hands of the sitter, the floor, and wall.

Nocturne in Blue and Silver: Old Battersea Bridge. A series of paintings he called *Nocturnes,* painted in the 1870s, are scenes of London. They show recognizable places, mostly waterfront locations in the gloom of night with reflected lights, silhouetted details, mist, and dark shapes. The impact is of oriental design and composition.

Nocturne in Blue and Silver: Old Battersea Bridge is in the Tate Gallery, London. The spindly bridge supported by tall pilings is silhouetted against the night sky. Huddled, indistinct figures linger on its arching narrow passage. In the lower foreground a barge man poles his craft toward the foreground, causing dark ripples. In the distance are low waterfront buildings and the masts of vessels. A signal rocket and cluster of sparks hover in the air, and distant lights reflect in the smooth surface of the river.

POST-IMPRESSIONISM

Several of the artists who entered the Impressionist exhibitions went on to other investigations of the many complex issues in modern art. Their directions were many and involved further color, line, and form study. Some returned or went on to particularize subject matter, symbolism, and expression.

GEORGES SEURAT

Georges Seurat (1859–1891) exhibited his large Sunday on the Island of La Grande Jatte in 1886 at the last Impressionist exhibition. There the term *Neo-Impressionists* was bestowed on him and his follow-

ers, Paul Signac and, for a time, Camille Pissarro. The paintings involve the use of "divisionism," in which local color, the color of light, and their interaction are all painted in small strokes, side by side on the canvas, with their complementary colors as well. The theory proceeds from scientific study of optical light and color in progress at that time in books by Chevreul, Charles Henry, and David Sutter.

Sunday on the Island of La Grande Jatte. The short-lived Seurat only made seven large paintings. The best and most famous is *Sunday on the Island of La Grande Jatte,* now in the Art Institute of Chicago. The painting shows dozens of figures strolling or sprawling on the greensward by the riverbank. Each is carefully positioned and balanced, creating a surface pattern as well as a three-dimensional depth.

Several studies for the work survive. It is surely not the kind of spontaneous artwork characteristic of the Impressionist movement. Seurat carefully calculated each brush stroke for effect and painted therefrom on meticulous theoretical grounds. Yet the contrast between the oddly stiff, calculated poses and the shimmering effect of the brushwork and bright colors makes a highly stylized and entirely enchanting world.

PAUL CÉZANNE

Paul Cézanne (1839–1906) worked in Paris after 1862 and exhibited in the Salon des Refusés in 1863. He was a close friend of the Realist writer Émile Zola and an activist against academism. He exhibited in the 1874 and 1877 Impressionist exhibitions, having worked at Pontoise with Pissarro in 1872.

Cézanne was an Impressionist only by extension, however. His painting has more to do with drawing and form than with atmosphere and the color of light. The search for form occupied most of Cézanne's work in the 1860s. He painted with a palette knife in a heavy, rather coarse style and preferred to use earth colors.

In the 1870s Cézanne's art became more controlled and colorful under Pissarro's influence. More variable colors and a lighter palette appear in the landscapes. But the work of Cézanne is chiefly concerned with color when it can be made to convey solid form and depth by juxtaposition with other colors. This is as true of his portraits and still-life paintings as of his landscapes. The paintings that Cézanne produced are critical to the art of the twentieth century.

The conviction that human experience differs enormously from the record of it determined by the rules of academic art freed the Realists to undertake subject matter far from traditional academic problems. The Impressionists sought to investigate perception through the properties of color. Cézanne was preoccupied with the visual understanding of form and depth

as seen through experience, rather than from the single, one-eyed viewpoint regulated by the constrictions of theoretical perspective.

Mont Sainte-Victoire. Cézanne's favorite landscape subject was Mont Sainte-Victoire in the south of France near his home in Aix-en-Provence. He made many paintings of the mountain from near and far, restricting his palette to greens, blues, and earth tones of yellow and orange. His brush strokes define distance and form, the depth and shape of the mountain, the foothills, roads and fields, houses and trees.

In his still-life paintings, Cézanne found further means to investigate form and dimension by planes and color, balanced against one another in arranged patterns. A few apples, arranged with some drapery and a bottle or bowl, provide shapes that the artist could work analytically into a powerful statement. He was able to achieve this, too, with figure studies and portraits.

VINCENT VAN GOGH

Vincent van Gogh (1853–1890), the son of a Dutch parson, worked for an art dealer and was a schoolmaster and a missionary before turning to painting in 1880. Van Gogh went to Paris in 1886 to live with his brother. Theo van Gogh was an art dealer who is noted for encouraging the work of Degas, Gauguin, Seurat, Toulouse-Lautrec, and others. Vincent, who was mostly self-taught, learned from these men. In 1888 he went to Arles in the south of France where he worked and attempted to persuade other artists to join him. Gauguin was the only artist to travel to Arles, and the result was a disastrous quarrel between the two men. Two years afterward, in 1890, Vincent van Gogh took his own life.

The Night Café. Van Gogh acknowledged that his color concepts were derived from Delacroix rather than those of the Impressionists. That is, he used color to invoke a mood rather than to reproduce visual experience. The *Night Café*, in the Yale University Art Gallery, painted in 1888 at Arles, is certainly not an Impressionist work. Its colors overpower its half-dozen melancholy denizens. The lamps glare at the room, which can only be said to glare back. The red walls acknowledge nothing; no hint of their color affects the room, nor do the yellows and greens of floor and ceiling find any response in the color of the walls. It is a place where, as the artist himself said, "One can ruin oneself, go mad, or commit a crime."

The Starry Night. Even more expressive is van Gogh's *The Starry Night,* painted in 1889 and now in the Museum of Modern Art in New York City. Above a village is an ethereal display of night stars radiating light pulses against the deep blue of the sky. A green cyprus tree edged in earth-red tones sends its branches like tongues of cold fire aloft to the left. A swirling, wind-driven cloud pattern wedges its way across the painting among the stars.

PAUL GAUGUIN

Paul Gauguin (1848–1903) lived a life that reads like a classic tale of the driven, misunderstood, and uncompromising artist, searching for verities against all odds. He was born in Paris, partly of Peruvian Indian extraction, and spent his early years in Lima. For six years Gauguin was a seaman and afterward a businessman. When he was thirty-five he gave up his career to become a painter; two years later he abandoned his family to spend all his time painting. He worked in Paris, Brittany, Martinique, and Tahiti, and died in the Marquesas Islands.

Pissarro was an early influence, and Gauguin showed works in two of the Impressionist exhibitions. But Gauguin, too, was not an Impressionist at heart. He sought art using ideas rather than the tangible world as a starting point. In this he was influenced by the artist Emil Bernard (1868–1941) and by the Symbolist movement among poets (like Rimbaud and Baudelaire) and artists to which Bernard belonged.

The Spirit of the Dead Watching. In 1891, Gauguin settled in Tahiti after visits to Brittany, where his friend Bernard worked, and to Martinique. His taste for the provincial and tropical thus stimulated, the colony at Tahiti seemed a place for earlier and non-European inspiration. *The Spirit of the Dead Watching,* in the Albright-Knox Art Gallery in Buffalo, New York, was painted in 1892.

Gauguin's paintings are not recapitulations of Polynesian art. A world of experience governs his choice of a reclining nude watched over by a Tahitian cult figure with bright fabric patterns, tropical leaves, and hibiscus. Like the Symbolists, Gauguin uses these feelings and ideas as the starting point for his work of art.

HENRI DE TOULOUSE-LAUTREC

A follower of Degas, Henri de Toulouse-Lautrec (1864–1901) began painting in 1882 in Paris. He centered his paintings on subjects close to the life he led in Paris: scenes from the Parisian dance halls, nightclubs, and cafés in Montmartre. He made a great many studies of nudes, either as washing and dressing figures or in brothels, awaiting customers.

Toulouse-Lautrec had an enormous talent. He did not follow any particular school or movement. In painting he was basically a Realist, using light and color to define what he saw. An additional factor in his art was the extraordinary capacity he had for color lithography, with which he revolutionized the art of the poster. Inspired partly by Japanese prints, the artist designed lettering and image in a balanced and expressive calligraphy.

A childhood accident crippled Toulouse-Lautrec's legs, leaving him dwarfed and partially crippled. The pain of this prompted him to self-exile and to an alcoholic, dissolute life. He died at thirty-six.

At the Moulin Rouge. Toulouse-Lautrec's painting *At the Moulin Rouge,* of 1892, is in the Art Institute of Chicago. A citified version of van Gogh's *Night Café,* Lautrec's work shows the figures sinister in the strong, unnatural interior light. Faces turn garish blue-green or jaundiced yellow, and the puffy fin-de-siècle clothing makes strange rhythms echoed by the loops of bentwood chair backs. The artist and his tall cousin walk across the room to the rear.

Symbolism in the Late Nineteenth Century

Théodore Chassériau (1819–1856) was a pupil of Jean-Auguste Dominique Ingres. He was also deeply influenced by the art of Eugène Delacroix. Chassériau's art is relatively obscure but through him may be traced sources that ultimately would affect the same major aspects of modern art. Two of Chassériau's pupils were Pierre Puvis de Chavannes(1824–1898) and Gustave Moreau (1826–1898).

Puvis was an idiosyncratic, academic painter who became the leading muralist of his day. He was admired by all camps, a painter of inner visions of classical themes. He used a limited palette producing a fresco-like pallor. The Post-Impressionists were captivated by his imagination.

Gustave Moreau worked in the world of fantasy more elaborately, combining the complex opulence of Delacroix with themes expounded by Ingres in exotic and visionary fashion. Moreau eventually was the teacher of Henri Matisse and Georges Rouault.

ODILON REDON

Linked to Puvis, Moreau, and Gauguin's friend Bernard was Odilon Redon (1840–1916), who carried flights of fantasy and the idiosyncratic even further. Redon was a friend of the Symbolist poet Stéphane Mallarmé, whose poetry often dealt with similar fantasies of apparent meaning.

The Cyclops. Redon, painting the myth of Galatea and Polyphemus in *The Cyclops,* shows a sleeping Galatea menaced by the loving yet horrifying one-eyed giant. It is painted in tender yet resonant Impressionist color. In this way, Redon's image assumes a believable reality, thus all the more startling.

Redon was also capable of painting bright and scintillating still-life works of flowers. Further, he was a powerful printmaker. He made very evocative series of lithographs in homage to Goya and to the American writer Edgar Allan Poe, who was much admired in France in excellent translation by Mallarmé.

THE NABIS

Nabis is a Hebrew word for prophet. A group of artists who exhibited together from 1891 to 1900, calling themselves the Nabis, were Symbolists who related their style to Puvis, Emil Bernard, Gauguin, and Redon. Their

leader was Maurice Denis. Among them were Édouard Vuillard (1868–1940, Pierre Bonnard (1867–1947), and Aristide Maillol (1861–1944), before he turned exclusively to sculpture.

JAMES ENSOR

The painter James Ensor (1860–1949) trained in Brussels and lived most of his life in Ostend, in Belgium. He is the most prominent of the twenty Belgian artists who exhibited together in Brussels as Les XX (*les vingt*) from 1884 to 1894. The group is celebrated for exhibiting non-Belgian artists, including Seurat, Gauguin, van Gogh, and Cézanne.

Ensor's isolation kept him from major movements in art, but he is considered with Edvard Munch as a forerunner of Expressionism. His work shows an imagination akin to Moreau and Redon, though he turns to Bosch, Bruegel, or Callot as a source. He often uses masks for sinister effect in his works.

Christ's Entry into Brussels, 1888. Ensor's best known painting is the most controversial. It was excluded from the 1889 exhibition of Les XX for blasphemy. Entitled *Christ's Entry into Brussels,* it is reminiscent of Bosch and Bruegel in showing all that is garish and false in society greeting Christ in the empty ritual of welcome, evocative of the welcome he received in Jerusalem.

EDVARD MUNCH

Edvard Munch (1863–1944) was a Norwegian painter who began his studies in Oslo in 1880. At first a social realist, Munch emerged with new ideas from 1889 to 1892 while in Paris. There he encountered the art of the Symbolists, particularly Gauguin, Moreau, and Redon. Munch made particularly insightful paintings of intense feeling. These he worked into prints, making woodcut and lithographic versions of many. His prints, partly influenced by Gauguin's techniques, were in turn very powerfully influential on the German Expressionists.

Munch painted landscapes, often in somber color with a brooding, melancholic figure or two. The shapes and colors of the landscape seem to impose a sense of isolation on the figures. Munch displays a world of brooding, interior thought. This world is constantly compared to that in the plays of Ibsen and Strindberg.

The Scream. There is no escaping the direct impact of *The Scream*, painted in 1893. It is in the Munch Museum in Oslo. The scream is uttered by a solitary terrified figure who faces out of the lower center of the painting. The figure is depersonalized to no more than an idea of a screaming soul. It is worse for its silence, an interior experience we thereby share.

ALBERT PINKHAM RYDER

The American painter Albert Pinkham Ryder (1847–1917) received formal training in painting, and he traveled to Europe. Otherwise his reclusive ways and individualistic paintings might be taken as naive art. Ryder had a special genius for Romantic landscape, seascape, and symbolic representations.

Death on a Pale Horse. The image of *Death on a Pale Horse,* c. 1910, alternately titled *The Race Track,* is a characteristic work, one of Ryder's best. It is in the Cleveland Museum of Art. The theme is partially from the Apocalypse; Death is the fourth of the visionary riders. He circles a bleak oval track lined by a rail fence and is shadowed by a cobra in the foreground, the devil's symbol. One dead tree stands at the right. The landscape is otherwise empty of life beneath its bleak sky.

Ryder's paintings are subtle yet strong compositions. Many have deteriorated because of the heavy impasto built up by the artist who would constantly repaint them, sometimes with incompatible materials.

Sculpture in the Late Nineteenth Century

In the course of the nineteenth century, painting had become the leading art and Paris had taken the lead in painting. Late in the century a number of artists working in sculpture brought that art forward again. During the second half-century, Daumier, Degas, and Renoir worked in sculpture. Gauguin also produced a number of sculptures, but none of these artists exhibited their work in sculpture.

JEAN-BAPTISTE CARPEAUX

Jean-Baptiste Carpeaux (1827–1875) was a pupil of the sculptor François Rude (1784–1855). Rude is best known for his sculpture on the Arc de Triomphe d'Étoile in Paris, of 1833 to 1836, called *La Marseillaise,* or *The Departure of the Volunteers*.

The Dance. Carpeaux's best work is *The Dance,* a sculptural group he modeled in clay between 1867 and 1869 as one of the designs for the carved limestone sculpture on the façade of the Paris Opéra. The plaster cast of the original clay sculpture is in the Musée de l'Opéra. The bacchanalian, sensual dance was the object of great criticism when the Opéra was finally opened in 1874. A public newly attuned to Realism found these fleshy figures a little too suggestive.

AUGUSTE RODIN

François Auguste René Rodin (1840–1914) was the first European sculptor of major consequence since Bernini. His work focused on the figure, and in most cases, it was built up in clay to be cast in bronze. Rodin had worked as a craftsman in porcelain. He studied sculpture in Brussels from 1871 to 1877, during which time he also traveled to Italy in

1874 and 1875. While in Italy, Rodin was profoundly moved and inspired by the work of Michelangelo.

Rodin's work combines almost all the elements of nineteenth-century art; Romanticism, Realism, Impressionism, and Symbolism have been seen in it by assorted biographers and critics. Ultimately, Rodin is all and none of these, a pivotal artist who represents the end of one tradition and provides groundwork for a resurgence of sculpture as a compelling art form in the twentieth century.

Man of the Age of Bronze. The first of Rodin's major pieces is the *Man of the Age of Bronze*, done in 1876. The standing nude figure combines elements of Classical art and of the art of Michelangelo. Yet the gestures express an interior tension or troubled realization, emotions unknowable in Michelangelo or Polyclitus.

Gates of Hell. Many of Rodin's sculptural themes were worked up from designs incorporated into his *Gates of Hell,* a monumental door that he designed for the Musée des Arts Decoratifs in Paris. Rodin never finished this commission, which he received in 1880. Bronze casts of the last stage of its preparation before the death of Rodin are in the Musée Rodin in Paris and the Rodin Museum in Philadelphia.

Burghers of Calais. The *Burghers of Calais,* commissioned in 1884, represents a group of six Calais citizens who, in 1347, offered their lives to the conquering English king, Edward III, in exchange for sparing their city. Rodin finished the work in two years, making many studies of the gestures and expressions of these figures in their proud sorrow.

The Realist in Rodin wanted the figures displayed at street level in Calais in order that the viewer could identify with the emotional fervor and the tension of the event. The sculpture was finally installed as Rodin wished in 1924.

Balzac. The memorial to Balzac took a long time to complete (1892 to 1897). It was not accepted by the city of Paris at first and was not set up on the Boulevard Raspail, at the Boulevard Montparnasse, until 1973. Like the hero of one of his books, Balzac is a great striding figure, enwrapped in a bulky robe, deep in thought.

CAMILLE CLAUDEL

The sculptor Camille Claudel (1864–1943) was Rodin's assistant and mistress for a long period of time. Claudel also exhibited and gained recognition on her own as a sculptor of importance. After breaking with Rodin, she continued to exhibit until 1905. Tragically, Claudel's later years were denied her by mental instability. She spent the last thirty years of her life in a mental institution.

Architecture of the Late Nineteenth Century

CHARLES GARNIER

The Opera House, Paris. The Paris Opéra, built by Charles Garnier (1825–1898), was opened in 1874. It was designed in 1861 and built over a period that saw the end of the Second Empire (1870) and the opening of the Third Republic.

The Opéra is an opulent, Neobaroque part of the reconstruction of Paris. It is enriched by sculpture, including works by Carpeaux. The building was designed at the end rather than the beginning of an era, however. What saves it is its function as a social gathering place for audiences attending theatrical productions. When people go there, practical and realistic architecture is not much on their minds.

Napoleon I had designed a system of avenues radiating across the city from the Arc de Triomphe. Napoleon III, who reigned from 1852 to 1871, engaged the engineer Georges Eugène Baron Haussmann (1809–1891) to connect these avenues with boulevards. These wide streets with their chestnut and plane trees characterize Paris today.

The Opéra is approached from The Louvre by its own avenue. Like so many others of the new boulevards and avenues, the Avenue de l'Opéra cut across an overcrowded neighborhood. Haussmann made the "most thoroughgoing transformation of a European city in history," as Spiro Kostof observes in his *History of Architecture*.

H. H. RICHARDSON

One of the extensions of the Gothic Revival, a movement that continued in many regions until the twentieth century, was a revival of other medieval architectural styles. Among the best of these was the revival of Romanesque. Among its most celebrated practitioners in America was Henry Hobson Richardson (1838–1886). Trinity Church, built from 1872 to 1877, in Copley Square in Boston, is probably his best work in this idiom.

Marshall Field Warehouse, Chicago. In Chicago, Richardson built the Marshall Field Wholesale Store from 1885 to 1887. Still related to his Romanesque style with its great round arches, the architecture nonetheless divides into planes of its stories and is steadied by its vertical piers in reminiscence of a Renaissance palace. Its clear organization predicts the commercial utilitarian building style that will develop in the skyscapers of the twentieth century.

LOUIS SULLIVAN

With Louis Sullivan (1856–1924) the organization advanced by the Marshall Field Wholesale Store takes advantage of an internal steel skeleton, first in the Wainwright Building in St. Louis, Missouri, begun in 1890, and later in Chicago.

Carson Pirie Scott Building, Chicago. Sullivan's last skyscraper is the Carson Pirie Scott & Co. Department Store, of 1899 to 1904. Simply sheathed in white terra cotta that follows the steel grid, the Carson Pirie Scott Building is modern in the functional undecorated style that will mark much of twentieth-century commercial architecture.

T he latter half of the nineteenth century marks the change to an art of the modern world. Painters, sculptors, and architects all were given new areas, technologies, and economic support systems with which to work. The concerns of the academic idea of art were foreign to the newer social class capable of supporting the arts. Philosophical trends, often first expressed in literature and poetry, quickly challenged artists to concerns with perception. The Industrial Revolution and any number of political upheavals brought questions of "man's fate" to a more tangible reality.

With the Realists and Impressionists we have the roots of modern painting. Sculpture as well turned away from the academic tradition, and the advancement of industry and needs for larger and more practical buildings set the technology of architecture on a new track.

Selected Readings

Boimé, A. *The Academy and French Painting in the Nineteenth Century.* New York: Phaidon, 1971.

Chassé, C. *The Nabis and Their Period.* New York: Praeger, 1969.

Denvir, B. *The Impressionists: A Documentary Study.* New York: Thames and Hudson, 1986.

Delevoy, R. L. *Symbolists and Symbolism.* New York: Rizzoli, 1982.

Elsen, A. E. *Origins of Modern Sculpture: Pioneers and Premises.* New York: Braziller, 1974.

_____ . *Rodin.* Garden City, NY: Doubleday, 1963.

Gibson, M. *The Symbolists.* New York: Abrams, 1988.

Herbert, R. L. *Impressionism: Art, Leisure and Parisian Society.* New Haven, CT: Yale University Press, 1988.

Hilton, T. *The Pre-Raphaelites.* New York: Abrams, 1971.

Kelder, D. *The French Impressionists and Their Century.* New York: Praeger, 1970.

Nochlin, L. *Impressionism and Post-Impressionism: 1874–1904.* Sources and Documents. Englewood Cliffs, NJ: Prentice-Hall, 1976.

_____ . *Realism, Style and Civilization.* Harmondsworth, Baltimore: Penguin, 1972.

_____ . *Realism and Tradition in Art: 1848–1900.* Sources and Documents. Englewood Cliffs, NJ: Prentice-Hall, 1966.

Rewald, J. *The History of Impressionism.* 4th rev. ed. Greenwich, NY: New York Graphic Society, 1973.

_____ . *Post-Impressionism: From Van Gogh to Gauguin*. 2d ed. New York: The Museum of Modern Art, 1962.

Weisberg, G. P. *The Realist Tradition: French Painting and Drawing, 1830–1900*. Cleveland: Cleveland Museum of Art, 1981.

_____ . *Japonisme*. Cleveland: Cleveland Museum of Art, 1975.

Wilmerding, J. *American Art*. Harmondsworth: Penguin, 1976.

25

Twentieth-Century European Painting and Sculpture

1900	Freud, *The Interpretation of Dreams*
1903	Wright Brothers, powered flight
1910	Einstein, general theory of relativity
1914–1918	World War I
1917	Russian Revolution
1936–1939	Spanish Civil War
1939–1945	World War II
1957	First earth satellite
1969	First lunar landing

*T*he trends that changed artists' objectives and intentions during the nineteenth century continued after 1900. The concepts of visual experience, social consciousness, color theory, primitivism, and symbolism all found interrelated artistic pursuit in the first half of this century.

Newer trends have appeared since the mid-century; we talk, today, about "Post-Modern" art. The objectives of artists during the twentieth century come gradually into historical focus as we reach its end. Most fascinating are

the studies that suggest our own location in this long narrative. When reading about the art of the twentieth century we are led to wonder whether change among artists' objectives takes place faster in our age of advanced technology or whether we simply know more about every aspect of change through improved and instantaneous communication, through living memory, and through the enormous amount of information to which we have access.

TWENTIETH-CENTURY EUROPEAN PAINTING

Most of the Impressionists were still alive and working at the end of the nineteenth century. Their lives overlapped those of the Post-Impressionists and the newer generation who would give variable force and direction to the art of the beginning twentieth century. The new approaches to art produced in the second half of the nineteenth century are the starting place for studying the art of the present.

The Fauves

In 1905 at the Paris Salon d'Automne, a group of painters who exhibited together in one room shared vivid, unorthodox uses of color and vigorous drawing. Their work was criticized as that of *fauves,* or "wild beasts," and they collectively assumed that name.

The Fauves were never a wholly coordinated school. All had been influenced by the divisionist art of Seurat and Signac. They carried the ideas forward by painting in colors that were bright and deliberately different from the natural color of the objects painted. Matisse is usually said to have headed the group. Others included Maurice Vlaminck, André Derain, Albert Marquet, Othon Friesz, Kees van Dongen, Raoul Dufy, and Georges Braque.

The Fauves as a group did not last long. They exhibited together in 1906 and 1907 but by 1908 had all chosen to pursue other directions.

HENRI MATISSE

Among the Fauves, Henri Matisse (1869–1954) was the artist most expressive and effective in the images he created of landscapes with figures, portraits, and interior views. For Matisse, color was a serious, selective process related to the Neoimpressionism of Seurat and Signac. Matisse had trained with Gustave Moreau and worked with Pierre Bonnard and Édouard Vuillard before joining with Derain and Vlaminck for parts of the years 1901 to 1905. Cézanne also had a profound effect on Matisse's work at this time.

Joie de Vivre. Matisse's *Joie de Vivre* (Joy of Life), in the Barnes Foundation in Merion, Pennsylvania, is among his most important works. It combines the Classicism of Cézanne in some of his late paintings of bathers

with the South Seas simplicity of Gauguin's search for unfettered subject matter. Matisse uses classical themes of nudes, pipers, shepherds, and an idyllic glade, more Arcadian than Tahitian.

Clearly, however, the landscape and the figures are no longer defined in a Classical or Realist sense. The colors are broken into planes, sometimes delimited by wiry tree trunks. The figures are little more than linear contour drawings, freely suggesting a variety of attitudes and poses.

On exhibition in 1906, *Joie de Vivre* was the controversial and pivotal picture in the Fauves' development. It also profoundly affected Picasso. In the realm of the Fauves it was the last painting to make reference to the Classical past. Matisse and his colleagues afterward concentrated on landscape, figures, and portraits plus the effects of vivid color.

The Red Room. Matisse's painting *The Red Room*, of 1908–1909, in the Hermitage, St. Petersburg, is a summing-up of Fauve works. It combines extraordinary color and juxtapositions of drawn objects that flatten the painting to patterns. The wall and tabletop share identical intense red with blue floral designs. Visually there is but a single plane. A figure arranging fruit, two chairs, and a window intrude upon this simple area without bringing dimension to it except by rationalization.

ANDRÉ DERAIN

André Derain (1880–1954) made landscape paintings in London in 1905 and 1906. Many of these depicted Thames River scenes in "deliberate disharmonies," as he called them. He used yellows, greens, oranges, reds, and blues in startling brightness.

London Bridge. Derain's painting *London Bridge*, in the Museum of Modern Art in New York City, is a view of the bridge and the traffic over and under it. The bridge forms yellow arches over a yellow and green river. Dark blue boats pass through blue-black shadows under the arches. Vivid purple, red, yellow, and green buildings appear on the opposite riverbank under a bright orange sky. These colors are at odds with our expected visual experience. Yet the consistency of Derain's color shift makes the scene comprehensible.

GEORGES ROUAULT

Georges Rouault (1871–1958) was included in the Fauves' exhibitions, but he is better known for characteristic dark-outlined works. He painted religious subjects, clowns, and the destitute of society with glowing colors, usually with heavy impasto outlined in thick black lines.

Rouault's early years had been spent in stained glass workshops. This experience produced a strong influence on the mature forms of his art. He was later a pupil of Gustave Moreau, through whom he met Matisse and others of the future Fauve group. His individualism led him far from the

ideas and ideals of the Fauves as his art matured. He maintained a personal kind of Expressionism in religious works, bleak landscapes, and occasional floral paintings.

Rouault also made prints in series of etchings, color etchings, and lithographs. These are almost all of subjects similar to the paintings.

The German Expressionist Movement

Expressionism is the deliberate use of color and line in an exaggerated style for emotional impact. Historically, Expressionism is more frequently found in northern European countries than in Latin Europe. The emergence of Expressionist movements in Germany in the twentieth century follows upon the emerging awareness of works by van Gogh, Gauguin, Ensor, Munch (who exhibited in Berlin as early as 1892), and the Fauves in Paris.

Awareness of the new movements in art of the latter half of the 19th century led to German unrest in art schools in the 1890s, including secessions (*Sezessionen)* of faculties from the academies in Munich, in 1892; Vienna and Darmstadt, in 1897; and Berlin in 1899. This was followed by the formation of groups of Expressionist artists in Dresden, Munich, and elsewhere. *Die Brücke*, of Dresden, and *Der Blaue Reiter,* of Munich, are the most famed and influential of these groups.

Die Brücke

Die Brücke (the Bridge) was the Expressionist group founded in 1905 in Dresden by Ernst Ludwig Kirchner, Karl Schmidt-Rottluff, and others. They were painters also instrumental in the revival of woodcuts, based on their admiration for Gauguin and Munch, who had each made expressive woodcuts.

EMIL NOLDE

Emil Nolde (1867–1956) joined Die Brücke in 1906. He painted religious scenes very much influenced by the Fauves, though his work usually had narrative content; that is, it showed episodes or events from religious history. Examples include the *Last Supper* and *St. Mary of Egypt Among the Sinners*.

St. Mary of Egypt. Nolde's painting of *St. Mary of Egypt Among the Sinners*, painted in 1912 and now in the Kunsthalle, Hamburg, shows the saint in a carousing, half-naked dance with three leering and drunken sailors. A suggestion of rigging sets the scene at sea, on the way to Jerusalem before Mary's conversion. The powerful colors and boisterous revelry of the close-up figures bring Hieronymus Bosch's Passion scenes to mind.

Two Women Expressionists

PAULA MODERSOHN-BECKER

Paula Modersohn-Becker (1876–1907) was born in Dresden, trained in Berlin, and worked in a German artists' colony at Worpswede, near Bremen. She traveled to Paris several times, which introduced the influence of the

Fauves and Gauguin into her work. A friend of the poet Rainer Maria Rilke, she was a rising Expressionist painter of genius at the time of her early death.

Modersohn-Becker made self-portraits, and paintings on the theme of motherhood. Her work is not as strident as other Expressionists, yet it has the strength, color, setting, and determination that characterizes the Expressionist movement.

KÄTHE KOLLWITZ

Käthe Kollwitz (1867–1945) lived and worked in Berlin. Her best-known work is graphic art: lithographs, etchings, and woodcuts—many on a powerful pacifist theme, others on a left-wing socialist theme. Kollwitz's work is personal, not associated with the Expressionist movements, but her powerful and emotional compositions are among the most effective of Expressionist works.

Der Blaue Reiter

The other major Expressionist group in Germany was Der Blaue Reiter (Blue Rider), in which the artists Franz Marc, Wassily Kandinsky, and Paul Klee were active. Der Blaue Reiter was formed in Munich in 1911 and lasted until 1914, when World War I began.

FRANZ MARC

Franz Marc (1880–1916) made paintings of animals; especially well known are his studies of red horses and blue horses. Among his last works, done in 1914, are almost entirely nonrepresentational paintings, *Animal Destinies,* of 1913, in the Kunstmuseum, Basel, and *Fighting Forms,* in the Bayerische Staatsgemäldesammlungen, in Munich, done in 1914. Marc was called up for army service in 1914. He died in World War I.

WASSILY KANDINSKY

Wassily Kandinsky (1866–1944) was a Russian artist who lived and worked in Munich. Kandinsky gave up a university professorship to become an artist. He wrote on art theory. In 1910 he wrote *Concerning the Spiritual in Art,* published in 1912, in which he outlined an artist's goals to find a spiritual rather than formal reality in his art. Kandinsky's goal was a nonrepresentational art, abstract and devoid of pictorial image yet containing the spiritual values of the artist.

To the same end Kandinsky painted his *Improvisations,* about forty nonobjective paintings of colors, lines, and "spontaneous expressions of inner character." Kandinsky was only one of several artists and theoreticians who were painting and discussing abstract art at the end of the first decade of the twentieth century. His work is an important contribution to the concept of painting nonobjectively, an important aspect of the art of the whole twentieth century.

PAUL KLEE

The Swiss-born artist, Paul Klee (1879–1940) had been trained in Munich and traveled in Italy before settling in Germany in 1906 to work. In 1911 he joined Der Blaue Reiter. His early graphic work and his watercolors and paintings are individualistic; Klee was not simply an Expressionist artist.

In the 1920s he became a teacher in the Bauhaus at Weimar and Dessau. He was the author of the *Pedagogical Sketchbook,* which was published in 1925 at the Bauhaus, representing his witty instructional approach to art. His art is frequently delicate, subtle, and humorous, yet it contains the strength that makes Klee one of the most important artists of the twentieth century.

Twittering Machine. No small selection of works of art can serve to characterize the variety and multilevel meaning of Klee's paintings. The *Twittering Machine,* 1922, in the Museum of Modern Art in New York City, is a drawing in pen and ink with watercolor on prepared paper. It shows a schematic, simplified rendering of an automaton with four birdlike contrivances on an eccentric axle to be cranked. As in many of Klee's works, the title implies the meaning or function of the image.

Cubism

Another important movement that began in France was that of the Cubists. Their art emerges in part from the forms, planes, and colors worked into his paintings by Paul Cézanne in his late paintings of landscape, still life, and bathers. Overlying planes of color, used to interpret form, are the beginning signals of Cubist works.

PABLO PICASSO

Among the artists who gathered Paul Cézanne's ideas into a working theory of twentieth-century painting was Pablo Picasso (1881–1973). Picasso was born in Spain and studied at the academy in Barcelona, but he spent most of his life in France. He visited Paris in 1900 and settled there in 1904. From 1903 to 1906 Picasso made very sensitive and delicate paintings of figures and still-life compositions. This work represents the "Blue Period," the first of a number of phases or periods in Picasso's art.

Cubism, as the new form of painting was called after 1911, depends very closely upon the expressive way that Cézanne used color and form: painting without linear description or a static, single point of reference. Cézanne described his own work as an attempt to treat nature in terms of the sphere, cylinder, and cone—simple geometric solids. This clear element of Cézanne's art combined with the unnaturalistic approach to form, to be seen in African sculpture, to establish the roots of Cubism as Picasso and Georges Braque (1882–1963) were to develop it.

Demoiselles d'Avignon. Picasso's painting called the *Demoiselles d'Avignon*, in the Museum of Modern Art in New York City, was made in 1907. This is the painting that began the Cubists' approach to art. It marks a reversal from Picasso's Blue Period painting as well as a challenge to established norms in art.

The Demoiselles d'Avignon is not an easy picture. It shows five figures of women, nude or mostly so, painted as slabs of color. They are more or less broken into segments, as is the background with its variously colored shards of blue, brown, and greenish-gray. A still life of grapes, pears, and a melon slice is at the lower right. Everything is flat on the canvas. It is our own wit that pushes or pulls the surfaces into a semblance of depth and order.

Avignon is the name of a street in a disreputable district of Barcelona. Its *demoiselles* are prostitutes. Such women had posed for Degas, Toulouse-Lautrec, and many other artists at the end of the nineteenth century. It is clear that Picasso is not making a judgment or particular social comment with his canvas. Instead he is challenging vision by recreating it. Just from looking at the faces of these women we see negations of logical appearance, multiple viewpoints, and forms that deny logic.

Three of the faces appear in coloristic planes that read as if based upon African tribal masks. The other two have been seen to relate to native Iberian sculptural forms. These sources were clearly on Picasso's mind at the time, and his use of them here, if startling, is in accord with the disorientation of the torsos and limbs of the figures as well. We see them out of perspective and from more than one angle at once.

Cubism developed after this work. It was the creation of Picasso and Braque working together. At one point they claimed not to be able to tell their works apart. From still recognizable landscapes and nude studies, they went on to more and more intensive fragmentation of planes, forms, and colors.

GEORGES BRAQUE

Not often do two artists collaborate so closely on the invention of a style as did Braque and Picasso working at the beginning of Cubism. Braque had settled in Paris in 1900. Through Dufy he knew and admired the Fauves, but in 1907 he was profoundly impressed at the memorial exhibition for Cézanne. Shortly thereafter he met Picasso. During the period immeidately after that they worked together.

Houses and Trees. Braque's painting *Houses and Trees* in the Kunstmuseum, Berne, painted in 1908, characterizes the beginnings of the movement. Braque painted the simple cubic forms of houses in orange, overlapping one another in limited perspectival relationship. In the foreground and middleground are tree trunks; additional tree foliage is indicated by irregular patches of green outlining some of the roofs. Color intensities are built up to the edges of individual planes.

From 1908 to 1910 the two artists worked at the reduction of forms to surface planes on the canvas. From 1909 until 1912 they developed *Analytical Cubism*, as Cubist Juan Gris would call it. They fragmented the forms still further, added occasional lettering, and painted in colors, mostly earth colors and gray, still further reduced. In 1912 Picasso and Braque added *collage* (pasted-on materials) to the paintings they were doing. Picasso went further, gluing and fabricating sculpture of wood, sheet metal, wire, and other materials into Cubist sculptures, mostly still designed as wall-mounted versions of his painted subjects.

After 1912, the Cubist works of Picasso and Braque changed to the development of color and simplified form in *Synthetic Cubism,* which is often clearer in subject matter and lighter in spirit. Synthetic Cubism uses overlaid planes of color. The details of the subject—hands, faces, and objects—can be seen more readily.

In 1914, Braque was called up in World War I. The two artists did not collaborate afterward. Braque continued to paint still-life compositions in a balanced color pattern after 1917, when he was discharged from the army.

Three Musicians. Picasso's painting *Three Musicians,* in the Museum of Modern Art in New York City, painted in 1924, is a good example of Synthetic Cubism. It clearly depicts three figures seated at a table. Two hold instruments; the other holds sheet music. They include a clown, a harlequin, and a monk.

A large number of artists, attracted to the insights of Cubism, began their own researches and expression in this movement. Juan Gris (1887–1917), a Spanish painter who trained in Madrid and settled in Paris in 1906, began painting Cubist paintings in 1912. Robert Delaunay (1885–1941), his wife Sonia Delaunay-Terk (1885–1974), Fernand Léger (1881–1955), Marcel Duchamp (1884–1968), Frantisek Kupka (1871–1957), and Francis Picabia (1879–1953) all devised a form of Cubism, called *Orphic Cubism,* in which the forms no longer are of definable subjects but consist of similar broken planes of nonrepresentational color.

Futurism

From 1908 to 1916 the artists in the Italian Futurist movement, which began as a literary movement in Milan, produced art and manifestos about art that developed international impact. The Futurists saw inspiration in the pace of modern life; they revered the automobile. A racing car "that seems to run like a machine gun is more beautiful than the Victory of Samothrace," said the poet Emilio Marinetti, founder of the movement.

GIACOMO BALLA

Giacomo Balla (1871–1958) was one of the original signers of the Manifesto of Futurist Painting in 1910. The Futurist objective was to portray machines and figures in motion.

Dog on a Leash. Balla's painting *Dog on a Leash* is one of the most appealing of the Futurists' works. It shows a tiny dachshund; his legs, tail, and ears appear in multiple exposures, suggesting his rapid pace in time with the fast-moving feet of his owner. The leash vibrates in response to their movements.

UMBERTO BOCCIONE

Umberto Boccione (1882–1916) was a painter and sculptor. He was a strong leader among the Futurists. He wrote a book about the Futurist movement in 1914. Boccione died in World War I, and it is very likely that this loss cost the movement its momentum.

Unique Forms of Continuity in Space. Boccione's masterpiece is a sculpture called *Unique Forms of Continuity in Space*, made in 1913. The work is in the Tate Gallery in London; versions are also in the Museum of Modern Art, New York City, and elsewhere.

A striding figure is the subject of Boccione's work. Detail is subsumed in planes and curved spatial surfaces. The strong parallel with Cubist work appears here, though the influence is disclaimed. Here it is motion and light that disintegrate the materiality of bodies, rather than the analysis of form.

RAYMOND DUCHAMP-VILLON

Raymond Duchamp-Villon was a sculptor influenced by both the Cubist and Futurist movements in art. He was the brother of Marcel Duchamp and Jacques Villon. The most important works in this combination of styles were Duchamp-Villon's series of sculptures of horses. These show relationship to the Cubists, it is true, but the strong suggestion of power and movement in them relates implicitly to Boccione's sculpture as well.

Constructivism and Suprematism

Additional movements that relate to the development of the Cubists and the Futurists are to be found outside France and Italy. In Russia, two interrelated movements that can be traced to these are the Constructivists and Suprematists. A number of young and eventually influential artists came into contact with these movements prior to the Russian Revolution and subsequent suppression of modern art after 1920. Many of them left to find significant places in the art of modern Europe.

VLADIMIR TATLIN

Vladimir Tatlin (1885–1953) was a Russian painter. In 1913 he turned to sculpture after visiting Picasso in Paris and learning of sculptural developments in Synthetic Cubism. He founded Constructivism, a sculptural movement which evolved from collage. For a period, the sculptor Naum Gabo (1890–1977) and his brother, the painter and sculptor Antoine Pevsner (1886–1962), worked as Constructivists with Tatlin and exhibited in the Constructivist exhibition. Tatlin chose to remain in Russia after 1921,

working on stage sets and theatrical design. Pevsner and Gabo, along with such artists as Marc Chagall and El Lissitsky, elected to leave Russia in order to keep working in art.

Monument to the Third International. The monument for which Tatlin is remembered is a work of sculptural architecture, designed in 1919 and 1920 but never built except as a model. The *Monument to the Third International* was to have been some 1,300 feet (396 m) high. It was a canted, double-spiral, tapering, openwork structure. Suspended within its framework were to have been revolving office and conference chambers.

KASIMIR MALEVICH

Suprematism was the invention of the Russian painter Kasimir Malevich (1878–1935). A step beyond Cubism, Malevich's Suprematism led to abstract painting of geometrical shapes on a prepared surface with limited colors.

White on White. The painting *White on White,* of 1918, in the Museum of Modern Art in New York City, is an extreme example of Suprematism. It consists of a white square painted on a white canvas.

Neoplasticism and De Stijl

Neoplasticism was a theory of art propounded by Piet Mondrian. An outgrowth of Cubism, Neoplasticism limited the work of art to horizontal and vertical lines and rectangular shapes in primary colors (red, blue, yellow), black, and white.

PIET MONDRIAN

Piet Mondrian (1872–1944) was a Dutch painter who had studied in Amsterdam and worked in landscape painting and various Post-Impressionist styles until 1909, when he moved to Paris and became conscious of Cubist painting. He returned to Holland in 1914. There he set forth the concept of Neoplasticism and created a series of *Compositions* using the limitations of his concept.

With his pupil Theo van Doesburg, Mondrian was part of a larger movement named *De Stijl.* Van Doesburg founded and edited the group's journal of the same name. Many artists, including architects and sculptors as well as painters, were attached to De Stijl. Its influence, too, extended to the Bauhaus.

Dada Art

Dada was an artistic movement that began in Zurich during World War I. Its original members were an international group of poets and artists who had come to Switzerland to escape the war. Their movement was frequently nihilistic in its outspoken aims. These were: to protest the war and the society that created it; to make meaningless works as a reflection of meaningless society; and to reject everything, including Dada.

Tristan Tzara, a Romanian poet and playwright, was founder of the group, edited its periodical, and wrote about the movement. The Dada artists of most note were Francis Picabia (1879–1953), who had been an Orphic Cubist and later would join the Surrealists; Kurt Schwitters, a German who had begun as a Cubist and founded Dada in Hanover, Germany; and Hans Arp (1888–1966). Arp, from Alsace, began in Der Blaue Reiter Expressionist group and later exhibited with the Surrealists.

MARCEL DUCHAMP

Marcel Duchamp (1887–1968), who had preceded the Dada group in many of its outrageous formal approaches to art, worked in the United States, where he settled permanently in 1913. He and Picabia led the American Dada and Surrealist movements during and after World War I.

Nude Descending a Staircase. In 1913, the major Paris-centered art movements of the modern artists were exhibited in a controversial exhibition, the Armory Show, in New York City. Duchamp's painting *Nude Descending a Staircase, No. 2* became the most controversial work in the show.

The painting is now in the Philadelphia Museum of Art. It is a Futurist-Cubist work, combining influences in a similar manner to Duchamp's brother's sculpture. The work emerges out of sequential photography, shifting emphasis to the linear progress of motion rather than the description of forms.

Ready-Mades. While Duchamp was a painter by training and first production, it is difficult to classify his art. In the Dada mode he set up found objects as works of art. An ordinary snow shovel became a work called *In Advance of a Broken Arm.* An industrially cast porcelain urinal turned on its back became a work called *Fountain.* It was signed "R. Mutt, 1917." (*Armut*, in German, means "poverty," or "destitution." Duchamp was particularly fond of puns and wordplay.)

The Bride Stripped Bare by Her Bachelors, Even. The most enigmatic of Duchamp's works is *The Bride Stripped Bare by Her Bachelors, Even* called the Large Glass and made between 1915 and 1923. It was accidentally broken in 1927, completing it, in Duchamp's terms. It is in the Philadelphia Museum of Art. The Large Glass is a work in two sections, each of paint, wire foil, dust, and varnish between two sheets of glass. The upper section represents the bride undressing; the lower, seven bachelors variously attracted and repulsed by the bride.

Many notes on the picture made by Duchamp have been preserved and many interpretations published by modern scholars. The material of the Large Glass is transparent; its meaning still seems opaque.

Surrealism

A descendant of the Dada movement was Surrealism. The Surrealist leader was a poet, André Breton, who had been a psychiatrist. His recognition of Freud was an important aspect of the interpretable meaning in

Surrealist art. In parallel with Dada, Surrealism began as a literary movement, but the works of its painters and sculptors have become far better known. We can suggest that painting became the chief vehicle of Surrealism, because the images of dreams are more powerful than verbal descriptions of them. Dreams, chance images, and controlled accidents are the materials of Surrealism.

The term *Surrealism* was coined by the French poet Apollinaire in 1917 for the work of several artists, including Marc Chagall and Giorgio de Chirico. Chagall never belonged, though, to the group organized in 1924 by André Breton. The Surrealists included Hans Arp, Max Ernst, Salvador Dali, and Joan Miró.

MAX ERNST

Max Ernst (1891–1976) was a German painter. After World War I, when Arp founded Dada in Cologne, Ernst developed a style using found objects with painted images and giving them strange titles. He made "collage novels," series of images with nineteenth-century book illustrations cut up and recombined into the imagery of fantasy. His first, called *La femme 100 têtes,* was assembled in 1929.

JOAN MIRÓ

Joan Miró (1893–1983) was a Spanish artist who settled in Paris in 1920. In the 1920s he associated and exhibited with the Surrealists using bright colors and calligraphic forms.

SALVADOR DALI

Salvador Dali (1904–1989) was also Spanish. He is the best known of all the Surrealists, largely through his own efforts at self-promotion. Dali termed his works "hand-painted dream photographs."

The Persistence of Memory. The painting called *The Persistence of Memory* is, indeed, a persistently remembered image. It shows a bleak landscape with distant sea, cliffs, and sky. In the foreground a dead tree, a shelving cliff, and a collapsed organic form support pocket watches. One watch is closed and covered with ants. The others are draped in melted or limp and drooping fashion over the few features of the foreground space.

RENÉ MAGRITTE

The Belgian painter René Magritte (1898–1967) lived in Paris from 1927 to 1930 and there came in contact with the Surrealists. He painted with a clarity similar to that of Dali, using various apparent optical illusions and comic juxtapositions in his works.

Late Pablo Picasso

Pablo Picasso painted in many inventive ways after the periods of Analytic and Synthetic Cubism. He became something of a symbol of twentieth-century artists and modern movements. As he progressed he worked themes from many art traditions into his own compositions. Picasso worked in many media. His sculpture, graphic arts, and ceramics reflect a quality of expression that is no less significant than his paintings.

Guernica. In 1937, Picasso painted *Guernica* for the pavilion of the Spanish Republic at the Paris International Exposition. It represents his reaction to the Spanish Civil War by selection of a particularly violent and horrifying event, the saturation bombing of a defenseless city, Guernica, in northern Spain. He does not show the specific event; rather, the painting draws upon the symbolism and expression of grief in war common to humankind and particularly apropos to the twentieth century.

TWENTIETH-CENTURY EUROPEAN SCULPTURE

The twentieth century has been an important one for sculptors working with new vigor, and particularly with new materials. Auguste Rodin is the most important antecedent for this development. It is also important to note that Daumier, Renoir, and Degas made sculpture as well as paintings and prints.

Matisse and Picasso were both accomplished sculptors, and most of the early groups and movements of this century included sculptors in their number. Among the Cubists, Alexander Archipenko (1887–1964), a Russian living in Paris since 1908, and Jacques Lipchitz (1891–1973), of Lithuanian birth, who settled in Paris in 1909 and in New York from 1941, deserve acknowledgment for their contributions.

Accomplished Sculptors with Individualistic Styles

ARISTIDE MAILLOL

Aristide Maillol (1861–1944) began working as a painter with the Nabis in the early 1890s. He turned to sculpture almost exclusively after 1897. Maillol also made woodcut illustrations for several books.

His sculpture was influenced by Rodin, though Maillol's work has a strong Classical form. This can be contrasted to the romanticism and sensuality of Rodin's sculpture. Maillol's work in sculpture is almost entirely of female nude figures. While he applied names to his works, they seldom if ever are referential to the particular pose, form, or nature of the sculpture itself.

Mediterranean. *Mediterranean*, made about 1901, is a bronze statue of a figure seated on the ground. It is presently in the Museum of Modern Art in New York City. The head-in-hand pose is solemn and pensive. The other hand props up the figure, expressing weight. The forms are strong and simple.

CONSTANTIN BRANCUSI

The Romanian sculptor Constantin Brancusi (1876–1957) studied sculpture in Bucharest after learning carpentry and stonemasonry. In 1904 he settled in Paris. Rodin exerted an early influence on Brancusi's work, but the artist evolved primarily into a student of pure form. Some of his works are highly polished, suggesting motion and speed; others are rough carvings in wood, suggesting primitive and folk arts. Brancusi is not associated with any specific early twentieth-century modern groups; indeed, his sculpture is important for all of them. He has had a profound effect upon succeeding generations of sculptors.

The Kiss. The simple block figures embracing in Brancusi's sculpture called *The Kiss* represent the sculptor's ability to reduce form to a few details. The first version of *The Kiss* was made in 1909 and appears on a tomb in Montparnasse Cemetery in Paris. It is a stone sculpture. A second version, of 1912, is now in the Philadelphia Museum of Art. Both exhibit the artist's interest in "primitive" art, or art from other than the European tradition, parallel to Picasso's interest in African and Iberian sculpture.

Bird in Space. Brancusi's *Bird in Space*, of 1928, exists in several versions. The sculpture is intended to represent the flight rather than the form of a bird, reduced to direction and airstream and streamlined to utmost simplicity. This abstraction of form can be related to Futurist ideas about motion.

HENRY MOORE

Henry Moore (1898–1986) was a British sculptor profoundly influenced by both Rodin and Brancusi. He worked mostly in stone with a recurrent theme of reclining figures. Moore's extraordinary work sometimes extends to the use of two separate carved blocks to express a single figure. Set separately side by side, the blocks are given their integrity by the interactive relationship of their forms.

BARBARA HEPWORTH

Barbara Hepworth (1903–1975) worked in association with Henry Moore in the early 1930s. Her sculpture also is powerful in its formal shapes, frequently in stone. Later she worked in wood and occasionally added string or wire refinements to the larger forms.

ALBERTO GIACOMETTI

Alberto Giacometti (1901–1966) was a Swiss sculptor whose work is the exact opposite of that of Moore and Hepworth. Giacometti's figures are little but sketched lines. There seems to be no serenity, no interplay in his figures with their land and space nor with each other when placed in groups.

The twentieth century cannot be characterized by any single direction or force in the fine arts. It began and continued with movements and groups of artists working in greater or lesser proximity to one another, seeking an aspect of visual expression that often led to group exhibitions, interaction, and sometimes very specialized forms of expression.

Art has become very much harder to define in all of the directions and movements associated with it. Among the most difficult for an audience to comprehend has been the emergence of nonobjective, or abstract, art and movements in which art seems to work against itself in various ways. With the development of intellectual movements of twentieth-century art it is not uncommon for a public to feel disenfranchised from the work that artists do. That has not been uncommon in any century.

Selected Readings

Arnason, H. H. *History of Modern Art: Painting Sculpture and Architecture*. 2d. ed. Englewood Cliffs, NJ: Prentice-Hall, 1977.

Breton, A. *Surrealism and Painting*. New York: Harper & Row, 1972.

Elsen, A. *Origins of Modern Sculpture*. New York: Braziller, 1974.

Hamilton, G. H. *Painting and Sculpture in Europe:1880–1940*. 3d ed. Baltimore: Penguin, 1981.

Hunter, S. *Modern French Painting: 1855–1956*. New York: Dell, 1956.

Martin, M. *Futurist Art and Theory*. Oxford: Clarendon, 1968.

Rosenblum, R. *Cubism and Twentieth-Century Art*. New York: Abrams, 1976.

Russell, J. *The Meanings of Modern Art*. New York: Museum of Modern Art/Thames and Hudson, 1981.

Vogt, P. *Expressionism: German Painting, 1905–1920*. New York: Abrams, 1980.

26

Twentieth-Century American Painting, Sculpture, and Architecture

1908 Exhibition "Eight American Painters"

1913 Armory Show

1917 The United States enters World War I

1929 The Great Depression begins (U.S.A.)

1941 The United States enters World War II

1969 First lunar landing

During the twentieth century the center of world art became New York City. Paris, which had seen the birth of most modern movements in art, has remained a vigorous center of European art and the focal point of additional movements, but the tension and strain of two European wars took a great toll upon the energies and material resources of all participants. A large number of the artists of the early years of the twentieth century moved to the United States.

American artists who studied with Eakins and came to know the works of Homer, Sargent, and Ryder also traveled in Europe. Their experience appears in particular adaptations of European modern movements. There is an original vigor and a perceptible candor in the works of twentieth-century Ameri-

can art as it comes into its own. In many instances the roots in Europe are obvious, but no longer are they the primary motivation. The catalyst for American art and the modern movements was the Armory Show, held in New York in 1913. It included painting and sculpture by European and American artists.

The Armory Show had been preceded by an exhibition of 1908 called "Eight American Painters." It was held at the New York Gallery of William Macbeth. Macbeth was a friend of the American painter Arthur B. Davies, whom he asked to assemble an exhibition of the work of good American contemporary painters. The Eight, as they were known henceforth, were Robert Henri, John Sloan, George Luks, William Glackens, Everett Shinn, Ernest Lawson, Maurice Prendergast, and Davies. Henri, Sloan, Luks, Glackens, and Shinn had all studied at the Pennsylvania Academy of Fine Arts. Critics and the press scorned the exhibition, calling it an anti-American plot. The painters were dubbed the Ashcan School; but paintings were sold, and the entire exhibition was borrowed by the Pennsylvania Academy.

The Association of American Painters and Sculptors, born from the exhibition of the Eight, decided to mount a show that would present contemporary European and American art to the public. Davies, its president, aided by Walt Kuhn, Walter Pach, and Alfred Maurer, assembled the exhibition at the 69th Infantry Regiment Armory on Lexington Avenue in New York City. After New York it was shown in Chicago, and part of it was exhibited in Boston.

The Armory Show also raised a great critical storm. But through it the segment of the American public that was concerned with art learned of Monet and the Impressionists; Cézanne, Gauguin, and other Post-Impressionists; Matisse, the Fauves, and other Expressionists; Picasso, Braque, and the Cubists; as well as the sculptors Rodin, Maillol, and Brancusi. In all, about 1600 works were seen by 70,000 people, who paid admission. A critical whirlwind raged around Marcel Duchamp's Nude Descending a Staircase, No 2. *But it sold to a California dealer for a few hundred dollars, and Duchamp himself settled in America in the same year.*

TWENTIETH-CENTURY AMERICAN PAINTING

The Eight never exhibited as a group after their exhibition in 1908. The initiative unleashed on the public by the Armory Show revealed a far more powerful current of artistic expression than theirs. A New York resource for it, little noticed until after the Armory Show, was the gallery "291," run by the photographer, promoter, and defender of artists Alfred Stieglitz from 1905 to 1924.

Stieglitz exhibited works of Alfred Maurer, Max Weber, Marsden Hartley, Arthur Dove, John Marin, Charles Demuth, and Georgia O'Keeffe. Also he obtained Rodin watercolors, Picasso paintings and prints, sculpture by Brancusi, and African tribal sculpture.

The American knowledge of modern art grew, and American art took new vigor from the exposure to European movements afforded by the Armory Show and Stieglitz's gallery. American artists gained new challenges and viewpoints by traveling to the European centers represented by these artists.



American Painting During and After World War I



JOSEPH STELLA

Joseph Stella (1877–1946) was born in Italy and traveled there when young. As an artist he was closely associated with the Futurists, and his paintings of 1910 to 1923, with American subjects the Brooklyn Bridge and Coney Island, are as energetic as the works of Giacomo Balla and Umberto Boccioni. They, too, are of great importance to the growth of modern art in America.

Brooklyn Bridge. Joseph Stella's painting *Brooklyn Bridge*, painted in 1917, now in the Yale University Art Gallery, is a good example of his Futurist contact. It represents a play of lights, cables, and girders within the city and paired arches of the bridge in distant, prismatic, fragmented sections. A high horizon is indicated, and we seem to look down on traffic below as if suspended high over the roadway.

MARSDEN HARTLEY

Marsden Hartley (1887–1943) was one of the artists supported by Stieglitz in the early days of American modernism. Hartley traveled extensively, published poetry, and was invited to exhibit in Germany with Der Blaue Reiter Expressionist group. His Expressionism is drawn, at least in part, from Kandinsky.

Portrait of a German Officer. Hartley's *Portrait of a German Officer*, in the Metropolitan Museum of Art in New York City, was painted in 1914. It expresses the militarism of Germany at the outset of World War I as well as Hartley's association with the Munich Expressionists. The painting is an abstract group of shapes and insignia in bright colors. They suggest parade-ground uniforms.

GEORGIA O'KEEFFE

Georgia O'Keeffe (1887–1986), working in the 1920s and after, made large graceful paintings of flowers, skulls, and desert landscapes. With O'Keeffe the extreme close-up and emphasis on natural symmetry make ordinary objects extraordinary and impart a sense of abstraction to them. O'Keeffe also made a few paintings that are entirely abstract.

Black Iris. *Black Iris*, in the Metropolitan Museum of Art in New York City, represents the interior, unfolded center of the blossom. It is magnified as a detail, an abstract layering of the rhythmic, curved folds of its petals. There is a cool yet deliberate sexuality about the design and an assertive confidence that places O'Keeffe among the leading artists of the twentieth century.

JOHN MARIN

For a period in the 1920s, John Marin (1872–1953) was the dominant modern American artist. At first an architect, Marin studied at the Pennsylvania Academy and traveled extensively in Europe between 1905 and 1910. He was primarily a watercolorist on returning to the United States. He also worked extensively in printmaking, influenced by James Abbott McNeill Whistler.

CHARLES DEMUTH

O'Keeffe, Marin, and Charles Demuth (1883–1935) represent the three major Americans to emerge during the period just after World War I with an art that is as distinctly fresh and American as it is a vital extension of the emergence of modernism in Europe. Demuth was also in the Stieglitz group, and he was aware of Cubism and Futurism.

I Saw the Figure Five in Gold. *I Saw the Figure Five in Gold* is Demuth's most famous painting, combining, as it does, the imagery of a poem by his friend William Carlos Williams and the Cubism and Futurism he knew through Duchamp and Stella. Its blazons of light, its gold and red colors, and its details are evocative of a speeding fire truck, the subject of Williams's poem.

Demuth later developed a style of painting called Precisionism which included urban and industrial scenes, especially in connection with Lancaster, Pennsylvania.

EDWARD HOPPER

Edward Hopper (1882–1967) is the leader among painters known as the American realists. Others include Charles Sheeler and Charles Burchfield. Hopper is a master of the everyday city view, whether it is the façade of a row of shops as in *Early Sunday Morning*, in the Whitney Museum of American Art in New York City, or the lonely figure of a woman looking out the window of her hotel room in *Eleven A.M.*, in the Hirschhorn Museum, in Washington, D.C.

American Art in the Depression Years

The crash of the stock market in 1929 affected every aspect of American life. Artists, who depend upon patronage from an educated and wealthy society, were as much affected as any other group of workers. This was recognized in the government's attempts to re-establish an economically

viable life for victims of the Great Depression. A Public Works of Art Project set out in 1933 to give relief to the unemployed artists and to provide works of art to enhance public buildings. By 1935 this was reorganized within the Works Progress Administration (WPA) as the Federal Arts Project.

American Painting After World War II

The art of the early postwar period, the late 1940s and 1950s, was dominated in America by Abstract Expressionism, an art form that based itself on many aspects of the modern movement of the first part of the century. Abstract art had appeared in Kandinsky's work in the Expressionist movement in Germany as well as in André Malevich's Suprematism and Piet Mondrian's Neoplasticism.

American Abstract Expressionism also depended to a degree upon automatic painting—allowing the subconscious to guide the hand, an idea that is rooted in Dada and Surrealist art and in the Freudian psychology behind them.

JACKSON POLLOCK

Jackson Pollock (1912–1956) was the major Abstract Expressionist, an exponent of Action Painting, in which the paint was poured or dripped onto the canvas in what appeared to be random patterns. While this has been likened to Native American sand paintings that Pollock saw in his youth in the American Southwest, the results are an infinitely more evocative and powerful collection of images.

Autumnal Rhythm: Number 30, 1950. The color choices and the sense of rhythm and depth are strong in Pollock's *Autumnal Rhythm: Number 30, 1950,* in the Metropolitan Museum of Art in New York City. Here, black and white combine with a buff sand color. The complex linear patterns have been compared to calligraphy, but there is also a sense of depth in the work as the colors overlap or intertwine.

WILLEM DE KOONING

Willem de Kooning is also an Abstract Expressionist painter. De Kooning was born in Holland in 1904. His work is not completely abstract. Figural images, though much altered and painted with great powerful strokes, are retained in the canvases. His best-known works are a series of paintings of women, done in the early 1950s.

Woman I. The first of De Kooning's series, *Woman I*, is in the Museum of Modern Art in New York City. It is painted with harsh slashes of brush stroke on the surface. Rough drawing evokes the figure of a seated woman, yet no element is refined or drawn with description in mind. The power of the work is carried by the lines and the planes they isolate rather than by the accumulation of forms.

MARK ROTHKO AND COLOR FIELD PAINTING

Mark Rothko (1903–1970) was born in Russia. In America he studied art early on with Max Weber, a former pupil of Matisse and a Fauve painter. Rothko also interested himself in Surrealism and took part in the WPA projects of the 1930s. After 1948 he developed his own form of Abstract Expressionism in large paintings of horizontal color rectangles, soft-edged and merging to a continuous background color. Rothko's art is not as agitated as that of Pollock and De Kooning. Rather than Action Painting it is often called Color Field Painting. Others working in this idiom included Helen Frankenthaler and Morris Louis. Frankenthaler and Louis used dyes and other means to eliminate brush strokes completely from the "color fields" of their work.

BARNETT NEWMAN, ELLSWORTH KELLY, AND HARD-EDGE PAINTING

Barnett Newman, born in 1905, Ellsworth Kelly, born in 1923, and others among the Abstract painters used single strong colors divided from each other in varying shapes to express purity of color and the experience of its advance and recession. Frank Stella, born in 1936, added the feature of shaped canvas, no longer quadrilateral, to the interaction of colors in his works.

POP ART

The incredible changes in the world's pace have increasingly intrigued artists in the twentieth century. American television, interspersing world news or attempts at serious drama with quickly delivered commercial interruptions with visual emphasis, has affected all of our experience. Reaction to this in artists' terms came with a movement called Pop Art in which such a culture was reviewed with humor and critical wit.

Serious studies in visual imagery with no more purpose in mind than to create memorable labels for cans and boxes invoke serious questions about art. Artists including Andy Warhol, Jasper Johns, and Roy Lichtenstein joined in the creation of intellectual parody of this apparent inroad into their own realm.

TWENTIETH-CENTURY AMERICAN SCULPTURE

While the Armory Show in New York City and Alfred Stieglitz's gallery "291" included sculpture from the developing Cubists and other movements in Europe, it took longer for the art of sculpture to emerge in the American twentieth century. Gaston Lachaise (1882–1935) worked first in his native France as an Art Nouveau jewelry designer. In the United States, after 1906,

he gained fame as a sculptor of large studies of the female nude. Elie Nadelman (1882–1946) was a Polish-born sculptor who emigrated to the United States in 1914. His sculptures of dancers and circus performers were done in a humorous, naive style. Joseph Cornell (1903–1972), born in New York state, was self-taught as a sculpture and assemblage artist. He was influenced by the Surrealists, particularly by Max Ernst. Cornell is best known for his boxes made in the 1940s to the 1960s with bits of mirrors and everyday objects arranged in them.

Major American Sculptors in the Second Half-Century

ALEXANDER CALDER

Alexander Calder (1898–1976) is the American sculptor who invented the mobile (name given by Marcel Duchamp). From a family of artists—his mother was a painter, his father and grandfather were sculptors—Calder trained as an engineer but later became the leading twentieth-century sculptor of welded metal. He first exhibited his mobiles in 1932; these served as prototypes for both American and European kinetic art. A mobile is made up of small colored solids cut into irregular shapes with curved edges, joined by wire and moved by cranks, an electric motor, or the wind. An important example called *A Universe* (1934) is at the Museum of Modern Art in New York City. He received commissions to make works for most major public building complexes in large American and European cities, including both mobiles and stabiles (name given by Hans Arp), Calder's stationary, often large, sheet-metal sculptures. One of his stabiles, at the Museum of Modern Art, is called *The Whale* (1937).

Calder's ingenious works have a whimsical character, displaying his childlike sense of humor and play. He was a pioneer in exploiting chance and the interesting relationships of forms moving in space—crucial elements in much modern sculpture. Calder's mobiles depart radically from the traditionally still, solid forms of representational sculpture. They are non-representational, composed only of delicately balanced flat shapes and thin lines in slowly changing positions.

DAVID SMITH

David Smith (1906–1965) studied at the Art Students' League after working in factories that assembled metal parts. In 1938 he worked on the WPA Federal Art Project. In the 1940s Smith began making welded constructions of steel wire and rods that were linear and witty, similar in tenor to Calder's early work. An example is *Hudson River Landscape* (1951), at the Whitney Museum of American Art in New York City. In the 1950s, however, he also created Expressionist works modeled after the human figure, some with violent themes. Smith's early work was often highly symbolic and dramatic, appropriately called "social Surrealist," or anecdotal, incorporating machine-made objects in rhythmic silhouettes.

Smith changed his style again in the 1960s, building the *Cubi* series for which he is most well known. These are monumental, geometric volumes, arranged in tangent to one another, forming dynamic three-dimensional compositions. The stainless steel medium, the factory-polished surfaces, and the paradoxically buoyant arrangement of the *Cubis* make Smith's sculptures thoroughly modern expressions of the machine age. He wrote that steel "possesses little art history. What associations it possesses are those of this century: power, structure, movement, progress, suspension, destruction, brutality." Smith's early Surrealist motives changed in favor of Constructivist formal concerns.

LOUISE NEVELSON

Working with wood, Louise Nevelson (1900–1988) combined small pieces of furniture, tools, containers, and architecture into reconstructions of dense visual complexity. Painted black, gold, or white, a Nevelson assemblage has a rich texture of varied surfaces and shapes within an overall scheme of interconnected shallow boxes. Each box has a distinct design of shapes that is linked to the other boxes by the single-color surface and by Nevelson's finesse in composing shapes, contours, and lines. Many of her sculptures look like massed cases on a collector's wall, cases holding odd bits of the everyday world in a new, extraordinary montage. Nevelson is called an environmental sculptor, one who takes things she finds around her and assembles them into intricate patterns.

Nevelson's importance lies in her elegant sense of pattern and in the discovery of the effects of light and shadow as integrated components in the sculpture itself. She also founded a school of "relief" sculpture for the modern modes of assemblage and construction techniques. An often reproduced work is *An American Tribute to the British People* (1960–1965), in the Tate Gallery, London, a grand wooden "door" that is 10 feet high and 14 feet wide and painted a brilliant gold.

GEORGE SEGAL

Sculptures that are casts of live figures in plaster are the trademark of George Segal, born in 1924. The plaster is left rough. Segal's iconography often describes all too modern themes: alienation and the lonely existence of many people. In *Bus Riders* (1964), in the Joseph H. Hirshhorn Collection, he literally re-creates a dehumanized group of commuters. *The Execution* (1967) is a chilling drama of torture and death in an unnamed third-world nation. Segal's unseeing people are alarmingly expressive, eerie mirrors of the world around us. Although just shells, hollow casts of actual people, these sculptural groups are still art. The poses and blurred expressions are chosen by Segal to communicate his unique vision, and they have proven to be profoundly evocative.

CLAES OLDENBURG

Unlike Segal, Claes Oldenburg (born 1929) takes commonplace objects and re-forms them into images of humor and satire rather than evocations of numbing pain. Some feature of the object is exaggerated, usually enlarged, or it is made out of odd materials. Oldenburg's early works were daily amenities made soft: a drooping toilet, a mushy typewriter, a flexible telephone. His later "monuments for today" are colossal enlargements: an enormous plastic ice cream cone, a couch-sized cloth hamburger, condiments and all. *Giant Icebag* (1971) is made out of vinyl and is fitted with a hydraulic lift that expands the bag from 7 feet to 16 feet high. Oldenburg also did a series of unexecuted designs for "appropriate" monuments in large cities. For example, he outlined a project to attach huge toilet-tank floats to the London Tower Bridge that would rise and fall with the tides. This controversial realm of conceptual art—art that is only manifest in the artist's intention, in his or her gesture or fragment of an idea—is well illustrated by Oldenburg's hypothetical projects.

Oldenburg's work is generally classified as Pop Art, roughly defined as art related to objects produced and reproduced by mass, popular culture. Our unthinking, "civilized" perception of the world is shocked, forced out of focus, by sharp incongruity and confusing displacement. Oldenburg's monumental *Lipstick* (Yale University, 1969, steel, aluminum, and paint, 24 feet high) and *Clothespin* (Philadelphia, 1976, steel, 45 feet high) elicit a double-take on our artificial environment and lifestyle.

ROBERT SMITHSON

Minimalist Art sponsored questions about the relationship of the artwork to its immediate environment. Robert Smithson (1938–1973) responded by radically collapsing his objects with their site in what has been called Earth Art. He created art "events" by moving enormous amounts of rock and dirt into new patterns that remained in the old environment. His most well-known work is the *Spiral Jetty* (April 1970), a ridge of earth bulldozed into the Great Salt Lake, Utah, forming a 1,500-foot long arabesque in the water. An important part of this work was Smithson's film of the entire process in which he incorporated time, action, and materials into an artwork that tried to express every aspect of an artistic venture.

Smithson's work is a revolution against the previous "closure" of sculpture. He accepts no architectural boundaries, no limits of any kind. Earth Artists energetically explore the unity of the world by reshaping it physically, by experiencing the tremendous amount of effort and power this change requires.

CHRISTO

Christo Javacheff (born 1935), called Christo, took the concepts of Earth Art and experimented further with artworks that enclose, wrap, partition, or adorn the earth itself. He wrapped 1,000,000 square feet of rocky Australian coastline in plastic. He strung a *Running Fence* (1976) through the hills of northern California that was 24 miles of nylon sheeting billowing in the breeze for two weeks. Christo's art is ephemeral, lasting only as long as the materials hold up or until they must be taken down. His stated objective is to create a harmony of art with nature, using the environment as the primary medium that he merely accents for a time, calling attention to the earth's inherent artistic interest.

Like both Smithson and Oldenburg, Christo documented every phase of his large-scale undertakings. The procedures, permits, purchases, and so forth are all part of the artwork. This is especially important in Earth Art, because these "events" are not themselves meant to last but are media memories perpetuated after the fact in movies, photographs, and souvenirs.

ARCHITECTURE IN THE TWENTIETH CENTURY

As with the arts of painting and sculpture, the focus of architecture shifted to the new buildings erected in America during the twentieth century. Many architectural movements that came to fruition here began in Europe. Victor Horta (1861–1947) and Antonio Gaudí (1852–1926) are the chief European exponents of Art Nouveau, a primarily European movement best represented in America by Louis Sullivan, who added rich architectural ornament to many of his buildings. Many see Art Nouveau as most effective in that it represents a definitive break with the past architectural traditions. Future architects will look more directly to the materials, their function, and the space they enclose.

Frank Lloyd Wright and the Prairie Style

There is no doubt that the founder of modern architecture is Frank Lloyd Wright (1867–1959). Wright was a pupil of Sullivan and by 1900 had evolved a style of his own. His early work, the Robie House, in Chicago, Illinois, was built from 1907 to 1909. Its long rooflines and walls and low profile express sheltered space rather than confinement. Wright's houses of this period are called "prairie houses" for their sweeping lines. Wright has the distinction of being the first American artist to have a major effect on the history of a European art form.

The International Style

After World War I, the major movement in architecture was the International style. Its roots were the works of Frank Lloyd Wright. Among its great European masters are Charles Edouard Jeanneret-Gris (1887–1965), called Le Corbusier, a Swiss, and Ludwig Mies van der Rohe (1886–1969), who was German.

LE CORBUSIER

Le Corbusier was also a Cubist painter and an influential critic. His interests in architecture centered early on functional houses, or "machines for living," as he called them. The simplicity and spaces of Wright designs were made even more purely functional by the use of reinforced concrete slabs, combined as floors and ceilings and steel posts to support them, with walls that bear no loads to subdivide the space. Le Corbusier's masterpiece in this idiom is the Villa Savoye, built in 1929 at Poissy-sur-Seine near Paris.

LUDWIG MIES VAN DER ROHE

Ludwig Mies van der Rohe, the other master of the International style, built the German Pavilion at the Barcelona International Exhibition in 1929. Earlier he had designed a glass-walled skyscraper, though it was never built. The form was to be prophetic, however. Glass was an extensive part of the walls of the new Bauhaus structure built in Dessau when the school moved from Weimar in 1925. Walter Gropius was the architect. Mies van der Rohe was on the Bauhaus staff until both moved to the United States when the Bauhaus was closed by the Nazi government in 1937. Gropius moved to the architecture department at Harvard University, Mies van der Rohe to Chicago.

DE STIJL: GERRIT RIETVELD

The architects of the De Stijl movement who had been fascinated by Mondrian and van Doesburg's Neoplasticism were also influenced by Wright. Gerrit Rietveld (1888–1964) built the Schroeder House in Utrecht in 1924. It has been likened to a three-dimensional Mondrian painting, but its planes and overhanging roofs suggest Wright's style.

Later Wright: Organic Architecture and Falling Water

Emergent in Wright's style, however, was the aspect of "organic architecture," as he called it, which shaped itself to the landscape. Away from the flat prairies, Wright built houses with the same acute awareness of space but also interactive with the forms of nature. The best of these is the Kaufmann House, called Falling Water, at Bear Run, Pennsylvania, built between 1936 and 1939. This house is in a woodland setting over a stream with a waterfall. Its planes, projecting decks, roofs, and combinations of ashlar and concrete construction are all placed with compositional and spatial strategy to enhance both landscape and building. Wright's architecture can be seen as a

critical response to the linear and machine-age purity of the International style.

The International Style in America

As it grew more evident in the 1920s in Europe that the International style had a practicality and effectiveness about it, it followed that its use would migrate to America. The Philadelphia Savings Fund Society Building in Philadelphia is the first major American building of the International style. It was designed in 1931–1932 by George Howe and William E. Lescaze.

The style survived well after World War II in America. Two late works by Mies van der Rohe are the Lake Shore Drive Apartment Houses, in Chicago, built between 1950 and 1952, and the Seagram Building in New York City, built with Philip Johnson (American, born 1906) from 1956 to 1958.

LE CORBUSIER: NOTRE-DAME-DU-HAUT

Le Corbusier's late works of architecture are increased in sculptural forms. The most amazing is the chapel Notre-Dame-du-Haut, built at Ronchamp in France, from 1950 to 1955. Its shaped sides, roof, and bell tower and deeply recessed windows in random sizes and placement completely abandon the International style's regularity.

WRIGHT: THE GUGGENHEIM MUSEUM

Frank Lloyd Wright, too, having built many houses and other structures with a particular sensibility to the landscape, built the Solomon R. Guggenheim Museum in New York City in 1959. Beginning with a design he had started in 1943, Wright fashioned a large sculptural structure based on a spirally expanding cylinder with a continuous ramp for exhibition space.

Recent Architecture

A wide range of building styles has emerged in the late part of the twentieth century. Wright's inventive use of form in the Guggenheim Museum initiated a variety of buildings for museums that take particular care with patterns of use, light, space, and exhibition needs. Louis I. Kahn (1902–1974) was architect of the Kimball Art Museum in Fort Worth, Texas, from 1966 to 1972, using concrete vaulting systems and light filtration. In 1978, Ieoh Ming Pei (born 1917) built the skylit National Gallery addition in Washington, D.C., dramatizing an unusual triangular site plan. I. M. Pei is also the designer of the controversial Pyramid, added to The Louvre.

Recent years have brought forth a new architectural relaxation of the International style's modernism. It is called *Post-Modernism*, a term now applied more widely to the arts of the present. Architects Robert Venturi (born 1925), Denise Scott–Browne (born 1931), Charles W. Moore (born 1925), and Michael Graves (born 1934) are among those working in this idiom.

*W*e noted at the beginning of this chapter that America had taken the lead in the arts during the twentieth century. The Armory Show awakened all the potential that was already gathering force in American centers at the outset of the period. The internationalism in all the arts of this century has led to major changes. It is now commonplace for great art exhibitions to be seen in several American cities and many world capitals.

All kinds of movements at the beginning of the century were part of the developing causes of art. Expressionism, Surrealism, and various kinds of abstract art seem to have most moved American painters and sculptors. The genius of American architects set important movements in motion internationally, followed by technical innovations that enabled greater refinement. Movements of the last part of the twentieth century seem no less innovative and seem to combine media with even more imagination and willingness to join resources.

We are all of this century—participants in such an explosion of knowledge and the means to transmit it that it is important to keep our cultural wits about us. It seems important to know the answers to Gauguin's questions "Where do we come from? What are we?" even if none of us knows just "Where are we going?"

Selected Readings

Amaya, M. *Pop Art and After*. New York: Viking, 1972.

Andersen, W. *American Sculpture in Process 1930/1970*. Boston: New York Graphic Society, 1975.

Ashton, D. *American Art Since 1945*. New York: Oxford University Press, 1982.

Brown, M., S. Hunter, and J. Jacobus. *American Art: Painting, Sculpture, Architecture, the Decorative Arts, Photography*. New York: Abrams, 1979.

Goodyear, F. H., Jr. *Contemporary American Realism since 1960*. Boston: New York Graphic Society, 1981.

Hunter, S. *American Art of the Twentieth Century*. New York: Abrams, 1973.

Lippard, L. R. *Pop Art*. New York: Praeger, 1966.

Ritchie, A. C. *Abstract Painting and Sculpture in America*. New York: Arno, 1969.

Rose, B. *American Art Since 1900*. New York: Praeger, 1975.

Wilmerding, J. *American Art*. Harmondsworth: Penguin, 1976.

Glossary

Acroterium (pl. acroteria) A statue and other ornament placed above the apex and lower angles of a pediment.

Addorsed Back-to-back; used for decorative sculptural figures and heraldry.

Aisle; side aisle The spaces to either side of the nave of a church, usually separated from the nave by a colonnade. There may be one or two aisles on either side, rarely more.

Alternate (Alternating) system In architecture of the Romanesque and Early Gothic periods, a system in which the piers of the nave arcade alternate in size. Large, usually compound, piers support the groin vaults of the nave at each bay. The vaults of the side aisles, half the length of the bay, are supported by smaller, often columnar, piers at mid-point between the larger piers.

Ambulatory A covered walkway, particularly an extension of the side aisle of a basilican church around the exterior of the apse. Also, the aisle surrounding the central space of a centrally planned church and the covered walk surrounding a cloister.

Apotheosis Deification; the act of becoming a god.

Apse A semicircular, or sometimes polygonal, niche at one or both ends of a Christian church terminating the nave or choir. Apses are sometimes at the ends of side aisles, transept arms, and chapels. Characteristically they are topped by a semidome.

Arch A curved structure spanning an opening. Various shapes of arches are used in different architectural styles. Round arches using wedge-shaped blocks in a semicircle above the opening are the simplest. The individual blocks are called voussoirs.

Atmospheric perspective *See* Perspective.

Balustrade A railing supported by short pillars called balusters.

Barrel vault *See* Vault.

Basilica An ancient Roman building, large and oblong for public meeting, often with apses on either end and aisles alongside the central hall. Also, a Christian church built similarly with a central hall called a nave, side aisles, and an apse, usually at the east end when the church is on an east-west axis.

Bhakti Ritual devotion to a personalized god or goddess in Hinduism.

Bodhisattva A being who is destined to become enlightened, but who remains behind to guide others on the Buddhist path.

Breviary A Christian service book in which the prayers for the canonical hours are recorded, often in abbreviated form.

Buttress; flying buttress A support for the wall of a building, a vault, or an arch.

Campanile (Italian) The bell tower of a church.

Cassone (Italian) A large coffer or chest used as a marriage-chest, especially in the fourteenth to sixteenth centuries. Cassones frequently were decorated with panel paintings.

Catechumen A Christian convert under instruction before baptism.

Celadon Semitranslucent glaze with a greenish tinge on Chinese and Korean ceramics; a name for wares with this glaze.

Cella The walled chamber of a classical temple.

Centering Wooden framework built to shape to support an arch, vault, or dome under construction.

Chaitya A sacred object or place in India; usually refers to the stupa inside Buddhist rock-cut worship halls.

Cinerary urn A vessel (cinerarium) to hold the ashes of cremated dead.

Ciré perdu The "lost wax" technique of bronze casting; a wax model is covered with clay, the wax is melted away, and then molten bronze is poured into the clay mold to fill the space left by the melted wax.

Clerestory Windows above the roof of the side aisles opening into the hall or nave of a basilica.

Collage Picture wholly or partially made with pieces of paper or other material pasted to the surface.

Corbel A projection from the face of a wall. When a series of courses project from two opposed walls and ultimately meet, they form a corbelled vault.

Cromlech A circle of monolithic stones.

Crossing The bay of a church where the transept and nave cross one another.

Cyclopean (walls) Walls made by the ancient Hittites and Mycenaeans, among others, of immense blocks of stone. Said to have been built by ancient giants, called Cyclopes.

De sotto in su (Italian) "From below, upward"; used to describe the viewer's position relative to that of the subject matter in a work of art.

Diptych, triptych, polyptych Painting or relief-sculpture in two (diptych), three (triptych), or many (polyptych) adjoining panels.

Dolmen Prehistoric European structure formed from two upright stones supporting a horizontal slab; probably a tomb.

Dome, drum, lantern A rounded structure over an architectural support system. It is sometimes raised on a cylindrical support called a drum. Its top is occasionally open to a small, windowed turret called a lantern.

Drafting In masonry, a squared groove around the outer edges of a building stone.

Drum *See* Dome.

Elector A prince of the Holy Roman Empire entitled to take part in the choosing of the emperor.

Exegesis, exegetics Critical theological interpretation of Scriptures.

Flamboyant A style of Gothic, noted for flame-shaped tracery.

Flying buttress *See* Buttress.

Gallery 1. Building or rooms designed for the display of artworks. 2. In architecture, a second story over the side aisles of a church or over the aisle around a centrally planned structure.

Genre Art, usually painting, in which the subject matter represents everyday life.

Gopuram Monumental gateways with massive, decorated towers at the entrances of South Indian temples.

Harlequin Character from traditional comedy and pantomime, masked with a parti-colored costume.

Hemicycle A curved, approximately semicircular structure.

History painting Theoretical term (from Italian *istoria*) for the highest form of painting in the academic tradition. Paintings of classical history, mythology, or Biblical stories as representations of the passions or the intellect are accepted in this category.

Illumination; miniature Painted illustrations in manuscript books.

Impasto Thick paint applied by the artist to the surface of his painting. "Heavy" impasto shows the tracks of the brush or palette knife.

Jataka Stories about the previous lives of Shakyamuni Buddha in which he demonstrated exemplary self-sacrifice and discipline to become enlightened.

Kami Gods or spirits of the Japanese Shinto pantheon; Shinto means "way of the kami."

Lakshana Visible sign of divinity on a Hindu or Buddhist deity; identifying iconographic attributes on an image.

Lantern *See* Dome.

Lintel *See also* Post and lintel. Horizontal element spanning an opening beneath it and supporting superstructure above.

Lithography A printmaking process in which the principle of water being repelled by grease enables the inking process on stone, zinc, or aluminum for transfer to paper.

Loggia Open roofed gallery; part of a building and open on at least one side.

Lunette Semicircular architectural surface or opening.

Mahayana One of the major types of Buddhism that includes many sects which emphasize the role of the bodhisattvas as saviors; dominant form in Tibet, China, and Japan.

Mandala A complex geometric symbol of a cosmology; used ritually as a model for building temples and as the visualized or actual arena for transformative Hindu and Buddhist rituals.

Mandapa Porch or hall of an Indian temple, usually pillared; sometimes an assembly hall, sometimes a worship or dance performance area.

Mansard roof A roof with two slopes, the lower steep, the upper nearly flat. Named for the seventeenth century architect François Mansart.

Martyrion; martyrium (also martyry) A shrine to a martyr, particularly at the site of his or her martyrdom.

Memento mori An object used as a reminder of death; often a skull or skeleton.

Mihrab A niche in the Qibla wall of a mosque indicating the direction of Mecca.

Minar (minaret) Tower attached to a mosque with one or more projecting balconies from which the muezzin gives the call to prayer.

Miniature *See* Illumination.

Moslem (Muslim) A follower of Islam; literally, "one who surrenders" to God.

Narthex The entrance hall of a church. Sometimes open to the atrium on the exterior.

Nave The central aisle or main hall of a Roman basilica or Christian basilican church. It extends from the narthex to the apse or the transept.

Oculus A round opening in a wall, dome, or vault.

Odalisque (French, adapted from Turkish word for a female slave or concubine in a harem) Nude or seminude figure in an Oriental setting in painting.

Oratory Chapel for prayer.

Pagoda Buddhist tower in Nepal, China, and Japan; has multiple roofs with winged, bracketed eaves.

Pastel Dry pigment bound (held together) with gum, used in stick form for drawing.

Pendentive Inward-curved triangular vault converting a square bay to a round support for a dome.

Perspective Any system of drawing or painting on a two-dimensional surface to indicate three-dimensional depth. One-point linear perspective utilizes orthogonal lines visualized as perpendicular to the picture plane and converging at a vanishing point on the horizon. Two-point linear perspective involves two vanishing points toward which the contiguous sides of a right-angled form vanish respectively. Aerial, or atmospheric, perspective indicates depth and distance by reducing color intensity and detail in objects distant from the picture plane.

Pigment The coloring agent in paint, pastel, crayon, etc., mixed with a binder (oil, gum arabic, casein, or other) for use.

Plinth The lowest element in a base; a block used as a base for a statue.

Polyptych *See* Diptych.

Porcelain An impervious pottery made with a base of kaolin, a fine white clay; sometimes used for any translucent pottery, more properly called porcelaneous.

Porphyry Very hard, dark purplish-red rock.

Post and lintel System of construction using two or more uprights (posts) supporting a horizontal beam or beams (lintels).

Pronaos The architectural space in front of the cella (*naos*) of a Greek or Roman temple.

Qibla wall (qiblah, kibla) The wall of a mosque on the side toward Mecca that is faced during prayer. *See* Mihrab.

Quatrefoil A four-lobed decorative form in framing or tracery.

Quincunx A church with five domes, one at the center and one at each corner.

Rasa Indian term for the taste or character of an artwork, the emotion prevailing in or incited by music, painting, or sculpture.

Rayonnant Late Gothic style of architecture.

Reserved Form cut out of "living rock" in rock-cut tombs or churches.

Rustication Stone cut to appear roughed out rather than dressed.

Sacristy Room where the vestments and sacred utensils of church services are kept.

Sanctuary The location of the high altar in a church.

Sarcophagus A stone coffin, often carved or inscribed.

Shikhara In North India, the entire curved tower over the sanctum of a temple; in South India, the uppermost domed portion of the tower over the sanctum of a temple.

Side aisle *See* Aisle.

Squinch One of a series of vaulted arches used to convert the square bay of a structure to a round support for a dome. Alternate method to the use of pendentives.

Stele Stone marker of grave or commemorative site used in ancient Near East and in Greece, particularly.

Still life Paintings of inanimate objects, flowers, fruit, tabletop arrangements, etc.

Stupa A funerary mound honoring the Buddha or Buddhist saints and priests; has a distinctive shape in each region of Asia.

Terra cotta Italian word for baked earth that has become hard and compact; used for figures and architectural ornaments.

Torana Gateway or door frame in an Indian temple complex.

Torii Gateway to a Japanese Shinto temple complex.

Trabeated Constructed on the basis of a post-and-lintel system.

Tracery Ornamental and branching stonework in Gothic windows, usually supporting glass panes or stained glass panels.

Transept The lateral passage forming the cross arms of a Christian church, usually separating the nave from the choir and apse.

Triforium A blind gallery of decorative arches masking the juncture of aisle roofs and nave in a Gothic Church.

Triptych *See* Diptych.

Tumulus Above-ground mound of an ancient grave.

Tympanum Space between the lintel over the doorway of a Christian church (Romanesque or Gothic, especially) and the arch above; usually filled with carved relief sculpture.

Vault, barrel vault, corbelled vault, groin	A system of covering open space between walls or colonnades. Combines arches and extended tunnels through the use of stone or brick webbing. A barrel vault is an extended arch; a corbelled vault is created by joining overlapping courses of material at the top of an opening; a groin vault is an intersection of two barrel vaults at right angles.
Vihara	Monastery dwelling for a Buddhist community of monks or nuns.
Vimana	The main sanctum and tower above it that centers an Indian temple complex; usually used for South Indian structures.
Voussoir	Wedge-shaped block of a true arch.
Ziggurat	Ancient Assyrian and Babylonian temple base in the form of a pyramidal tower, either stepped or in the form of a spiral ramp.

Index